SWEET CANADIAN GIRLS ABROAD

SWEET CANADIAN GIRLS ABROAD

A Transnational History of Stage and Screen Actresses

CECILIA MORGAN

McGill-Queen's University Press
Montreal & Kingston · London · Chicago

© McGill-Queen's University Press 2022

ISBN 978-0-2280-1137-8 (cloth)
ISBN 978-0-2280-1138-5 (paper)
ISBN 978-0-2280-1327-3 (ePDF)

Legal deposit third quarter 2022
Bibliothèque nationale du Québec

Printed in Canada on acid-free paper that is 100% ancient forest free (100% post-consumer recycled), processed chlorine free

This book has been published with the help of a grant from the Canadian Federation for the Humanities and Social Sciences, through the Awards to Scholarly Publications Program, using funds provided by the Social Sciences and Humanities Research Council of Canada.

We acknowledge the support of the Canada Council for the Arts.

Nous remercions le Conseil des arts du Canada de son soutien.

Library and Archives Canada Cataloguing in Publication

Title: Sweet Canadian girls abroad : a transnational history of stage and screen actresses / Cecilia Morgan.
Names: Morgan, Cecilia, 1958- author.
Description: Includes bibliographical references and index.
Identifiers: Canadiana (print) 20220214662 | Canadiana (ebook) 20220214808 | ISBN 9780228011378 (hardcover) | ISBN 9780228011385 (softcover) | ISBN 9780228013273 (PDF)
Subjects: LCSH: Actresses—Canada—Biography. | LCSH: Actresses—Canada—History—19th century. | LCSH: Actresses—Canada—History—20th century. | LCSH: Actresses—Canada—Social conditions—19th century. | LCSH: Actresses—Canada—Social conditions—20th century. | LCGFT: Biographies.
Classification: LCC PN2307 .M67 2022 | DDC 792.02/8092520971—dc23

Set in 11/14 Filosofia
Book design & typesetting by Garet Markvoort, zijn digital

To David Westlake (1960–2018)

and to Paul Jenkins

CONTENTS

Acknowledgments
ix

Introduction:
Why Actresses? The Personal
and the Professional
3

CHAPTER ONE
Becoming an Actress: Childhood,
Family, and the Stage
23

CHAPTER TWO
Working Lives
50

CHAPTER THREE
The Plays
83

CHAPTER FOUR
Celebrity
129

CHAPTER FIVE
Citizenship
174

CHAPTER SIX
The Interwar Decades:
Retaining Old Patterns, Facing
New Challenges
215

CHAPTER SEVEN
The Modern — and Transnational —
Sweet Canadian Girl Onstage in London ... and New York ...
and Sydney ... and Auckland
249

Epilogue
303

Dramatis Personae
307

Figures
309

Notes
315

Bibliography
379

Index
419

ACKNOWLEDGMENTS

Words cannot express how delighted — and relieved — I am to be writing this part of the book. My deepest gratitude to the Social Sciences and Humanities Research Council of Canada for providing me with an Insight Research Grant for this research. SSHRC support made it possible to conduct my own "research tour," going on the road to visit archives in Australia, Canada, and the United States. Many thanks, as well, to the archivists and librarians in those institutions: the Billy Rose Theatre Division, New York Public Library; the Houghton Library, Harvard University; the Folger Shakespeare Library; the Australian National Library; and the Hamilton Public Library's Local History and Archives Collection.

I'd also like to thank Mark Abley, now retired from McGill-Queen's University Press, for his unending support of my work, and Jonathan Crago, who took over from Mark and helped get this book to publication with patience, efficiency, and wise counsel. Much gratitude, too, to McGill-Queen's staff, including Alyssa Favreau, Kathleen Fraser, Joanne Pisano, and Jennifer Roberts. Thanks to David Drummond for creating such a lovely cover for my book; it captures the spirit of this research in so many ways. Thanks as well to Grace Rosalie Seybold, my copy editor, for her fine work on my manuscript.

Matthew Dunleavy, Sasha Kovacs, and Kate Zankowicz provided important research assistance; I'm so glad to have had their input and suggestions. My thanks to Mike Di Tomaso, who walked me through the mysteries of eBay. As well, I'm grateful to members of the audience, fellow panelists, and commentators at the following conferences, seminars, and workshops: American Historical Association; Australian Historical Association; Canadian Committee on Women's History Conference, Simon Fraser University; Canadian History of Education Association; Canadian Historical Association; Centre for Theatre, Performance, and Drama, University of Toronto; Colloquium for Magazines, Travel, and Middlebrow Culture, Carleton University; North American

Conference on British Studies; Society for the History of Childhood and Youth; Society for the History of Emotions; Victorian Studies Association of Ontario; and Transnational Lives: Biography Across Boundaries Conference, Humanities Research Centre, Australian National University.

Portions of this book have appeared in the following:

"English-Canadian Actresses and the Multiple Networks of the Urban Atlantic, 1890s–1920s." In *Cities and the Circulation of Culture in the Atlantic World: From the Early Modern to Modernism*, edited by Leonard von Morzé, 207–30. New York: Palgrave Macmillan, 2017.

"'She Is a Canadian Girl': English-Canadian Actresses' Transatlantic and Transnational Careers through the Lenses of Canadian Magazines, 1890s–1930s." *International Journal of Canadian Studies / Revue internationale* 48 (2014): 199–236.

"'That Will Allow Me to Be My Own Woman': Margaret Anglin, Modernity, and Transnational Stages, 1890s–1940s." In *Biography Across Boundaries: Transnational Lives*, edited by Angela Woollacott, Desley Deacon, and Penny Russell, 144–55. New York: Palgrave Macmillan Press, 2010.

I would like to thank the publishers for permission to use these works, which form part of chapters 2, 3, and 4.

Special thanks to Kristine Alexander, Arianne Chernock, Desley Deacon, Paul Deslandes, Nancy Ellenberger, Faye Hammill, Lorna McLean, Nicole Neatby, Jane Nicholas, and Angela Woollacott for their encouragement, insights, and suggestions. I owe Desley her own round of applause for her support, generosity, and willingness to share her thoughts about actresses and transnationalism. My thanks to the anonymous reviewers for their feedback and for convincing me that I did not have to do everything.

Working on this book involved a fair bit of academic boundary-crossing, which at times was enjoyable, exciting, and inspirational. Even more gratifying was the opportunity it gave me to revisit an earlier part of my life and to have the input of those who make their living in professional theatre. Severn Thompson, thank you very much for sharing the biography of Margaret Anglin that inspired me to think more seriously about this project. Mike Wallace, of Theatre Museum Canada, I'm so pleased you welcomed my proposal for an exhibit on the "Leaving Ladies" and that we could work together to make it happen. Theatre Museum is a true

cultural treasure and deserves far more support than it receives. Matthew Dunleavy's design work for the exhibit warrants a special note of thanks for his creative and technical skills. On a sadder note, I greatly regret that Brent Carver did not live to see this book, and the thanks he deserves, come to print. I was honoured and touched that an "actor of his calories" (Brent's words) took such a keen interest in this research and kept asking me about Miss Anglin and my ladies. I greatly enjoyed our conversations, about this work and about so much more. I hope the same was true for him.

Readers of the dedication page will notice that this book, which focuses on female performers, is dedicated to two men, neither of whom was an actor. Yet both spent their working lives in theatre and live performance, providing the high levels of skilled craft, years of expertise, and talent that enable performers to create different worlds. David Westlake was not just a very talented builder; he also was a good friend, who didn't mind hearing about the number of backflap hinges it took to build Greek theatre at Berkeley (and a lot more besides). I miss him. Paul Jenkins is now enjoying retirement from a very long career at the Shaw Festival but, fortunately for me, has not retired from supporting my work with good humour, a sympathetic ear, and much love.

SWEET CANADIAN GIRLS ABROAD

INTRODUCTION

Why Actresses? The Personal and the Professional

Prelude

Why study actresses? I was asked this question by a fellow historian at a talk I gave about this research a few years ago. The following is an attempt to answer her; I hope it's more comprehensive and articulate than my response at the time.

This book comes from several locations, personal and professional. Growing up in rural southwestern Ontario, I loved to read, was entranced by my family's trips to the theatre, both Stratford and Theatre London, and found actresses fascinating. For reasons that I don't really understand, given the devout Catholicism of much of my family, we had biographies of the (somewhat notorious) French tragedienne Sarah Bernhardt and the (much more notorious) Irish actress and dancer Lola Montez (Eliza Gilbert) on our living room shelves. I devoured both. I can't explain exactly why they interested me so much, other than to say that histories of women's lives in general did and that Bernhardt and Montez lived highly dramatic ones, marked by adventures and global travel. What's more, at the age of ten I saw Martha Henry perform Titania in *A Midsummer Night's Dream* at Stratford. It remains one of my favourite Shakespearean plays and her performance sticks in my memory as magical and compelling, an example of how a woman onstage could be commanding and important.

I didn't go on to be an actress but I did go on to train and, for a few years, work in theatre, primarily in stage management, so I saw actors in many ways. And even after I returned to university and retrained as an historian, theatre was still part of my life, not least because my partner began working for the Shaw Festival in 1980 until his recent retirement (much of his time, coincidentally, under the artistic direction of

Christopher Newton, Henry's Oberon in that Stratford production of *Dream*). However, when I returned to academic study in 1984, theatre history was — at least in the context of Canadian history — considered the purview of those based in English and drama departments. Moreover, the theatre history I had studied at Dalhousie University and Ryerson Polytechnical Institute was not connected to the burgeoning field of social history and its categories of gender, class, race, ethnicity, and sexuality that I encountered in completing my undergraduate degree and in graduate school. But while researching a book on English-Canadian middle-class tourism in Britain and Europe for the late-Victorian and Edwardian years, I was struck by the number of times these tourists went to the theatre and live performances while abroad, and, too, by the attention paid to actors and actresses by magazine and periodical writers. Far from being dominated by an anti-theatrical bias, many members of the English-Canadian middle class embraced theatre (and not just Shakespeare) as part of their cultural heritage. I also had discovered, partly through my research, partly through teaching a course in comparative cultural history, that there was a very rich body of scholarship on theatre and performance in the Anglosphere and that much of it dealt with questions of gender, race and ethnicity, class, and sexuality.

Why actresses, though, as my questioner asked? And why this group of actresses? Although many of the themes that run through this book have interested me for some time — movement across geographic, national, and cultural borders, the relationship of gender, class, race, and empire to culture, and the place of nineteenth- and early-twentieth-century Canada in transatlantic and transnational worlds — it's more than possible that I could have explored them looking at other phenomena, other casts of characters. Yet these actresses held a special relationship to many of the questions that have driven my scholarship, not least because their lives shed light on the themes of gender, transnationalism and empire, and, in particular, middle-class formation.

Theatre, Gender, and Mobility in the Transatlantic and Transnational Worlds of the Nineteenth and Early Twentieth Centuries

As historians who have looked at actresses' position and significance within Victorian and Edwardian theatre and society have argued, they

were among the most highly visible women, ones who transgressed the boundaries that divided home, work, and public space.[1] While for some their status remained controversial, as older notions of actresses as being akin to prostitutes or "public women" did not vanish, nevertheless their ability to be highly conspicuous, at times highly notorious, and yet also highly admirable has proven rich ground.[2] Historians on both sides of the Atlantic have pointed out that actresses became integral to the spread, reach, and cultural import of theatre and performance, particularly from the 1890s to the 1920s. This phenomenon was accompanied by the growing number of middle-class women in theatre audiences and a proliferation of representations of femininity in Anglo-American culture, in genres and venues such as photography, sculpture, pageants, magazines, and advertising.[3] Moreover, as Tracy C. Davis's groundbreaking work has demonstrated, they also were workers (something I had seen "up close and personal"), ones whose labour took place on many levels: physical, mental, emotional, and, most importantly, cultural.[4] In some cases, they were workers who became — at times simultaneously — managers of their own companies; a few were involved in other entrepreneurial and artistic endeavours, such as publishing and playwriting.[5] As those who have studied the (sometimes fraught) relationship between actresses and the woman's suffrage movement have pointed out, a number of female performers either lent their names and celebrity to it or were significantly involved in suffrage organizations.[6] Thus, given the many studies of these women, what does focusing on those English-Canadian women add? To paraphrase my questioner, why these particular actresses?

My answer has multiple components, since I see this work as contributing to multiple fields. The most straightforward and obvious reasons for looking at these particular women are bound up with the basic premises of women's history: to reclaim their lives, which generally have not been well-studied, to restore them to a historical narrative that has overlooked many of them (even those who were well-known during their lifetimes), and to do so within a framework and method of critical feminist biography, one in which the narrating of collective lives can have significant weight and meaning for our understanding of gender relations in the past and their entanglement with those of class, race, nation, and empire (more about collective biography later).

Although groundbreaking work by theatre historians David Gardner, Denis Salter, and Paula Sperdakos has pointed to the number of women from English Canada who pursued careers as actresses in the United States, my study expands their numbers, explores travel to both Britain and the Antipodes as well as to the US, and, moreover, is based on both a wider range of primary sources and historiography in related fields, the latter developed after these historians published their studies.[7] As well, despite the extensive range and depth of Canadian women's and gender history, with its attention to women's experiences, activism, and agency,[8] apart from a few studies of individual performers the stages on which these women mounted their lives and careers have not attracted an audience in that field.[9] While theatre and performance historian Marlis Schweitzer writes about the need to convince her colleagues in theatre and performance studies of the need to study history within theatre, and her colleague Heather Davis-Fisch calls for a revisionist approach to the study of Canadian performance history, my task, it seems to me, is rather the opposite: to convince my historian colleagues of the importance of theatre, both in Canada and beyond.[10] With that hope in mind, my exploration of these women's lives suggests that we can gain much by including them. For one, working as an actress was not, as the sheer number of women whose lives are considered within this book demonstrates, simply a curiosity or exception that had no greater social or cultural significance beyond a few prominent individuals.[11] Rather, a life as a performer was a path that a number of English-Canadian women chose and that had meaning and legitimacy. It offered as many opportunities and possibilities as domestic service, teaching, and pink-collar work (if not more), which, outside of marriage, were the most common forms of employment for many such women. This book points to the different ways in which performance could open up new worlds for women, and, for some, provide attractive and meaningful ways of making a living, crafting a career, and, in the words of Ottawa-born Margaret Anglin, "'becoming [their] own woman.'"[12]

It also was a career that had to be pursued in multiple locations. By the late nineteenth century, theatre in North America was heavily reliant on touring, leaving its practitioners with little choice but to be highly mobile. Moreover, unlike their counterparts in Britain or the United States, the women in this book had to move across multiple national

borders to make a living as performers. Such was particularly the case after American theatrical syndicates entered the Canadian marketplace in the 1890s, a development that made the theatre industry in Canada one of the first economic sectors to be affected by American monopoly capital.[13] The women whose lives form the substance of this book thus toured North America and went to Britain, while a few sailed across the Pacific to Australia and New Zealand, experiencing "transnational lives" that might have started in Hamilton, Nanaimo, Ottawa, or Winnipeg (or, in some cases, England or Ireland) but then were lived out in New York, Boston, London, Sydney, and many other cities and towns in between, including those in Canada. What's more, their continual mobility across borders, continents, and oceans differentiated their lives from many of their counterparts. While other women also voyaged across oceans and continents during this period — accompanying families, seeking paid work and higher education, and joining religious missions — often their travels were intended to be finite, to end at a particular destination (even if those intentions did not always match their experiences). For actresses, like other performers, constant motion was an accepted, if not always welcome, reality of their work. Because of their mobility, this book uses a transnational perspective to explore multiple aspects of their lives, thus contributing to the small, albeit growing, body of literature on Canada's historical relationship to transnationalism, to transnational perspectives on Canadian women's and gender history, and, more broadly, to scholarship in transnational history, reminding us of the need to consider gender and culture — as well as politics and the economy — in the spread and reach of transnational ties.[14]

Given the growing ubiquity of transnational histories, it may be helpful to explain just what a "transnational perspective" for a historian might be. As Pierre-Yves Saunier has argued, adopting this vantage point does not replace other frameworks or arguments; rather, it provides a point of view that strives to complete them. As Saunier goes on to point out, "transnational history is the chronological peninsula of a wider body of scholarship, firmly connected to it but with distinct contours," a perspective that provides "continuity," not rupture, with the work of those who have explored the entangled relationships between politics, societies, and communities.[15] Moreover, as he and many other scholars of transnationalism's histories have pointed out, taking such a perspective

does not mean denying "nations as realized categories," since they have often played an important role in framing both individual and collective lives.[16] Rather, it means that we query the "composite" natures of both nation and state, thinking "with and through" them, and attempt to understand their multifarious natures, thus questioning their own narratives of "autonomous production." Adopting the multi-sited method demanded by a transnational perspective, one that tracks the circulation of people, things, or ideas and imaginations, allows us to take stock of the reciprocity between "demarcated territorial units" and circulations, how one works on the other and vice versa.[17] Moreover, while transnational historical perspectives are closely related to comparative, global, and world history, as Desley Deacon, Penny Russell, and Angela Woollacott emphasize, such perspectives rely on connections and, unlike world history's large-scale approach, they include sites that are regional as well as global. Furthermore, unlike world history's common emphasis on political and economic themes, transnational perspectives also pay attention to cultural and social links.[18]

In many ways, theatre and performance of this period are ideal subjects for writing history from a transnational perspective, with their highly mobile practitioners, far-flung networks and circuits, and scripts and practices (such as acting styles, directing and design techniques, and forms of management) that represented exchanges across and through national borders,[19] all of this carried out in ways marked by modifications, rearrangements, or reimaginings in local and regional contexts. Theatre's potential for explorations of such historical dynamics is not always acknowledged by historians of transnationalism: overviews of transnational circuits and exchanges during the nineteenth and early twentieth centuries tend either to only glance at theatre or to focus on other types of entertainments (circuses, exhibitions, film, and radio).[20] Simultaneously, theatre historiographies have at times relied on the nation-state as a central framework, in ways that can, in Alan Filewod's words, deny the "porousness of theatre culture."[21] While, as S.E. Wilmer points out, there are good reasons for paying close attention to the nation-state,[22] nevertheless a growing number of historians of nineteenth- and early-twentieth-century theatre have pointed out how deeply it was bound up and intertwined with transatlantic exchanges and transnational networks.[23] To be sure, this scholarship is not limited to

relatively recent work, since Canadian historians have long made contributions to our understanding of ways in which nineteenth-century theatre in Canada was shaped by international networks. As Schweitzer has pointed out, essays in *Early Stages* and *Later Stages*, work by Salter, Sperdakos, and Gardiner, and other studies were marked by a desire to move beyond the nation and think more "hemispherically" in ways that included not just the United States but also the Caribbean.[24] Given the cultural and economic significance of theatre and related forms of performance in this period, those exchanges and networks were far from inconsequential.[25]

Not only was Canada part of those transnational theatrical networks and extra-theatrical cultures, but English-Canadian actresses also were deeply embedded in them and provide multiple vantage points on transnationalism. Canadian actresses' lives embodied forms of mobility that could be linear — for example, moving from Canada to the United States or Britain and then returning to Canada to tour (and, for some, to retire). Their movements, though, could also be more circular and follow different routes and circuits of performance. An actress might tour both Canada and the United States, sail across the Atlantic to Britain, return for a tour of North America, venture across the Pacific to Australia and New Zealand, then embark on yet another round of touring that crisscrossed borders and oceans. Moreover, these women's status as celebrities was marked by discussions of their national affiliations in ways that could be more complicated than was the case for American or British women; such discussions opened up questions of national belonging and, simultaneously, might reinforce national identities. Those who performed primarily in the United States might see their origins in and connections to Canada obscured or simply ignored as being inconsequential, something to be absorbed into the category of "American." At other times, though, the same women were hailed by the press — and chose to describe themselves — as being from "Canada," a place distinguished by its abundance of nature, its simpler and more innocent ways: in short, a place that produced "sweet Canadian girls." Canadian cultural critics noted — with varying degrees of either lamentation or celebration — that it was possible for English-Canadian women to be successful in a theatrical world that both encompassed and transcended Canada.[26] Moreover, these actresses provide a particular perspective on

the intertwined relationships of nation and empire during this period. Canada's position as a Dominion within the British Empire shaped the ways in which women such as Lena Ashwell, Julia Arthur, Margaret Bannerman, or Beatrice Lillie were received in the Canadian and British press. Because of their ties to Canada, reporters claimed, these women were distinct from British performers in interesting ways; simultaneously, though, because they were Canadian, they had little difficulty understanding English cultural mores and practices, particularly when it came to accents and pronunciation. The same could not always be said of their American-born counterparts. Furthermore, although in many ways these actresses resembled Australian women, being members of a settler Dominion who were obliged (in historian Angela Woollacott's words) to "try [their] fortune in London" as performers, differences of geography (the proximity of the United States, for example) and culture (a less noticeable accent, for one) created distinctions between the two groups.[27]

As well as being subject *to* transnational movement, representatives of the connections and circulations that it entailed, these actresses were in many ways intermediaries *of* transnationalism, as they facilitated the movement of ideas and practices circulated by transnational theatrical circuits and networks (and much more). For one, they performed in plays that were themselves shaped by transnational movement: plays brought from or set in a number of European countries that were then adapted for the stages of North America, Britain, and the Antipodes; plays that, while penned by British or American playwrights, evoked Britain's imperial possessions as important settings or plot devices; plays that hinged on the transatlantic relationship between Britain and the United States; plays in which racial and imperial fantasies, whether of America's frontier, African-Americans in the US South, or Orientalist dramas, were given free rein; and, in the 1920s, musical revues that originated on London stages, represented particular forms of English modernity, and were then brought to New York. Furthermore, a number of these women supported the woman's suffrage movement or the Allies in World War I (or both), thus claiming forms of political subjectivity and citizenship that were rooted in national formations but that also went beyond them. Moreover, the Roman Catholic church, itself a transnational institution, played an important role in the life of Margaret Anglin.

Transnationalism, Middle-Class Culture, and Racial Identity

These actresses also participated in a particular form of transnational exchanges and entanglements: the global spread of middle-class culture. As Christof Dejung, David Motadel, and Jürgen Osterhammel have argued, although the nineteenth century has long been seen as the European bourgeoisie's "golden age," sites around the world — Shanghai, Delhi, New York, Cairo, Vienna, and the Gold Coast — were marked by the shared "lifestyles, tastes, and values" of the middle class. Global exchanges and connections, fuelled by nineteenth-century imperialism, transportation and communication systems that became more widespread and denser, and the spread of international capitalism, provided the context and impetus for the spread of middle-class norms and practices.[28] We cannot assume that this was a straightforward, linear process in which models developed in Europe simply were applied to other contexts (national or colonial). Instead it was an uneven, heterogeneous process, in which the flow of exchanges could be from colonies to Europe, thus changing the worlds of the latter's middle class, and members of the middle class in some contexts had little or no relationship with their European counterparts.[29] Nevertheless, the spread of middle-class sensibility, manners, morals, and taste, expressed in social institutions (clubs, coffee-houses, and voluntary organizations), social practices (balls and reading circles), and cultural sites (operas, universities, public parks, grand hotels, and, in particular, theatres), was shaped by "transnational and transimperial structures," all of which represented "processes of socialization on a global scale."[30] Moreover, this history has importance beyond just our understanding of the diffusion of the bourgeoisie. A. Ricardo López and Barbara Weinstein have argued the increased spread of the middle class has been "one of the major transnational political projects of modernity through which historical actors have struggled to define themselves as belonging to a social collectivity."[31] Yet unlike, for example, the United States or England, work on the formation of middle-class communities and middle-class consciousness in English Canada has received less attention from historians: "middle class" in English-Canadian historiography often serves as a means of identifying already-formed groups, attitudes, and institutions, rather than as an ongoing historical process.[32] Furthermore,

to date little has been written about the ways in which English Canada's middle class was shaped by and participated in transnational currents.[33] This study thus suggests how Canadian actresses — and theatre in general — should be considered as important participants in the formation of middle-class attitudes and discourses, part of the process by which the English-Canadian middle class was constituted and represented itself both within Canada and on international stages. Moreover, their lives also suggest possibilities for future research that places middle-class formation in Canada within transnational and transatlantic worlds.

Studying these actresses sheds light on questions of class and its ongoing constitution in many ways. Just as the middle class itself has been defined as a heterogeneous structure, one that ranged from some of the world's richest to those with very modest backgrounds,[34] so too did this particular group of English-Canadian women run a socio-economic gamut. Some came from modest means (Elizabeth Jane Phillips), others were from middling backgrounds (Julia Arthur, Catherine Proctor), and a few came from well-off, prosperous professional families (Margaret Anglin, Frances Doble). Still others — Arthur, Viola Allen — rose from comfortable backgrounds to great wealth, because of both their work and their marriages to rich men. Like many members of the nineteenth-century bourgeoisie, a number of these women also experienced financial reverses and degrees of economic insecurity, shaped by the commercial nature of nineteenth-century theatre. And, like the bourgeoisie in general, this group represented salaried employees who struggled to make a respectable living, but it also included those who became managers and entrepreneurs. As a group of performers, these women thus provide us with a range of insights into "what it meant to be — and live — the middle class" in multiple geographical locations.[35] Moreover, these women also represented the middle class to itself, both within Canada and beyond. They provided ways for the middle-class audiences they reached to ponder questions of identity and subjectivity: through the subject matter of many of the plays in which they appeared; the emotional values they either represented or questioned, both onstage and off; the social mobility they achieved through theatre; and the contours of their celebrity, the latter shaped by claims to respectability, self-improvement and education, hard work, concerns for family and heterosexual domesticity, and social responsibility, not least in their

charitable work for their profession and beyond. This is not to argue that there weren't moments when they either challenged or contradicted such norms and ideals, both directly and implicitly, nor that their work and images were always stable and fixed. It is, though, to acknowledge their imbrication in transnational currents and exchanges that helped constitute middle-class subjectivities and practices.[36]

Throughout this book I point to examples of heterogeneity and difference; however, these women shared one critically important form of identity and affiliation – their whiteness. Given the growth of global racial hierarchies over the course of the nineteenth century, the fact that these performers were overwhelmingly white is probably not too surprising; to make even a meagre living in mainstream theatre was linked to a level of racial privilege denied racialized or Indigenous women.[37] As numerous scholars have demonstrated, the worlds of theatre and performance on both sides of the Atlantic were shaped by ever-increasing forms of racial stratification and hierarchies. Notions of race and empire permeated performances, while theatre managers perpetuated practices of racial segregation, ranging from the kinds of performers they hired, to the types of performances they promoted, to the ways in which audiences were seated.[38] Far from being immune to these racially charged discourses and practices, these women's careers were embedded in them; in many ways, it was their representations of white, middle-class womanhood that gave them the status of subjects both empathetic and authoritative. For one, they appeared in plays that included Orientalist fantasies of exotic others; *Uncle Tom's Cabin*, with its messages about white innocence and benevolence; English drawing-room comedies and dramas in which distant colonies played a central role in advancing the plot; performances that incorporated blackface and yellowface mimicry; and American frontier dramas that relied on white women, both as imperilled by and as domesticators of Native Americans and Mexicans, to secure white settlers' advancement.

It was not just onstage that race and concepts of white supremacy shaped their lives. Throughout this period the British Empire continued to expand its reach in ways that extended and consolidated its rule, an expansion that was felt in Britain in many ways, not least in the realms of advertising and consumption, popular culture, and literature.[39] In turn, the United States saw an ever-increasing hardening of racial hierarchies

with the passage of Jim Crow laws, the disenfranchisement of African American voters, the implementation of tactics of racial terror such as lynching and massacres of newly emancipated African-American communities, and state-sponsored warfare on Native American nations and in Cuba and the Philippines. In Canada, the consolidation of the nation-state after 1867 was shaped by the dispossession of Indigenous nations, the expansion of white settler communities, the continued marginalization of African-Canadian communities, and the new confederation's entanglement with, in historians Marilyn Lake and Henry Reynold's words, the "global colour line" in which immigration was shaped by racially exclusionary policies and laws.[40] Despite the vicissitudes and uncertainties of being an actress, then, these white Canadian women enjoyed a degree of freedom to move across a number of borders, one denied to many racialized and Indigenous women in the decades covered by this book. Such privilege is most clearly illustrated by Margaret Anglin and Margaret Bannerman's ability to enter and tour Australia after the 1901 passage of the White Australia Policy. Being a "sweet Canadian girl" meant, in this period, being a "white" Canadian girl.

Thus, in their involvement in the ongoing formation of the global middle class, these women also helped shape the latter's racial landscape. As Fiona Paisley and Pamela Scully point out, while "myriad forms of agency and subjectivity have been formed in the spaces between the national and the transnational ... transnationality has never been and is not in itself liberatory."[41] Too, Emily S. Rosenberg reminds us that while transnational networks and webs of affiliation may well have "transcended geographical boundaries ... they nevertheless participated in other kinds of boundary drawing."[42] The life of Montreal's Frances Doble, whose acting career in England and involvement in 1930s European fascism ends this book, is an unambiguous reminder of that point.

Collective Biography

In exploring the themes discussed above, feminist collective biography seemed to me to be a particularly productive method, a decision shaped by both practical and conceptual matters. Although at times these women worked for the same managers, for the most part they were dispersed across a range of companies (which might include their

own), thus making a more institutionally focused approach on specific companies less fruitful. Collective biography itself, the study of multiple lives connected by membership in a profession, institution, or experience, has a long history as a method in social and women's history. For these women's contemporaries engaged in writing feminist history, such a method was "the main avenue into historiography."[43] To be sure, it would have been possible to look only at a small handful of women, particularly those who enjoyed successful, lengthy careers and who thus have left extensive traces in the archives, such as Margaret Anglin, May Irwin, or Beatrice Lillie. Indeed, theatre historians and scholars in English have written well-researched and thought-provoking biographies of some of these women.[44] Yet as previously stated, looking at a wider group of women demonstrates that Anglin, Irwin, or Lillie were not exceptions; the lens of collective biography allows us to see similarities between these women, moments when their lives fit into larger social, economic, and cultural patterns, and the emergence of "common themes and concerns" in their careers.[45] Such patterns may not be discernible through a focus on one individual; certain aspects of their lives may seem anomalous, for example. In turn, it is equally important not to lose sight of those moments in which individual personalities, specificities of their backgrounds, and contingencies of circumstances brought about different outcomes. Those whose careers were curtailed by illness, premature death, and changes in performance styles or those who, while managing to maintain a long-lived career, were less celebrated also have valuable lessons to teach us about the practice and pitfalls of life as a performer, even if (especially if) they have not left enough of a trail through the archives to warrant a more traditional biographical treatment.[46] As historian Alison Mackinnon points out, while the use of collective biography might not give readers "access to a complete 'life,'" nevertheless "we can become acquainted with a 'self' represented at a particular time."[47] What's more, biography in general has proven to be a highly effective way of studying transnational and imperial history, as it "retraces how individuals come to terms" with both the opportunities and constraints that underpin transnational movement.[48] In this way, "focusing on people and their connections can help make visible how the realms of the transnational, the national, and the local intersected."[49] And as Paisley and Scully point out, "sometimes it is just good to be reminded that

actual individuals peopled the past."[50] This book thus combines narratives of individuals' lives with arguments and analysis, both important elements of the historian's craft.

In determining who walks onstage in the pages of this book, I have been relatively catholic in my choices. Readers may note that I include women such as Viola Allen and Lena Ashwell who were not "Canadian born," or that Clara Morris, who was, spent only a few years in Canada. Their lives, though, have much more to tell us than simply letting, in Australian historian Jill Julius Matthew's words, the "death grip of the national" determine how, when, where, and (importantly) why we see them.[51] It is not my intention to determine just how innately or objectively "Canadian" the women who appear here were, to set up some kind of national litmus test to determine who gets to be included in this book and who does not. Furthermore, for these women being "transnational" did not mean losing all ties to their birthplace or childhood home. The press, both international and Canadian, and many of the women themselves claimed Canada, reminding audiences that it was a fundamental part of their history and sense of self, even as they were depicted – or depicted themselves – as denizens of stages that ranged from New York to San Francisco, London to Edinburgh, and Auckland to Sydney. As well, while for the sake of coherence and manageability I have made a deliberate choice to limit my "cast" to actresses from English Canada, I hope that similar research could be done on women in Quebec: for example, to see if opera singer Emma Lajeunesse's success inspired others to follow her across the Atlantic.[52]

Chronology and Place

In tracking these actresses, I have adapted a chronological framework that covers childhoods that began in the late 1860s and '70s and extends into the 1920s and '30s. Many of these women were born into a period in which American stock companies (a troupe of actors that performed regularly in a particular theatre in one city) began to be displaced by touring companies (the latter phenomenon shaped by the widespread expansion of railroads after 1865) and the growth of theatrical syndicates that, by the late nineteenth century, came to exercise monopoly control over American theatre.[53] Toronto-born Clara Morris experienced

many of these changes, as she began her career as a performer with a stock company in 1860s Cleveland. Her move to New York in the 1870s allowed her to benefit from the expansion of larger companies, run by prominent actor-managers such as Augustin Daly, that specialized in the kind of sentimental melodrama in which Morris excelled. Women such as Anglin, Arthur, Allen, Annie Russell, and Caroline Hoyt forged their careers from the 1880s to the 1910s, decades that saw a boom in middle-class leisure and, related to that boom, a growing sensibility that theatre could be a respectable entertainment, one that attracted audiences of middle-class women and girls. Over this period, "the actress," both North American and European, became a prominent figure of celebrity; many more women opted for a career on the stage.[54] Simultaneously, promoters such as Tony Pastor transformed saloon variety shows into the more orderly and "refined" form of vaudeville. While vaudeville also became subject to monopoly capital and centralized control, it offered opportunities for women such as Amelia Summerville and May Tully as performers, authors, and managers.[55]

Although it seems that, unlike their Australian contemporaries, fewer women from Canada went to Britain than to the United States, nevertheless the careers of Lena Ashwell and Mary Keegan, for example, were interwoven with several significant developments in late-Victorian and Edwardian British theatre. The decades after the passage of the 1843 Theatre Regulation Act, which limited the British state's power over playhouses and plays, saw a host of new theatres spring up in London.[56] Between 1865 and 1895, single, long-running productions became more popular and audiences became more respectable, well-off, and (like those in the United States) increasingly made up of middle-class women.[57] Both Ashwell and Keegan appeared in London's West End theatres. Keegan also spent much of the 1890s touring throughout England, Scotland, and Ireland, appearing, for example, with Herbert Beerbohm Tree's Haymarket Company's production of the comedy *A Bunch of Violets* in 1894.[58] Ashwell also participated in early English feminist theatre, as she created the role of Diana in Cecily Hamilton's 1908 *Diana of Dobson's* and appeared in Hamilton's 1910 suffrage pageant *A Pageant of Great Women*. Ashwell and Keegan, then, were part of the rise of new forms of British drama from 1890 to 1918 but worked in a context dominated by commercial (and socially elite) actor-managers.[59] They also were tied

to transatlantic theatrical currents by more than birth or childhood in Canada. In 1906 Ashwell toured the United States in a production of *Mrs. Dane's Defence* and would also appear in Canada, while in 1892 Keegan appeared at London's Adelphi theatre in the American adaptation of German playwright Ludwig Fulda's *Lost Paradise*, a drama that dealt with the themes of social mobility and marriage, as well as the relationships of capital and labour.[60] Yet others travelled across the Atlantic to appear either with English companies – Julia Arthur with Henry Irving's Lyceum – or as part of theatre impresario Charles Frohman's "American invasion" of the late 1890s. The latter saw Russell star in the American frontier drama *Sue*; she returned to London in 1905 and originated the role of Barbara Undershaft in George Bernard Shaw's *Major Barbara*.

My story of these actresses carries through into the twentieth century and extends to the 1930s. Although theatre and performance historians treat the decades of 1880–1918 as a discrete and distinct period (as do many other historians), my approach warrants a longer chronology. For one, individual lives do not always fit within scholarly frameworks; "finishing the story" of Arthur's and Anglin's lives within their specific historical contexts necessitates exploring the interwar decades. Although they became prominent in the 1890s and 1900s, they continued their careers into the 1920s and '30s, along with their counterparts Catherine Proctor, Lucille Watson, and Mae Edwards. Moreover, just as work on the history of commemoration and public memory has identified considerable continuity in cultural forms and genres with the late-Victorian and Edwardian eras,[61] these actresses' experiences also demonstrate surprising amounts of continuity with the Edwardian years: the middle-class audience at which much of their work was aimed; their status as respectable, morally admirable celebrities who might serve as role models for a younger generation; the struggle to make a decent living on the American touring circuit; and, for Lena Ashwell, the problems of commercial West End theatre's continued dominance.[62] Taking stock of their lives also allows me to explore how these women dealt with age, a question particularly pertinent in the youth-obsessed 1920s. Yet during World War I and into the 1920s and '30s a new "generation" of Canadian actresses, Beatrice Lillie, Margaret Bannerman, and Frances Doble, travelled to Britain, the United States, and, in Bannerman's case, New Zealand and Australia to pursue their

careers. They encountered theatrical worlds that had been affected by newly reworked forms of entertainment (musical comedy, variety, and revues), more working-class and even more feminine audiences (in the case of London's stages), and the interwar decades' much-vaunted cultural and social fascination with new forms of modernity, manifested in technology, codes of behaviour, and fashion. Yet despite these important shifts in transnational middle-class culture, these women's lives also provide evidence of continuity with those of their predecessors, in the realms of celebrity, charity work, and national, imperial, and racial affiliations. Taking this research into the interwar decades allows me to explore questions of continuity and change; equally importantly, it demonstrates that working in theatre continued to be a viable and legitimate choice for twentieth-century Canadian women, not merely an anomaly of the late-Victorian and Edwardian decades.

Living in the Digital World

As mentioned previously, a few of these actresses are not completely unknown to historians of nineteenth- and early-twentieth-century theatre. Several biographies, biographical entries, and discussions of their work in monographs have provided me with important insights and, too, the foundations for narratives of their lives. However, the more recent digitization of newspapers and periodicals — not just for North America and Britain but also for Australia and New Zealand — provides a rich archive of performance advertisements, reviews, feature profiles, and actresses' engagement with philanthropy, first-wave feminism, support for World War I, and the world of advertising and consumption. This public, often far-flung record is the only source of information on many performers. Few kept personal records, or, if they did, these have not survived. The large archival collection of Margaret Anglin's papers or the fewer yet telling personal papers left by Lena Ashwell and Beatrice Lillie are exceptional. Relying on newspapers and periodicals as heavily as I do is a strategy that can be fraught with many pitfalls, most notably actresses' (and their press agents') desire to craft public images that might well be at odds with their experiences. Unlike Anglin's voluminous files of correspondence, press coverage cannot easily shed light on the daily business of running theatre companies, nor the conduct of relationships

with other performers, producers, and playwrights (not to mention fans), which might run the gamut between affectionate and supportive to wary and, at times, downright acrimonious. Moreover, while feature articles became ubiquitous in the early twentieth century, they cannot provide us with those insights into interior lives and subjectivity that more intimate or epistolary writings offer. Thus, in poring over these actresses' accounts of their lives, I have endeavoured to read with degrees of judicious skepticism, attempting to gauge where they might have been exaggerating, fabricating, or omitting details that might cast them in a less-than-appealing light (or all three): performing their lives, in other words, in ways that molded and reshaped certain facts in pursuit of a more desirable or exciting image (certainly such was the case for Clara Morris). Yet I caution against taking such a strategy to its logical extreme, a stance of extreme skepticism that mistrusts much of what these women tell us unless it can be verified by others. Feminist scholarship has taught us that while paying attention to women's words does not mean unquestioning acceptance of their veracity, it does remind us that "public space is always a dynamic intersection where various participants strive to fasten meaning on individuals and events. In such contests, public figures cannot control the meanings assigned to their persona, but they do set the parameters of plausible interpretations for their actions."[63]

The digitization of newspapers and periodicals, too, can be no less a selective process than the traces offered in the traditional archive. Such is particularly the case for Canada, where far fewer newspapers have been digitized than in the United States, Britain, Australia, or New Zealand.[64] While I have attempted to counter this problem by working with different databases, I also acknowledge that this is a solution available to a scholar housed at a well-funded research institution and equipped, moreover, with a generous research grant. Although I have used theatrical publications, such as *Theatre Magazine* (in both the United States and Australia) and the British weekly *The Era*, readers will notice that many of the reviews and feature pieces I cite come from non-theatrical publications, the daily and weekly press that became ubiquitous across the geographies I cover, growing at an immense rate from 1850 to the end of the 1920s.[65] I have done so partly because of their sheer volume; a search for "Margaret Anglin" or "Julia Arthur," for example, in the commercial database Newspapers.com can produce at least 5,000 "hits,"

ones that range from in-depth reviews to very basic notices of their appearances. By using publications that had an even wider reach than theatrical ones, I also wanted to see how these women were part of broader society. The scale and extent of coverage that these women received, captured by the digital archive, suggests the wide-ranging nature of theatre audiences over these years. That people across North America, Britain, and the Antipodes might read about these women, even if they had little opportunity to see them, suggests how newspapers might help constitute, paraphrasing Benedict Anderson, "imagined communities" of audiences, as well as nation-states. Although a more detailed exploration of this process is outside the scope of this book, it is worth remembering that theatre audiences might be transported by the plays they watched or the reviews they read, even if they did not leave St Louis, Winnipeg, Vancouver, or Bristol. While our tendency is to "think about mobile actors, connections are not always mobile."[66]

The Chapters

Chapter 1 takes us to the realm of childhood and youth and examines the reasons these women chose a career on the stage or, in some cases, explores the circumstances that led to it being thrust upon them. As well, it looks at those who were child or youthful performers and seeks to contextualize their experiences within the larger debates over children's labour in theatre and live performance in the late nineteenth and early twentieth centuries. Chapter 2 moves to the working conditions that actresses encountered in a period when "the road" dominated many performers' lives, but it also points to the possibilities, such as being a tourist, that extensive travel might provide. Some women, though, decided to exert more control over their working lives by becoming managers or producers, an area also explored in chapter 2.

Chapter 3 deals with the great variety and range of plays these women's careers encompassed, from the 1870s until the 1910s. An exhaustive exploration of all their productions would be very lengthy (and probably exhausting for the reader). Instead, I have chosen to highlight plays that illustrate this book's central themes: transnational exchanges, race and empire, the relationships of labour, capital, and class, the shaping of middle-class sensibilities (whether through the medium of domestic

melodrama or social reform), and the period's fascination with the European past. Chapter 4 tackles celebrity culture and looks at the multiple ways in which these women participated in its growth over the course of the late nineteenth and early twentieth centuries. While they came to the public's attention because of their work onstage, this chapter draws our attention to the many layers and meanings of celebrity that existed in this period. It argues, nonetheless, that a common thread that united their public image was that of respectability and modesty, a celebrity that was in many ways the epitome of bourgeois, liberal order (although I point to moments when that image was undercut by messy, disordered private lives). Keeping with the theme of their lives offstage, chapter 5 explores their public identities as transnational citizens: as members of charitable organizations, for causes both within and outside the theatre; as part of the woman's suffrage campaign; and as workers for the Allied cause in World War I.

Chapters 6 and 7 explore the 1920s and '30s. Chapter 6 continues with the careers of Margaret Anglin and Julia Arthur, performers who were prominent in the late nineteenth century and pre-WWI decades and who continued to act and, in Anglin's case, produce after the war. Chapter 7 introduces Beatrice Lillie and Margaret Bannerman, women who represented new ideals of glamour and feminine modernity, onstage and off, in the interwar decades. Both women differed from many of their predecessors because of their work in West End revue, a form of entertainment that drew on older genres (music hall, in particular) but that also had a particular set of meanings attached to identities of class and nation in 1920s Britain. Simultaneously, though, their public images relied on many of the same tropes that had marked those of their predecessors. The book ends with an Epilogue that reflects on the significance of these women's histories.

CHAPTER ONE

Becoming an Actress: Childhood, Family, and the Stage

Introduction

What were the paths that led these women to become actresses? When asked why they had chosen their careers, the women themselves showed little consensus regarding their reasons for going on the stage. Some felt "born" to perform, their talent so innate that it only needed the right circumstances to flourish. Viola Allen (1867–1948), for example, claimed that while education, practical knowledge, hard work, and experience would help a young woman realize her ambitions, "'talent alone can bring utmost success.'"[1] Allen also claimed that even if she had not been successful, "'I'd have to act. The application of my gift is life itself, and I would die if I had to give it up.'"[2] Others, such as Julia Arthur, stressed that they had been "made" through training, exposure to theatre, and family connections, or simply by chance.[3]

No matter how they described their personal histories and backgrounds, in surveying the childhoods and adolescences of women who became performers between the 1860s and the early 1900s, one thing becomes apparent. Just as their acting careers represent a range of genres, so too did these women's childhoods represent heterogeneity, shaped by their class position and familial background.[4] Some went on stage as either children or young teenagers; in more than one case they did so as part of a family troupe. Others became actresses after having been exposed to amateur theatre in their family: growing up with siblings who enjoyed putting on plays in the home, for example, or having had parents (often mothers) who read Shakespeare and poetry to them. Still others attended schools where dramatic readings, classroom plays, pageants, and recitals sparked an interest in theatre and performance. And

for some, choosing a career in theatre was a means of escaping poverty and, in a few cases, an unhappy, potentially dangerous home life, one that stood in stark contrast to the ideals of middle-class domesticity that they claimed as adults. Those who worked as child performers experienced transnational mobility at a very young age; all, though, worked in a context in which the meanings of childhood, performance, and labour were hotly debated by middle-class commentators.

Schooling, Family, and the Stage

While child performers attracted their fair share of attention from Victorian social commentators, not all these women began acting professionally as children or as very young teenagers. For Margaret Anglin (1878–1958), convent education in both Toronto and Montreal exposed her to the world of theatre and make-believe. Anglin was first sent to Toronto's Loretto Abbey's convent school and claimed that her love of drama was fostered at the age of five, when she was taught to recite Irish poet Thomas Moore's "The Exile of Erin."[5] In another interview with the Canadian publication *Everywoman's World*, Anglin remembered that the nuns at her Montreal school, the Convent Sault-au-Recollet, were very kind and considerate, "although they were strict to a degree," and for the most part her school days were somewhat dull. (However, according to Anglin, the sisters also were extremely proud of the fact that they had taught the internationally famous opera singer Emma [Lajeunesse] Albani.) Yet the convent's curriculum included the staging of plays by French dramatists, "not alone for amusement, but also as an educational factor, since the nuns believed that the lines of these plays would make for fluency of speech and add to our vocabulary." Anglin's school debut, as a vulture in *La Columbe et Le Vautour*, was reviewed by the Mother Superior, "a distinguished Belgian lady of noble birth," as being "'too theatrical'"; unlike subsequent reviews, she took this critique to heart, profiting from "her candid and helpful remark."[6] The convent also gave her a glimpse into the mechanics of staging a play, as she watched Pierre, the convent gardener, paint and move scenery and create sound effects. Still more wonderful, though, was "the privilege of shedding for the nonce our relentless uniform dress of black cashmere and rigid linen

collars and cuffs in favour of marvellous silks and satins from the 'play closet' ... a source of never ending delight to me whenever I was allowed to delve into its beauties and its mysteries." Anglin remembered, with great delight, a blue satin dress that she thought "worthy of the Queen of Sheba's most magnificent magnificence," even though it was "no more or less (certainly no less when the nuns had added modesty to it in a very high neck and very long sleeves) than a ballroom dress of the period, donated by some wealthy ex-pupil."[7]

To be sure, Anglin denied that this experience alone turned her toward the stage. At sixteen she decided to leave school, returned home, and insisted on discarding her shorter schoolgirl dresses for long skirts; her family then gave her "light routine" domestic tasks which she completed with "notable lack of enthusiasm or even interest." After a trip to Chicago's 1893 Columbian Exposition, "the turning point between domesticity and professionalism," Anglin decided she would become a "dramatic reader" (presumably an elocutionist). While her father did not approve, her mother (possibly out of pragmatism, possibly because of her own artistic background) overcame his objections. Over Anglin's protests, as she felt more than ready to embark on a professional career, her parents insisted that she attend acting school. In 1894, "with much less moral support than financial aid," she enrolled in New York's Wheatcroft School of Acting, which was linked to Charles Frohman's Empire Theatre. During her six months at Wheatcroft Anglin studied a wide range of parts and developed a great love of Shakespeare, going to as many New York productions of Shakespeare and other plays as her allowance would permit. In New York her ambition "grew ... by leaps and bounds."[8]

Anglin's contemporary, Quebec's Lucille Watson (1879–1962), spent her early years with private tutors but then went to the Ursuline Academy in Quebec City.[9] Like Anglin, Watson made her way to New York where, in 1900, she enrolled in the American Academy of Dramatic Arts.[10] Unfortunately, while Watson had a lengthy and prominent career on both the stage and film, she does not appear to have discussed her early years in much detail. It is possible that growing up in the Roman Catholic Church, with priests donning special clothing to say Mass and performing rituals in a highly theatrical manner, might have stimulated Anglin's and Watson's love of drama. Too, as Anglin's account suggests, elite private

schools for girls, Catholic and Protestant, might offer classes in music, drama, and art that generally were not part of state-sponsored schools' curricula, even though the former institutions intended to inculcate in their students a taste for genteel, refined pastimes that would serve them well as future wives and mothers, not a love of the theatrical profession. While Lena Ashwell (1872–1957), who attended the all-female Anglican Bishop Strachan School in Toronto, had little good to say about her time there, she remembered quite fondly the drama club she and her fellow students formed. In an act of daring, Ashwell "played a hero in borrowed pants" and smoked a cigarette onstage; its fumes went to her head and caused her to forget her lines.[11]

Not all convent schools welcomed the children of actors, though. Actress Eliza Nickinson Peters remembered that on arriving in New York from Montreal (most likely in the 1840s), her father, actor John Nickinson, sent his offspring to St Patrick's School in the vicinity of Mulberry Street. This was, she claimed, a common practice in Protestant families, "but when the sister in charge heard that the children were the daughters of an actor they were promptly sent home ... the naive surprise of the good Sisters upon hearing that actors may be as virtuous as other people shows how the old tradition lingers."[12] While anecdotal, Nickinson's story suggests that earlier in the nineteenth century, children from theatrical families were not always welcome in certain institutions. In this case, the nuns may have been concerned that the hint of immorality still clinging to actors' reputations might taint other pupils. They may not have welcomed students whose family's livelihoods depended on them being highly mobile and unable to put down roots in a neighbourhood school.

By the mid-nineteenth century, though, the parents of these young women – whether from theatrical families or not – would have been able to send them to elementary schools, as free education became more common in both North America and Britain. However, as social historians of education have made clear, a family's own resources – or lack of them – played a crucial role in determining just how much education a young girl would receive.[13] Anglin's privileged background played a role in her convent education; while Ashwell's family was not rich, her father was a naval officer who went to Canada to recover his health (and

to become a minister) and her mother's family also had ties to the British navy.[14]

The highest level of education attained was by British Columbia's May Tully (1886?–1924). She was born to Frank and Nancy Tully, an American couple who had been attracted north by the Cariboo gold rush. After Frank Tully was killed in a mining accident, Nancy Tully moved to Victoria and married Gustave Steffen, a German immigrant who owned a number of hotels. It may well have been Steffen's money that paid for May Tully's university education; whatever the case, she attended McGill University, where, she claimed, she developed a love of baseball and played on a women's team. According to the press, her parents' 1898 departure for the Klondike gold fields allowed Tully to cut short her university education and leave for New York, where she attended the Wheatcroft Dramatic School.[15] Tully went on to craft an acting career in theatre and vaudeville and became a playwright and a director of silent films.

In contrast, while Julia Arthur's father was a tobacconist and cigar manufacturer, it seems that when she met manager Daniel Bandmann her father's business was not thriving. Furthermore, at that point Arthur was the eldest of nine siblings, born between 1869 and 1883. It is little wonder that her parents decided that meeting Bandmann was fortuitous, even though it ended her formal education.[16] Margaret Mather's (1859–1898) family circumstances were even more dire. Born in Tilbury East Township in Canada West to farmer and mechanic John Finlayson and Ann Mather, Margaret Mather, along with her three brothers and two sisters, was taken by her parents to nearby Detroit when she was five years old. Mather's childhood was marked by severe poverty, since her father was often out of work. From the age of ten she sold the *Detroit Free Press* in the streets, one of the many children who worked in full view of the public; their plight (and public presence) would attract the attention of late-nineteenth-century social reformers and child-saving movements.[17] Supposedly in such despair that she attempted suicide one night by trying to drown herself in the Detroit River, Mather was rescued – by whom, it is not clear – and sent to New York. Accounts vary about her arrival and early years in the city; she may have lived with an older brother, who sent her to school until his death in 1880. Whatever the case, Mather decided to try her luck as an actress and began studying

with George Edgar, an actor and elocutionist who also taught and had set up his own company with casts recruited from his pupils.[18] In a similar vein, as a young teenager Coburg's Marie Dressler (1868–1934) left home with her sister and joined the Nevada Stock Company, a decision made not out of a desire to support her family but, rather, to escape her father's ferocious temper, his outbursts of physical violence, and the family's poverty, which forced them to move from the Ontario towns of Coburg and Lindsay across the border to Findlay, Ohio, and then to Bay City and Saginaw, Michigan. Dressler thus was unable to attend school on a regular basis.[19]

But if formal education might either steer a young woman towards the theatre or be so truncated as to have little effect on her choice of career, the realm of domesticity and the family could also play an important role. These women's memoirs suggest the varied influences that family dynamics had upon their future choices; the cultural dimensions of family life in nineteenth-century Ontario; and the importance of an image of stable, middle-class family life in claiming respectability as a performer.[20] Arthur and Anglin told interviewers that family theatricals and other forms of "amateur" performance were important in developing their love of the stage. For Arthur, her mother was "'her idol. Through her she learned to love beautiful English. From her, too, came the fine sense of values in life, the independence of spirit, which refused to bow to anything but genius.'"[21] (Although Arthur did not publish a formal memoir, she gave multiple interviews to newspapers and periodicals in which she discussed her childhood and her early career.[22]) While Arthur's siblings also were talented and a number of them would go on to have careers in theatre and music (the press and Arthur made much of her support of them throughout her career), she was the "more determined" from a young age to make her living in the theatre. As we have seen, Arthur declared that her interest in theatre began because of her mother's love of Shakespeare, classical music, and opera; every afternoon she and her siblings recited poetry and drama for their mother. Arthur also staged plays in her family's attic to an audience that consisted of whichever sibling – no matter how unwilling – could be recruited to watch, along with her dolls.[23]

As well as her school days, Anglin claimed that her connection to the theatre began when as "a wee little tot, I was held playfully up in the air by

Oscar Wilde at a garden party. Very distinctly I remember that Mr. Wilde, on this festive occasion, wore a happy smile and a brilliant sunflower in his buttonhole." If an onlooker gifted with the ability to see the future had been present, Anglin claimed, they "might easily have startled Mr. Wilde by whispering in his ear that the small bit of frilly pink and white creation he was so merrily tossing about in his gleeful mood would someday produce his plays."[24] To be sure, Anglin made it very clear to her readers that, despite her encounter with Wilde, her family's attitude towards a career in theatre was not straightforward. Although he was "one of the broadest minded of men," her father, Liberal politician and journalist Timothy Warren Anglin, "was sincerely and unmovable [sic] opposed to my undertaking a professional career upon the stage. I feel quite sure, then, that I inherited none of my love of the theatre from him" (although she admitted hearing about her father's talents as an "eloquent and forceful speaker"). Anglin went on to point out that during his tenure as Speaker of the House of Commons, her father refused to come and hear her mother, Ellen McTavish Anglin, a well-known amateur singer, perform, even though Governor-General Lord Dufferin had arranged for the House to adjourn so Anglin could attend. Although out of love for his daughter Timothy Anglin was in the audience for her professional debut, his "radical prejudice against any of his family appearing on the stage, either as amateur or professional," was so intense that "he kept his head bowed and his eyes tightly closed during the entire performance."[25] Yet even though Anglin denied that she was either, in her words, a "'born actress'" or encouraged by her family to choose the theatre – she claimed that "politics and statesmanship" were a more important part of her background – it is hard to see how her mother's involvement with amateur theatrics and *musicales* at Rideau Hall, the governor-general's residence, was not an influence, even if indirectly.[26]

Theatre, Families, and Children on Stage

What, though, of those women who started their acting lives as child performers? They did so within the context of significant debates about conceptions of childhood, particularly the notion that childhood, innocence, fragility, and dependence were synonymous, a construct inflected by conceptions of a middle-class white childhood as the epitome of these

qualities.[27] These debates were present in a number of theatrical depictions of children, so much so that a childhood lived on and represented by the stage became an important site on which cultural, political, and social tensions were played out.[28] Yet despite child actors' usefulness in negotiating cultural and moral tensions on both sides of the Atlantic, their presence onstage became increasingly contentious. Debates about the need for child labour and concerns about its desirability, along with the rise of child-saving movements and the spread of formal, state-controlled compulsory education, had important consequences for children who worked in public entertainments. As Benjamin McArthur has shown, by the 1870s, reformers' concerns about children's onstage work erupted into a campaign to regulate it, a drive spearheaded by Eldridge Gerry, head of the New York Society for the Prevention of Cruelty to Children (NYSPCC). Gerry succeeded in persuading the city of New York to make the onstage exhibiting of any child under sixteen a misdemeanour punishable by a fine; although the mayor's office could grant an exemption, it could do so only upon the recommendation of the NYSPCC. While the society lacked the resources to police all the city's theatres and child performers continued to appear in several venues, Gerry's actions had consequences for theatre managers and for child performers.[29] Yet as Shauna Vey argues, Gerry's crusade was shaped primarily by class and ethnic biases, and less by his opposition to theatre itself. The society focused much of its efforts on children in popular, working-class entertainment: street musicians, saloon singers, and circus and variety performers. Moreover, Gerry was supported by some theatre managers such as Augustin Daly, who demanded standards of middle-class, respectable behaviour from the actors he employed and whose use of child performers did not include song and dance, a particular *bête noir* of Gerry's.[30] In 1892 Gerry's legislation came under attack from prominent figures in New York theatre, with the result that the city's mayor became the final arbiter of child performers' legitimacy; the society's role was reduced to that of an advisor. However, the mayor's office continued to follow the society's suggestions and it continued to be a "thorn in the side of producers."[31]

Notwithstanding these obstacles, child performers retained their appeal. A growing demand for their work can be seen in steadily increasing applications for their licences, which went from fewer than 200

in 1896 to 4,000 in 1903.³² The matter thus was not resolved and, with the rise of the Progressive Era's child-saving movement in the 1910s, child performers once again came under scrutiny, this time at a national level. Even though the theatrical industry was using fewer child actors, a number of states passed laws that restricted their employment. This legislation was met, though, by vociferous opposition from managers, producers, and, in particular, actors. In 1910 representatives of these groups formed the National Alliance for the Protection of Stage Children, which publicized the work of child actors and lobbied state legislatures for amendments to their laws governing child labour, calling for protection from "immoral" places of work and from unsafe work, for limits on children's hours of work in the theatre, and for children on tour to be accompanied by a guardian.³³ The alliance's campaign had mixed results. While Louisiana overturned its ban on child performers and California exempted out-of-state children, in New York the permit situation was retained and touring companies throughout the United States continued to face a mixture of state codes and different levels of municipal regulation.³⁴

Casting an eye across the Atlantic tells us that the American context was part of wider, transnational discourses around childhood and child entertainers; such a perspective also, though, points to the importance of national and regional contexts. As British scholars have pointed out, child performers were ubiquitous in Victorian theatre. They were gathered *en masse* in pantomimes, singing, marching, and dancing; as infant prodigies they performed Shakespeare; in a number of productions they might even appear as babies; music-hall ballets deployed spectacles of children dressed in costumes from around the world, fuelling the popular imperialism of the late-Victorian and Edwardian eras; and in the early twentieth century African-American children appeared in Britain and Europe in troupes led by singers, the children dancing and singing in "picaninny choruses."³⁵ Although exact figures are hard to come by, Tracy C. Davis has suggested that by 1887 5,000 children were employed in British theatre, 1,000 of them in London; a number of schools were founded in the city that taught dancing for pantomimes and ballet.³⁶ For those children whose alternatives were informal work in domestic service, shop work, or light manufacturing, work as a performer offered better pay, the chance to tour, and the possibility of advancement.³⁷

Yet, like in the United States, child performers in Britain evoked varying degrees of uneasiness in reformers, who believed children's work robbed them of formal education, exposed them to unsafe and immoral environments, and exploited their vulnerable status.[38] Pointing to campaigns such as Gerry's, the London Society for the Prevention of Cruelty to Children (LSPCC) lobbied to have the 1889 Prevention of Cruelty to Children Bill introduced in the House of Commons; amongst other provisions, it called for a ban on the employment of children younger than ten in public entertainments. Opposed by leading members of the theatrical profession, various members of Parliament (including the attorney general), and some trade unions, the act when passed was amended to ban only children under the age of seven. Those between seven and ten could be granted a special license, provided their working conditions were healthy and safe. The responsibility for inspecting theatres and enforcing the act was left in the hands of factory inspectors.[39] In 1903 the act was changed to raise the minimum age to ten and that of licensees to eleven; the government placed new restrictions on the hours children could work and transferred the responsibility for inspection to local authorities.[40] Yet attitudes towards the act were equivocal. Aside from objections coming from the theatrical community, not all members of the public wished to see their enjoyment of performing children — and the entertainments that depended so heavily upon them — curtailed. Furthermore, a number believed that parents had the right to place their child in the workforce as they, not the government, saw fit.[41] While by 1919 the number of child performers had declined, they did not disappear, nor did the public's desire for them.[42]

Social reformers worked diligently to expose the hardships and abuse endured by these children; in doing so they relied heavily on middle-class notions of childhood innocence and the losses that children experienced because of their employment, not least that of formal education. Yet while influential, the reformers' perspectives were not necessarily the only means of thinking about nineteenth-century child performers. To be sure, the rhetoric of theatre managers might be self-serving and the views expressed by actors might be myopic, since those active in the campaigns against limiting children's work were successful members of the profession. Nevertheless, in their depositions to the child-savers and legislators on both sides of the Atlantic, theatre managers, actors,

child performers' guardians, and those who enjoyed watching them made a valuable point: that children experienced even worse working conditions in factories, on farms, and on city streets, conditions that those who focused on theatres tended to overlook.[43] Moreover, as Marah Gubar argues, the popularity of child performers in melodramas embodying vulnerability and fragility should not obscure the fact that they also were seen as competent, disciplined, and independent workers, traits that they shared with a number of young Americans who, despite the growth of free (and then compulsory) education, were employed in paid labour.[44] According to Gubar, American children onstage, whether in *Uncle Tom's Cabin* or in child versions of *H.M.S. Pinafore*, were compelling to watch not because they merely reaffirmed preconceived notions of innocence but because they blurred the boundary between childhood and adulthood, their precocity reflecting "how genuinely unsettled the question was of what young people could or could not do, how much protection they did or did not require."[45]

While not all these campaigns directly affected the women whose childhoods are discussed here, nevertheless they formed an important part of the contexts that shaped their entrance into acting. They also may have helped shape their memories of their childhood careers.

Coming of Age on the Stage

Viola Allen came from a theatrical family. Her father, Charles Leslie Allen, was a well-known character actor and her mother, Sara Jane Lyon Allen, was an actress who worked alongside her husband. Although Allen claimed in a 1906 interview that she knew nothing of the stage until an understudy was needed for Annie Russell in *Esmerelda*, a play in which her father was appearing, she was disavowing her past as a child performer.[46] Born in Alabama, in 1870 Allen appeared alongside her parents at Halifax's Olympic Theatre in *Rosedale, or, The Rifle Ball*, playing Lord Arthur May. A reviewer claimed that "it would be injustice indeed to pass over little Viola Allen, who played 'Lord Arthur May' with a care and accuracy which astonished the audience" (in an example of the ways in which these women's lives were interlinked, Clara Morris also appeared in this production).[47] It is not clear why Allen insisted throughout her career that she had not had an early connection to the stage,

despite it being the source of her parents' income. She also downplayed her mother's theatrical career, leading audiences to think that only her father had any real theatrical connections. Allen may have done so to keep up her image as a dedicated artist who, as we have seen, vowed that sheer talent, not personal connections, made a great actress; she also cultivated an image of a simple, unpretentious, and unremarkable background.[48] Furthermore, it is possible that the campaigns against children's stage employment may have made her reluctant to openly claim her earlier work. Whatever the case, though, after her Halifax debut her family moved to Toronto, where Allen attended Bishop Strachan School and then boarding schools in Boston and New York.[49] However, unlike Lena Ashwell, in interviews Allen had little to say about her school years: we do not know if she too smoked cigarettes and donned men's clothing onstage (although it seems unlikely). Allen's decision to take up acting was shaped by her family's connections and, too, a degree of serendipity. Her father may have played the role of proud "stage father" in promoting his daughter's career: C. Leslie Allen claimed to have been showing her picture to a fellow actor in the theatre's green room when the owner happened to stop by, thus helping to launch his daughter's adult career.[50]

In the case of Annie Russell (1864–1936), though, whom Allen understudied, the need to contribute to her family's support prompted her to enter an acting career. Born in Liverpool of an Irish father, Joseph Russell, a civil engineer from Dublin, and Jane Mount, an Englishwoman from Suffolk, Annie Russell came to Canada with her family in 1869 and settled in Montreal. Prior to their departure, Russell told one of her biographers that she had lived in a Dublin convent, perhaps because her mother had been recently widowed and might have needed to place her daughter with the nuns for a short time.[51] Jane Mount thus probably welcomed American actress Rose Eytinge's 1872 arrival in Montreal. Whatever the case, the timing for the Russells was fortuitous, since Eytinge needed a child performer to play a young boy for the play *Miss Multon*, in which she was appearing at the city's Academy of Music.[52] As Russell's family had noted her "mimetic ability" and she had appeared in amateur productions and at the church fair, her mother decided to take her to see the manager. Although hired for the part, Russell's hopes were crushed, albeit temporarily, at the first rehearsal when Eytinge heard her newest cast member had no experience on the stage and thus was

going to let her go.[53] In a novel-worthy anecdote told thirty-two years later that, in its telling, affirmed Russell's ability to create a dramatic moment, Russell claimed to have rushed to the wings and "'set up such a dismal howling'" that Eytinge allowed her to speak a few lines, upon which she changed her mind.[54]

In 1878 Russell joined Haverley's Juvenile Company in a touring production of Gilbert and Sullivan's comic operetta *H.M.S. Pinafore*; the following year she made her New York debut in it.[55] One of the plethora of American juvenile touring productions of the light opera, *Pinafore* was notable for the skill, polish, and professional competence demonstrated by its young cast.[56] It was also noteworthy for its young audiences' enthusiastic reception: they found it "arresting, empowering, and even crush-inducing."[57] Russell then performed in a number of roles in New York, appearing as a little boy in *Rip Van Winkle*, as Eva in *Uncle Tom's Cabin*, and as a page in Edwin Booth's company. In discussing her work with Booth, Russell recalled that in the play *Richelieu* part of her work involved taking his hat; whenever possible, she would dodge the dresser in order to give it back to him personally. "Once she was rewarded by a pat on the hand and the remark, 'When you grow up, little girl, you shall play Ophelia.'"[58] Although it doesn't seem that Russell ever played Ophelia (she did appear in *A Midsummer Night's Dream*), such incidents feature frequently in these "origin stories" of young performers, moments when the child's future talents are noticed by a perceptive and prescient senior star performer. Whether they took place is difficult to determine: nevertheless, for their audiences (and possibly for the teller), such anecdotes might have affirmed that the adult actress was part of a long line of legitimate, celebrated performers.

Russell went on to tour the West Indies and parts of South America with Eugene A. McDowell and his wife Fanny.[59] The accounts of this tour are contradictory, though. In one interview, Russell claimed to have been twelve, but she was more likely to have been sixteen. She also maintained that she went to care for her young brother, Tommy, who was appearing as the company's child actor; although she too performed, it was to be "useful in many minor ways on the stage" in both drama and burlesque.[60] However, the American actor Charles Arnold told a reporter in 1889 that Russell was one of the company's leading members. According to Arnold, they were warmly received in Kingston, Jamaica,

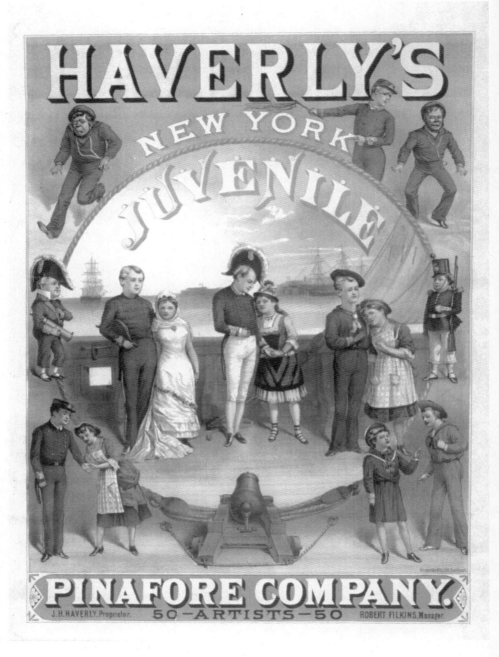

Fig. 1.1 Haverly's New York Juvenile Pinafore Company, c. 1879.

and were quite financially successful. It was, though, memorable for other reasons, as Arnold also claimed to have acted as Russell's protector during an earthquake.[61] If Russell was grateful for Arnold's (possibly exaggerated) chivalry, she did not mention it in her account of the tour. Instead, she focused on her need to curb her young brother's generosity to the Jamaican children he met, claiming that Tommy was apt to give away his clothes, an act of charity that the siblings could not afford (Annie was responsible for sending a portion of their earnings home to their mother in New York).[62] He and Annie were not the only Russell family members to help support the family with a stage career. Their sister Marion Russell also appeared in a number of New York productions in the 1880s and '90s. She too seems to have been overshadowed by Annie: one reviewer described her as "substituting for her more richly gifted sister" and as being "pretty, but not very interesting."[63] Similar to Julia Arthur's tale of becoming an actress, there is little in Annie Russell's narrative that suggests she viewed her family's circumstances as extraordinary or that she resented interrupting her childhood by entering the workforce.

It probably mattered, of course, that the career thrust upon a child or very young woman resulted in success: that was certainly the case with May Irwin (1862–1938). Upon her father's death and with their mother's encouragement, the young May and her sister Flora formed a singing duet; May had been a soloist in her church choir in Coburg, Ontario, since she was eight.[64] The "Irwin Sisters" made their debut at Buffalo's Adelphi Theatre in 1874 and went on to appear in theatres in New York, Massachusetts, Washington, DC, Pennsylvania, Ohio, Illinois, Indiana, and California.[65] While the sister act ended in the early 1880s, May continued to perform, moving into silent film, vaudeville, and Broadway revues and dramas; she also appeared in Augustin Daly's theatre company and played a number of seasons in London. Far from damaging or depriving her, Irwin's early career allowed her to set the foundation for an extremely successful life as a singer and actor. Her talent, combined with her financial and professional acumen, resulted in her becoming a wealthy and well-regarded performer.[66]

Toronto's Clara Morris (1847–1925), though, recounted her "origin story" in a far more melodramatic tone: one fitting, perhaps, for an actress who had become well-known in the 1870s and '80s for her portrayals of suffering heroines such as Jane Eyre and Camille. According

to her autobiography, Morris's parents' marriage was bigamous and when the family's secret was made public, out of shame and a need to flee her child's father (who was attempting to abduct Clara), her mother took Clara and left for Cleveland, where she eked out a living as a housekeeper. Clara's turn to the stage was not an act of egotism but, rather, a means of contributing to her and her mother's livelihood.[67] Although, as her biographer points out, neither Morris's narrative nor an unpublished account of her life that contradicted the story of her parents' marriage can be fully believed, it is highly likely that she began working onstage as a way of supporting her mother.[68] She began performing in 1862 at the age of fifteen, appearing first as a dancer at the Cleveland Academy of Music and then in local manager Daniel Ellsler's stock company. As a result of her family upheavals and entry into the workforce, Morris received very little formal education, although that did not prevent her from becoming a prolific author once her performing career ended.[69]

Early Lessons in Acting

These performers, then, came to the stage through various routes and networks. How, though, did they experience and remember the start of their careers? As historians of childhood and youth would agree, this is a particularly challenging area to explore when dealing with those who are long dead and whose memories cannot be explored more deeply through the medium of oral history.[70] However, in the case of performers, the culture of nineteenth- and early-twentieth-century celebrity intersected with the increased popularity of memoir and autobiography. A growing number of these actresses published their thoughts and impressions of their childhood, whether in book form or in newspaper and magazine interviews. To be sure, these narratives cannot be read as completely straightforward accounts of "what happened" since – like other autobiographies and memoirs – they are highly mediated by the context of the period in which they were written, not to mention their authors' desire to stake out and perform certain subjectivities. As those who have studied nineteenth- and early-twentieth-century British actresses' memoirs have pointed out, their narratives were shaped by the desire to claim feminine respectability, which led their accounts of childhood to stress qualities such as hard work and dedication to one's

family.[71] Furthermore, although difficult to prove definitively, it is likely that their authors also reacted — albeit in varying ways — to reformers' attacks on children's work in the theatre.

Although the bulk of Mary Pickford's (1892–1979, born Gladys Smith) career was spent in movies, her memories of her youthful beginnings on the stage provide important counterpoints to those crafted by other women, not least because they were provided in a (relatively) more intimate interview, instead of the pages of the press. In a 1958 interview with Arthur B. Friedman, a prominent faculty member in the University of California–Los Angeles's Motion Picture and Television Department, Pickford reflected on her early career in Toronto theatre with a mixture of pragmatism, wistfulness, and insight. Like Morris, Pickford began her story of a stage life as a family narrative, one in which poverty and the absence of a father necessitated children's labour. Her life as a performer began in 1897 — not, Pickford claimed, out of choice but rather out of necessity, as a way of supporting her widowed mother and two siblings.[72] In her autobiography and her interview with Friedman, Pickford stressed that the harsh conditions she and her siblings experienced after her father's death left them with few options but to go onstage, constantly leaving their Toronto home for Manhattan and the road. She recalled loathing New York's theatrical boarding houses, for example, and found herself profoundly disappointed by the city. The family's first trip was an "intensive and discouraging job hunt," marked by "the motley crew of the fly-by-night theatrical companies of those days, the merciless summer heat of New York; the rudeness of the receptionists; the sight of starving actors with their celluloid collars and brave faces, the overly bleached blondes with their inevitable turquoise jewelry and one lingering piece of soiled finery, like a blouse or jabot, and the lip rouge that would begin to wear off as the heat grew and the day lengthened. The picture of Mother, Lottie, Johnny, and me trudging along to these offices will stay with me to my dying day."[73]

Worse still was the "terrifying uncertainty of the nightly attendance." Throughout her life, she confessed, she had been disturbed by recurring dreams of either appearing in front of an empty house or forgetting all her lines.[74] It is unclear, though, whether the uncertainties of Pickford's early career contributed to her unease and anxiety or whether she would have suffered from stage fright if she had begun acting as an

adult. In her oral history Pickford also reflected, with great regret, on her loss of formal education, telling Friedman that she was subject to this "drawback" and was instead taught by her mother, private tutors, and herself.[75] Pickford's narrative thus was one of premature responsibility, struggle, and deprivation. She compared her lower salary to those of other, better-paid performers; claimed to have had no playmates; noted that she lacked formal education; and, worst of all, described how she had suffered the emotional distress of being separated from her mother at various times, when the casting demands of stock companies split the family up.[76] "Indeed we (she and her sister Lottie) did feel like grownups."[77] Pickford's insistence, though, that her early start as a performer had robbed her of her childhood may well have been conditioned by mid-twentieth-century discourses that insisted that North American children and teenagers should enjoy a "normal" childhood and adolescence, one marked by formal education and ample leisure time. It also might have been shaped by her own realization that her image as the young, innocent "America's Sweetheart" masked a history of hard work, loneliness, and exploitation. In contrast, Annie Russell's more celebratory account of becoming a child performer may have been a reaction to attacks on child performers in early-twentieth-century America.

Arthur recounted her early years onstage and her start in Alexander Bandmann's company in a similar manner to that of Russell. Upon his arrival in Hamilton, Bandmann began scouting for junior actors. Eager, it seems, to promote his prodigy, her acting instructor, English performer John Townsend, introduced Arthur to him. Initially "languid" about Townsend's recommendation, Bandmann's demanding attitude annoyed her, as she had "received more adulation than was good for a child of thirteen." Instead of Shakespeare, Arthur chose to recite two poems including "Curfew Shall Not Ring Tonight," an audacity that made Bandmann sit up and "look her over." His scrutiny made her "restless," as she felt her appearance was not "an asset." While the young Arthur might be "long on art" she was "short on beauty": small, thin, all "eyes and temperament," and self-conscious about a facial scar, the result of an encounter with the family dog. Bandmann told her father he would "'try her out'" but would not pay her until she had received her first favourable newspaper notice.[78] Arthur was thus "tossed into work on a sink or swim basis," appearing as the Player Queen in *Hamlet* on her second night with

the company, a role she enjoyed as she was able to wear boy's clothing of doublet and hose. Her account of touring with Bandmann's company is one of confusion, rush, and hard work coupled with the excitement of her first pay cheque and her subsequent attainment of the rank of a professional. In addition to appearing as a child, the teenage Arthur played a range of roles, including Juliet and her nurse, the Player King in *Hamlet*, and the Prince of Wales in *Richard III*.[79]

In addition to roles as adult characters in Shakespeare, these girls and young women also played children in melodramas, thus participating in the displays of racially charged innocence that marked the American stage.[80] Yet whatever roles they played and however much they were part of a larger system of representation and symbols, the onstage work of these girls and young women was also mediated by a range of relationships, both intimate and familial, and friendships that taught them much about their new craft. In many ways their lives resembled African-American child performers in Europe, who, as Jayna Brown points out, grew up on trains and in performance spaces, received their education from older performers, and experienced childhood in ways that were not always mediated by their birth families.[81] For these girls and young women, work as a child or teenage actor was a kind of apprenticeship, an exposure to a wide-ranging pedagogy at a time when formal training in acting was not the norm for most. While often depicted in publicity photographs as innocents subject to society's vicissitudes, these actresses' youthful experiences were marked by both multiple forms of vulnerability and the greater range of possibilities that their work as child performers opened up for them. Although they did not shy away from describing their youthful mistakes and mishaps, these women's narratives in many ways substantiate Gubar's arguments about the extent of skill, confidence, and competence that they developed through their onstage work.

Arthur, for one, believed that in Bandmann's company she received an education in her craft and art that could not be achieved anywhere else. She learned how to apply her makeup, how to learn a part quickly, how to study the faces and demeanours of the wide range of characters (the elderly, the mentally ill, the sick) demanded by stock, and how to keep an audience's attention. As well, from watching and listening to much older, more experienced actors, Arthur believed she learned both the

history of the theatre and the meaning of being an artist.[82] To be sure, her recollection of these years may well have been shaded by nostalgia and a certain wistfulness for a supposedly simpler and less fraught time. In an interview published three months after her death, Arthur claimed to have been very happy in those hard years, as she struggled to establish herself in a profession "which has, as the stage then had, not exactly a stigma but – shall we say? – a slightly beclouded social position." Nevertheless, from her perspective, North American theatre in the 1880s was not an overcrowded field and the competition was not as strong, so that a "really talented girl" – Clara Morris, Julia Arthur, or Mary Anderson – just had to work hard in stock and she would become a leading lady in due course.[83]

However, unlike Morris or Anglin, Arthur did not leave a collection of private papers, the letters and diaries that might either provide a counterpoint to or complicate her narrative of teenage pluck and adventure on the stage. At times she undercut such narratives with accounts of homesickness, although it was her mother, not the city of Hamilton, that Arthur missed while touring.[84] Moreover, there is nothing in Arthur's public accounts that suggest her vulnerability to sexual harassment and assault while working so far removed from her parents' or guardians' protection, even though the spectre of young women "adrift" in urban spaces disturbed the imaginations of early-twentieth-century transnational social reformers and women's rights groups.[85] While the absence of such threats from her narrative is not surprising, since Arthur carefully cultivated an image of feminine respectability that she used to balance countless accolades to her "exotic" beauty,[86] there may have been more to the story. A note in a collection of family portraits suggests that her youngest sister was really Arthur's daughter, born during her years of touring either with Bandmann or shortly afterwards.[87] Although this story is difficult, possibly impossible, to authenticate, Arthur was known for taking her younger siblings with her, both on the road and to England, perhaps as a way of encouraging their theatrical aspirations while simultaneously protecting them. She told one of her interviewers of "borrowing" one of her little sisters to take to Quebec, as the company she was in needed a child for certain plays. "From a supply that seemed unlimited ... I selected an infant of five," she recounted, a charge who was a comfort on the road.[88]

Even though Morris denied that her head had been filled with dreams of stardom and fame, once she began performing, she found the theatre a mysterious world of imagination, filled with the promise of fantastical adventure. Equally important, though, was the excitement of her first pay cheque. Morris rushed home to give it to her mother, whom she found worn out, shelling peas for dinner. Her mother refused to take it, telling Morris that she had earned the money and should do with it as she pleased. After signing on for a second season with the ballet and thus ensuring future pay cheques, Morris's response was to buy her mother a "flowered muslin gown. After that I was conscious of a new feeling, which I would have found it very hard to explain then. It was not importance, it was not vanity, it was a pleasant feeling, it lifted the head and gave one patience to hear calmly many things that had been very hard to bear. I know now it was the self-respect that comes to everyone who is a breadwinner."[89] While Morris's readership might not have associated a teenage ballet dancer with the term "breadwinner," clearly her ability to contribute to her mother's well-being gave her – at least in hindsight – self-respect and dignity, as well as presaging her entrance into adulthood.

As well, leaving school to take up performing was not as great a wrench or loss for Morris as it was for Pickford (nor did Arthur write much about school or seem to remember it fondly). When she started public school in Cleveland, "what a poor, meagre course of study I entered on ... Only one class in the grammar-school studied history." Yet Morris "hungered and thirsted for knowledge – I craved it – longed for it."[90] She then pursued her education in other venues – reading widely whenever she could, for example – but also by gaining knowledge of her new profession. Some of her lessons were prosaic, as she was taught, for example, how to do her makeup properly and not look like a "'cheap china doll.'"[91] Morris was also initiated into the secrets and mysteries of her tights. Described by another, more experienced young dancer as "tricky, unreliable, and malicious in the extreme," tights were prone to creating "mortifying mishaps ... dread disasters" for those who did not understand them and allowed themselves to be bullied by their undergarments. Morris, though, learned how to put them on properly and not "'be afraid of them.'"[92] Other lessons were less utilitarian, perhaps, but no less important. Morris claimed to have gained a valuable education

in interpreting Shakespeare and in the conditions of the early American theatre from her fellow actors. In particular, her exposure to the latter allowed her to see change over time in her profession; in her eyes it went from a marginal status to one that garnered greater social respect, money, and celebrity.[93] To be sure, her observations about an earlier time in which actors struggled valiantly to cultivate their art in the face of public indifference may well have been inflected by nostalgia: Morris admits to experiencing the continuing poverty and poor treatment of actors that shape Pickford's account of her early years.[94]

Nevertheless, for Morris, during "those first seasons, with choruses, dances, and small parts to learn, with rehearsals every day and appearances every night, I was getting an education." Realizing, perhaps, that her readers' concept of "education" would have been that of formal schooling, she elaborated:

> But that depends on your definition of the word. If it means to you schooling; special instruction, and formal training, then my claim is absurd; but if it means information, cultivation of the intellectual powers, enlightenment, why then my claim holds good ... And let me tell you the stage is a delightful teacher; she never wearies you with sameness or drives you to frenzy with iteration. No deadly-dull textbook stupefies you with lists of bare, bald dates, dryly informing you that someone was born in 1208, mounted the throne in 1220, died in 1258, and was succeeded by someone or other who reigned awhile ... But no one can forget that Edward V was born in 1470, because he is such a tragic little figure, only thirteen years old and of scant two months reign, because there was the Tower and there the crafty, usurping Duke of Gloster [sic] eager for his crown.[95]

Morris went on to tell her readers that "to be a good actress and do intelligent work, one should thoroughly understand the play and its period in history, as the mainspring of its action is mainly political." To gain such an understanding, the performer must have "a large fund of general information," one that in her case was developed by reading widely. "From my babyhood," she claimed, she had read everything that came her way, a "promiscuous reading" that ranged from dime novels to Cowper.[96]

Morris's was not, though, a completely romantic tale. She discussed the problems of working in a touring stock company, run by a family of actors, in which nepotism — which did not benefit her — was rife.[97] As well, her "first vacation," spent in the oppressive summer heat of a Cleveland boarding house while waiting for her season and pay cheque to start, was "purgatory."[98] However, throughout her early years in theatre Morris was given comfort, support, and sound advice by Mrs Bradshaw, an older member of the company. "I can never be grateful enough for having come under the influence of the dear woman who watched over me that first season — Mrs. Bradshaw, one of the most versatile, most earnest, most devoted actresses I ever saw, and a good woman besides." Widowed young and left with two children to support, Mrs Bradshaw's life had been marked by "sorrow, trouble, and loss." To Morris, though, her conduct was an example of feminine fortitude and quiet strength, as she "rehearsed, studied, acted, mended, and made, for her salary absolutely forbade the services of a dress-maker." Despite this taxing schedule, "Mrs. Bradshaw set an example of neat orderliness that was well worth following. 'I can't see,' she used to say, 'why an actress should be a slattern.'"[99] Not only did Mrs Bradshaw set a professional example to Morris, but she also became a surrogate mother to her. Morris wrote of being mistaken for her daughter because of the attention and care she paid to the older woman (this was unlike her own daughter Blanche, a charming but irresponsible and often thoughtless fellow actress).[100] Morris also remembered sharing their love of reading and, too, the lessons that Mrs Bradshaw taught her about discipline and hard work. "To this woman's example, I owe the strict business-like habits of attention to study and rehearsals that have won so much praise for me from my managers."[101]

Marie Dressler's account of her early career mirrors many of the themes Morris explores. While she remembered her first years on the stock circuit as gruelling and marked by her homesickness for her mother, Dressler also believed they had provided her with a sound theatrical education.[102] For Dressler, the precariousness of life on the road was preferable to a childhood of emotional and physical abuse, poverty, and transiency. And even Pickford, who lamented a lost childhood and her lack of formal education, saw her early years as an education in her future profession (moreover, given the family's economic situation, it is

doubtful that Pickford or her siblings would have been able to stay in school after they turned fourteen, after which education in Ontario was no longer compulsory). At one point she was taught by her stage manager not to upstage her fellow actors, while simultaneously she was told that the "business" she had invented in this incident was clever and creative.[103] She also learned not to take her own publicity so seriously that she risked becoming the real-life embodiment of the "spoiled child." (This character, created for Isaac Bickerstaff's 1790 play of that name, became well-known to British and Anglo-American theatre audiences as representing first the child-savage and then the precocious and poorly behaved child.[104]) Only the stern intervention of Pickford's mother prevented her from becoming a "'naughty, spoiled, swell-headed little upstart.'"[105] She also, though, became aware of her own abilities and determination. When she decided that she wanted the part of an older child in *The Silver King*, which required more advanced skills in reading than Pickford possessed, she learned the role while waiting "under the lamplight" for the streetcar and during her ride home. "I'm grateful to say I was a quick study," Pickford recalled, as "that was actually what started me in the theatre." Pickford also claimed the role of a child autodidact, telling Friedman that when not acting or rehearsing she read "on average a book a day. At twelve, I was reading things like – oh, philosophical books – much heavier books than the average twelve-year-old reads. Dickens."[106]

Pickford's critical moment came when, at "not quite thirteen," she decided that she would either start appearing on Broadway or give up acting for a career as a clothes designer. Her family having returned to Canada, Pickford stayed in Manhattan with her aunts, sleeping on a Morris chair, running errands, and doing the shopping to pay for her board, and making weekly trips to the office of David Belasco, the influential American director and impresario. When Belasco's manager stalled her, Pickford appealed to one of his stars, the American actress Blanche Bates. In an anecdote redolent of racial symbolism – that of African-American women's care of white children – the latter's "coloured maid" entreated Bates to see "'the little girl with the blonde curls.'" Bates's intervention led to Pickford being granted an audition with Belasco at which, in her words, she convinced him that she was indeed an actress but "'now I want to be a good one.'" Belasco not only cast her in his play *The Warrens*

of Virginia, he also renamed her Mary Pickford and taught her much about dealing with strong-willed directors.[107] In her account, her innate talent and mimetic abilities, coupled with an active imagination, determination, and a strong work ethic, undercut some of her ambivalence about her early acting career. Furthermore, while Pickford was at times eager to depict herself as one whose childhood had been blighted by her stage career, in her autobiography and oral history it is her mother who appears to have suffered and sacrificed the most for her children.[108]

Conclusion

Child performers did not, of course, vanish in the twentieth century; chapter 7 explores the careers of Margaret Bannerman and Beatrice Lillie, who began performing as teenagers. Moreover, although her career ended early because of her death in a car accident, Marjorie Guthrie White (1904–1935) suggests the continuing great appeal of child performers in theatre and the various uses to which they were put. Born in Winnipeg in 1904 as Marjorie Guthrie to Winnipeg feed-mill owners Robert Guthrie and Nettie Giulietta Rowe, Guthrie first began performing at her school, Maple Leaf, "where she showed aptitude for comedy, singing, and dancing beyond her years."[109] By 1915 she was performing at Winnipeg's Dominion Theatre with the Permanent Players in, amongst other plays, *Mrs. Wiggs of the Cabbage Patch*. She also "takes the part of Charlie Chaplin," *The Winnipeg Tribune* reported, "with such acceptability that many have been heard to say that she is 'better than Charlie,'" and the Dominion's manager, Mr Edwards, "prophesies a brilliant future for this talented little Winnipegger."[110] Although the paper's report was likely hyperbolic, Edwards was not completely wrong. Guthrie was also hired to perform with the Returned Soldiers' Association Juvenile Entertainers of Winnipeg; the Association had been formed to entertain wounded soldiers and raise funds to support them and their families. Formed in March 1916, the Juvenile Entertainers toured several venues around the province and then extended their reach to western Ontario, North Dakota, and Minnesota. They and Guthrie proved highly popular with the public: a 1916 review in the *Manitoba Free Press* described her as the "'leading lady of the troupe. She is an accomplished little actress and has been seen often on the regular local stage. She is the

mainstay of the group.'"[111] In March 1917 the Entertainers travelled even further afield, embarking on a six-week tour to western Canada, American border cities, and Victoria, British Columbia. In 1919 the troupe's name was changed to the Winnipeg Kiddies; they continued to tour and in 1921 extended their circuit to Toronto and Montreal.

As Heather Fitzsimmons Fry has argued, in their performances for the war the Kiddies "challenged adults" to create a Canada "where children could be healthy, robust, and innocent members" of the British Empire's white Dominions.[112] The images of the Kiddies, especially those of Guthrie, that appeared in their souvenir programs certainly reinforced such messages.[113] Yet carrying the weight of such imperial and national fantasies meant that there was little room for the children's own perceptions of their role. While there is ample press coverage of Guthrie's career with the Winnipeg Kiddies and of her work as an adult performer, no reporter seems to have asked her during her childhood about her thoughts on her work onstage. This is probably not surprising: child performers embodied the paradox of being highly visible figures yet, simultaneously, were often silenced by the press, their promoters, and those reformers concerned about their welfare.[114]

In 1921 Guthrie left the company and, with fellow Kiddies member Thelma Wolpa, went into vaudeville; she and Wolpa changed their surnames to White and became known as the White Sisters. Since both women were quite small — Marjorie was 4'10" and Thelma was even shorter — their vaudeville act consisted of the "Sisters" performing comedy skits and musical numbers wearing children's clothing. As a New York reviewer commented, "'With their frilly little frocks and socks and slippers, they look as though they ought to be still sitting in their desks in school.'"[115] Perhaps not surprisingly, what the writer did not mention was the possibility that some audience members might have entertained sexualized fantasies about adult women dressed as children.

These girls and young women, then, became actresses as transnational theatrical circuits were increasingly expanding their range and reach. While the route to the stage was not a straightforward one for all, nevertheless few seemed to regret the choices they had made, as children, young teenagers, or young adults. To be sure, those who became child performers faced middle-class audiences and commentators who saw them either as representative of child workers' exploitation and

abuse or as more hopeful embodiments of their racially charged fantasies of childhood innocence (or a mixture of both). Nevertheless, those who have left us reflections on their early lives in theatre — no matter what their perspectives on them — suggest that they believed themselves to be more than objects of audiences' projections. Instead, they framed their youthful experiences onstage as those of thoughtful and articulate speaking and, often, writing subjects, who took the opportunities afforded them by their early apprenticeships in theatre to craft lives that were meaningful and, in many ways, memorable. Such was the case even when, as chapter 2 will show, those lives were marked by hard work and uncertainty.

CHAPTER TWO

Working Lives

Introduction

Stop, Look and Listen was the title of a 1906 vaudeville comedy-drama sketch starring May Tully. Based on an 1898 *Munsey's Magazine* story, Tully played an actress who has been stranded at an unnamed location in the United States by her road company's misfortunes. Walking the railroad ties, she meets a "country girl" who plans to make her way to New York City to become a great actress. Touched by the young woman's innocence, Tully's character determines to save her from heartache and trouble and tells her of the great hardships and uncertainty that await her. She succeeds in doing so and, out of gratitude, the young woman gives Tully her rail ticket. The sketch was laden with knowing winks about the profession, since in her advice to the young woman Tully imitated well-known Broadway actresses. Moreover, the title was a familiar admonishment to performers left in Tully's character's situation, warning them to be careful about oncoming trains as they trudged along the railroad tracks.[1]

While an amusing showcase for Tully's comic talents, the sketch encapsulated an all-too-familiar scenario for her and her contemporaries. To be a performer in the nineteenth and early twentieth centuries meant being a body in constant, sometimes unrelenting, motion, moving through multiple spaces and traversing multiple time zones. While travel had long been a reality for those who worked in theatre, the expansion of touring circuits throughout nineteenth-century North America meant new opportunities and new forms of excitement but also new challenges, new ways to be anxious, exasperated, and exhausted. Moreover, while performers were certainly no strangers to ocean voyages, the expansion of steamship lines meant that although transatlantic travel continued to be uncomfortable (and at times even life-threatening), productions and those who performed in them might travel much more quickly and

efficiently; the same could be said of trips across the Pacific Ocean. Too, developments in transportation were tied to those of communications: the telegraph, for example, which allowed theatrical promoters and impresarios to work across large geographic distances, or the spread of newspapers, which shared wire services and provided coverage of these women's careers to audiences that spanned equally large stretches of land and ocean.[2]

While other chapters explore the themes of representation and celebrity, the material conditions of these women's work were an unescapable part of their working lives. Magazine articles and performance reviews rarely captured the railway soot, grittiness, motion sickness, and overall physical exhaustion that went along with being a performer in this period. Diaries and personal correspondence, though, provide us with glimpses of the less-celebrated but no less real aspects of performance, ones shaped by the conditions of late-nineteenth- and early-twentieth-century capitalism, as well as the possibilities for pleasure that such travel brought. Some women, though, sought to play a role in those structures and to become managers and producers, work that gave them a sense of greater control and freedom over their careers but also brought greater responsibilities, stress, and frustration.

On the Road Again ... and Again ... and Again

As theatre historian Thomas Postlewait has argued, "if there was one real thing that all performers had in common" in late-nineteenth- and early-twentieth-century America, "it was touring."[3] Star performers, family enterprises, minstrel troupes, vaudeville entertainers, African American actors, and circus troupes — everyone toured. Those who did well on Broadway found they were then expected to take their popularity across the continent (and, in some cases, the ocean). For many "the road" was the primary source of income; they began their careers on a touring circuit and ended them there.[4] By 1877 Americans were being entertained by just under one hundred combination companies that toured across the United States. By 1900 the number of road productions was double that of New York's offerings, and between 1880 and 1910, New York sent out 250–300 combination shows throughout the country.[5] Yet, although as Postlewait points out, "everyone toured," not everyone enjoyed it.

Travel could be both tedious and tense, as actors endured journeys that consisted of long stretches of boredom interspersed with anxiety about delays, missed connections, and the prospect of rail accidents, some fatal.[6] Although intensive touring came slightly later to British theatre, brought about by the late-nineteenth-century decline of resident provincial stock companies,[7] nevertheless London-based performers also went on the road. After debuting at London's Royalty Theatre, Hamilton's Mary Keegan appeared across the United Kingdom, playing theatres in cities such as Dublin, Aberdeen, Dundee, Huddersfield, Darlington, Leicester, and Plymouth.[8] Keegan had little to complain about, at least not in interviews she gave to the Toronto press.[9] However, Lena Ashwell confessed that "touring with a star is one thing, but [in] just an ordinary company in those days there was a great deal of discomfort ... [on] Sunday, the trains only crawled languidly through the country." She remembered a journey from Cork to Birmingham that meant "travelling all night with the rain dripping through the roof," none of which was helped by the prospect of a "rough crossing" over the Irish Sea.[10]

All this travelling was made possible by the expansion of railroads across Britain and North America. By mid-century, Britain's rail networks were, for the most part, in place, linking the majority of its towns and villages.[11] In the United States, between 1850 and 1910, railroad mileage increased from 9,021 miles to 240,293; by 1905 the nation was linked by 2,272 connecting railroad lines.[12] The growth of railroads in mid-nineteenth-century Canada provided even stronger links between American centres and cities in the Maritimes, Montreal, and southern Ontario than had previous networks of lake steamships and canals. The completion of the Canadian Pacific Railway in 1885 gave performers and producers even greater access to audiences across the western provinces and territories.[13] But such access was not innocent of or unrelated to other relationships of power and dominance. As historians have pointed out, railroads, along with the commercial and government bodies who financed them and provided the legislative framework that facilitated their growth, were deeply implicated in the spread of imperial and settler dominion across North America.[14] Nineteenth-century theatre was, then, entangled with such changes, ones that operated both at the level of representations of ethnic and racialized "others" and in more mundane — but equally transformative — daily practices and mechanics.

Not all wrote about their time on the road in detail while they were on it; Elizabeth Jane Phillips (1830–1904), though, did. Hamilton-born Phillips worked for John Nickinson's Toronto-based company in the 1850s; she also had a relationship with Nickinson that led to the birth of three children, Charles, Harriet, and Albert Edward. In 1862 Phillips was hired for Pike's Opera House in Cincinnati; after four years of performing there, she worked in Indianapolis, New Orleans, and St Louis, and went on to tour the United States and Canada. Phillips began performing in A.M. Palmer's companies at New York's Union Square and Madison Square theatres in 1877; her extensive correspondence about her experiences touring for Palmer and playing in New York covers the 1880s and 90s.[15] Phillips's letters provide a range of important vantage points into the life of a working actress and, most notably, the conditions of her work, ones that are rarely available for this period. They also provide a useful counterpoint to media representations that suggested actresses were either celebrated stars or stage-struck girls and young women.[16] Although she was not a leading performer by the time she wrote them, Phillips worked quite steadily; it is likely that many of her experiences were shared by many of her contemporaries.

In July 1886, en route to San Francisco, she was beginning to grow weary of the trip, telling her son Albert, "we do not get to San F'co until tomorrow – we are six if not eight hours behind time. Car shaking so you must excuse writing. Our trip has been a long one, and seems longer than when we started from NY. It is a great switch taking us by Denver & Rio Grande road – had we come by Union Pacific we should now be in San F'co."[17] Her arrival in San Francisco two days later was delayed by more than a poor choice of route: "We should have been here yesterday morning & did not get here until nearly seven. The train ahead of us, which was the regular train, our[s] being an extra, had the two engines thrown for the track yesterday morning ... We passed the wreck about 2 PM. No cars were upset but the two Engines were turned right over. They said no one was hurt – but I think the Engineer and his companion must have received injuries – but were not killed."[18] While Phillips was merely a spectator to this accident, on her way to Denver in September her equanimity about train travel was shaken. "On Saturday morning we had a very narrow escape from an accident, about two miles from the scene of our accident three years ago. Then five people were injured and one car

wrecked. This time no one was injured except one man who nervously jumped from the 'Observation car' amongst the rocks, but two cars were wrecked." The accident occurred in the morning and although the company was able to complete their journey, they arrived three hours late for their curtain.[19] Travelling between Canada and Buffalo, a "terrible smash up of two freight trains" resulted in a nine-hour delay and news that one of the train's conductors had been killed.[20]

As well as such anxieties and fears, practical considerations about her work were never far from Phillips's mind. To be sure, she was pleased when she was offered a part that met with her approval. "To-day we rehearsed the 1st Act which occupied about 3 hours," she wrote to Albert from New York. However, while "my part is good ... the play is weak and therefore a good part will not amount to much – have to get one very handsome dress."[21] Her pragmatism, though, did not prevent her from being proud when her work was recognized and telling her son about her glowing reviews. "I rec'd a splendid reception last Monday night – and splendid notices in all the papers ... *Our Society* has done more for me than any part I have had for the past three seasons – so that I feel lighter hearted professionally, than I have done for the same length of time."[22] Later in the month she confided to Albert that "I have regained all the prestige I lost while under Collier's management. I am feeling well and hope next Winter will set us on our feet again."[23] Phillips's need for an income, though, probably superseded any artistic or aesthetic scruples. "It is expected that we shall play *Pillars of Society* here," she wrote her daughter-in-law, Penelope, from Boston in 1890. "I am in it, but have not yet received the 'part.' Do not expect it to be a good one, and hope it is not very long."[24]

Salaries – their amount, the timing of their arrival, and if they might be paid at all – are a central theme in her letters to her family. Phillips's own personal circumstances no doubt played a role in her anxieties about money, as her son, Albert, struggled to find work, manage debts, and deal with the expenses of a new family. Given how many actors and managers died in illness and poverty (a situation that benefit performances, the newly formed Actors' Fund, and, after Phillips's death, Actors' Equity attempted to address), Phillips's situation was far from exceptional.[25] For one thing, as she reminded Albert, she received no pay while travelling between theatres.[26] Moreover, from Phillips's perspective, when

salaries were paid they were at best adequate, never lavish. After a discussion with A.M. Palmer in the winter of 1886, she agreed to be part of his company and to travel to Boston, Chicago, and San Francisco: "salary not raised I am sorry to say but the present might be less. And I am grateful to get what I do. Of course you know I do not like the long trip to San Francisco but it is either that or no work — and any savings this season will be too small to get through a long summer vacation."[27] As Phillips's letters and Clara Morris's memoirs testify, actors dreaded long summer layoffs, a time when many theatres closed and they were forced to fall back on already meagre savings. Even a long journey to San Francisco, with the cost of hotel bills along the way, was better than "four months idleness," Phillips thought, as the summer of 1885 had cost her $650 and she was now without any savings.[28]

Moreover, the unpredictability of commercial theatre constantly undermined her ability to make financial plans. Phillips was well aware that plays needed ticket-buying audiences: her letters are full of comments to her children about a production's chances of success. "*Engaged* has caught on and looks as if it might hold the boards until the end of the season," she told Albert, news that he probably welcomed, as Phillips then would have the funds to send his allowance the following week.[29] In Chicago the following year, though, she was "afraid *Jim the Penman* will not prove as big a draw as the management hoped for. There was quite a fall off last night, and the matinee was not good."[30] Not just poor box office might threaten a production: other actors' behaviour might jeopardize it. "Herbert Kelcey and A.M. Palmer are having a good time by telegraph," she told Albert. Kelcey was not happy with the part Palmer had given him in *Jim the Penman* and demanded the lead role. Palmer initially refused to acquiesce, so Kelcey and his wife, who also was in the production, threatened to leave. Fortunately for Phillips, the Kelceys' departure for a rival company was delayed and Kelcey remained in his role for the rest of the run. "If our season had closed here I do not know what I should have done, for as I wrote you I would not have a dollar to live on from now until Oct."[31]

As well as the uncertainty of theatrical engagements, Phillips worried about the cost of supplying her own costumes. During the Palmer Company's stay in Chicago in the summer of 1886, "my dress for the new play will cost $46," she told Albert, an expense she had to meet along with two

weeks' room and board.[32] Later that month she received a dressmaker's bill for $70 and paid $2.50 for her shoes, gloves, and lace for her caps "and I do not know how much more," but was relieved that she would not likely have to buy anything more "for the Stage" until she returned to New York.[33] Wardrobe expenses continued to drain her salary. Before leaving Boston for Utica and then Chicago, Phillips was worried that, having had to buy four dresses for the new play, she had "nothing to buy them with. Next week I get only 2 night's salary, scarcely 20 dollars but that is better than none. It will pay any expenses between here and Chicago."[34] Four months later she wrote from Boston that "[w]e are to open *Jim the Penman* in New York. I am tired of the play. And I suppose we shall be required to find new dresses for the opening of a new season and that I do not like — especially as two or three other plays calling for lots of dresses are to be produced."[35] Back in New York in 1888, Phillips hoped *Captain Swift* would be successful, "for I have an easy pleasant part & do not want to buy any more wardrobe this season."[36] While Phillips's concerns about dress might seem trivial, for actresses they were anything but: providing one's clothing, a crucial part of an actress's working life, was a widespread practice that, as we see, came at a considerable cost. Moreover, not having the right wardrobe might prove damning to one's employment. "Think if I cannot dress the part I may be cast for, I shall have to take a back seat, and somebody else will be put in my place," she told Albert while rehearsing *Marjory's Lovers* in New York."[37] Although by the late nineteenth century fashion designers began to work closely with West End and Broadway productions, this trend seems to have had little effect on the working lives of performers such as Phillips, who were not part of the pantheon of theatrical celebrities — Lillian Russell, Ellen Terry, Ethel Barrymore — who wore such creations.[38]

As Phillips's letters make clear, rail and steam were forms of mid-nineteenth-century technology that intensified the spread of theatrical networks. While these emblems of nineteenth-century modernity provided the infrastructure for these women's careers, so too did the growth of hotels across North America, particularly those urban commercial establishments whose growth was bound up with the growth of major cities.[39] It is impossible to know where all these women stayed while on tour, although Margaret Anglin's letters (including the letterhead on

which they were written) and telegrams, and those of her correspondents, suggest that when possible prominent performers patronized hotels that offered privacy, safety, and proximity to both the railway station and the theatre. Such establishments offered amenities such as private baths, telephones, and appealing decor (not to mention the ubiquitous hotel stationery).[40] Large hotels also drew those who could afford them into middle-class, consumer culture and commercial capitalism across North America. Actresses such as Anglin represented such developments onstage, but these processes also were interwoven into the daily round of their working lives.

To be sure, not all accommodations might represent the growth of middle-class prosperity. Writing from Wilkes-Barre, Pennsylvania, Phillips complained to her family that "theatres cold & dirty. Hotels not much better."[41] In Washington, DC, she found much the same: "bad theatres & hotels and felt pretty tired."[42] Despite her grumbling, perhaps sparked as much by the "bad theatres" as by her lodgings, Phillips admitted, "I may have considerable travelling to do, but I can live at first class hotels as cheap as I can live in boarding houses in New York."[43] While the hotels she stayed in while on the road were indeed "first-class,"[44] once back in New York finding affordable housing was far from easy. As her letters to her children clearly show, Phillips's time in the city was punctuated by a constant search for somewhere to live, weighing the advantages and disadvantages of hotels vs. boarding houses. While in Boston in the fall of 1887, Phillips decided she would make a trip to New York "and try to find a place in which to nestle before the winter. Do not want to go back to 39 W 12th. Paid there too much money for what I got. Hattie wants me to go to a hotel, but I am afraid New York Hotels are beyond my means."[45] While she had heard that The Stuyvesant was "reasonable," her company manager's inquiries on her behalf dashed that hope, as "a room heated and board for me for the winter" would cost her $28 per week. "Too steep for Mama!"[46] While she had hoped to be in "a hotel as I can have baggage attended to and a light in the hall when I get home at 11:30 or 12 o'clock,"[47] she took temporary rooms at the Rossmore at 41st Street and Broadway, telling her son, "I shall stop there until I can find something to suit my pocket-book. Of course I would prefer being nearer the theatre than 41st, although B'way cars are very convenient

but always crowded."[48] She ended up taking more permanent lodging at a boarding house at 50 West 24th Street and "there I can have 3rd story front room heated for $8 per week." The landlady "will try to give me breakfast in my room, and the other meals I will take out. I shall not have carfare or hansom fare to pay. And in the long run I think, be cheaper than anything else, and when I feel like eating I shall not be tied down to boarding house fare. In the hotels I cannot get anything comfortable under $4 per day, and have to waste a great deal of time in being waited on."[49] Six years later, back in New York, Phillips decided to stay at the Hotel Peterler, telling her Albert, "My room is not as large but the other conveniences are better. I am half a block from [the] back entrance of [the] theatre – board is very good, and I get it for $9 per week – quite a save on $20. I am saved the long ride after the performance and as we give 2 matinees – today, the other on Saturday, I am spared from riding up and down and buying lunches as I should have to do on Matinee days."[50]

The Actress as Tourist

Phillips's correspondence demonstrates how the uncertainties of their work, their concerns about personal finances, and their need to support family members could shape actresses' experiences of touring. Furthermore, they also suggest that performers' experiences might have much in common with those members of the middle class who struggled to maintain their status through the economic downturns and upheavals of the late nineteenth century. Yet despite the vicissitudes of touring that historians have documented, actresses' mobility can be viewed from another vantage point, one marked by pleasure and the ability to be a cultural commentator and self-styled authority on the places they passed through and their inhabitants. Phillips and several of her contemporaries were also tourists, participants in a cultural and social set of imperial and transnational practices that, like theatre, spread rapidly throughout the latter half of the nineteenth century and included growing numbers of the Western bourgeoisie.[51]

Despite its dangers and discomforts, rail travel might be pleasing, even thrilling, given the panoramas and vistas it provided. As Phillips journeyed through Wyoming towards Seattle, she wrote her son, "this is

the most pleasant trip I have taken over the plains, I suppose because it is a month earlier. The plains are green, even the sage brush is green and looks very pretty. We are now passing through a considerable amount of Alkali, but it is not so dry as I have before seen it, and therefore does not create the dreadful dust I have experienced in my former journeys." The fact that "we are a very agreeable crowd – no complaints and no bickering," were very comfortable, and were being fed at the "reasonable" rate of seventy-five cents may have added to her pleasure.[52] Six years later, while once again crossing the mid-western desert, she told her children, "our trip so far has been delightful."[53] Writing to Albert as she travelled through the Rocky Mountains to San Francisco, Phillips told him they had gone through "the Grand Canyon and Royal Gorge by daylight. Over Marshall Pass by Starlight – and over the Mountain Peaks we could look down on the Stars in the distant firmament. It was a lovely sight." The view became even more exciting as they went up a mountain. "We had two engines pulling us up the Mountain, and as they turned the curves we could see them puffing out flame and sparks and lighting up the way before them. It was better than fireworks at Coney Island." Moreover, the repetition of many tours had its benefits, as "we have the same sleeping car conductor we had on our last journey. It is pleasant so far away to meet someone who has met us before."[54] In Vancouver, producer Daniel Frohman took Phillips and some other company members for a drive in "Forest Park, and a more beautiful drive I never enjoyed. The grand old trees & the water views were beautiful."[55] After arriving in Tacoma, Phillips told her son that she was going out the next day "to see something of the place" and would take one of the city's "street cars ... worked by electricity." She also hoped to visit the "large Indian Reservation" nearby (although it is not clear that she was able to do so).[56]

In 1883 she went even further in her adventures. While making her way to San Francisco, Phillips decided to climb Colorado's Pike's Peak, telling her son, "Well, I have been to the top of Pike's Peak, and I am not sorry for it. It was the grandest sight I ever saw. Had I known what a journey it was I should never dared attempt it – but I started thinking it was about four or five miles, but when I had been traveling about an hour up the narrow path, so narrow in some places that two horses could not pass each other – I asked the guide how far it was, and he told me it was

13 miles from the place where we mounted the horses." Any misgivings she had were put aside:

> I was in for it, and had to make the best of it. The ascent takes about five hours, and the descent about three hours – the trail is over rocks, streams, hills and valleys. About half way up is a plateau of about 3 or 4 acres of level land. Here we were made to dismount to rest the horses – and take a drink of ice cold spring water. I felt pretty tired then, but as I did not want to spoil the party, I made up my mind to continue the journey to the top – about 15 minutes rest and we start again. Now the sun strikes us pretty hot & we all get nicely sunburned. We overtake a mule train and have to follow it a couple of miles before we can pass it – the path being narrow – and on either side very rocky. At last we dismount – we can scarcely stand – the air is so light – it makes everyone dizzy. My mouth was parched – froth settled on my lips. I was deathly sick, and for five minutes I thought my time had come. The guide helped me over the rocks to the signal service house – gave me a cup of very strong coffee without milk or sugar – and that revived me a little. I never felt such a strange sensation, sea sickness was nothing compared to it.

The end of her journey left her "feeling pretty sore and tired," but despite that, "I think it has done me good and I would not mind going again – but I guess I never shall have another opportunity."[57]

With her evocation of Coney Island and her pragmatic assessments of terrain and climate, Phillips's discussions of landscape showed little sign of being influenced – at least directly – by older, romantic conceptions of the sublime and picturesque, which shaped much middle-class travel writing of the nineteenth century.[58] Other actresses, though, participated in the genre's fascination with racialized people, their appearances, habits, and living conditions. During her stay in Santa Barbara to "rusticate," Clara Morris visited the city's Chinese area, exploring the community's "eating-house, their Joss-houses, and their opium dens." What was more, she was "received with high honor at their theatre, and taken behind the scenes. What a sight! They had one small department

to serve as wardrobe-room, green-room, and general dressing room." Backstage was filled with men since women were not performers; nevertheless, her guide and the company were delighted to find out that Morris was a fellow actor and greeted her with nods, smiles, and friendly comments (rendered by Morris in pidgin English). "I then visited the kitchen, for, *mon ami*, the Chinese actors live in the theatre; and their sleeping dens, pah, I sicken as I think of them. The leading man receives $700 (gold) a year and his rice."[59] Although Morris's account was clearly underpinned by racist conceptions of Chinese Americans, she also was sobered by the performers' working conditions and felt empathy, albeit limited, for the exploitation of fellow actors.

Actresses also used travel outside the United States to express their views of racialized others, writing in ways that underscored their position as white, middle-class women. Travelling to Australia, Ethel Knight Mollison Kelly's (1875–1949) party stopped in Honolulu, where they were saluted by war canoes paddled by "the satiny, brown bodies of the handsomest male creatures" she had "ever seen." After disembarking, the group was escorted to a "hall of public audience," described by her as a "garlanded shed." Here "aged chiefs" greeted them and "the prettiest girls in the village" presented them with welcoming drinks of kava. She continued to be impressed by the physiques of Kānaka Maoli men, with their "high, bushy hair, often tinted red with a coral paste used by them to exterminate insects. Their hair is the men's great vanity, though the chests, arms, and legs of the Governor's guard, whose uniform consisted of grass kilts and a white singlet, might well be any man's pride. More magnificent bodies it would be difficult to see in any picked lots of any nation of the world." Yet despite her fascination with these men's bodies – one clearly shaped by sexualized conceptions of exotic others – Kelly also thought that Hawaii was a "fantastically primitive" place, rife with "horrible cases of elephantiasis alongside funny old half-nude natives, wearing a fringed mat for trousers, elastic-sided boots on bare legs, often a linen collar without a shirt, and, whenever possible, an old top-hat [which] protected the high bushy hair from rain. Almost any treasure would be bartered by them for an old stove-pipe hat, when the few passenger ships that stopped there came in port."[60] As a tourist Kelly was impressed by that which she decided to construe as authentic:

however, Indigenous peoples' cultural adaptations struck her as comical and somewhat pathetic, not as examples of innovation and creativity.[61]

Six years after Kelly's stop in Honolulu, her contemporary Margaret Anglin toured Australia. While playing in Melbourne, Anglin took in many popular sights, such as the nearby gold mines at Ballarat. Here she donned overalls and a cap and descended 2,500 feet into the mine. Anglin also went to Corranderk, the Aboriginal community outside Melbourne which, with its Christian population, agriculture, and Western-style homes, had become a tourist attraction.[62] There she bought souvenirs and witnessed its male residents perform boomerang-throwing and foot-racing competitions. In a later interview, Anglin described Aboriginal Australians as having the "lowest intelligence" of the human family, adding condescendingly, "I believe that Bushmen of South Africa are below them but not far ... Still, they have a remarkable sense of humour, and may be recommended for their invariable good nature."[63] Clearly Anglin subscribed to the Scottish stadial philosophy of race and social organization that classified groups according to a hierarchy of economic and social practices and supposed intelligence, one that placed "modern" (white) nations at the pinnacle of civilization and relegated Australian Aboriginals to its nadir. As she travelled to England from Australia, Anglin and her sister Eileen stopped in Calcutta, Sri Lanka, and Egypt, where they took a boat trip up the Nile and rode camels in the desert. Yet although other female travellers from British colonies might use such a voyage to reflect on the value of being both British and white, Anglin was not one of them.[64] She compared various aspects of the Empire's colonies unfavourably with the United States, particularly Honolulu, where she had stopped en route to Australia. Aden, in particular, disgusted her: "I think Aden is the most frightful place I have ever visited for heat, dirt, squalor, and depression. Aden is another part of Great Britain's wonderful Dominions!"[65] While Anglin believed in white superiority, for her it was manifested most clearly in America, not the British Empire. As we shall see later, her sense of being "Canadian" was rooted in an identification with being Irish Canadian, not British: touring on a global scale allowed her to reflect on these matters. Moreover, for Anglin and her counterparts, it also allowed them to act as connectors between the places they visited and their audiences, whether the latter consisted of newspaper readers or their own families.[66]

Public Battles and Backstage Negotiations: Actresses as Managers

The vicissitudes (and pleasures) of touring were an important part of these women's careers, but some also turned to company management, an endeavour that granted a degree of control over their work but that also took up considerable amounts of time, energy, and patience. All would have been familiar with the figure of the actor-manager. Throughout the nineteenth century, on both sides of the Atlantic men such as Henry Irving were known for their productions of Shakespeare, new dramas and comedies, and popular melodramas, any of which might feature performances by the manager in a starring part.[67] This role was not limited to men, however. From 1831 until 1854 Lucia Elizabeth Matthews (Madame Vestris) both performed and produced at several popular London theatres, while in New York Laura Keene, the first significant female manager in the United States, ran Laura Keen's Varieties Theatre from 1855 to 1863.[68] Yet after the Civil War the role of the manager in America changed, becoming more of a full-time and separate job. Male producers or directors took charge of theatre companies' management, and as the position was hived off from acting, it became a male preserve. Furthermore, the rise of the male-dominated Syndicate, a group of companies that dominated American theatre, made it much more difficult for smaller proprietors — men or women — to survive.[69] The situation differed in Britain, though. While male actor-managers continued to exert a powerful presence in its late-Victorian and Edwardian theatres, J.S. Bratton and Tracy C. Davis have shown that women managers, lessees, and proprietors flourished during the mid-Victorian years and made critically important contributions to the development of theatre in London's West End.[70] During the Edwardian years, women such as Gertrude Kingston and Elizabeth Robins were at the forefront of producing and performing in feminist, non-commercial forms of theatre.[71]

For some of the women considered here, running their own company was a matter of financial necessity, often precipitated by the death of a spouse. Toronto's Charlotte Nickinson set up her own company in the Grand Opera House in 1871 after her husband died, leaving her with three young children to support, while Kate Horn ran Montreal's Theatre Royal after her husband's death. In this respect Nickinson and Horn were very similar to American women managers who, as Jane Curry has

argued, depended on a theatre as their sole source of financial support and took over the management of one after becoming widowed.[72] Both Nickinson and Horn were in charge of buildings as well as bodies, while those women who came after them tended to focus not on the management of a building but, rather, on company and artistic decisions.

One of the most common reasons for striking out on one's own was, simply, a desire to have a greater say over one's affairs. Margaret Mather's career testifies to such a desire; it also, though, demonstrates just how onerous such management could be. Mather began wrangling with her manager, J.M. Hill, in May 1888 when Hill took her to court to attain an injunction that would prevent her from changing her management. Hill, charging Mather with "petulancy," claimed that he paid for her education; moreover, she had signed a contract that bound her to him until 1893.[73] Mather responded with her own suit against Hill, a trial closely covered by *The New York Times*.[74] Matters ended with a judge vacating Hill's injunction and giving Mather the option to sue Hill for her money, which she claimed he had lost through bad investments.[75] Although another judge ruled against her suit, Mather (who decided to launch yet another action against Hill) was happily signed with Gilmore and Tompkins by then and was reported as being "buoyant and confident, and glad to be at work again."[76] Yet the matter was not resolved. In December yet another judge ruled that Mather had to return to Hill's management;[77] the case then went to the Supreme Court, which eventually ruled in Mather's favour.[78]

Two years after the Supreme Court's decision, Mather announced she had bought Jules Barbier's *Jeanne d'Arc* from Sarah Bernhardt's manager. "The ambitious American actress has purchased the entire production," reported *The New York Times*, "including the scenery, about 300 hundred costumes by Worth, the manuscript, score, and properties," and would travel "under her own management after this season" with a business manager, Mr Willoughby.[79] No doubt Mather's legal battles made her determined to avoid such problems in the future by forming her own company and performing in productions of her own choosing. She also, though, may have been inspired by Bernhardt's example of running her own artistic affairs, since according to the paper the two had met during Bernhardt's American tour: the famous French performer "became much attached to the hard-working young actress." Mather was

reported to "look upon this acquisition as the greatest piece of good fortune that has befallen her since she adopted the stage as a profession, and she will work hard to fit herself to play the part which has been made famous by Bernhardt."[80] Unfortunately for Mather, the critics did not feel that all her hard work was indeed enough: the play received poor reviews and closed not long after opening.[81] According to the American actor and author Otis Skinner, at the request of Mather's lawyer, General Horatio King, Skinner became her manager for a year. Mather's "constantly shifting managers had been unsatisfactory" and it may have been that Skinner, well-connected in New York theatre and with experience in Augustin Daly's London-based theatre, seemed suited to the task.[82] Writing about his experiences many decades later, though, Skinner remembered that "my hands were full!" As well as performing in several roles, he had responsibility for booking, hiring, drawing up contracts, ordering printing of programs and advertising, and planning productions of a number of plays that were new to both him and Mather.[83] Hardest of all, though was "the task of holding my star in order. I might as well have tried to manage a cageful [sic] of wildcats. She could never learn the lesson of restraint. The stress of her acting would often react upon her physical strength." Such a "tumultuous" season took its toll on Skinner, and he dissolved their partnership halfway through the season.[84]

Skinner's account of Mather's behaviour should be read carefully. As well as his overblown prose style, Skinner tended to patronize Mather, using deeply gendered metaphors that suggested she inhabited the realms of emotion and nature, feminine caprice, and disorder. Although Mather had little "conversation," underlying her "silence was a chaos of fancy, ambition, sympathy, generosity, jealousy, timidity – all ill-adjusted and treading each upon the other's heels ... There was no control, training, and little schooling to direct the wild turbulence of her nature. It grew to maturity like one of those trees sprawling upon the hills of the California coast that are listed into grotesque shapes by the blasts from the Pacific Ocean."[85] During her informal apprenticeship with Hill, Mather's "brain tied itself into knots in the attempt to understand many strange things."[86] Skinner also characterized her as "continually changing managers, her suspicious nature detecting unfairness in the handling of her business."[87] Although Skinner acknowledged that Mather had little formal education, he did not concede that

her early life of poverty might well have left her suspicious of others, particularly powerful men such as Hill. Moreover, like the newspaper coverage of her legal battles with Hill, Skinner's account of her troubles with managers suggests that Mather was nothing more than a puppet in her husband's control. Although Emil Haberkorn may well have drawn Mather's attention to Hill's mismanagement of her funds, given her drive and ambition it seems unlikely that she was only a passive Trilby to his all-powerful Svengali.

To be sure, Mather's subsequent career was marked by various types of controversies. Booked to stage *Romeo and Juliet* at Toronto's Academy of Music in the fall of 1890, Mather refused to perform when she saw the scenery, which, according to her business manager, was inadequate. "'When we booked the engagement in New York,'" Mr Cotter stated, "'we thought we were coming to a first-class home ... but there were only seven pieces of stuff,'" adding, "'I think she was quite right in the course which she took. This was a favourite engagement of hers in Toronto; she has lots of personal friends here, and has brought a special wardrobe with her, so that it's very easy to understand why [she] declines to appear on a naked stage.'" Mather quickly booked another theatre, the Grand Opera House, but the Academy's management seized her trunks; Cotter was forced to go to court to regain her wardrobe. The Academy's manager then attempted to obtain an injunction to prevent her from appearing at the Opera House, which was unsuccessful.[88] For the next few years, Mather's domestic life took up considerable amounts of her time and energy: she divorced, remarried, left the stage (according to some press reports, at the request of her new husband's family), and divorced again.[89] In 1896 Mather returned to managing and performing, producing both *Romeo and Juliet* and *Cymbeline*, as well as a number of other plays, and touring across the United States and Canada (she also hoped to take *Cymbeline* to London).[90] Although by then Mather had another business manager, John Major, she oversaw all other aspects of the company and acted each night, most notably as Juliet and Imogen.

It may well be that her hard work, combined with Major's illness and the uncertainties brought about by the introduction of four new company members, brought about Mather's onstage collapse on 6 April 1898, during a performance of *Cymbeline* in Charleston. Mather did not recover consciousness and died the next day of convulsions brought

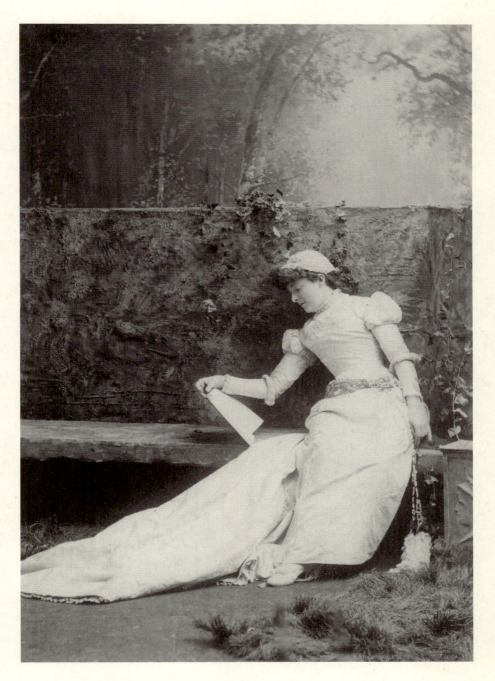

Fig. 2.1 Margaret Mather as Juliet, c. 1880s.

about by "acute Bright's disease."[91] Falling ill from stress was not unique to Mather: other actor-managers battled ill-health that may have been partly caused by worry and overwork.[92] Yet while the press was sympathetic to Mather's sad end and freely acknowledged throughout her career that she was hard-working and dedicated to her craft, like Skinner it also treated her condescendingly, its coverage of her acting redolent of gender and class bias. Unfortunately, Mather does not seem to have left her own writings that would contradict or, at the very least, provide more nuance to the public record.

Other women found company management to be less contentious, if tiring. After working for over twenty years in various companies run by prominent men (Lawrence Barrett, Tommaso Salvini, and Charles Frohman) and having become a popular star in 1898, playing Glory Quayle in Hall Caine's *The Christian*, in 1903 Viola Allen decided to form a company devoted to Shakespeare, with her brother, Charles W. Allen, as her business manager.[93] Judging from Allen's own correspondence, though, she carried a great deal of the financial, as well as the artistic, worry of running the company. She confessed to William Winter, the prominent American writer and drama critic, that while she had hoped to "present Shakespeare continuously doing one play each year as thoroughly and well as possible until I had formed a repertoire ... I must confess to you that New York has not been over kind to me its encouragement of the classic drama making it impossible to run one play of this kind more than 3 or 4 weeks in town."[94] For one, competition from other productions worried her intensely. Reading Winter's review of *Twelfth Night* in New York "took away all my courage and enthusiasm," she told him. While she "rejoiced" that "the most lovely of plays is being done so adequate and beautifully," she wondered if she was being "foolhardy" to attempt her own production. Although she wished to play Viola in it and Imogen in *Cymbeline*, as she felt they were "close kindred ... if I failed in one, how can I succeed in the other?"[95] Although she decided to proceed with *Cymbeline*, Allen initially found it difficult to hire the actors she wanted for the production. She also continued to worry about rival companies, telling Winter that while she wanted to book New York's Lyric Theatre – since everyone in the city "would know we were there" – it would interfere with her plans to mount a coast-to-coast tour after a "good long season." William was attempting to find out if Julia

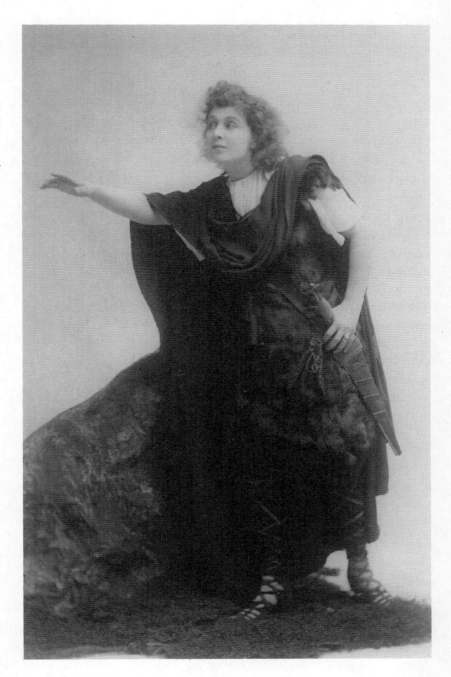

Fig. 2.2 Viola Allen as Imogen in *Cymbeline*, c. 1906.

Marlowe would be performing Shakespeare at the Lyric: if such was the case, did Winter think another venue, such as the Knickerbocker, would be preferable? And would it be best to play *Cymbeline* in four, not five, acts?[96] Winter was working on an edited version of the script for her, and Allen continued to consult Winter about her artistic decisions, thanking him for his suggestions about casting and about her interpretation of Imogen.[97]

Their relationship was not without tensions, though. In response to Winter's letter of 23 September 1906, Allen told him, "I cannot for a moment let you believe that I hold anyone's judgement or option before yours. On the contrary I am certain there is *no* one who knows as much about adapting Shakespeare to the stage as you do. But I did think that *adapting* and *producing* were two distinct provinces in most cases." The disagreement between Allen and Winter, it seems, rested in her decision to make cuts to his adaptation ("certainly a great piece of work"), as well as having hired a "Mr. D" to stage it. The latter had "great ability in creating atmosphere and illusion and I had found him so reliable, studious, and serious in his business that I was relieved of all anxiety as to details of production."[98] According to Allen, "D" had gone to England in 1904 where he studied staging, lighting, costumes, and properties and returned with a number of ideas that, among other aspects of the production, would allow Allen to save time on scene changes. "So when he arrived a few weeks ago," she told Winter, "with the result of all this labor you can see the situation and that it would not be right to bring a man over here to direct the stage without giving him control of it." She hastened to assure Winter that "of course [D] felt the greatest admiration for your adaptation of the play as you know we all do and realize that without it the risk of producing *Cymbeline* would be increased many many times." But she was very surprised that find that Winter had made "a *complete stage manager's* prompt book. I would not have believed it possible that such an entirely comprehensive work could have been done in advance because I have never yet seen a play in course of production that business and effects have not been changed half a dozen times — and perfect as the direction seems I'm certain even a capable stage manager would fall far short of realizing your ideas. It would be the *letter* without the spirit. To produce the desired effect the mind that conceives the pictures and environment must see to the execution of them. So as I have intimated,

I expected you would give me (as you have done) a perfect text, authoritative on all disputed points and that Mr. D could put it on the stage, neither arrangement interfering with the other."[99]

It is clear that Allen was attempting to be diplomatic, but it is equally clear that she felt Winter had overstepped his role in the matter. She was gratified to have Winter, a revered figure, involved in her production in his capacity as a writer. Nevertheless, her letter also suggests, however respectfully, that writers might not be the best judge of what would work on stage: such matters should be left up to those who did the work of performing and running the production. Winter did not seem to have been offended: one month later Allen thanked him for "his kindness, and the exquisite way in which you spoke of me personally."[100] In his 1911 publication, *Shakespeare on the Stage*, Winter stated that "Viola Allen was amply successful with her impersonations of Viola, Hermione, and Perdita."[101] They continued to write to each other about matters both personal and professional, exchanging Christmas cards and news about her tours and travels.[102] Allen was involved in the 1916 testimonial staged for Winter at the Hotel Manhattan and also corresponded with his son, Jefferson Winter.[103]

It is not apparent if Allen lost money on these plays, as no financial records for her company seem to have survived. Perhaps she did not make as much as she had hoped, though. Her performances as Glory Quayle had made her one of the best-paid actors in the United States and she might have had higher expectations of a profit than were realized.[104] While Allen seemed disillusioned about staging Shakespeare in New York, her disappointment might have been eased by the high level of critical and popular acclaim her productions received across North America.

Like Allen, Annie Russell turned to managing her own company after years of working for other managers and directors. In 1908 Russell's then-managers, Lincoln A. Wagenhals and Collin Kemper, announced that they would build a theatre in New York named for her, in which she would appear as the opening act in 1909. Said to be "modern in every respect," the theatre was going to cost $300,000. Wagenhals explained that "'Miss Russell is under contract with use for a considerable length of time and it occurred to Mr. Kemper and myself that she might as well have her own theatre,'" one located in the centre of the city's theatre district.[105] If the Annie Russell Theatre was built (and it does not appear to

have been), Russell did not remain there for long. She went on to work for the New Theatre Company, the Leibler Company, and Charles Frohman's Empire Theatre before founding the Old English Comedy Company in 1912. According to the *New York Times*, the impetus for the company came from a group of "prominent women" who were searching for plays suitable for children; Russell, who attended the lunch where the discussion took place, was asked by the group to spearhead its organization. There is little doubt that the Old English Comedy Company was tied to elite New York society; subscribers included Mrs Andrew Carnegie, Horace Mann, Mrs J.D. Rockefeller, and two members of the Whitney family. Moreover, the women submitted their plan to the "heads of several prominent private schools" who were asked to choose the plays.

Russell's Company moved into the newly built Princess Theatre on West 39th Street, a small building with seating for just under 300 on the ground floor and twelve boxes. In addition to a clear Anglophile mandate (and name), the company hired Oswald Yorke as its stage manager; he had formerly worked with England's Frank Benson on Shakespeare and English comedies.[106] Russell's company began their 1912 season in November with a production of *She Stoops to Conquer*, followed by *Much Ado about Nothing*.[107] The following year the Old English Comedy Company toured to Toronto's Royal Alexandra Theatre with *The Rivals* and *She Stoops to Conquer*. *The Globe*'s drama critic, E.R. Parkhurst, noted approvingly that "its members are by no means unknown to Canada playgoers. They are all English players, having had their training in English companies of established merit, and having supported the most notable English-speaking stars in England and America."[108] Russell's backers were, it is likely, touched by mingled sentiments of both Anglophilia and anti-modernism, expressed in their view that plays suitable for children could be found primarily in a version, most likely sanitized, of early modern English drama. They also may have been reacting negatively to the Progressive Era obsession with prostitution that had made its way onto New York's stages in the form of popular musicals and more "highbrow" social problem plays.[109] Russell's own motivations, though, may have been more complex. While she might have been touched by the same anti-modernism as her backers, in the Old English Comedy Company Russell was able to stage and perform a type of comedy in which she excelled.

Julia Arthur's trajectory was in many ways like those of Russell and Allen. For Arthur, running a company followed many years of working for prominent men, such as E.A. McDowell and A.M. Palmer, and a stint at Irving's Lyceum Theatre, both as part of its London company and on tour in North America. When she returned to the United States from London in 1897, Arthur did so as the star of her own company. Like Allen, she worked with family members; her brother, Arthur Lewis, and her soon-to-be husband, Boston millionaire Benjamin Pierce Cheney, were her investors and managers. As historian Denis Salter has pointed out, Arthur's company suffered from not having leased a New York theatre; she opened her plays outside the city with the aim of transferring successful ones to Broadway.[110] Arthur's first production, *A Lady of Quality* (an adaptation of Frances Hodgson Burnett's novel), opened in Detroit on 4 October 1897, but was particularly ill-fated: the theatre burnt down after the third performance and $30,000 worth of scenery and costumes were lost. While newspaper coverage acknowledged the great loss Arthur incurred, unsurprisingly it did so in ways calculated to catch readers' attention.[111] In contrast, Ethel Knight Mollison Kelly, who was acting with Arthur's company at the time, captured the event's enormity on a more personal level, one that drew attention to the labour involved in such a lavish production. "The entire company stood with a great concourse of people in the street all the night, watching the hissing, cruel, crackling fire lick up, with burning tongue, all that meant income for a year to the actors, and in many cases must have represented a lifetime's careful collecting of stage jewellery and valuable properties, manuscripts, and personal wardrobe. Miss Arthur's six thousand pounds worth of scenery and costumes was lost; possessions that artists had spent weeks designing, and that costumiers, wigmakers, and bootmakers had been working on for months – in an hour it was all rendered useless."[112] Fortunately for Arthur and her company, Lewis and Cheney found the capital to re-mount the play for its scheduled New York opening at Wallack's theatre on 1 November.[113]

Like Mather and Allen, Arthur wished to specialize in Shakespeare, staging *As You Like It* and *Romeo and Juliet*. But as Salter argues, she was more successful – at least so far as the critics were concerned – in romantic modern productions, such as *A Lady of Quality*, *Mercedes*, *More than Queen*, and *Pygmalion and Galatea*.[114] Arthur's career as a manager

was short-lived, however. In 1900 she decided to leave the stage for a year, which turned into sixteen years of retirement. The stress of running a company and being its leading actress seems to have taken a toll on her health and her artistic abilities. Furthermore, unlike Peter Duryea's support for Viola Allen, Arthur claimed that her husband (she and Cheney married in 1898) was not happy about the demands of her career, particularly those of touring.[115] Ironically, when Arthur returned to the stage, Cheney's financial difficulty was one of the reasons for her comeback.[116]

Other prominent women also became managers of their own companies, with varying degrees of success. In England, Lena Ashwell founded her own company, announcing in 1904 that "'under the prevailing system I cannot get the characters I am ambitious to appear in, and my ambition will not be satisfied until I have a theatre in London at which I can produce serious works, and prove there is as big a public for them, when they are of the right sort and properly presented.'"[117] While Ashwell's initial productions, which included an American tour of *Mrs. Dane's Defence*, met with mixed results, by 1907 she was able to lease a small West End space, the Great Queen Street Theatre, which she had renovated and renamed the Kingsway.[118] Her major production, *Irene Wycherley*, in which she also played the lead role, was a critical success and did well at the box office. Ashwell also supplemented her London performances with so-called "'flying matinees'" outside the city to Brighton and Cardiff, made possible because of the Great Western Railway's routes from London. Ashwell followed *Irene Wycherley* with Cicely Hamilton's *Diana of Dobson's*. Not only did it sell well at the Kingsway, but it also toured to a number of cities throughout Britain and became one of Ashwell's best-known roles.[119] However, despite the Kingsway's strong record, early in her career at the theatre Ashwell had lost her financial backer's support; without it she gradually ran out of money. Although the details are somewhat murky since, like so many other companies discussed here, there are no financial records of Ashwell's enterprise and she used pseudonyms to identify her "benefactors," the latter's desire to control Ashwell and treat her like a servant led to the parties breaking off contact.[120] In 1909 Ashwell found a producing partner for the Kingsway but was tied to its lease, writing in her memoirs that she "had to do many hateful things to pay for it until, after the War, I was able to sell the

Fig. 2.3 The Kingsway Theatre, 1956, shortly before its demolition.

lease."[121] From Ashwell's perspective, the problem was not just that she was at the mercy of her patron's whims: she also came to believe that in order for theatre in England to fulfill her goals of being socially relevant and intellectually challenging, it had to be supported by the state, not

private enterprise.[122] In the 1920s Ashwell continued to work towards this goal.

As well as tackling work on controversial subjects, Ashwell preferred to avoid the highly masculine world of London's actor-managers.[123] For Margaret Anglin, male colleagues *per se* were not the problem: the male-dominated Theatrical Syndicate, though, was. To bypass the Syndicate's hold on many American theatres, from 1903 to 1905 Anglin joined forces with Henry Miller, a British-born fellow actor who had lived in Canada; they appeared in various smaller theatres in the United States. Miller, an experienced and well-regarded performer, took over management of New York's Princess Theatre in 1905, going on to direct Anglin in *Zira* and then to star with her in William Vaughan Moody's *The Great Divide*. A story of the American frontier, *The Great Divide* was extremely popular and toured across the United States for the next two years.[124] In 1910, a year after her return to the United States from her tour of Australia, Anglin began presenting Greek classical theatre. She started with Sophocles's *Antigone* at the University of California, Berkeley's amphitheatre and then expanded her repertoire to *Electra*, *Medea*, and *Iphigenia in Aulis*. For the next eighteen years, Anglin supervised, directed, and performed in Greek tragedy in venues across the United States, as well as adapting and rewriting scripts, a practice she would continue with other productions.[125]

Anglin used the profits from her other productions to support her work in Greek theatre, substantiating her frequently made claims that playing Medea or Electra was not about making money but, rather, being able to tackle roles that allowed her to give full expression to her dramatic range. "In no other drama can an actress find such opportunity for styling shows of emotion that are so nearly alike and yet so subtly different," she told *Hearst's*.[126] While like Allen she also hoped that theatre could be more than mere diversion, she also (here, too, like Allen) wanted her work to be, not a museum piece, but entertaining for contemporary audiences. Anglin also declared that "there is no reason for us to retain the riding conventions of Greek drama, for we may rest assured that were the Greek dramatists alive today, they would be the first to utilize, from the modern playhouse, whatever would best serve Greek theatre as they saw it."[127] As William Dallam Armes, chairman of the Music and Drama Department at Berkeley, told Anglin's business manager

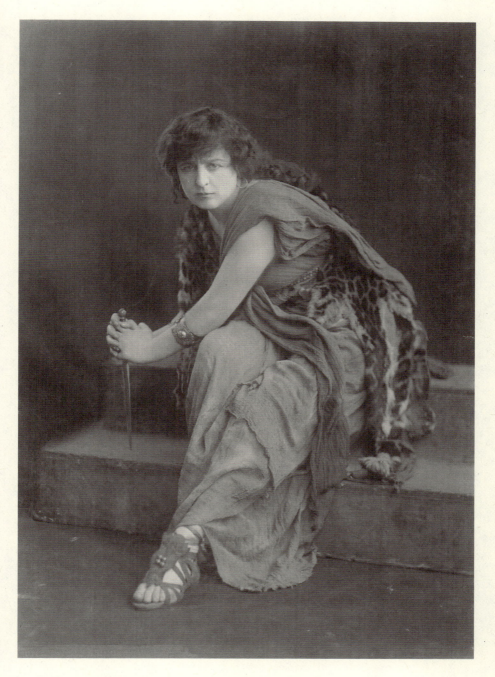

Fig. 2.4 Margaret Anglin as Medea, c. 1912–16.

Louis Nethersole, Anglin was also concerned with filling the seats with an audience drawn from a wide range of backgrounds and intended that her work reach more than a small group of scholars. Armes told Nethersole that Anglin remarked that opening *Antigone* on 5 July would conflict with the "'meeting of the gladiators,'" which puzzled Armes until he discovered that the "'gladiators'" were the boxers Jack Johnson and James J. Jeffries, scheduled to fight 4 July in Reno. "That Miss Anglin, so far away, should know of this while we, near at hand, did not: that she should think it of such interest to all classes of our people that San Francisco would be upset the day after by the outcome; and that she thought that it would in any way interfere with the attendance at her performance of the Antigone of Sophocles struck us as amusing," Armes wrote. Anglin's perspective on the boxing match was distorted in subsequent press reports, which suggested she was "'seriously disturbed by the fact that the fight would interfere with the interest'" in her play, a feeling that, Armes told Nethersole, was certainly not the case. Anglin, he believed, recognized that her audience might encompass a wide swathe of the population: it was not unthinkable that they might wish to attend both the boxing match and the theatre.[128]

Scholars have pointed out that her work in Greek theatre was in many ways a turning-point in Anglin's career. It took her from being a highly regarded "serious" actress who was esteemed for her performances in both comedy and domestic melodrama (in which she would continue to appear) to even greater cultural prominence.[129] Anglin's experiences in Greek theatre also, though, introduced her to running a company, a process that involved both artistic and material concerns. As well as prompt scripts and floor plans, the production files for her Greek plays are stuffed with contracts for musicians, stage managers, carpenters, and wardrobe mistresses and invoices for rehearsal pianists, sewing machine and typewriter rentals, chiffon, braid, and silk, men's sandals, back flap hinges, tips for hotel doormen, and press entertainments: the objects and the transactions surrounding them that made such large-scale performances possible.[130] Although Anglin did not personally oversee the flow of money and materials, over time she became more and more involved in such details.

More immediately, after the success of *Antigone* Anglin was able to move into another of her passions: directing and performing Shakespeare.

In 1913 Anglin announced that she would stage *Antony and Cleopatra*, *Twelfth Night*, *The Taming of the Shrew*, and *As You Like It*. Calling her "one of the most enterprising producers of next season," *The Toronto Daily Star* told her audiences that they would see Shakespeare produced "after the new methods of Germany."[131] As well as appearing in New York, Anglin's company performed across North America, touring with forty people and three rail cars full of scenery.[132] Although the press coverage painted a picture of a smooth and, ultimately, successful tour, one that culminated in Anglin's 1916 production of *As You Like It* at the St Louis tercentenary of Shakespeare's death, Anglin's private correspondence depicts continuous negotiations over plans that came to fruition and others that did not. As part of her Shakespearean productions, Anglin hoped to form an acting partnership with William Faversham in *Romeo and Juliet*, with the two of them in the lead roles. The English-born Faversham was no stranger to Shakespeare. He had played Romeo to Maud Adams's Juliet in Charles Frohman's company and from 1912 to 1914 had staged and performed in his own productions of Shakespeare, including *Julius Caesar*, *Othello*, and *Romeo and Juliet*.[133] Initially Faversham was eager to see the project succeed, as he shared many details about his own production, recommended casts, and began (often rather tortuous) negotiations for a theatre in Chicago.[134] However, his enthusiasm dissipated quite quickly, as a few weeks later he withdrew from the company, arguing that Anglin's own Shakespearean productions, due to open before their joint venture, would undercut the latter. Although Faversham claimed not to bear any ill will towards Anglin and Hull,[135] the tone of their correspondence with him became decidedly frosty, lacking the warmth and good-will of their previous letters.[136] Furthermore, when the prospect of Anglin appearing with Faversham arose nine years later, it seems she might not have forgiven him entirely. Asked to forgo a play because Faversham did not wish to appear in it, Anglin replied "you can well imagine my consternation on finding myself [in a] position, where the keeping of an agreement or shall we say understanding so far as my interests here are concerned depended entirely upon Mr. Faversham's wishes in the matter." Although Anglin considered Faversham to have always been good-natured, fair, and considerate, she was furious that "my activities must be regulated entirely by his wishes ... you can't in your heart blame me for beginning to think I must look only for myself – what I can do for myself – will

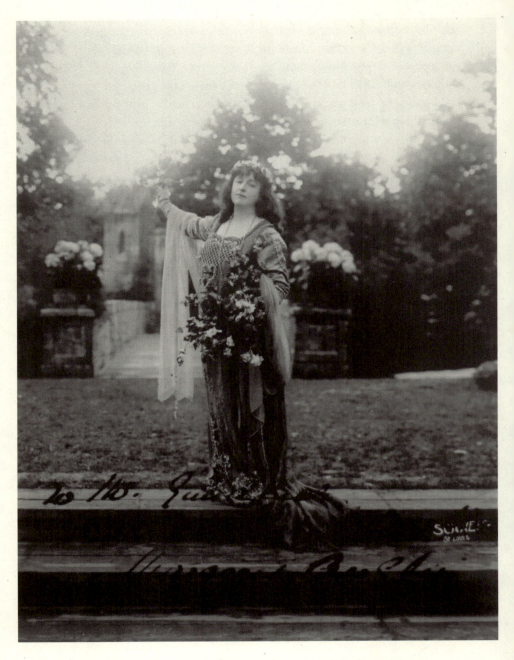

Fig. 2.5 Margaret Anglin as Rosalind in *As You Like It*, Wake Forest Theatre, St Louis, 1916.

probably not be much — but at least I can do the few things myself."[137] Her negotiations with Faversham — and their tense ending — were not an anomaly or merely a matter of strong personalities clashing. In the years to come Anglin would encounter her share of disputes and conflicts with other actors, producers, and playwrights over matters both artistic and administrative; in some cases, business arrangements that started on cordial, and at times quite friendly, terms ended in acrimony and hostility.[138]

Matters seem to have gone more smoothly, though, with her appearance at the Forest Park outdoor theatre in St Louis in June 1916. Part play and part pageant, staged to honour Shakespeare and reflecting the Progressive Era's fascination with community pageantry, the production featured both Anglin's company and a chorus of 1,000.[139] It ran for eight performances to large crowds. John H. Gundlach, the pageant committee chair, estimated that at least 20,000 people saw the production, with some having to stand outside when performances were sold out.[140] While her performance as Rosalind opened in a downpour on a "soggy stage," it was greeted with "repeated applause," the "stars came out, and the production was brilliant," reported the *New York Times*.[141] Despite the rain, Anglin declared the Forest Park stage "the most beautiful in the world," with a magnificent natural setting. Overall, the press — and Gundlach — thought the pageant a great success, both at the box office and artistically.[142]

While taking on the responsibility of company management could be the source of much stress and headaches, it also gave the women involved a degree of both financial and aesthetic control, one that was not available to those who, like Phillips, were employees. Anglin, for example, was able to hire Livingston Platt for her company; he designed sets and costumes for her that were more stylized and imaginative than the "cumbersome [and] pseudo-realistic" settings that dominated other Shakespearean productions of the period (they also allowed for more rapid scene changes).[143] As we have seen, Lena Ashwell's interest in new forms of drama, particularly feminist plays, was given greater space to develop with her management of the Kingsway. And it was not just in the legitimate theatre that female performers sought to exercise a greater degree of independence: such was the case as well for vaudeville stars May Irwin and Marie Dressler.[144]

Conclusion

Mobility, then, might bring its own challenges: sore backs brought about by lumpy beds, chills caught in draughty train carriages, stomachs tied in knots over the prospect of one's wages either appearing late or not at all. It also could mean the excitement of charming, moving, and creating memories with audiences that extended beyond the limits of Broadway and the West End. What's more, travelling within North America and beyond provided opportunities for actresses to be tourists, to participate in one of the period's most rapidly growing social and cultural middle-class pursuits. But no matter one's experiences with touring, positive or negative (or both), most performers had little choice in the matter. Even those celebrated "stars" who decided to run their own companies had to contend with touring, for better or for worse. Unlike, for example, women theatre managers in London's West End, the pleasures and vicissitudes of "the road," as well as the increasingly competitive world of late-nineteenth- and early-twentieth-century American theatre, shaped the worlds of Allen, Anglin, Arthur, Mather, and Russell. Yet they and Lena Ashwell shared in the hopes that they could not just "support themselves but could potentially succeed on their own in the business ... [a] capacity that gave them more choices, more independence, than their contemporaries."[145] Although such independence could not always be realized (or maintained), nevertheless it is important to recognize their desire to attain it, to move from being an employee to becoming a cultural entrepreneur. Furthermore, their offstage efforts to stake out greater degrees of autonomy take on added significance when we explore the ways in which their onstage work often capitalized on their ability to please others and conveyed mixed messages about middle-class women as independent beings. Chapter 3 examines the range of plays in which these women appeared and their relationship to transnational middle-class culture.

CHAPTER THREE

The Plays

Introduction

If these actresses came to their work from a variety of backgrounds, the work itself was equally diverse. The genres in which they appeared were wide-ranging, to say the least: Shakespeare, historical dramas, domestic melodramas, comedies that ranged from those of the Restoration to those of Oscar Wilde, Greek tragedy, New Woman dramas, musical comedy, operettas, and vaudeville. Such heterogeneity suggests several things. For one, their careers remind us of the great range of commercial theatre in this period, which cannot be characterized by one type of play or performance. As Meredith Conti has pointed out, "Victorian-era theatre was transitional and heterogeneous, with a wealth of genres and styles" that encompassed "melodrama, cup-and-saucer plays, light comedies and burlesques, Shakespearean revivals, and French translations."[1] Moreover, such an exploration tells us how widespread these actresses' presence was in transatlantic and transnational theatre, the multiple ways in which they were part of theatrical networks, and, too, the very wide span that these networks encompassed. These women also linked types of theatre and performance, since many of them appeared in a variety of roles and scripts, playing in Shakespeare at one point and then in a contemporary melodrama at another. Furthermore, a number of them were connected to each other through this array of plays and productions. Elizabeth Jane Phillips, for example, appeared onstage with Annie Russell; Annie Russell understudied Viola Allen; and Lena Ashwell and Margaret Anglin alternated the role of Mrs Dane in the North American production of *Mrs. Dane's Defence*.

Just as they had moved across national boundaries to pursue their careers, the productions in which they appeared represented a wide swath of not just genres but also national contexts, as work by British, French,

German, and other European playwrights was adapted and translated for the British or North American stage.[2] Concepts of race and empire also permeated many of the plays in which they appeared, whether through images of white womanhood, fallen or threatened, or in depictions of racialized and ethnic women. Historical dramas reflected the nineteenth and early twentieth centuries' engagement with the past as an ocular and sensory experience and highlight the work of actresses in this process. In turn, several productions tackled contemporary questions that would have preoccupied many of their middle-class audience members: gender relations, marriage, social reform, and the relations of labour, capital, and class. The themes that ran through their performances tied these women to the world of the transnational middle class.

Transatlantic Connections

"The nineteenth century," writes Peter W. Marx, saw "the emergence of an international and increasingly internationally connected sphere of theatre," with "exchanges of plays," particularly from Paris; a leader in the export of prestigious luxury goods overall, Paris became "the leading exporter of dramatic commodities."[3] For Clara Morris, American adaptations of French and English plays helped establish her reputation in emotionally moving sentimental drama, whether in *Camille*, *Alixe*, *Jane Eyre*, *L'Article 47*, or *Miss Multon*. Based on a French version of *East Lynne*, *Miss Multon* tells the story of Sarah Multon, a young wife who leaves both husband and child for a lover and gives birth to their illegitimate child. When he inevitably deserts them, she returns disguised as a governess to her former home, now presided over by her husband's new wife. The play ends with her husband's discovery of her true identity, his forgiveness of her, and her death.[4] Margaret Mather's 1886 performance as the outcast Leah in Augustin Daly's *Leah the Forsaken*, an adaptation of German playwright S.H. Mosenthal's *Deborah*, was set in the early-eighteenth-century Austrian countryside. *Leah the Forsaken* is the story of a young Jewish woman whose romance with the Christian Rudolf comes to an end when he decides to marry Madalena, a "pure" young Christian woman. Although Leah's first instinct is for revenge, she changes her mind once she realizes the couple's daughter is named after her; she then leaves them and dies, "still an outcast but spiritually elevated."[5] A reporter for

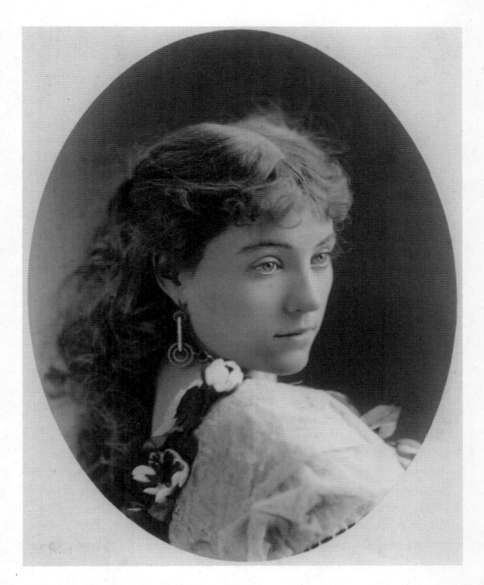

Fig. 3.1 Clara Morris as Camille, c. 1870.

the *Chicago Tribune*, though, thought *Alixe* suffered "from those impurities that are the groundwork of the meretricious drama." While it was improved by Morris's performance in the title role (she played a young, illegitimate daughter of a count who kills herself when she realizes that

she faces a life as a courtesan), nevertheless Daly had brought "the worst specimens of the French school of dramatic composition for reproduction upon the American stage" and in doing so had done a "great wrong" to American society, feeding the "diseased appetites" of his "countrymen ... gild[ing] vice by presenting vicious plays in sumptuous setting; lost in contemplation of the frame, the public forgot to study the picture."[6] Not all welcomed exchanges of transatlantic culture.

Critics were enthusiastic, though, about Lena Ashwell's appearances in plays based in Russian culture. In 1903 Ashwell played the peasant Katusha in an adaptation of Tolstoy's novel *Resurrection*; Katusha starts life "an innocent, charming child" but as a young woman is put through numerous trials. "Outraged by the Prince" and wrongfully convicted as an accessory to murder, Katusha becomes a "drunken sot" in prison. She starts on the path to "salvation" with her work in a hospital prison ward and ends by becoming "a saint in Siberia."[7] Two years later Ashwell appeared at London's New Theatre as Leah Kleschna, a young, virtuous Russian peasant girl who is led astray by her father, an experienced and accomplished jewel thief. Her salvation comes in the form of a confrontation with a member of the Chamber of Deputies, Paul Sylvaine, whom Leah has been sent to rob by her father. The Deputy sees her innate morality; instead of turning her over to the police, he feels "pity and sympathy" for Leah and helps her to a better life, which includes their eventual romance.[8] Originally produced in the United States with Minnie Maddern Fiske as Leah, *Leah Kleschna* was brought overseas by Charles Frohman. It was warmly received by the London critics, who praised both Ashwell's performance and the script (Fiske, though, threatened to sue Frohman, claiming that she had bought the English-language rights to C.M.S. McLellan's play).[9]

Other productions directly addressed the theme of transatlantic worlds clashing. Annie Russell's first major role as a young adult at the age of seventeen was in Frances Hodgson Burnett and William Gillette's *Esmeralda*. The play tells the story of a North Carolina farmer's daughter whose family's fortunes take a dramatic turn when iron is discovered on their farm. Esmeralda is then whisked off to Paris by her socially ambitious mother, where she moves in fashionable circles and is wooed by a marquis, her mother having cut off her daughter's ties to her hometown sweetheart. However, Esmeralda and her "fond old bucolic papa" (played

Fig. 3.2 Annie Russell as Esmeralda, c. 1882.

Figs. 3.3 and 3.4 (*above and opposite*) Annie Russell, scenes from *The Royal Family*, 1900. Fig. 3.3 demonstrates Russell's love of comedy, while 3.4 highlights Russell's appeal as a romantic figure, as well as the play's fascination with European aristocracy (no matter how imaginary).

by C. Leslie Allen, Viola Allen's father) decide the marquis is not for her; their decision is strengthened by her former sweetheart having "come into a little money of his own." The marquis, who is eventually found to be a confidence man, is sent packing and Esmeralda and her lover are reunited. In an exception to the general enthusiasm for French culture among the American middle class, the simple values of rural North Carolina, not the sophistication of Paris, triumph.[10] *Esmeralda* opened

at New York's Madison Square Theatre and ran for a year; Russell also toured in it across the United States and appeared in an 1884 revival.[11] The play's run was one of the longest of the period and gave Russell and other actresses a popular role for twenty years.[12]

Russell also had a taste for plays that dealt with royalty, whether set in an imagined kingdom, such as *The Royal Family*'s Arcacia,[13] or one closer to home. Written by Mrs Everard Cotes (Sara Jeanette Duncan), *His Royal Happiness* dealt with the marriage of Hilary Lanchester, an American woman whose father becomes president of the United States, to the Prince of Wales. During the course of the play, he becomes the king and thus an American woman becomes England's queen.[14] The play's "substance," *The Toronto Star* noted, "is the often used romance of the illimitably wealthy American girl of beauty and brains who captivates the titled scion of Europe's ancient families." Transatlantic romance, though, was interwoven with a "political ideal; that of the absolute harmony which by all the laws of nature should exist between United States and Great Britain."[15] Moreover, while the paper thought that "Canada is still awaiting the Canadian play," it was nonetheless satisfying to see a play written by a "genuine" Canadian author being produced in a Canadian theatre.

After *Mrs. Dane's Defence*, written by English playwright Henry Arthur Jones and set in England, made its English premiere in 1900, it travelled across the Atlantic. Ashwell created the role of Mrs Dane, a woman with, in Ashwell's words, "a murky past," for London's audiences,[16] a performance described by the city's *Express* as her "great moment." She "has held the audience spellbound all through the scene, and as the curtain falls on her heart-cry of sheer desperate misery the whole house breaks into a great shout of applause."[17] When Ashwell brought the play to New York she alternated roles with Margaret Anglin, albeit to more mixed reviews than those of the London press. In Chicago, where Ashwell alone played Mrs Dane, W.L. Hubbard thought her interpretation was quieter, more subdued, world-weary, and gentler than Anglin's, a performance that the reviewer judged effective overall, if a bit slow at times.[18] *The New York Times* believed that to compare the two was quite difficult, since the two were very different actresses. Anglin's "great triumph" as Mrs Dane was the result of her demonstrating "tremendously overpowering emotion" in the third act, which "rose to a veritable pitch of frenzy." Ashwell, in contrast, was more self-contained, her third-act

Fig. 3.5 Lena Ashwell as Mrs Dane, 1900.

interpretation marked by "sustained intensity" and sincerity that combined to "strike a note of very genuine and moving pathos." The paper also noted both women were Canadians and that Mrs Dane herself had spent a great deal of time in Canada.[19] Another *Times* reviewer, though,

felt that Anglin's "American" style of acting (apparently her birthplace had not left any discernible marks on her craft) was superior to Ashwell's British restraint.[20] Although "cross-border traffic" can confound supposedly secure national identities and concepts of national identity and national sovereignty,[21] this particular kind of theatrical traffic appears to have confirmed reviewers' sense of American national identity. In this case, playwrights, performers, and producers from different nations helped contribute "to the very definition of national definitions, and to the definition of nations themselves."[22] Ashwell herself, however, was less interested than the critics in staking out such boundaries, remembering the production in her memoir as a "stunt, like a boxing-match."[23]

Imperial Ties and Performances of Whiteness

Discourses of national identities in this period were also interlaced with those of empire, the two often being mutually reinforcing sets of associations in which notions of race, belonging, and exclusivity were at play.[24] American stages and audiences, it seems, enjoyed English plays in which the British Empire played an important role. Such was the case for Zira, a role said to have been written expressly by English-born playwrights J. Hartley Manners and Henry Miller for Margaret Anglin to "display her emotional powers." A tale of romance, impersonation, and betrayal, Zira (also known as Hester Trent) is a nurse; her life has been blighted by a man's betrayal, and she is tending to the British wounded during the South African War. The apparent death of a friend, Ruth Wilding, with wealthy (and unmet) family connections in England inspires Zira to take Ruth's identity, return to England, and pass herself off to the Clavering family as their relative. While working with her "cousin" Gordon in a London mission, Zira runs across Ruth, who had not died but is thought to have lost her reason. However, just before she leaves the Clavering household for good, she is intercepted by Gordon, who "catches her, makes her confess her love to him, and their marriage is settled."[25]

Anglin's comedic hit *Green Stockings* also relied on a "distant" imperial possession to advance its plot. Set in an English country house, the comedy features the fortunes of the four Faraday sisters, most notably that of Celia Faraday, the unmarried eldest. As two of her younger sisters have married and the third is about to do so, Celia is fated to wear

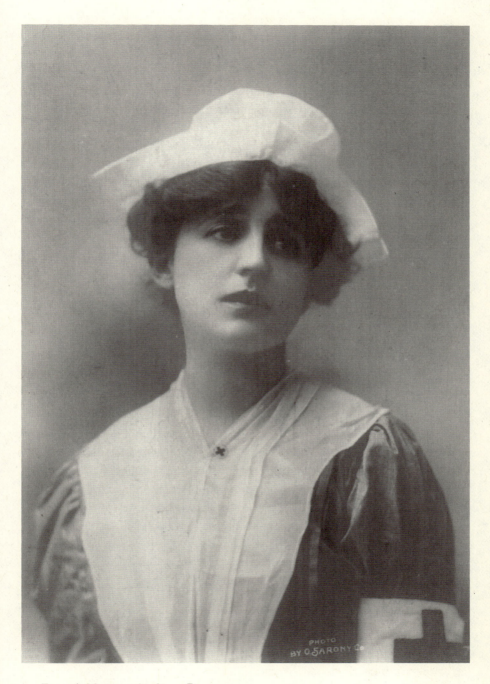

Fig. 3.6 Margaret Anglin as Zira, c. 1905.

green stockings to the third sister's wedding, a custom for unmarried older sisters in her English village. Attempting to avoid this sartorial fate and the humiliation that goes with it, Celia invents a fiancé, Colonel Smith, and announces he has been ordered to Africa with his regiment. A few months later, feeling embarrassed by his continued absence, Celia places an announcement in *The Times* of his death from battlefield wounds. Having gained her family's sympathy (although an aunt in Chicago knows the truth), Celia is then confronted with the arrival of a stranger, Colonel Vavasour, who purports to bring her fiancé's last message from his "lonely tent in the African desert."[26] Of course, "Colonel Vavasour" is really "Colonel Smith," who saw his obituary and decides to have some fun at Celia's expense. He also, though, hopes to become her real fiancé and the play ends on that happy note.[27] Despite their different tones, both plays end with Zira and Celia being reassured that they will enjoy the benefits and stability of an upper-middle-class English home, secured through marriage to suitable Englishmen. And despite the importance of colonial settings to these plots, neither woman is forced to emigrate to them or denied her right to English domesticity. In that way, both Zira and Celia can take their place "at home," as white English women who, presumably, will help further the cause of empire by becoming not just wives but also mothers of men who might well emulate the likes of Colonel Smith.

Such was not the case for Deborah Krillet, Ashwell's character in *The Shulamite*. Produced by and starring Ashwell, *The Shulamite* was written by Claude Askew and Edward Knoblock and first appeared at London's Savoy Theatre. Set in South Africa's Transvaal, *The Shulamite* is the story of Deborah, who, in the words of the *Daily Express* reviewer, is "mated to a bearded Boer twice her age." Although she represents "all that is lovely and fair" to her husband, just like the Shulamite in the Song of Solomon, he exercises brutal patriarchal power over her, whipping her for disobedience. England — and more civilized mores — appears in the figure of the farm's "handsome young English overseer, to whom the injured wife flees for sympathy, with the inevitable result." Here too, though, secrets and deception complicate matters, since the Englishman, Robert Waring, "is in bondage, too: he has fled to Africa to escape the shame of a drunken wife in England." To "escape a second entanglement," he leaves the farm; in the meantime, "by means of a forgotten diary," Deborah's

husband "discovers all." "Terrible, majestic, in his wrath," he threatens to shoot his errant wife. In the midst of getting his gun, he is followed by the Englishman; offstage shots are heard, and Waring reappears with the news of the husband's death. Yet although the couple are then free to marry, "complications, not too convincing, ensue, and after a series of thrilling scenes between the lovers, they part 'to meet in heaven.'" Although the reviewer felt let down by the play's resolution, he felt that *The Shulamite* "will do much to enhance Miss Lena Ashwell's reputation. It confirms the impression that as an emotional actress she has few rivals and certainly no superior."[28] As well as appreciating Ashwell, the *Express* review also shored up British conceptions of "Boer" society as being retrograde, anti-modern, harsh, and brutal, noting too that "Miss Beryl Moore gave an exquisitely pathetic little sketch of an ill-treated Kaffir girl."[29] These comments suggested that the South African Wars had been necessary in order to provide Dutch women and African children with English protection. Even if the Englishman who promised such protection was an imperfect vessel for imperial benevolence, overall women such as Deborah and her "ill-treated" and unnamed Black servant could only benefit from the Empire's reordering of South African society. Such comments, though, overlooked both imperial violence in colonial settings and domestic violence and wife abuse in British homes.

The Times, though, was far more skeptical about English society's role in rescuing and reforming Dutch South Africans, let alone the Indigenous Black population. "Missionaries," wrote its reviewer, "find that the attempt to impose their set of opinions on people who have another set of opinions of their own raises difficulties ... which could hardly have been foreseen: that conversion itself creates sins and causes of unhappiness." Waring, not Deborah (and hence not Ashwell), received the bulk of this reviewer's attention. He had come to the Transvaal convinced of his own moral superiority and "caused terrible trouble" by trying to impose English norms on Krillet's family. Opposed to corporal punishment for "Kaffirs, servants, and labourers" as well as for wives, Waring was met with Krillet's deeply held belief that all three needed to be beaten in order to enforce order and morality. Moreover, the reviewer was critical of Waring for precipitating Deborah's whipping by lending her a copy of *A Midsummer Night's Dream*, even though he knew her husband had already punished her for reading *The Tempest* (presumably audiences

Fig. 3.7 Lena Ashwell in *The Shulamite*, 1906.

would understand the cultural and imperial significance of her interest in Shakespeare). Despite coming to see her husband's use of the whip as degrading to both herself and him, Deborah "has not found them unnatural. She is a Boer; she believes in 'the Book' as interpreted by the Boers; the husband must be the master, and all disobedient wives are beaten." By listening to "the missionary," though, and deciding that she will not be beaten again, Deborah becomes a liar. She tells her husband a falsehood: that she is pregnant, which ends his whippings of her and brings about much better treatment. However, by that point Deborah and Waring are too far gone in their romance and the result is Krillet's death.[30] Yet while critical of imperial intervention, *The Times* also assumed that brutality towards women, workers, and Black South Africans was fundamental to Dutch South African society and that opposition to such violence was a uniquely "British" characteristic. Although *The Shulamite* lacked the triumphalist and jingoistic tone of other depictions of the South African War present on British and colonial stages,[31] Deborah

may have appeared to British audiences as emblematic of those colonial European "poor whites" whose degradation, Ann Laura Stoler has pointed out, was a source of great concern to imperial policy-makers.[32]

For American playgoers, *The Great Divide*'s Ruth Jordan represented a more hopeful message for racial relations on the American frontier. Starring Margaret Anglin as Jordan, William Vaughan Moody's play told the story of a young New England schoolteacher who has come to Arizona to teach and who finds herself in an isolated wilderness cabin, surrounded by three rough miners, or, in the words of one reviewer, "drunken marauders." To "escape a worse fate," she offers to marry "the least repulsive" of them, Stephen Ghent (Anglin's co-star, Henry Miller), in exchange for his protection. Ghent shoots one, buys the other off, and "leads his Sabine Woman" to the local magistrate for their wedding. The play then traces the couple's fate. Jordan is so consumed by shame about the circumstances of their marriage that she leaves Ghent and takes their child to live in "what to her is respectability": a Massachusetts village. Ghent, whose "sincere native honesty and strength" have been allowed to emerge through his exposure to Jordan's "refinement," follows his wife and child to New England where the couple are reconciled. "The great divide," Moody's metaphor for "the barrier which exists between the rigour and dry formality of old civilization and the larger and freer, if more brutal, impulse of the frontier ... has ceased to exist, and the Sabine Woman becomes a willing captive to primitive, wholesome passion." Anglin's portrayal of Jordan was hailed as denoting "with consummate fineness the kindling of the Puritan maiden towards the freer and more vital life of the West. And even in her first horror of the deed of the half drunken and altogether reckless *Ghent*, she manages to denote her fascination before his rough manhood."[33] Although not all reviewers were enamoured with Moody's play — one writer believed that Ruth Jordan could have simply killed herself or Ghent, her "ruffian purchaser"[34] — overall *The Great Divide* was a great success for both Anglin and Miller; after its initial run in 1906 Anglin and Miller revived it in 1907–08.[35] Although plans to take it to Australia during Anglin's 1908–09 tour did not materialize,[36] *The Great Divide* also played in Britain and Europe with Miller reprising his role as Stephen Ghent.[37] Critics often greeted subsequent revivals of the play by mentioning Anglin's work as Jordan, often holding it up as the standard which other actresses must meet.[38]

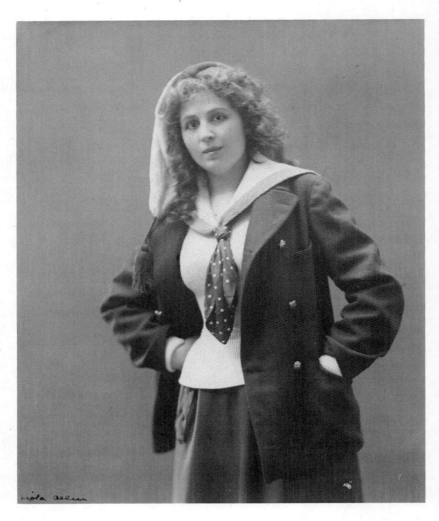

Fig. 3.8 Viola Allen as Glory Quayle, c. 1890s.

The Great Divide offered audiences a range of interrelated messages about gender, sexuality, race, and power on the American frontier. One of the threatening miners was Mexican: Ghent's elimination of this man suggested that white American masculinity needed to draw upon brutal force in protecting white female virtue. As well, the conjoining of primitive, at times overtly violent, white masculinity (albeit made less threatening because of its racial makeup) embodied by Stephen Ghent

in Arizona with the feminized "civilization" represented by Ruth Jordan, with her schoolteacher background and New England home, could reassure Americans who might be troubled by anxieties about the security of their country's newly closed frontier and the threat of too much civilization. Women such as Jordan could indeed refine and improve American society: the possibility that they might be too successful in their mission, though, thus producing a nation that was effeminate (and ineffective), was mitigated by the reassurance that female cultivation would be tempered by a wholesome attraction to the strengths embodied by unrefined, white, heterosexual men.[39] For audiences outside the United States, for whom the national themes of Moody's play might not resonate quite so clearly, the notion of white female sexuality as imperiled but also as an entity that would, over time, yield willingly to coercion (when exerted by the right person) may, like *The Shulamite*, have spoken to larger patriarchal discourses around heterosexuality and men's right to control women's bodies.

Three years later, Russell appeared in another play that reflected American racial politics, American playwright Edward Sheldon's *The Nigger* (Sheldon was known for tackling several Progressive-Era themes, such as women's rights and political corruption).[40] *The New York Times* praised her performance as Georgiana Byrd, a beautiful young white Southern woman who is engaged to Philip Morrow, the central male character and county sheriff. Both characters are unaware of his mixed-race background, and both hold racist attitudes towards African Americans. The couple become aware of his heritage; Morrow is able to accept it, but Byrd cannot, and their engagement ends. The plot also involves the rape of a white woman by a (drunken) Black man, his lynching, and Morrow's successful run for state governor on a temperance platform, while simultaneously revealing his racial heritage. The "unfortunately named" play, thought the reviewer, did little to shed any new light "upon a dark question" but as a "violent melodrama" it was interesting, a "good play for its kind."[41] To be sure, the play brought representations of the racial terror being inflicted upon African Americans by white Southerners to New York's stage; simultaneously, Morrow's political success offered hope of racial reconciliation. Yet those messages may have been undercut by its use of stereotypical dialect and tropes of threatened white womanhood; it also may have allowed Northern audiences to

congratulate themselves that racism in American society was, after all, only a Southern problem.[42] Furthermore, as a racial gatekeeper and upholder of racist hierarchies, Georgiana Byrd, Russell's character, represented the role assigned to white American women in real life, one that some eagerly embraced.[43]

Domestic – or violent – melodramas were not the only performances in which concepts of race and whiteness were so clearly present. May Tully's vaudeville sketch *Curves* played with two significant currents in early-twentieth-century American society: representations of Native Americans and baseball. Tully began her career in dramatic productions, appearing in Shaw's *Cashel Byron's Profession* at Daly's theatre.[44] Although hailed as a "society actress" because of her university education, reviewers also saw her as demonstrating great promise, having "unusual beauty" and a "superb" stage presence.[45] By 1907 Tully was working in vaudeville, a genre in which she would be extremely successful as both a performer and writer. After *Stop, Look and Listen*, Tully went on to star in the equally popular sketch *Curves*.[46] Written by New York sportswriter Bozeman Bulger, *Curves* featured Tully with two baseball players from the New York Giants, pitcher Christy Mathewson and catcher Jack "Chief" Meyers, a member of the California Cahuilla band (or "Mission Indians"). Both players were already sports celebrities in the city, for their athletic abilities, "gentlemanly" behaviour, college education, and good looks. As well, Meyers's Native American background fascinated reporters.[47]

Newspaper coverage of the sketch provided few details; most articles state that Tully watched the players from the sidelines, as they instructed both her and the audience in baseball techniques. When they went offstage to change, Tully mimicked various well-known performers; on Mathewson and Myers's return she then offered them acting lessons.[48] Although *Curves* enjoyed a very limited run of a few weeks, no doubt to accommodate the players' schedule, it further increased Tully's popularity, extending it beyond the world of vaudeville to the sports pages, where she was heralded as a true female fan of the game.[49] *Curves* thus tapped into the links between vaudeville's and baseball's audiences, pointing out how the physicality of the latter could be replicated on the former's stages. Equally importantly, though, as baseball historian R.J. Lesch points out, the sketch also played on the racial stereotypes rife

in American popular culture, mostly notably those of captivity stories and Wild West shows. During the "acting" portion of the sketch, Myers played "'the bad Indian'" who threatens Tully, and Mathewson "'the cowboy'" who comes to her rescue and overcomes Myers by hitting him in the head with a baseball.[50] Yet while Tully could be — however playfully — depicted as a threatened white woman, the sketch also allowed her to assert herself as competent and in control of the two men, reassuring audience members that because of their superior racial identity, such women need not always be helpless victims.

The Emotional Actress

While vaudeville performances tended to take a more pointed, satiric, and generally less empathetic stance towards human predicaments and suffering,[51] and a number of these women were popular in comic roles that allowed them to poke fun at humanity's problems, many of them also carved out significant reputations as "emotional" performers. The suffering of white women (frequently, although not exclusively, from the middle class) and their tears, prostrate bodies, and cries of anguish were at the heart of many of these plays.

Morris, with her ability to depict great amounts of suffering onstage — in parts such as Camille, Miss Multon, or Jane Eyre — was known for her work in the genre.[52] As one reviewer put it, "Clara Morris feels — that is nature; she conquers feeling — that is art. In both respects she is supreme. No one who sees her can remain altogether without the sphere of her influence. 'My God, how I suffer!' she exclaims; and mechanically the listener repeats, 'How she suffers!' 'You see, I am strong,' she says resolutely; and, behold, she has become strong. She dies, and the spectators weep with one consent, paying reverence to the presence of death. It is a moving sight, and few can witness it insensibly."[53] Her acting, stated the *Chicago Tribune*, "lays bare the nerves and tissues of a suffering woman. There has been no recent instance of a similar power to feel, to control feeling, and to acquaint an audience with fact that the feeling is controlled."[54] Morris was far from being the sole "emotional actress" of her generation. She shared that designation with contemporaries such as Ada Rehan, Mrs Leslie Carter, Maude Adams, Julia Marlowe, and, of course, Sarah Bernhardt, and would be followed by Viola Allen, Margaret

Anglin, Julia Arthur, and Margaret Mather. As Leah, Mather was called on to, in Kim Marra's words, portray emotions "that run the gamut from fervid love to vengeful rage, maternal sympathy, and mortal grief."[55] Nor was the category limited to the American stage: Lena Ashwell also was described as a "great emotional actress" at various points in her career. The role of Mrs Dane, whether performed by Anglin or Ashwell, called for a performer to depict a woman in the throes of deep emotional turmoil as she is confronted with her past transgressions; the same certainly could be said of Deborah. As a reviewer of *The Shulamite* stated, the play "will do much to enhance Miss Lena Ashwell's reputation. It confirms the impression that as an emotional actress she has few rivals and certainly no superior."[56] The "emotional actress," her sorrowful tears and her (seemingly) uncontrollable outbursts of passion, was critical to transatlantic theatre's domestic melodrama.

It was Anglin, though, who received multiple accolades from the press for her ability to portray great depths of feeling (and many comparisons to Bernhardt). As one reviewer declared, Anglin "showed wonderful emotional powers" in the role of Zira. During a scene in which Zira tells her life story to Ruth and asks for her mercy, "a glance around the audience showed intense attention and many had handkerchiefs in use."[57] Another reviewer compared Zira to the publican who asked the "stony Pharisee" for mercy: as both penitent and defiant sinner, "Miss Anglin's acting is beyond acting; it is life, and the choking breath and voice, rising note by note to almost frenzied strain, carries the audience almost gasping with her. The moral and physical collapse – the tearful confession that followed after her enemy [Ruth Wilding] was driven forth – was equally natural and simple and heartbreaking."[58] In 1910 Anglin starred in another "emotional" drama, *The Awakening of Helena Ritchie*. From its inception the production was dominated by white, middle-class women. Adapted by Charlotte Thompson, the script was based on Boston-based novelist Margaret Deland's book with Anglin's consultation.[59] Set in the 1860s in the village of Old Chester, a fictional recreation of Deland's childhood home of Manchester, Pennsylvania, the play tells the story of Helena Ritchie, who has come to live in Old Chester after separating from "her brute of a husband whose death abroad is eagerly awaited." Ritchie, whose past is initially a secret from those she befriends in the village, is visited by a lover who is pretending to be her brother; she has

also taken an interest in a young boy and wishes to take him in as her ward. However, as we might expect, her secret is discovered. After a confession of her past and "impassioned pleading" in the third and fourth acts, which, according to the reviews, "gives Miss Anglin the opportunity show her powers," Ritchie "sacrifices her lover and the keeping of the boy in order to do right." The awakening of her soul moves the town's "lovable old rector," who determines the boy's fate. He decides that she can keep the boy and the play concludes with Ritchie now assuming the role of a caring maternal figure, one that has been vetted by patriarchal authority.[60] Although Anglin was already a celebrated actress by the time she opened in *Helena Ritchie*, the role was hailed as being "the best work of her career," a "decided sensation," and a "tremendous success."[61]

What, then, did all these tears, cries, and displays of suffering mean? There were various ways to look at the phenomenon of the "emotional actress." She could serve, as Marra's insightful analysis of the relationship between Augustin Daly and Ada Rehan shows, as proof of the powerful male director's ability to manipulate and shape unruly femininity for his own ends, a means of augmenting his own "evolving American manhood."[62] Morris's departure from Daly's company was, as Marra points out, not only one of the most public and embarrassing exits he experienced, but also had been precipitated by the passions stirred up by the heightened emotions she (and others) had been pushed to portray by Daly.[63] To be sure, plays such as *Mrs. Dane's Defence*, *The Awakening of Helena Ritchie*, *Zira*, *The Great Divide*, *Leah Kleshna*, and *The Shulamite* differed from Morris's productions in the specific messages they conveyed about female morality, gendered forms of self-determination, and the consequences for women who chose to defy or transgress gendered norms of respectability. Whereas Morris's suffering heroines usually faced little choice other than death as a means of restoring their virtue, those who followed her faced a range of futures that did not include either fatal illnesses or (unlike their dramatic contemporaries Paula Tanqueray and Hedda Gabler) suicide. Instead, they were exiled from respectable society (Mrs Dane), were allowed to keep their social standing but not enjoy the love of husband or child (Helena Ritchie, Deborah Krillet[64]), created a happy family life against great odds (Ruth Jordan), or found love and marriage after undergoing trials, sacrifice, and, in some cases, penitence (Leah Kleshna, Zira). Unlike Ashwell's work with

feminist playwright Cecily Hamilton or characters such as Ibsen's Nora or Shaw's Mrs Warren, these plays did not challenge or even mock the status quo of gender relations. Although Zira's travel to South Africa and her work as an army nurse also suggested the greater amount of mobility enjoyed by white, middle-class women in the Edwardian years, shaped by imperial conflict, she made her journey to recover from a failed romance, a journey that led to deception and theft. As Heather Anne Wozniak has argued in her analysis of Arthur Wing Pinero's plays, the New Woman "could easily slip into the role of fallen woman, depending on social perception."[65]

The character that comes closest to such representations of female emancipation is Viola Allen's Glory Quayle, the heroine of *The Christian*. Based on the novel by English writer Hall Caine, *The Christian* tells the story of a young woman from the Isle of Man who becomes a popular London music-hall performer. To be sure, unlike other female characters in domestic melodrama, Glory is not a fallen or outcast woman. She is idealistic and thoroughly modern in her desire for independence and individual expression, a desire fulfilled by her career as a performer. Glory Quayle, though, shares one thing with her other onstage sisters: she sacrifices her wealth and fame for her first love, John Storm. A newly ordained minister in London, Storm becomes convinced that he must save her soul, which he believes has been exposed to grave danger through her work (indeed, at one point he considers murdering her in order to preserve her purity). The story has (at least for Storm) a happy ending in a Soho church, with Glory proving "her womanly love, no less than her force of character, by taking her place side by side with John when he is under a cloud."[66] Thus, despite Glory's search for individual fulfillment and "modern" dress that leads her to the London stage, she sacrifices that career for the well-being of John Storm.

Yet while these plays and domestic melodramas of this period in general provided strong messages about the potential ruin that "women with a past" risked,[67] there were moments in scripts such as *Helena Ritchie*, *Zira*, and *Mrs. Dane's Defence* when the female protagonist, with her secrets and dissembling, also rendered those around her, particularly young men, vulnerable to social stigma and ostracism. Such scenes suggested a degree of unease about these women's potential power to disrupt the social order and reminded audiences of its fragility, a message that

might well have resonated with those concerned about the New Woman and all that she represented: access to higher education and the professions, changes in married women's legal status, and suffrage. Unlike representations of white women as innocent victims (such as Ruth Jordan), these characters, while undoubtedly sharing Jordan's racial identity, suggested a gender-based ambivalence towards white, middle-class women; while they might indeed become mothers of the race, they also had the potential to do great damage to society. Moreover, although these domestic melodramas were often set in drawing rooms where affluence and social respectability were supposedly the norm and were performed for affluent audiences in increasingly lavish spaces, as Kirsten Guest has pointed out they also summoned up male anxieties about the aggressiveness of late-nineteenth-century capitalism, "even as long-established standards of private, moral rectitude remain in force."[68] Women's emotions formed part of this scenario.

In addition to these considerations, what was the appeal of those plays to the women who starred in them? For those who were religious or held strong spiritual convictions, such as Anglin, Allen, and Ashwell, representing suffering may have had heroic overtones, particularly when that suffering was linked to repentance, confession, and redemption (although she did not reflect on it, Anglin's Catholicism may have underpinned her portrayal of such characters). Furthermore, such roles allowed these women to express powerful feelings about social questions — sexuality outside marriage, the gendered power dynamics of marriage itself, the role of secrets and mysteries in private and public lives, the fragility of social reputation — that were increasingly the focus of discussion and debate in late-Victorian and Edwardian society, even when (perhaps especially when) they preferred to steer clear of such contentious questions in their offstage presentations of self. To be sure, such work might take its toll: actresses themselves could grow weary of having to portray great intensity six to eight times a week for weeks — sometimes months — on end. Ashwell joked in her memoirs that she had had "so many illegitimate babies that at least I felt I would have to murder one or two to get even."[69] More bluntly, in 1923 Howard Hull, Anglin's husband, hoped that Anglin would consider another comic script that had been sent to her, complaining, "I am getting tired of seeing Mab wailing around about a boy or a girl that she seems to have had out of wedlock for

the last twenty years for every other season."⁷⁰ Such sentiments aside, though, their work in creating characters such as Leah might allow them to explore aesthetics in ways removed from the realm of physical beauty or material wealth, ones connected to spirituality. Ashwell pointed out in her memoirs that writers such as Tolstoy, with his emphasis on the human soul's "imperishable beauty and indestructibility," inspired her whenever she played such a "range of criminals."⁷¹ She also defended her characters against the charge of sentimentality, writing in 1929: "Sentimental? Not at all. It is necessary to find every detail of ugliness and reproduce that fearlessly; to do all the ugly things by which the character would express itself, and not be afraid to do them; but yet to have the mind quite clear and to show that there is beauty to be found in spite of all. That was my quest."⁷²

Finally, their interpretations might provide modes of emotional identification for their audiences, particularly the women in them. Susan Torrey Barstow has pointed to the high levels of empathy that middle-class women felt with *Hedda Gabler*, a process in which "theatrical identification ceased to be a passive, private experience and became the active matrix around which women built a collective identity."⁷³ While it is difficult to make similar judgments about the reactions of those middle-class women who watched plays such as *Leah Kleschna*, *The Great Divide*, *Helena Ritchie*, or *The Shulamite*, not least because we lack a record of audience members' responses to them, it is not unthinkable that these productions evoked a range of emotions, even if they did not result in the political awakening Barstow describes.⁷⁴ The latter could encompass pity for those whose youthful mistakes might lead to adult ruin coupled, perhaps, with a sense of "there but for the Grace of God almost went I"; fear and anxiety about the discovery of these women's secrets, since the latter were frequently revealed to the audience early in the performance; and satisfaction and relief for those who managed to redeem themselves or who, like Glory Quayle or Leah Kleschna, made the right moral choice in the end. (It is also possible, too, that because these characters opted for the security of domesticity whenever it was possible, they might have sparked dissatisfaction in those whose sympathies tended towards the choices made by Hedda or Nora Helmer.) Whatever the case, it also is worth remembering the wider cultural, social, and political context and norms for displays of female affect. While Victorian and Edwardian

culture valourized certain displays of female emotion, such as the shedding of maternal tears over ill and dying children, nevertheless women's unchecked displays of certain kinds of emotion were viewed with great unease, and at times outright outrage and condemnation. Witness, for example, the anti-suffrage caricatures of female activists as "shrieking harpies" or the shock expressed at upper-class women's physical actions during the militant phase of the suffrage campaign.[75] If, as Sara Ahmed has argued, "the collective takes shape through the impressions made by bodily others,"[76] these women used their bodies and voices — both individually and collectively — in ways that might have shaped structures of empathy within their audiences, who could experience those feelings both as individuals and as a group. In a similar manner to the workings of individual and collective memory, "emotionality," as Ahmed goes on to remind us, "as a responsiveness to and openness towards the worlds of others — involves an interweaving of the personal with the social, and the affective with the individual."[77]

Playing the Past: History on the Stage

Representations of white womanhood thus could be found in English drawing rooms, in New England villages, and on the South African veldt. They also, however, populated European castles, war-torn Spanish villages, and an eighteenth-century English tavern. Historical dramas formed an important part of these women's repertoire. Not only were they part of a larger middle-class transatlantic and transnational fascination with the past, but they also reflected American society's great interest in European aristocracy, past and present.[78]

Viola Allen was particularly fond of historical dramas, starting with the much-tried Rosamond in English playwright Sydney Grundy's *Sowing the Wind*, which made its American debut in 1894 at Frohman's Empire Theatre. Set in 1830s London, the play tells the story of a singer in love with the adopted son of an elderly, well-off man, and the somewhat tortuous path she must take to prove her virtue and unite with her love.[79] Three years later Allen was the female lead in *Under the Red Robe*, staged in 1897 at Frohman's Empire Theatre and set in seventeenth-century France. Adapted from novelist Edward Rose's book, the play focuses on a nobleman (played by William Faversham) who had led a dissolute life and has

just killed an English counterpart in a tavern brawl. However, because in the past he had saved Cardinal Richelieu's life, he was permitted to escape execution if he succeeded in capturing the head of a great feudal family for Richelieu. The task involves much deception and danger and is complicated by his falling in love with the daughter of his would-be prisoner. He ends up failing, but all ends well since Richelieu takes pity on him and forgives his crime, and the two lovers marry. As the heroine Renée de Cocheforêt, Allen's "personal attractiveness, sympathetic voice and well-bred womanliness preeminently fit her for the dignified, important leading roles she is called upon to perform ... as the well-born lady of Cocheforêt, in the graceful, sensible dress of that period, she looked every inch the gentlewoman, and she delivered her lines with rare sweetness," creating a "winsome picture of noble womanhood."[80]

Three years later Allen appeared in another historical romance, Lorimer Stoddard's *In the Palace of the King*. Like *Under the Red Robe*, the play was written by another historical novelist, F. Marion Crawford. Set in sixteenth-century Spain, it told of the devotion and bravery of Dona Maria Dolores (Allen's character), who disguises herself to be close to Don John, a nobleman at King Phillip II's court; Dona Maria is able to save her beloved when he is falsely accused of attempted murder.[81] Here again Allen was "womanly," declared critic Edward Freiberger, displaying "exquisite sentiment and chaste comedy ... daring, self-sacrifice, devotion, quick reasoning and strategy," as well as bravery and loyalty to her love.[82] Both plays, then, allowed Allen to depict femininity in ways that — judging from her interviews — she would have found sympathetic, since Allen was careful to portray herself as dignified and unassuming. A reporter for the *Brooklyn Daily Eagle* compared Allen favourably to Maude Adams, finding Allen ideally suited for such romantic parts, and remarking, "when you put into conventional romance a representative American woman, who is not only a good actress but whose personality radiates the atmosphere of a good woman, who looks at you from out the face, you have nearly as material for fetish worship as you can get in the theatre ... [She plays Dolores with] breadth and strength" and with a decided absence of ranting.[83]

Fig. 3.9 (*opposite top*) Viola Allen as Dolores in *In the Palace of the King*, c. 1900.

Fig. 3.10 (*opposite bottom*) Viola Allen in *The Winter's Tale*, 1903.

"IN THE PALACE OF THE KING"

"THE WINTER'S TALE"

TWELFTH NIGHT

TWELFTH NIGHT

Julia Arthur also tried her hand at historical drama, including her 1893 production *Mercedes*, for which she won many accolades. The story of a Spanish woman whose village is attacked by French soldiers during the Peninsular Wars, Mercedes, along with her lover and their child, comes to a tragic yet heroic end. Not only was Arthur "the ideal Spanish type" (her dark hair and eyes were often seen as "exotic"), "in a dramatic sense her portrayal of Mercedes was correct and convincing ... always suggest[ing] a nature simply but intense." Although *The New York Times* reviewer believed that "in expressing determined will, dumb resignation, and hatred she was more effective than in the revelation of passionate love," the fault was the playwright's excess of words, not Arthur's.[84] And in French writer Emile Bergarat's *More than Queen*, she played the Empress Josephine. The play narrates her life from her first meeting with Napoleon Bonaparte through their courtship, marriage, coronation, and divorce, ending with "the loneliness of the woman who has been more than Queen after she has been cast aside." *The New York Times* thought Arthur's performance "powerful" and her "personal charm ... great," an evaluation with which Boston's *Journal*, along with many other newspapers, agreed.[85] Some were less impressed, though. Writing for the *New York Tribune*, William Winter thought it was primarily a spectacle play and without Arthur's beauty, "the performance would be flaccid, futile, and completely inconsequential." He conceded that she was "potent and impressive ... in several impassioned ebullitions of wounded womanlike feeling" as well as an eloquence and tenderness enhanced, it seems, by her vocal abilities. Winter's review ended on a rather sour tone. While he admitted that the play would doubtless prove popular for some time "and will doubtless extend the professional empire of Miss Julia Arthur," in general he disliked historical dramas, unless they were by Shakespeare.[86] Boston's *Times* was even more scathing in its review of the play than Winter, calling it "a great play for carpenters, dressmakers and burglars," as well as a long list of other craftspeople, but a "slap in the face for

Figs. 3.11 and 3.12 (*opposite*) Viola Allen as Viola in *Twelfth Night*, 1903. In Fig. 3.11, Allen is kneeling, downstage, while in Fig. 3.12, she stands downstage, apart from the rest of the cast. While the photographs capture different scenes in the play, they provide both close-up and more distanced impressions of the production's sumptuousness.

THE PLAYS

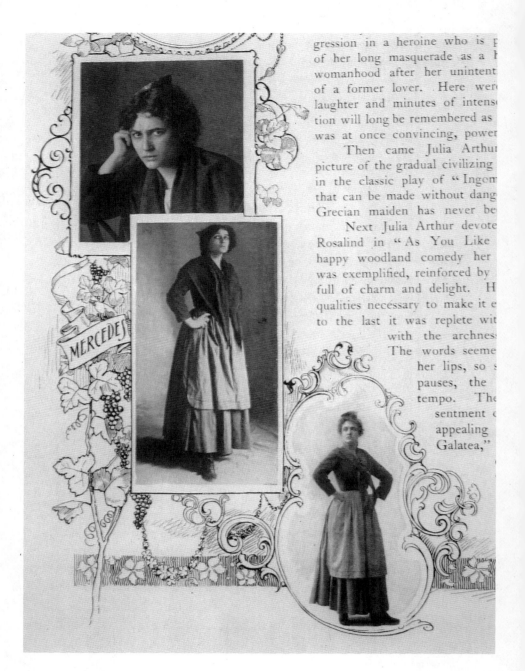

Fig. 3.13 Julia Arthur as Mercedes, c. 1893.

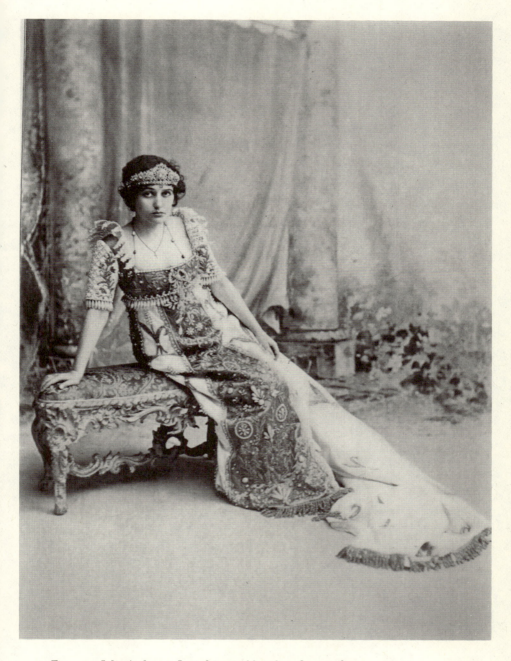

Fig. 3.14 Julia Arthur as Josephine in *More than Queen*, 1899.

Fig. 3.15 (overleaf) Poster for Julia Arthur, *More than Queen*, 1899.

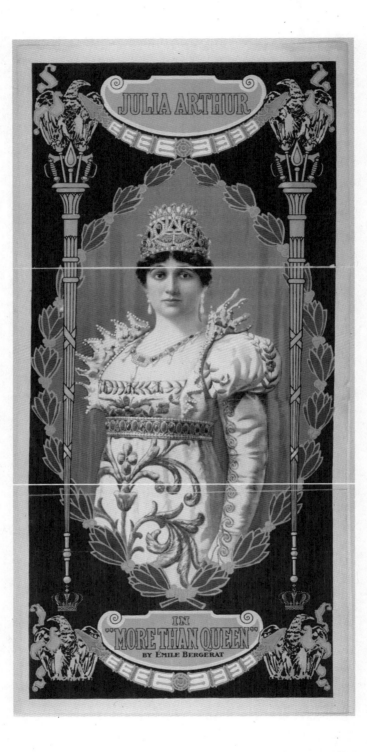

American dramatists." The production consists of "costumes walking on stage," accompanied by costly properties. The play, stated the reviewer, was a failure as a drama, as a history lesson, and as a piece of art. To make matters worse, it had cost its producers $30,000. Laden with highly gendered assumptions about "true art," the review claimed that only "fashionable dame[s]" and wives who wished to see if the "next petticoat was oil-painted or union-made" would enjoy it. It also had a not-so-subtle nativist tone to it, stating that if the American stage was to improve then it was a "pleasure to condemn" this play, and concluding that "the few people in this country who go to the theatre to see acting ... will stay away from the vulgar exploitation of the absinthe-stimulated brainwork of a canaille Frenchman."[87]

Arthur's other major production of a historical romance, the adaptation of Frances Hodgson Burnett's 1896 novel *A Lady of Quality*, was not as controversial. Set in early-eighteenth-century England, its subject the tribulations and adventures of the youthful Clorinda Wildairs, the play allowed Arthur both to be a fashionable London lady and to wear breeches, fence, sing drinking songs, and even commit manslaughter, by striking a spurned suitor (who had attempted to rape her) over the head with the butt of a riding whip.[88] Arthur, possibly anxious to distance herself from the novel's less sympathetic exposition of Clorinda's character, reassured the press that personally she did not "like" Clorinda (and that Burnett did not like her in the part) and that she had tried to soften her more abrasive aspects. While the book called for her to be "'as strong as a man,'" Arthur thought she possessed feminine weaknesses and that her attack on her rapist could not be excused on the grounds of her sex.[89] She may have been sensitive to Winter's charges that *A Lady of Quality* was a "coarse and feeble story" that evoked a "rancid flavour"; he greeted her revival of the play the next year as bringing back a "foolish and tainted drama."[90] Yet others thought much more favourably of it. *The New York Times* praised Arthur's intelligent, powerful, and splendid acting, describing a performance that more than reassured those who had critiqued her work a few years ago.[91] Furthermore, the critics' belief that the play itself was quite weak seems to have had little impact on audiences, who likely came to see Arthur and the beautiful costumes and scenery with which she surrounded herself. Covering a dispute between

Cheney and Wallack, the *New York Herald* reported that *A Lady of Quality* had made $18,000 in a three-week run.[92]

Unlike their work in Shakespeare, Wilde, and Shaw, the "history plays" in which these women starred have not withstood the judgment of later twentieth-century critics. Some did not do so even during their lifetimes. Their dramatic merits aside, though, these historical dramas had a particular significance and resonance within Anglo-American culture, especially with popular or middle-brow audiences. While historians have tended to focus on national, regional, and local narratives in the nineteenth century's fascination with the past, such plays suggest that audiences enjoyed dramatizations of histories that ranged beyond such borders. *Under the Red Robe*, *In the Palace of the King*, and *More than Queen* point to American audiences' enthrallment with tales with European royalty, a fascination that was not limited to the stage or novel. As historian Kristin L. Hoganson has shown, fashion reporting in the United States provided extensive coverage of European aristocracy; she argues that American women might entertain fantasies of "affiliations with [the] power and privilege" of contemporary aristocratic women, whose intimate lives received such extensive coverage that they became highly familiar to readers. While the characters these actresses played were from Europe's elite past, nevertheless it seems likely that such representations helped feed an appetite for these plays (and vice versa).[93] It is likely that *More than Queen* also benefited from the nineteenth-century rehabilitation of Napoleon, a process that transformed him from a brutal and thuggish threat to European stability into a admired military leader.[94] Too, historian Jackson Lears has pointed to the growing attraction that Catholic ritual and art, with its "feast of colour and incense and music" absent from much of American Protestantism, held for many middle-class Americans.[95] A growing middle-class Catholic audience also might have enjoyed seeing Catholicism portrayed onstage.

Furthermore, as historians who have studied popular representations of the past in Britain have pointed out, this particular "culture of history was predominantly, albeit not exclusively, visual": as such, it relied heavily on appealing to spectators' senses, not to the Whig rationalism, linearity, and sense of progress, purpose, and improvement often prized in nineteenth-century historiography.[96] The sensory dimensions of

these representations of history, and the importance of these women in shaping them, can be seen in reviews and feature articles that dwelled, often lovingly, on the sumptuousness of Arthur's and Allen's scenery and, in particular, their gowns. Allen's costumes in *Palace of the Queen* joined those of Henry Irving and Ellen Terry in *Robespierre*, Julia Arthur in *More than Queen*, and Richard Mansfield's marvellous productions, one reviewer insisted. These dresses "make feminine eyes wistful and masculine eyes wonder," particularly her green and gold embroidered cloak of silk and velvet that was a "triumph of the weaver's art and the embroiderer's skill." The cloak's origins were in a Madrid museum visited by Allen; she had sketches made of it and then turned them over to a Parisian dressmaker.[97] Margaret McKenna's interview with Arthur ran two full-length photographs of the actress wearing some of her costumes from *More than Queen* and provided very detailed descriptions of a number of the others: spangled grey satin, heavy gold brocade, and, for a scene in which Josephine dresses up as Cleopatra, a flesh-coloured crêpe-de-Chine gown covered with jewels, spangles, and snake motifs, along with a breastplate, a belt, a "magnificent" crown of coiled snakes with a spangled shoulder-length veil, hair ornaments of lotus blossoms, white pearls set in silver, and a silver necklace set with sapphires, diamonds, and pearls. All of this, McKenna noted admiringly, had been created by Arthur's costumer, Mme. Elise Freisinger, whom Arthur had sent to Paris to study both the French production, *Plus que Reine*, and historical portraits, an observation that underscored the extent of Paris's cultural appeal.[98] For her part, Arthur enjoyed making much of her costumes' weight. Playing Josephine was, it seemed, as much of a physical endurance test as it was an artistic creation, since one of her dresses alone weighed almost twenty pounds; her dresses' weight and the attack of "nervous prostration" they brought on helped contribute to her decision to retire in 1900.[99]

Yet this image of a fragile actress immobilized by her costume was far from the sole representation of Arthur's body onstage. As noted above, *A Lady of Quality* required Arthur to be highly mobile and agile. Not only did many reviewers comment on her fencing during the play, which they thought very effective, but several feature articles on Arthur also highlighted the lessons she took to prepare for the role. *The New York World*

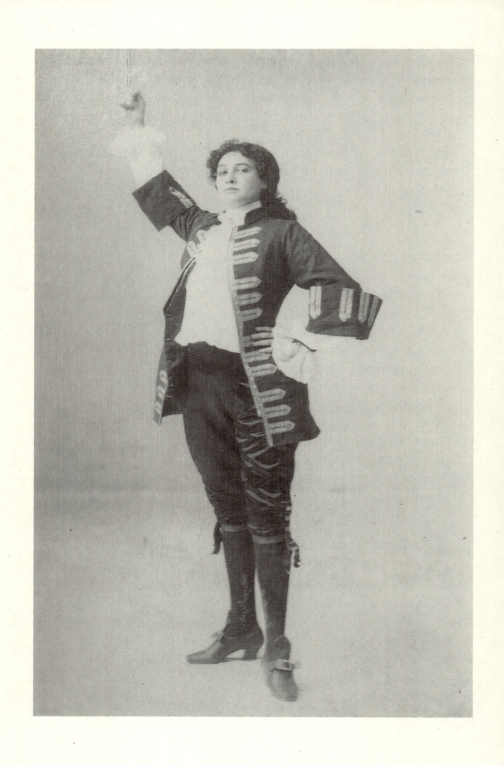

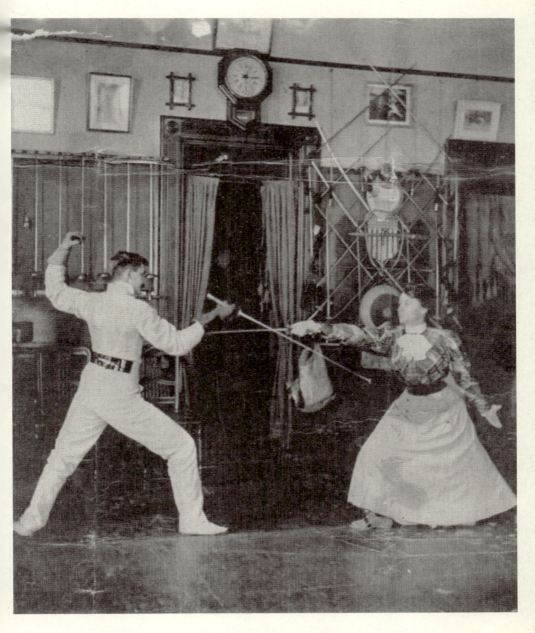

Fig. 3.16 (*opposite*) Julia Arthur as Clorinda Wildairs in *A Lady of Quality*, c. 1897–88.

Fig. 3.17 Julia Arthur and her fencing instructor, c. 1897–98.

took photographs of her demonstrating the "six different positions of the fencer," noting approvingly her "vigor and enthusiasm," her "magnificent physique and natural grace." These photographs, wrote the reporter, "make it plain that athletic exercise is becoming to a graceful woman." Another publication went even further, running photographs of Arthur fencing with her instructor.[100] Allen also advocated fencing, telling reporters that it had many health benefits for the "average" (by which she meant upper-middle-class) woman, including a strong waist, a quick eye, and good posture. Instead of driving in Central Park with their dog or sitting at the tea table, women should fence for at least one hour a day: they would soon find they had regained their eighteen-year-old figure.[101] Such representations and the actresses' own words linked their work to the figure of the New Woman, with her love of activities and sports such as bicycling, canoeing, tennis, and golf. As much as they enjoyed creating characters that represented romantic, bygone days, other aspects of their images were firmly embedded in early-twentieth-century modernity.

Except for Josephine de Beauharnais, whose "creole" background – and Arthur's ability to portray it successfully – was the subject of much critical interest,[102] the historical characters these women played were those from white European backgrounds. However, both Ashwell and Allen appeared in productions that evinced Western societies' early-twentieth-century fascination with East Asian cultures. In 1904 Lena Ashwell co-starred with Beerbohm Tree in the "weird and wonderful" *Darling of the Gods*.[103] Set in 1860s–70s Japan, the play was written by David Belasco and John Luther Long and first staged by Belasco in New York in the 1902–03 season. London reporters made much of its authenticity, its attempts to portray Japanese people as more than "'clever mimetic children'" and to depict the beauty of the country. *Darling*, one claimed, was described by a secretary at the Japanese embassy as being "'splendid ... a genuine representation of Japanese life'" of that period that made the secretary "'quite homesick.'"[104] Belasco approached the production with his well-known commitment to the reproduction of detail; Tree did much the same with his use of lavish display. Ashwell's brother, Roger Pocock, told *The Daily Mirror*'s reporter that his sister's wardrobe and makeup "were accurate copies" of those of the sister of Mr Markino, a Japanese artist and samurai who also superintended the

production's details. (The article also included sketches of Japanese performers Sada Yacco and Mr Kawakami, the "Ellen Terry" and "Henry Irving" of Japanese theatre.[105]) Ashwell herself remembered the production as being "exquisitely beautiful" and her part as "delicious," since unlike her other roles, her character was "pleasant" and not fallen, "just a liar." Although her "engagement was not a happy one," since Belasco wanted her and Tree did not, she was impressed by the "attractive and gentle" Yoshio Markino, the advisor who taught the cast movement, makeup, and manners. At the time of writing her memoir, Ashwell's conception of Japan was undoubtedly antimodern. She thought of it as a dignified and heroic society whose traditions had, sadly, been damaged by Western modernity: "our awful clothes instead of their beautiful ones, our hideous hats instead of their dainty ornaments."[106]

In turn, in 1912 Allen appeared in *The Daughter of Heaven*, set in seventeenth-century China and the last days of the Ming dynasty. Based on the novel by French writer Pierre Loti, adapted for the stage by Loti and Judith Gautier, and produced by the Liebler Company, *The Daughter of Heaven* told of the doomed love affair between the last Ming Empress-Dowager, mother of the child Emperor, and the Manchu Emperor (after her son is killed by Manchu soldiers, the play ends with the Empress's suicide). Newspapers ran multiple articles about the "authenticity" *The Daughter of Heaven* represented: the trip to China by Haywood Brown, Liebler's press agent, in order to gather materials, costumes, pictures, and properties; the "Chinese prince" who returned to the United States with Brown to promote it; the importation of "the first Chinese dancing girls" to arrive in the United States; and the reworking of "old" Chinese processional and coronation music by Gauthier, "one of the best Chinese students in the western world," for its score.[107] But while it was rooted (or at least so said the publicity) in Chinese culture and history, it also was described as representing a particular kind of transatlantic sophistication, since it had been created for Sarah Bernhardt (she could not afford to produce it, though), the costumes were designed by the famous Italian costume house Caramba, which also designed for La Scala in Milan, and Loti was accompanied to the United States by a horse given to him by the Chinese ambassador to France, Yu-Kang.[108] Moreover, the part of the Empress had been eyed by many significant "emotional" actresses in both the United States and England,

both because of the excitement of portraying the Empress in such a great spectacle and because the role was the "longest and strongest" part for a woman on the English-speaking stage (only Hamlet, Iago, and Richard III had more lines). For the Liebler Company, Allen – who had done so well for them in other roles – was their only choice.[109]

Critics, though, were decidedly mixed in their reactions. All admitted the production was a great spectacle, with its cast of two hundred, beautiful scenery that evoked imperial Chinese gardens, range of animals (pigs, peacocks, horses, and storks), and dazzling special effects such as the burning of Nanking and the huge funeral pyre on which loyal Ming soldiers immolated themselves.[110] Some praised Allen's performance, along with that of her co-star, British actor Basil Gill: it was an "impressive embodiment," declared one review.[111] But for some critics, its visual dazzle was not enough to offset a dull, prosaic script that allowed the actors to be obscured by the scenery and costumes.[112] Almost lost in the focus on the play's large and elaborate scale was its interpretation of Chinese history and culture; most took for granted that the latter was simply one massive spectacle of sound and colour. Yet one reviewer thought that Allen's "genius" was able to shift audiences' notions of the Chinese people as "washerman, eaters of rats and smokers of opium" to that of a "civilization that was ancient when the ancestors of Anglo-Saxons were wearing skins and living in caves."[113] Allen agreed, stating that "Europe was in swaddling clothes and America only represented on the old atlases by a huge blanket of blackness when literature and the fine arts flourished in China as they do in London, Paris, and New York today." However, Allen then went on to describe Chinese people as frozen in time, inscrutable, and marked by their worship of ancestors and religion.[114]

As historian Krystyn R. Moon has pointed out, *The Daughter of Heaven* was part of a shift to a greater range of images of China in late-nineteenth- and early-twentieth-century American culture; Allen's comment, though, demonstrated just how much her characterization of the role was still tied to racial stereotypes. Just as vaudeville performers such as Marie Dressler had donned blackface, Moon argues that the play also represented the practice of white actors donning "yellow face," a fact that at least one reviewer, Archie Bell, acknowledged with his comment that in it "Viola Allen, a thoroughly capable actress, Basil Gill, a

Fig. 3.18　Viola Allen as the Empress Dowager in *The Daughter of Heaven*, 1912.

first-rate London actor, and others paint curving eyebrows on their foreheads."[115] Moreover, with its reliance on spectacle and exoticism to convey the otherness of China for Western audiences, *The Daughter of Heaven* shared much with international and imperial exhibitions, known for their use of both commodities and human beings in ways that exoticized non-Western cultures while simultaneously suggesting that the West represented the pinnacle of social and cultural achievement.

Plays of the Present

Depicting the past, whether that of Europe or Asia, provided opportunities for degrees of escapism and fantasy, for both these women and their audiences (no matter that such depictions tended to reflect contemporary concerns). However, their repertoires also included plays that dealt very explicitly with late-nineteenth- and early-twentieth-century social and political questions. Not all these productions were sympathetic to movements calling for social change. Caroline Miskel (1873–1894), who began her career in Augustin Daly's company, starred in popular comedies – *A Temperance Town* (1893) and *A Contented Women* (1897) – that satirized the temperance and suffrage movements, both written by her husband, playwright and New York state legislator Charles Hale Hoyt.[116] Hamilton-born May Waldron Robson (1868–1924), though, made a name for herself in Bronson Howard's 1887 comedy *The Henrietta*, in which she played a number of roles.[117] One of a number of plays that attacked large corporations' practices in the Progressive Era, *The Henrietta* satirized American business life, becoming "one of the most memorable entertainments of its era," with regular revivals until the early 1900s.[118] According to George C. Odell, Waldron helped add "much fun" to the production.[119]

Although Annie Russell was well-known for her work in Restoration comedy, she too tackled plays that dealt with present-day social and political matters. In 1905 Russell created the role of Barbara Undershaft in George Bernard Shaw's *Major Barbara* at London's Court Theatre, an experience she discussed in an address to New York's St Ursula Club three years later. When she agreed to play "Major Barbara" Russell had neither read the script nor met Shaw, and approached her first day of rehearsal with great trepidation. Having had bad experiences with other famous

Fig. 3.19 May Waldron, *The Henrietta*, 1887.

playwrights, "whose attitudes towards actors were either that of a teacher towards dull or stupid pupils, or one of long-suffering impatience at our lack of instant grasp of their meaning," Russell expected to be intimidated by a "Mefistophelian, aggressive, untamed, uncouthly clothed

person" conjured up by her imagination.[120] Instead, she was greatly surprised to find a "charming, courteous gentleman clothed with exquisite neatness and elegance," whose kindness, sympathy, and humour were at great odds with his "thundering denunciation" of English society, religion, journalism, politics, "and all the rest." Russell admitted that at first the character defeated her, being "too great a departure from the usual type of stage heroine." Her real-life manifestation would be loved and revered but her stage counterpart, with her carelessly-fitted uniform, thick boots, plain hairstyle, and comradely, not romantic, treatment of her lover, Adolphus Cusins, was "too great a departure from the usual type of stage heroine."[121] Russell felt the audience did not appreciate Shaw's ideas as much as his wit, believing that Barbara's change of heart, as her "crushing disappointment" in the Salvation Army's spiritual crusade is replaced by support for her father's materialism, was undercut by an audience that failed to grasp his seriousness."[122] While *The Times* admired Annie Russell's performance, it thought little of *Major Barbara* overall, calling it a yawn-inducing "farrago" that, despite some amusing scenes, was "bewildering" and just too long.[123] Russell professed to be devastated by having let Shaw down, telling her audience that it "was more than I could bear" to read some of the vituperative reviews of the play. She was buoyed, though, by Shaw's cheerful – if somewhat chiding – letter, which advised her that rest and relaxation would improve her performance and leave her laughing at her discouraged state.[124] While Russell's memories of Shaw were overwhelmingly positive, they may have been shaped by more distressing encounters with other playwrights, leading her to overlook other aspects of his attitudes towards women. In the 1890s Shaw's support for the New Woman was qualified, as this "constructed category" of femininity deeply disturbed him and many other male intellectuals in late-Victorian society: even a "sympathetic and progressive man" might be ambivalent about the New Woman's ability to question deep assumptions about gender relations.[125]

As Kerry Powell points out, it was only when plays were written, acted, and produced by women that the "woman question" could shift away from caricatures and the London stage could offer more honest representations of New Women.[126] Cecily Hamilton's comedy *Diana of Dobson's*, featuring Ashwell as Diana, the "rebellious shop girl" whose £300 legacy allows her to quit her employment to live well (if only

temporarily), was part of the early-twentieth-century feminist challenge to British theatre. As Ashwell's biographer notes, *Diana*, with its discussions of the exploitative nature of women's work that left marriage as one of their few options for a decent life, was very successful. (Simultaneously, Ashwell became involved with the suffrage movement.[127]) In her 1936 memoir, *Myself a Player*, Ashwell described it as a "delicious comedy," remembering how "thankful" she was to appear in a comedy in which she might "revel." "How thrilling that life can have difficulties which are full of humour as distinguished from the tragedy that in all my big parts had forced me to make audiences cry their hearts out. I wanted laughter and happiness."[128]

Reviewers were less impressed with *Judith Zaraine*, though, in which Ashwell returned to North America in 1911, appearing first in Toronto's Royal Alexandra Theatre in early January and then in New York. Written by C.M.S. McLellan (the author of *Leah Kleschna*), the play was described as "belong[ing] to the capital and labor class of drama." *Judith Zaraine* is set in the fictitious "Minetown" and tells the story of a company owned by the "very estimable" Mr Isaacs, who employs between 3–4,000 workers but is crushed by a New York rival who then brings in imported labour and fires thousands of miners. The latter set up picket lines around the mine and the army (led by a corrupt colonel who owns stock in the New York company) is called out. Ashwell's character Judith sides with the strikers and encourages them to resist the army; she is also befriended by a senior company official, disguised as a New York reporter. The romance that develops between the two is the vehicle that eventually allows for "the capitalist" to reform his ideas, help end the strike, and stay in the town to look after the workers, while Judith (who had hoped to move to New York) becomes his wife. *The New York Times* described Ashwell's performance as feminine, sensitive, intelligent, and possessing "strength of purpose" but thought the script was marred by confusing plot developments, poorly developed characters, and a clumsy mixture of melodrama and social theory.[129] *The Globe*'s E.R. Parkhurst pointed out that the full house at the Royal Alexandra opening could be attributed to Ashwell's presence, since "a trade war play in which antagonism is the dominant note may not appeal to all theatregoers at this festive season." Nevertheless, the audience was not disappointed, since Ashwell's voice vibrated with intensity and left the audience hanging on her

"every sentence."[130] Ashwell herself thought little of the play, confiding in her memoir that she took the part only "in order to pay the Kingsway Theatre's rent" but had hoped that, given her ties to Toronto, "I might have a big success" if she had the chance to perform in the city.[131] Perhaps the opening-night acclaim in Toronto helped compensate for *Judith Zaraine*'s poor reception elsewhere. Whatever the case, though, the fact that a play based on labour conflict was staged at a theatre that was one of Canada's most "lavish," built with the support of a syndicate of wealthy investors, in a city that had recently seen both socialist rallies and anti-left riots is intriguing.[132]

Conclusion

By appearing in this wide range of plays, these women thus helped convey transnational discourses that both reflected and shaped middle-class social and cultural values. Some of these representations, such as *The Great Divide* or *The Shulamite*, were more grounded in contemporary national or imperial contexts and the position of white, middle-class women in them, while the history dramas reflected the fascination of middle-class audiences (and particularly their female members) with elite or exceptional European and Asian women and their agency in the past. Furthermore, far from being a seamless process with only one message, their performances highlight the contradictions and ambivalence that underpinned middle-class culture's gendered norms and conceptions of white femininity: it could represent the hope of imperial and settler societies while simultaneously posing a threat to the social order, not least because of women's ability to feel too passionately and inability to control those sentiments. White, middle-class women – Barbara Undershaft, Judith Zaraine – might critique the social order but, as in the case of Georgiana Byrd, they also might play a central role in upholding its racial and class hierarchies.

As the next chapter will show, though, their onstage performances were not the only places in which these women performed such cultural and social work. The culture of late-nineteenth- and early-twentieth-century celebrity became a significant "offstage" site, one that also contained multiple layers and conveyed a range of messages about gender, class, and racial forms of belonging.

CHAPTER FOUR

Celebrity

Introduction

As a growing body of scholarship has noted, nineteenth-century theatrical celebrity was not a new phenomenon. In Britain, celebrity took on its modern trappings over the course of the eighteenth century, a time when individuals and their fortunes (or misfortunes) became linked to "institutions, markets and media," their public activities and intimate lives increasingly crafted into personas disseminated for ever-growing audiences; theatre played a central role in this process.[1] Over the course of the nineteenth century, the press in both Britain and North America continued to be crucial in helping to create modern theatrical celebrity, publicizing the careers and lives of performers but also making them acceptable to middle-class audiences.[2] For the women considered here, celebrity status encompassed a range of identities, realms, and states of being. Their work onstage was the reason audiences were interested in them in the first place; these were not socialite-performers whose acting was secondary to their ability to craft eye-catching newspaper headlines or to wear beautiful costumes. Newspaper and periodical coverage of their performances had already garnered them considerable public attention across national borders. Yet this visibility was augmented by reporters' interest (often, of course, fed by press agents and the women themselves) in a wide range of other matters. These included their national affiliations, their intellectual acumen, their ability to give advice about their profession, and their intimate lives and domestic settings. At times, too, aspects of their careers and private lives became the subject of courtroom dramas and sometimes scandals.

For these actresses, then, being a celebrity figure thus involved many dimensions and touched on a wide range of social and cultural discourses, concerns, and tensions shared across national boundaries and the Atlantic. To be sure, some matters would have resonated in different

registers depending on where one lived. Not all performers were celebrated as much in London as they were in Chicago or Toronto, and not all aspects of celebrity culture would have been as familiar, been recognized as easily, or reverberated as strongly with every audience. Nonetheless, the discourses and images that the press and the actresses themselves deployed helped shape these women's celebrity profiles as examples of middle-class womanhood, even if — as with their depictions of it onstage — there were times when tensions over what it should be became apparent.

"She Is a Canadian Girl": National Belongings and Celebrity

National origins could play a significant role in shaping a performer's celebrity status. Underpinning accounts of Sarah Bernhardt's unconventional life, both public and private, was her exotic status as a Frenchwoman, someone from whom a degree of outrageous behaviour might reasonably be expected.[3] Other European performers in the United States were billed as representing the very best of continental and British elite culture, although they often found that some audiences (particularly in vaudeville) demanded that they become more "American" in their performances.[4]

So far as the women considered here are concerned, their national affiliations and the interplay between them were woven into the media's coverage of their careers and lives, a process that tended to be intricate and complex. At times the press could not decide who they were. Some reporters in both the United States and Britain simply claimed them as American, no matter where they had been born or grew up. A lengthy article about Julia Arthur's career, published in the *Detroit Free Press* in 1896, described her as an "American" actress who was currently appearing next to Ellen Terry in Henry Irving's company but also told its readers that she came from Hamilton, Ontario.[5] Given Viola Allen's birth in Alabama, it is perhaps not surprising that a number of American newspapers saw her as, in the words of one reporter, a "true-born American lady,"[6] or, in another's words, an icon of nationalism, "a representative American woman ... who looks out at you from the sixteenth-century machinations with big, honest American eyes."[7] Although M.A. Morehouse, who took it upon herself to tally the birthplaces of various "American" actresses,

identified Arthur, May Irwin, and Anglin as Canadian-born, she tied Annie Russell only to England, overlooking her upbringing and professional debut in Canada.[8] Obituaries also could mislead. On her death in 1934, Amelia Summerville was memorialized as a native of Co. Kildare who made her stage debut at the age of seven and went on to a leading role in New York's *Adonis*: while not technically incorrect, this account omitted her early life and career in Canada.[9]

Others simply left actresses' birthplaces out of their narrative. An anonymous reporter in the Boston *Herald* discovered in an English newspaper that Julia Arthur's father was a "'millionaire, who lost his money in trade.'" Not only that, but the news had also reached Paris before finding its way to the United States, as the reporter found the statement in the *Daily Messenger*, a "gossipy" Paris paper for the American "colony" in the city.[10]

In Clara Morris's case, one reporter hinted at a background slightly more exotic than "American," with its widespread connotations of Protestant, Anglo-Saxon origins. "Our foremost actress of the English-speaking stage has the French methods in her blood, being half French by birth. Her father was a Monsieur Le Mountain, played divinely on the fiddle, and when intoxicated, which was most of the time, treated his family – wife and two children – with such cruelty that at last the mother fled with her two infants."[11] While fictional, the supposed "Le Mountain's" French origins allowed the journalist to invoke a stereotype of brutal, drunken Frenchmen (particularly those of working-class or peasant origins), thus framing Morris's story as a melodrama similar to those she played onstage. One reporter stated that Clara Morris was born in Cleveland to "exceedingly poor" parents, thus erasing her Toronto origins.[12] Another journalist, though, stated that she was born in Toronto but had been taken to Cleveland while very young, growing up in great poverty in that city.[13]

Yet these women were not always seen as solely American or British. While they might live in the United States or Britain, some newspapers freely acknowledged their ties to Canada. The *Chicago Tribune*, for example, mentioned Amelia Summerville's Toronto childhood in her obituary.[14] *The Pittsburgh Press* told its readers that May Tully was born in British Columbia; her parents being wealthy, she then attended Montreal's McGill University, where "she graduated with high honours

and was the valedictorian of her class."[15] Although Lena Ashwell was a "London actress," stated the *Chicago Tribune*, she also had "swum one of the minor rapids of the St. Lawrence river ... and ... been as skillful as a red Indian with a canoe and paddle."[16] Canada was associated with not just nature and Indigenous people but also hardship and hard work: as a "plain child" in her Canadian frontier home, the now-beautiful Ashwell had scrubbed floors and baked bread.[17] These were not the only (and, by then, well-worn) representations of Canada linked to these women. "Margaret Anglin, America's Brilliant Young Actress" was in fact a "popular young Canadian actress," whose background was not one of household drudgery and privation but, rather, Ottawa's elite political circles and Montreal and Toronto's convent schools, declared the *Star-Gazette* of Elmira, New York.[18] And Canadians in the United States took note of their own. The Canadian Association of Utah bought out part of the theatre when Anglin appeared in 1910 in Salt Lake City with *The Awakening of Helena Ritchie*, reported the *Salt Lake Telegram*.[19] Julia Arthur, noted another publication, was a native of Hamilton, Canada, "and still retains a feeling of loyalty and love for her native place, not always found in people whose profession is so calculated to make of them cosmopolites."[20] Although British papers tended to see Arthur as "American" – mocking her accent when she appeared with Henry Irving's company in London – on at least one occasion her Canadian background was a cause for celebration. "Anybody or anything that can lay claim to Canadian origin is sure of a warm place in the hearts of Englishmen in this year of grace," declared *The Theatre* – so much so that even if Arthur had not been so talented, her birth in "that fair and wide Dominion" (publicized by Kipling as "Our Lady of Snows") would have won her acclaim with theatregoers.[21]

There were those, too, who wished to do more than pay lip service to these women's Canadian backgrounds. For some writers, being a "Canadian girl" was not incidental but an important aspect of these women's appeal. Unsurprisingly, English-Canadian reporters and cultural critics were particularly preoccupied with this question. Not all of them thought that transnational and transatlantic careers should be celebrated, though. That women such as Margaret Anglin or Julia Arthur were forced to move abroad to pursue a theatrical career certainly concerned more than one theatre critic, particularly in the years before World War I. Writing in *The Canadian Magazine*, a nationalist publication with an interest

in Canadian culture, noted critic Bernard K. Sandwell tackled the question of "The Annexation of Our Stage," citing (amongst other things) the dominance of American theatre trusts and syndicates in Canadian theatres and the ensuing exclusion of many British plays from Canada. To be sure, Sandwell wished to reassure his readers that he was not asserting that "our taste is identical with that of England; that were as foolish as to assert that is it identical with that of New York." After all, English drama's "eternal concern with the leisured few and contemptuous disregard of the very existence of the working many" was wearisome to Canadians. Nevertheless, for Sandwell, "the English drama is our drama to a far greater extent than is the American."[22]

In addition to his concern over American domination of Canadian culture, Sandwell also invoked a figure that, by 1911, would have been familiar to many of his readers: that of the "very intelligent and apparently somewhat talented Toronto girl" who was interested in a theatrical career. Sandwell felt obliged to ponder her concerns, which, "when I thought it over later, seemed to embody the protest of a young nation against the present conditions of its stage." Writing from the perspective of this invoked figure, Sandwell pointed to the frustration he felt she experienced. "'Do you know,' [she said,] 'that if it were possible to pursue a theatrical career here in Canada, in my own country, I would enter upon it tomorrow? As things are, the chief cause of my hesitation is the fact that I must go to a foreign country in order even to get an engagement, that I must play most, if not all, all my time in that foreign country, that I must make New York my headquarters, go the rounds of the New York managers, rehearse in New York, act the plays that New York wants, and by the time I get anywhere in my profession everybody, myself included, will have forgotten that I ever was a Canadian. It isn't fair!'" Sandwell went on to point out that any other career in the arts — painting, writing, music, sculpture, poetry — could be practised in Canada with great honour, contributing to the nation's culture. In the case of theatre, though, the best this "Toronto girl" could hope for was "the poor and unsatisfactory and halfway art of 'recitation,'" a genre that Sandwell held in particular contempt, stating, "by the way, there are a lot of clever Canadian girls wasting their time on this infantile pursuit and announcing to bored audiences that 'Curfew shall not ring to-night,' who would be giving good impersonations in the legitimate drama if the way

thereto did not lie beyond their means, beyond their courage, beyond the limits of their country and the helping hands of their friends."[23] *The Ottawa Evening Journal* pointed to the wealth of talent that Canada had sent to the United States, a list that included not just Anglin but also Eva Tanguay, Maud Allan, Irwin, Proctor, Dressler, Arthur, Yorke, and May Waldron Robson. Moreover, the country had produced several talented opera singers and the violinist Kathleen Parlow. Would it not be something, the author mused, to have all these talented women appear together in one company, acting, dancing, singing, playing, and doing vaudeville sketches? (For skeptical readers, the writer put together a program that listed the wide range of attractions that such an evening would provide.[24])

Other magazine writers, though, saw Canadian success in the United States and Britain as praiseworthy. Indeed, something about "the Canadian national character" lent itself to the phenomenon of Canadian-born men's and women's theatrical stardom abroad. In 1895, W.J. Thorold told *Massey's Magazine*'s readers, "our country seems to be especially adapted for the development of strong individuality – so indispensable and significant in the realm of art." Moreover, "ours is a nation of toilers. No labor is too arduous when it is the price of success."[25] Individuality, hard work, and ambition had shaped the careers of Mary Keegan, Caroline Hoyt, and Julia Arthur. Hamilton-born Keegan was notable for her modesty but also for her theatrical triumphs in London, Glasgow, and Edinburgh. Noted for her dislike of "conventionality and insincerity," Keegan was "a woman of rare personal charms and mental gifts. With her strong individuality, her exceptional natural endowments, both physical and intellectual, all enabled by high aspirations, she should feel free to paint the future in the brightest colours." Toronto's "beautiful and popular" Caroline Hoyt had been declared "by the unanimous continent ... to be one of the most beautiful and fascinating creatures of modern times."[26] Moreover, Hamilton's Julia Arthur was enjoying a "triumphant and brilliant" stage career that had led both the English and American press to compare her to Ellen Terry. Arthur's ethos of hard work and dedication to her art could not be doubted, Thorold believed, and she also "has a vast amount of common sense" and "refuses to let her head be turned by all the current eulogies ... the most unassuming woman I ever met. She does not seem to think she has done anything wonderful, is

quite unconscious of her beauty and thoroughly unaware of the fact that she is a genius. Amidst all flatteries and victories she remains a sweet Canadian girl, full of simplicity and charm."[27] Thorold's description of Arthur thus depicted qualities such as modesty and sweetness as intrinsically "Canadian," national virtues that he and his readers might contrast with the brashness and flair for self-promotion often associated with Americans; other actresses also were praised for their humility and lack of pretension. With the publication and popularity of L.M. Montgomery's *Anne of Green Gables*, simplicity and wholesomeness would become associated with "Canadianness" to an even greater extent in the following decades.[28] Although Thorold and other commentators did not state so explicitly, in this context "sweetness" also had a racial subtext, that of whiteness.

Such coverage continued over the next few decades, as Arthur was joined by Lena Ashwell, May Irwin, and Viola Allen in the periodical.[29] Yet if there was one person who fascinated Canadian writers and critics, it was Anglin. *Canadian Magazine*'s John E. Webber was particularly fond of her in his coverage of prominent Canadian performers. In *Mrs. Dane's Defence*, for example, Anglin was marked as an "emotional actress" who could move audiences with her performance as a woman "with a past."[30] However, Canadian followers of the Ottawa-born actress would have been best-served by the coverage provided by *Saturday Night*, a news-oriented publication that tended to focus on celebrities.[31] During the years leading up to World War I and throughout the war years, *Saturday Night*'s regular columns on "The Drama" paid close attention to the various trajectories of Anglin's career. It informed Toronto audiences of her upcoming appearances in that city – that she would be starring in the Royal Alexandra's production of her New York hit *Green Stockings* or would be coming to the city's Princess Theatre in *Lady Windermere's Fan* – and that they should watch for the arrival of her Shakespeare company, currently touring western Canada and featuring a distinguished group of actors who had performed with such British notables as Herbert Beerbohm Tree, Johnston Forbes-Robertson, and Henry Irving.[32] Anglin's tours across Canada also received much attention from the English-Canadian press.[33] "The distinguished Canadian actress," Winnipeg audiences were told, had "long cherished the ambition of a transcontinental tour of her own country" and, in fact, started promising one

even before she became a star, partly out of her own desire and partly because of the requests from her "prominent compatriots." (Doing so partly because of others' requests also helped bolster Anglin's image as modest, lacking in an "American" desire for self-promotion.) Anglin was putting the final transportation details together "to carry vast and elaborate scenic productions" of her Shakespeare company in a grand tour that would start in Victoria and visit important cities in British Columbia, the Northwest provinces, Ontario, Quebec, and New Brunswick; after ending in Halifax, she would then move to Boston and New York.[34] Not only was Anglin an important cultural figure, then, she tied Canada together through her tours and also linked the country to important theatre centres in the United States, being both transcontinental and transnational. Shortly after the outbreak of World War I, *The Globe*'s Polly Peele interviewed Anglin, who confessed she had hoped to play Shakespeare at Stratford-on-Avon, but events had thwarted her plans. However, "Canadian audiences came in for a hoped-for bit of appreciation," especially in the west; moreover, "Canadian summers, with swimming and canoeing, have Miss Anglin's heartiest support." Anglin had been apprehensive about the war's effect on Canadian theatre audiences: "when we expressed our conviction that Toronto people would cut their theatre-going somewhere else than miss the performance of their own Canadian actress, she smilingly assured us that that was 'what she liked best to be called.'"[35]

In a similar vein, Julia Arthur was "the greatest actress Canada ever produced," declared *The Globe*; the same article also featured her sister, Flora Fairchild, who was appearing at Toronto's Princess Theatre in *Way Down East*.[36] Canadian coverage of Arthur's career in this period focused primarily on her work in the United States and England, her personal life, and her family members, less so her performances in Canada.[37] Nevertheless, she too was a "daughter of Canada," proclaimed the *Vancouver Daily World*, which, by recounting anecdotes about Arthur's relationship with Ellen Terry, reminded readers that theatrical networks tied the Canadian-born Arthur to London's theatrical elite.[38] After a long absence from professional appearances, when Arthur returned to performing with *The Eternal Magdalene*, the majority of Toronto papers were happy to have her back. Although *The Mail and Empire* thought the play was unimportant as either drama or social commentary, its reviewer had

no doubts about the significance of Arthur's reappearance, calling it "one of the outstanding events of the present season." "It is nearly a generation since the meteoric career of a young actress from Hamilton roused the pride of people in all parts of the Dominion, for Miss Arthur was the first Canadian woman to win an international reputation in the theatre."[39] Arthur was also the subject of some gentle rivalry between southern Ontario cities. Hamilton, said *The Evening Telegram*'s "Cornelia," is "mad" at Toronto since Julia Arthur has not yet visited her hometown. Nevertheless, her courage in coming back to acting "is the same proof of her splendid spirit that made a daughter of Canada a reigning queen of the American stage whom the late Henry Irving chose as a co-star."[40] Hamilton may have forgiven her, though, since the *Hamilton Spectator*'s review found Arthur superb and was happy to tie her to the city.[41]

But Arthur's "return" was not without controversy. James M. Curley, Hamilton's mayor, also weighed in with a letter to the Toronto *Telegram*, lamenting the "tragedy" that so many gifted "sons and daughters" had to leave Canada. Many who are known as Americans, he declared, are in fact Canadians; if one talks to them, it is possible to discern a "hint of bitterness" about their departure. Curley went on to link performers such as Arthur to patriotism and the war effort, arguing that "with all the made-in-Canada movements which the war has brought, surely ... native talent as well as tin pans should be encouraged." He was, though, angered by the inconsiderate treatment Arthur, a "distinguished Canadian actress," had suffered at the hands of a "certain yellow sheet of this town," which had attacked her and labelled her play "the nastiest" ever seen in Toronto. An unnamed Canadian newspaper had published an article criticizing the moral message of *The Eternal Magdalene*, one that had prompted a letter to Arthur telling her that "only a vile woman" could participate in her play and, moreover, that "Canada wanted none of her." According to the *Telegram*, Arthur had been quite upset by the letter, stating, "'To think that I had to come home to get this.'" "As an actress who has been famous on two continents and revered not only on the stage but in private life, Toronto criticism has hurt Miss A bitterly this week," the *Telegram* concluded.[42] Did that paper, Curley asked, realize how she would receive this reception? Despite the many distinguished women who praised her, it was far more likely that the general public would pay attention to the paper. He finished his letter by contrasting

its critique with the support she received in Boston, pointing out that its mayor wanted Arthur to perform in the city's Shakespeare Tercentenary celebrations.[43] Whether the "yellow sheet" article was the result of a press agent's attempt to stir up controversy and thus boost ticket sales is impossible to know; others did not seem to find *The Eternal Magdalene* offensive. Although the *Toronto Daily Star*'s reviewer was very happy to see Arthur, a "Hamilton girl" and Canadian actress, back on the stage and praised her "wonderful impersonation" and "rich voice," they did not think much of the play, pointing out that things had changed since the New York police banned Shaw's *Mrs. Warren's Profession*. By 1916, this script was far from being contentious.[44]

Reviewers also noted other performers' returns to Canada, albeit with less controversy, welcoming home May Tully, Amelia Summerville, Kathleen MacDonell, and Catherine Proctor with praise for and pride in their accomplishments abroad.[45] Even those who were not born in Canada could still earn their place in the national canon. *The Ottawa Journal* cited a "clever article" from the *Montreal Daily Herald* that discussed Russell's Montreal childhood and debut in that city, comparing her to Anglin as another of the Canadians "who have made good."[46] While, like Russell, neither Viola Allen nor Lena Ashwell had been born in Canada, that did not prevent Canadian newspapers from assimilating them into the pantheon of "stage" Canadians abroad. Allen, wrote Cyrus Macmillan, was a Toronto girl, just like Clara Morris, dancer Maud Allan, and musical comedy star Alicia Yorke. Like Sandwell, Macmillan's central theme in this article was the lack of "home-grown" Canadian drama; unlike Sandwell, though, Macmillan chose to trumpet the achievements of stars such as Allen, Irwin, Marie Dressler, Arthur, and Henry Miller.[47] For her part, the "celebrated Lena Ashwell" was a "Canadian girl" who had begun her schooling in Canada as Daisy Pocock at Toronto's Bishop Strachan Church School for Girls; her father, the former Royal Navy Captain John Pocock, had been a Church of England clergyman in Brockville. Daisy had distinguished herself at Bishop Strachan by winning the James Henderson gold thimble for "proficiency in darning," an achievement that the paper noted, "although no doubt commendable ... could scarcely, by the wildest stretch of imagination, be thought an indication of histrionic ability." The brilliant career that nonetheless followed had been predicted by no less a figure than Ellen Terry; the writer thought

it "rather a coincidence" that the two women had recently met in Toronto as part of their respective tours.[48] Furthermore, noted "A Canadian Woman in London," no less an authority than Henry Arthur Jones had singled out Anglin and Ashwell as important actresses, something that had pleased the writer greatly, since both were Canadians.[49] A more skeptical opinion, such as that voiced in 1909 by "Lorgnette" in *The Globe* that questioned the "Canadianness" of Ashwell or Morris, was less frequently voiced.[50]

Like the press, in his collective biographies Henry James Morgan, a civil servant and lawyer from Quebec, included actresses tied to Canada through birth, childhood and education, or long-standing work in the country.[51] Morgan's choices included a number of actresses that many of his readers might have known: Allen, Anglin, Arthur, Kate Horn (or, as Morgan called her, Mrs Buckland), Caroline Miskell Hoyt, Irwin, Margaret Mather, Charlotte Nickinson, Morris, and Robson.[52] He also, though, featured women who might not have been as familiar to Canadian audiences. Currently living in New York, Louise Beaudet (1859–1947) was an "accomplished actress" from Montreal, who was educated at the Lachine Convent, took elocution lessons in New York City, became one of Daniel Bandmann's principal actresses, and then toured on her own.[53] "Miss Prentice," or Eweretta Lawrence, was born in England but grew up in Canada, her father a Montreal stockbroker. On returning to England, Lawrence debuted at London's Court Theatre and then appeared at the Adelphi, after which she began writing her own scripts and producing as well as acting in them. However, after a number of provincial tours, Lawrence suffered a "temporary nervous collapse" and took up writing instead; she had also appeared in Paris "as a reciter."[54] Ethel Mollison's career followed paths both familiar and less conventional, though. Born in Saint John, New Brunswick, and educated in England, she began acting professionally in 1894, touring with Olga Nethersole in the United States. Mollison spent the next eleven years working primarily in American theatre, a career that included three seasons with Julia Arthur's company; in 1902 she also played the lead in a production of *Mrs. Dane's Defence* at Montreal's Proctor Theatre. In 1903 Mollison left North America for a tour of Australia; while there she married Thomas Herbert Kelly and retired from the professional stage.[55] In addition to Morgan's work, the National Council of Women of Canada included a

section on Canadian actresses for their 1900 souvenir book, *Women of Canada*, which was published for the Paris International Exhibition.[56]

Equally importantly, though, how did these women see themselves? Did they share the feelings of critics such as Sandwell and lament their need to leave the country of their birth (or childhood) in order to pursue their careers? There is little in the archival record to suggest this was the case. Instead, those who addressed this question — even obliquely — tended to deal with it in a matter-of-fact manner, as something that was necessary but did not warrant dwelling on, let alone mourning. A hint of resentment does surface in Arthur's pronouncements to the press concerning her reasons for leaving the United States for England. In an interview given to New York's *Dramatic Mirror* from London's Marlborough Hotel, Arthur stated that "'the critics ... declared that my work was crude,'" so she went to England to try to acquire polish, adding, "'I went abroad simply because there was no opportunity for me here, and because I thought it would be a good experience for me.'"[57] Yet these women also did not attempt to hide their Canadian origins. In interviews or in the biographical features they wrote themselves, they acknowledged their ties to Canada.[58] To be sure, returning to Canada to tour, give newspaper interviews, and be a presence in Canadian cultural circles were decisions likely shaped as much by an economic desire to tap into existing theatrical networks and help create new ones as by patriotism alone. There is little sense that they did so grudgingly or reluctantly: to do so would be counterproductive and only alienate audiences and the press. Those who were involved in wartime fundraising often spoke about their work as emanating from their love of Canada. Furthermore, for these women attempts at deception and subterfuge would have been a deviation from the public persona that they, their press agents, and the media had created for them. Unlike, for example, Bernhardt or American performer Adah Isaacs Menken, who had made as much of a career out of refashioning herself as she had from acting, these actresses presented themselves as sincere and transparent. One finds very few differences or contradictions, for example, in their accounts of their lives and work.[59]

To be seen as a "Canadian" on international stages was, of course, a slippery matter. As English-speaking white women, it was quite possible for these women to be Americans in the United States and Britain but simultaneously (sometimes within the text of the same newspaper

article) to be Canadians as well. That such fluidity was possible is worth noting, given the drive for national identity and representation among some prominent members of the American stage and cultural elite.[60] Because of the ties between national identity and accent in English theatre and English society in general, it was harder, albeit not impossible, for a North American woman to pass as English, a fact made clear to Julia Arthur (although on returning to the United States from her first trip to Europe she was mocked for having acquired "a thirty-third degree hot-potato-in-the-mouth accent"[61]). In Britain, though, discussions of Imperial Federation and an appreciation of the Dominions meant that Arthur could be welcomed as part of the imperial family. That was also the context in which Ashwell organized entertainment for Empire Day celebrations at London's Royal Botanic Gardens, recited at the Ladies' Empire Club, and performed at a benefit for the victims of the 1900 fire in Ottawa and Hull.[62]

Not all these women celebrated imperial ties, even though they might embrace certain aspects of English culture. Anglin identified herself as both Canadian and Irish and could be quite hostile to any suggestion that she was part of the British Empire. When she toured Australia in 1908, reviews of her plays were accompanied by stories designed to link her to the country's Irish Catholic community. Although (curiously enough) little was said about her father's support of Catholic rights in New Brunswick during his career as a journalist, Sydney's *Catholic Press* called her "a celebrated Irish American Actress" and discussed Anglin's Irish descent, her faith, and, in particular, her convent education at Montreal's Loretto Abbey, where she supposedly had her first taste of performance, reciting Thomas Campbell's poem "The Exile of Erin" at the age of five.[63] In Australia, Anglin became yet another linchpin in those transnational communities, the Irish diaspora and Catholicism, that forged bonds between the United States and Australia.[64]

In English Canada, then, late-nineteenth- and early-twentieth-century nationalism and imperialism led to a range of attitudes about these women's celebrity status. Their success might be celebrated as proof not only of their own abilities — that independence and strength of character that some journalists saw as a "hallmark" of being Canadian — but also of the relatively new Dominion's own ability to perform with confidence and poise on transnational stages. However, the fact that

Fig. 4.1 Interior of His Majesty's Theatre, Ballarat, Australia. Anglin performed in this theatre during her tour; the interior has been restored to approximate the early twentieth century. One wonders what she made of appearing in a space named after the British monarchy.

those performances were staged elsewhere was also, as we have seen, discussed with great wistfulness or even anger by some writers. In particular, departing for the United States was regarded by some with great sorrow and regret, not least because of the anti-Americanism of many of English Canada's cultural critics. To be sure, those who had gone to Britain could still be regarded as dwelling within the household of the imperial family. But whatever the critic's, reporter's, or actress's stance, these discussions point to the importance of culture in general – and theatre in particular – to these articulations of nationalism and belonging. Moreover, just like the plays in which these women appeared, accounts of their national origins suggest that transnational movement could lead to both an effacement of nations and, simultaneously, an intensification of their importance.

An Intelligent and Hard-Working Woman

Being a "Canadian girl" meant honesty, sincerity, and humility; it could also signify a desire to work hard for one's achievements, a quality that features in many of these accounts as intrinsic to these women's lives and the bedrock of their success.[65] While some members of the public might believe that actresses' lives were ones of glamour and leisure, reporters were quick to disabuse them of such notions. Although nouns such as "talent," "inspiration," and, at times, "genius" abound in press coverage of these women, words used to distinguish them from other, less noteworthy members of the profession and that also suggested the natural qualities of their acting, both the press and the women themselves also used "work" as both noun and verb. As innumerable interviews stated, it was work that they did: while they may have been providing leisure and entertainment for their audiences, staging a play was not "play" but rigorous, hard labour.[66] Perhaps, then, the public would see that there were similarities between acting and other forms of middle-class labour that required skill, experience, intellect, and dedication. Annie Russell, for example, wrote that the public would be surprised to know just how physically taxing rehearsals might be — on her feet for hours at a time — but also how mentally arduous it was to prepare a role.[67] "Miss Anglin has worked hard," stated the *Milwaukee Free Press* in its review of *The Eternal Feminine*, "and after a singularly short time wears a crown of laurels, rightfully, as a victor."[68] "She is an indefatigable worker," was another writer's description of Viola Allen.[69] A writer for the *Buffalo Express* who had gone to watch Arthur's dress rehearsal of *Ingomar* admitted being transported into a magical place but also noted Arthur's hard work and keen attention to detail: a rehearsal is a "serious thing" and a workshop but it does not result in a finished product, as there are always "basting threads" to trim and "'cuttings' are always strewn about," he concluded.[70] Arthur herself was not shy about describing her origins as cultured but humble, her "rise to fame" occurring not overnight but as a result of years of toil and study.[71]

Her public also would appreciate that being an actress of this calibre required intelligence. Although the press was not above portraying some female performers as flighty and empty-headed — particularly those who appeared in musicals and certain aspects of vaudeville — these women

Fig. 4.2 Julia Arthur as Mrs Erlynne in *Lady Windermere's Fan*, 1893.

were seen as thoughtful, intelligent, and rational, even though much of their work required them to demonstrate heightened, supposedly uncontrollable emotions onstage or to portray the past in ways that emphasized its sensory dimensions. As a young actress living in New York, the *World* was pleased to report, Arthur seldom went out shopping or sight-seeing: instead, she spent her days reading or studying new roles. Such was her capacity for learning that, while playing evening shows in *Lady Windermere's Fan*, she memorized two leading roles and was line-perfect in a few days.[72] Asked by writer Fanny Enders if she would choose beauty or brains, Arthur replied she would plump for genius, since those are few but beauties are "'plenty.'"[73] Anglin too was hailed as an intelligent actress, particularly for her productions of Greek drama.[74] Careful study helped make her so. After appearing in an evening performance of the comedy *Beverley's Balance*, wrote *The New York Times*, Margaret Anglin did not go out to a supper dance, "as actresses are supposed to do; instead she went home and worked out detail of her Greek drama productions" on a model in her library.[75] Allen "must be reckoned today among the most intelligent, resourceful and dignified exponents of the drama," declared J. Herman Thurman in an article about the revival of Shakespeare in the United States.[76] Although most critics depicted Annie Russell as delightful and charming, they felt she displayed, in the words of a *New York Times* reviewer, "a degree of artistic intelligence" that was extremely rare in American theatre and that owed much to her own intellectual abilities.[77]

Not only were these actresses characterized as bringing an intelligent, thoughtful approach to their work, they also were seen as eminently suited to advise others about it. Anglin and Allen wrote articles about their interpretations of Shakespeare[78] and they, and others, were asked about their approaches to acting in general. For her part, Arthur believed that there was no such thing as a "national" style of acting, nor did she believe in acting schools, seeing their products as "hard, pedantic, measured."[79] (So far as national performance styles were concerned, Arthur might have been somewhat disingenuous, since on returning to the United States after her time in England she had a number of things to say about the difference between Irving's company and American stock.) What was more, actresses were frequently asked to counsel those girls and young women who were contemplating a career on the stage.

According to Boston's *The Herald*, Arthur had "much good common sense advice to young actresses." Her counsel included foreign travel, not just for the sake of working with an English company but, rather, in order to leave "one's familiar surroundings." Aspiring actresses should lead an artistic life outside the theatre and travel, study public art galleries, and associate with men and women who "take art seriously and reverentially," as they will help the young performers to "broaden their views, enlarge their minds, and add to their refinement." When asked how a young actress could achieve success, Arthur advised patience and simplicity. There were no short cuts or "royal roads" and having too much self-consciousness and artifice was detrimental to a young actress's performance. (She also had strong words for managers who cast inexperienced or inadequately trained people simply because they looked the part, adding that this opinion was not just her fancy. No less than an authority than Arthur Pinero had told her he despaired when this happened to his plays.[80]) Those who wish to go onstage, declared Allen, must harbour no doubts that this is the road "Nature" has chosen for them; they should also be educated and accomplished, even if they believe their beauty will carry them far. Unlike Arthur, Allen thought that acting schools might help a young woman, both with vocal training and with determining which kind of dramatic genre best suited her talents. If she could not afford such schools (and Allen was adamant that the aspiring actress should not go into debt to attend one), she could apply to agents and managers. Here too Allen warned her readers that this route was a hard one, since getting an interview or a part in New York was difficult; the alternative would be to perform as an extra, which might lead to a small speaking role or becoming an understudy. Allen warned that while the media made much of those women who became financially successful, "we hear little of the vast majority who toil for just a bare living," struggle every season to get a role, or suffer financially or in their reputation when the play they are in fails or a company disbands. After all, while the dramatic profession might afford women "the speediest and perhaps surest means of attaining position, influence, and monetary independence, it must be remembered that success cannot come to everyone who desires it." All an actress could do was to "see the truth" and express it, qualities that are "rare" but are crucial for those who wish to become successful.[81]

Speaking to the graduating class of New York's Empire Theatre's American Academy of Dramatic Arts, Russell counselled both men and women to cultivate and practise good manners. Women in particular, though, needed to be "notable but not notorious," to cultivate knowledge, to work hard "for true meaning," and to not behave with "exaggerated emotion."[82] Frequently asked for her advice to would-be performers, in "The Stage as a Career for Women," Anglin drew on her own experience by telling them that they should attend a good acting school, not be disheartened by setbacks in their early career, and no matter what they thought of a part, play it to the best of their abilities. She believed that with the growth of more theatres and a more business-like approach by managers, young women had increasingly greater opportunities to make a living as actresses and could build their careers methodically. Moreover, in a statement probably meant to reassure worried parents more than their daughters, "as regards the temptations of the stage that are spoken of by moralists, I believe that question can be summed up in the simple statement that the stage offers no greater temptations to women than any employment that takes them from the household circle."[83] Clara Morris went even further than newspaper articles and interviews for periodicals. Her books about the American theatre were (at least ostensibly) autobiographical and advised young women about the profession.[84]

To be sure, some writers were more skeptical about the value of such guidance. A short piece in the *Vancouver Daily World* reported that the "silly season" had descended on London, with the result that newspapers, for lack of more "interesting" things to print, had resorted to asking well-known actresses, which included Lena Ashwell, for their thoughts on the stage's suitability as a profession for young girls. The result was a series of familiar but not new or valuable statements, with the overall message that "a good deal depends upon the girl."[85] Yet such cynicism was unusual, shaped, perhaps, by discomfort that middle-class women were being sought for professional advice. For the most part, these articles were presented with great sincerity.

As Charles Ponce de Leon's work has shown, asking performers about their opinions was part of a larger project on the part of the American press, that of demonstrating theatre was an eminently respectable endeavour in which middle-class men – and especially women – could

participate without any fear of social stigma.[86] To be sure, theatre's promise of social mobility achieved through hard work and industrious application may have resonated differently on either side of the Atlantic, since the United States (and, to a lesser extent, Canada) was often perceived as offering greater opportunities for socio-economic mobility than Britain. That was particularly the case for American theatre. The author of "America Has Richest Actors" pointed to the much higher salaries available to that country's actors compared to their English and European counterparts. Even highly paid women such as Lillie Langtry, Ellen Terry, Mrs Pat Campbell, Bernhardt, and Ashwell, whose pay ranged from $35,000 to $100,000, were worth far less than Maxine Elliott, Maude Adams, Ida Conquest, and May Irwin (who had "over a million").[87] The actresses made clear, though, that the uncertainties of the profession made even that promise a potentially elusive one. Finding employment as an actress could be much more difficult than job-hunting in other middle-class female occupations, such as teaching or white-collar work. Yet despite the profession's precarious nature — or perhaps even because of it — by sharing their thoughts on these matters, these actresses participated in a long-standing practice of advice literature crafted both for middle-class audiences in North America and the United States and those who wished to join their ranks.[88] In doing so, they claimed that as women and as performers they had undertaken the hard work of building careers, a process that involved planning, careful thought, and dedication and that ultimately demonstrated considerable strength of character, itself a hallmark of middle-class belonging on both sides of the Atlantic. As Sharon Marcus points out, this model of celebrity was highly dependent on liberal values of orderliness, self-consciousness, logic, and control: this was not the illogical, volatile, and potentially violent appeal of a star such as Bernhardt (or even the type of power these women exercised over audiences in their on-stage performances).[89]

Moreover, while acclaimed for their ability to portray emotion, simultaneously women such as Ashwell, Anglin, and Arthur were seen as rational, intelligent, studious beings, an image that emerged during a period of intense debate over white, middle-class women's intellectual capacities for higher education and the professions.[90] Just like in those debates, at times the press suggested how vulnerable these women's

bodies and nervous systems might be to such hard work. Numerous articles stressed that an actress must be strong to undertake the hard work of rehearsing, performing, and especially touring. The women themselves recommended constant exercise, including horseback riding, bicycling, rowing, baseball, and long walks, to maintain their physiques and stamina; avoiding late hours and sticking to a schedule were also crucial.[91] If not, they risked becoming like Mrs Pat Campbell and Bernhardt, whose cadaverous affect was well-noted by critics; closer to home, Clara Morris, Annie Russell, and Margaret Mather provided examples of how weak constitutions might risk jeopardizing a woman's career.[92] Even Anglin, normally the picture of robust health that was a happy result of her Canadian background, might experience serious problems. Press reports that she needed to rest her voice for fear she would lose it permanently motivated Oklahoma's G.C.M. to advise Anglin to consult Dr D.M. Myers, a Christian Scientist from the writer's hometown, who had cured a young female singer who had been in danger of losing her voice.[93] Such attention to health and corporeality was not new: the state of celebrities' health had fascinated Western publics for much of the nineteenth century, as did the illnesses performers portrayed onstage.[94] In this context, though, like those missives that warned about the dangers of too much study to white, middle-class women's reproductive capacities, such articles often carried an undercurrent of warning that these women's work could have serious consequences, perhaps even leading to disaster, if they did not keep their ambitions in check.

Such articles, though, may also have been a response to the fact that increasingly large numbers of girls and young women wanted to make a living on the stage. The actresses' claims that they were responding to the growing number of those who wrote to them was not a boast aimed at self-aggrandizement.[95] Anglin's correspondence suggests how frequently and fervently young women sought out the help of "dear Miss Anglin." Lillene Loeb, for example, had been "the uninvited guest at the informal reception given you on the stage after your glorious performance, not being able to resist the temptation of trying to see and talk to the one woman on the stage – or off – who unknowingly (and most likely not caring) was the inspiration and the ideal I see for myself for my future stage career." Planning to graduate in June from high school and expecting to begin her stage career soon after, Loeb felt before "you

have something in you which will find response in me — and which will awaken me — and help to bring me where I want to be. I am *not* a stage struck young girl — unless I have been stage struck all my life — and I am writing you to beg an interview with you before you leave. Won't you please grant me one? any time — anywhere — any place?" Unfortunately for Loeb, Anglin was preparing to leave for Europe and regretted that she had no time to meet before her departure.[96] Others had begun their stage careers but hoped that Anglin would provide them with advice, and, even better, work. Having just read about Anglin's repertory company, twenty-year-old Diana Bourbon lost "no time in asking you *please* to see me at once — and count me in them, as your 2nd lead! That is a pretty cool request as you don't even know who I am but I'm sure you are one of those people who encourage ambitious youth — you just — look that way!" Margaret Anglin, Bourbon declared, was a great artist and a great actor and "that's what I'm going to be, one day. I *really can act*, Miss Anglin and I'm going to succeed." Best of all, "I *love* to work, you can't tire me as long as it's to do with the theatre! (*as* my family found out when they didn't want me to go on stage)." While she was "young and inexperienced and have a lot to learn ... I'm *trying* to learn, always."[97]

Even across the Pacific, Anglin was an inspiration, wrote Cathie Cansdell from Sydney's Criterion Theatre. "No doubt," Cansdell told her, "you will be surprised when you have read these few lines, at hearing from one who always thinks of [you] as 'my ideal of an actress.'" Cansdell had seen Anglin in Sydney in *The Thief* and, obviously, the experience was memorable. "I loved you, as an artist I worshipped you, and as such you were beautiful and to be *loved*. Do not think this is an ardent lover, only a girl who's [sic] ambition for a stage career at the age of sixteen, that is when I saw you, I'm now 22. I've studied my work well, and I've always thought just to be a little like you if possible. Each teacher I've been to asked me if I liked and admired an actress and I told [them] that I just loved your acting better than any artist I've ever seen." Cansdell had acted with J.C. Williamson's Company for two years in minor roles and was now in Muriel Starr's company at the Criterion, having been promised an understudy's role. "It seems very slow progress," she confessed, "but I surpose [sic] we must all begin on the lowest rung of the ladder. Miss Starr is very beautiful" and also very nice. Above all the autographs Cansdell had collected, there was still one she wanted above all others:

"Margret [sic] Anglin." I've always called you that and my people have copied me – I've never called you Miss I don't know whether you are married or not? but you will always be Margaret to me. You are the 1st artist I've ever written to, but ever since I was 16 I've been promising myself I would write to you – I have never forgotten you – year in and year out and if you would be so kind as to send me a photo with your autograph, I should treasure it above all others. No doubt you'll think me very silly and say I wish these people would not write such rubbish but I flatter myself I'm sensible – but if I lived to 100 years, I don't think any actress will ever come up to my Ideal. Oh if you would only write to me, I should love to hear from you, and if you are ever coming to Australia again? I would love to see you play *Thief* once more you did one thing that night you stole my heart.[98]

As well as being an affirmation of their shared profession, Cansdell's letter to Anglin seems to have been animated by the same emotional ardour displayed by the "matinee girls" who, with their support for their favourite actresses, were an unabashedly feminine presence in theatrical spaces in late-nineteenth-century New York and London.[99]

Parents were not above asking Anglin to steer their daughters in the right direction, even casting them in one of her productions, a group that included Anglin's acquaintances and fellow theatre professionals.[100] Writer Percival Chubb, who was helping organize the St Louis Shakespeare Tercentenary Pageant, asked Anglin if his daughter could come and see Anglin in New York, to which Anglin replied that she would be happy to help in any way she could.[101] Both composer Walter Damrosch and his daughter Anita corresponded with Anglin about Anita's career, asking for her thoughts on whether Anita should continue at the Sargent Dramatic School, take private lessons (possibly at Paris's Conservatoire), or (Anglin's suggestion) go to England to work with Frank Benson's Company. Anita assured Anglin of her commitment, writing to her, "I do hope you will believe that I feel *very* seriously that I want to work awfully hard and would be more than grateful for any help or advice you could give me, and rather have your opinion than anyone's!!"[102]

Not everyone hoped that Anglin would hire them, though. Katherine Kory thanked Howard Hull, Anglin's husband, for his offer of a part but

as she had not trained as an actress and had other things to consider, she had to turn him down. However, she would very much appreciate talking to either Hull or Anglin about "how I should train and prepare myself for the stage."[103] And there were some who wished that Anglin could dissuade a loved one from a life onstage. Earl Price wrote to her in August 1923, apologizing for trying to see her directly at the theatre but simultaneously hoping that she might provide his fiancée, Miss Aldrich, who had an appointment to discuss her career with Anglin, with a realistic picture of her prospects on the stage. Price believed that "on account of your position, you are probably the one person whose voice will carry most weight with her, except her own parents!! I therefore ask you to consider carefully what you say to her. I have offered her that which I know, and you know, is infinitely more essential to her than any career or any amount of $$ or affluence, and if you encourage her to pursue a sham and a make-believe happiness and thereby lose a real one, yours will be some responsibility. I am sure you understand." (He also begged Anglin not to mention his correspondence with her to Aldrich.)[104] Price's might not have been the most tactful approach: his depiction of the stage as "sham" and "make-believe" was definitely at odds with that of her other letter-writers, who believed in the reality and authenticity of Anglin's work and life. His letter, though, suggests that Anglin was someone in whom members of the public might place their trust.

Private Lives, Family Affairs

When these women were not busy studying parts, rehearsing, maintaining their health, and advising the next generation of performers, they also managed to enjoy the benefit of heterosexual family life in homes that were havens of middle-class domestic comfort. In fact, in their offstage lives these women appeared to be the antithesis of celebrity, as they stated that the spotlight of fame was the last thing they sought. For them, to be a celebrity could mean appearing to not be one at all.

Performers, reporters, and, most likely, press agents favoured a type of interview that helped manage this seeming paradox. At first the reporter appeared to be setting up the reader for an encounter with a glamorous, possibly difficult "star," who then turned out to be a regular woman, unpretentious, warm, and welcoming. *The Globe*'s Polly Peele's

"Behind the Scenes with Margaret Anglin," was typical of the genre, in which the journalist, somewhat discombobulated by being backstage, expected to meet a haughty, "scornful" diva but instead met a warm, gracious woman, attended by her French maid, who welcomed her and shared her experiences freely.[105] The actress's dressing room as a space that combined both work and domesticity fascinated American music critic and author Gustav Kobbé, who called the room a "home behind the scene," or the actress's "'professional home.'"[106] Viola Allen, he wrote, paid particular attention to her dressing room; her agent visited it one week before she arrived at the theatre and ensured it met her standards of cleanliness, comfort, and ventilation. Furnished with a couch for her naps between matinees and evening shows, it also served as a dining room on those occasions. As well as being practical, though, the room was decorated, whether with her bright dresses for her Shakespearean productions or, at Christmas, with the evergreen boughs and tree provided by the stage manager and stagehands. However, Allen insisted on doing her theatre business in her dressing room, so that she could maintain a clear separation between "stage life and home life."[107] Like Allen, Margaret Anglin also insisted on cleanliness and comfort, "without making any special demands ... or having any fads about" her dressing room.[108] Kobbé also provided his readers with photographs of Allen and Anglin in their dressing rooms, spaces that, with their upholstered armchairs, glass-covered sconces, floral arrangements, carpeted floors, and large, wood-framed mirrors, could easily have been found in a well-appointed middle-class home. Such an ideal of domesticity was a transnational one, shared across national borders in Britain, Australia, and the United States: it is likely that performers and reporters were well aware that their portraits of actresses' love of home would strike a chord with a wide swathe of readers.[109]

Dressing-room interviews were one way of getting to the "real" woman; features about the actress "at home" were equally popular. In 1899 Allen was still living in her parents' substantial brick home in New York, a privilege and luxury, stated reporter Grace Drew, afforded few other young actresses in the city (a statement with which Allen agreed). There is no doubt that Allen was living in a much more agreeable setting than the boarding houses in which Elizabeth Jane Phillips lodged. Lace curtains, mahogany furniture, a piano covered with Japanese textiles,

and a colour scheme of rose and ecru in the drawing room were followed by the library, with its hardwood floor and Oriental rug. Here Allen, wearing a green cloth afternoon dress trimmed with bits of lace and ribbon, poured tea, surrounded by "embroidered linen, choice china, a steaming metal kettle, souvenir spoons, and plump black grapes on a doily."[110] "Glimpses of Viola Allen's Home Life" emphasized Allen's international literary leanings, with a library full of books (some inherited from her father, C. Leslie Allen) that covered a range of authors and topics: Euripides, Aristotle, books from across England and Europe and in multiple languages, theatre history, general history, and the history of costumes and arms. Such cosmopolitan libraries, the writer pointed out, were very popular with "theatre people." Allen's home was full of souvenirs of her many travels around the world such as Irish lace, English pottery, Flemish metalwork, Parisian carved wood, and Egyptian inlay work.[111] As well as signifying Allen's own transnational voyages, these items, as Kristin L. Hoganson has argued, had become an important component of many white, middle-class domestic spaces, emblematic of their owners' desire to appear sophisticated and worldly.[112] All this was in keeping with upper-middle-class respectability. Finding "Miss Viola Allen at Home," another reporter was relieved to tell readers that there was not a hint of "theatrical" in her home; no French plays or prompt books were strewn across the table and "not even a pug dog or a box of bonbons, common symptoms of the actress in general."[113]

Even on tour, Margaret Anglin preferred domestic comforts over luxurious hotels. While in Australia, "to meet her simple tastes" Anglin rented a house at Darling Point while she was in Sydney, "a quaint little house on the Eastbourne Road belonging to the Whites ... tucked away in a little nook behind some real Australian foliage." Her sister Eileen Anglin, who accompanied her to Australia, kept house for her, along with two American and two Australian maids, "her home whilst with us."[114] When Anglin moved on to Melbourne, she rented a house there since, the press told its readers, she preferred the comforts of a private home to the public life of a hotel.[115] "Stars of the Stage at Home" included Anglin, depicting her reading with her husband, although unlike Allen they had brought their work home, as they were "studying stagecraft." Arthur was also photographed for this article, seated in her parlour, holding a book, and studying a maquette.[116] Annie Russell's home in

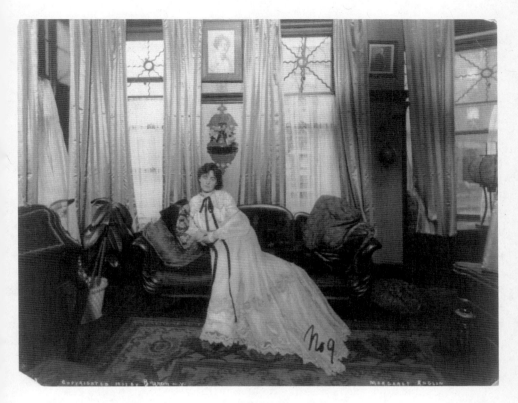

Fig. 4.3 Margaret Anglin in her drawing room, c. 1903.

Maine was a showcase for her love of outdoor sports (swimming, sailing, baseball), gardening, and farming, wrote Kobbé. "There isn't much of the successful actress, beautifully gowned, about Annie Russell at these times, – standing on a load of hay, with sunbonnet on her head, whip in hand, skillfully driving her horse and load over ruts and rocky places."[117] Russell shared her "simple and artistic" home, with its sea-facing windows and "pretty flower-patterned chintz hangings," with her brother Tommy. While it was a haven of wholesome leisure that allowed her to escape the heat and bustle of Manhattan, in August Russell began reading scripts there and using the woods as an impromptu rehearsal space; guests could find her singing, dancing, laughing, and reciting as she prepared for the coming theatre season.[118] These articles were accompanied by photographs that invariably portrayed the actress seated in the midst

of the accoutrements of gracious (yet never ostentatious) living so lavishly — and lovingly — described in the text. These images were underscored by the plethora of articles that, while they dwelt on the actresses' beauty and fashionable dress, stressed that the former was natural and wholesome, the latter appealing but simple, a matter of tasteful choices in colour, fabric, and style.[119]

Articles in women's magazines also attempted to reassure their female readers that actresses shared their domestic worries and concerns, a genre that was itself part of the larger fascination with American middle-class domestic life in the early twentieth century.[120] Anglin's "Domesticity and the Stage," the first of a series of articles by prominent actresses on this topic for *Good Housekeeping Magazine*, admitted that she knew very little about the "domestic tragedies of incompetent servants and overlooked meals," since her mother and then "her most treasured handmaiden, a highly executive creature," had taken care of such matters for her; nor could she speak for mothers of young children whose husbands' work took them away from the home. However, for the woman whose work was outside the home, "I *am* qualified to speak."[121] Having spent many years living in hotels and longing for a home life, Anglin realized that while she had disliked being set to domestic tasks as a child, she enjoyed visiting the kitchen, turning the pages of *Mrs. Beeton's Book of Household Management* and watching the family cook prepare jellies and cakes. Her domestic routine mirrored her childhood experience, as she began each morning (admittedly later than most because of her evening performances) with a visit to the kitchen "with serious purpose." Although her schedule was somewhat different from those of other wives, Anglin believed that she ran her household just like a theatre company. Everyone in the home had a purpose and was expected to fulfill it or, she added rather ominously, "retire." Although in other articles Anglin was depicted as dealing with stagehands and other theatre staff equitably, in this piece her comments about servants resembled those of other middle-class women of the period, a discourse that could be found (with regional variations) in Britain, North America, Australia, and many other colonies.[122] "It is the worry, worry, worry of watching the Swede, or the German, or the Irish or the native product, and wondering if she is going to be all right as she comes and comes and comes and goes and goes and goes."[123] But despite this statement, redolent with class and

ethnic biases, Anglin also believed that treating servants fairly and "judiciously" was the best way of ensuring domestic harmony, although she, not her cook or housemaid, was the judge of such treatment.[124] While she was all in favour of cleanliness, not least because of the constant dust stirred up in New York (especially by "other people's motors"), Anglin argued against fanatical cleaning and against false economy, telling stories that mocked her own money-saving attempts that ended in domestic disasters and cost her more in the long run.[125] Having a sense of humour, both at home and in the theatre, was crucial. In the latter, where domestic interiors were frequently used onstage and mishaps could easily occur, Anglin believed that "a sense of humor is the cantilever, and this applies to the housekeeping of the theatre, oh, so much!"[126]

Claims that these women led simple, "down-to-earth" lives that simultaneously were models of gentility, with its accumulation of objects that signified cosmopolitan refinement and culture, were never straightforward. There were a number of contradictions and cracks in these images of uncomplicated domesticity. For one, the mechanisms of celebrity culture placed the home, that supposed sanctuary that signified intimacy and privacy, squarely in the public eye, inviting in innumerable strangers to gaze at and comment on these women's living arrangements. Furthermore, while domestic servants were not unknown to middle-class North Americans, not all women could afford to hire personal maids who accompanied them everywhere. The citizens of Lawrence, Kansas, for example, were surprised to see Anglin accompanied by a "really truly live 'petite' French maid, of the fascinating type with the high heel slippers," when the actress arrived in their city. No other actress had arrived with a maid, and ladies' maids in general were "rather lacking" in Lawrence, being seen as something of an "aristocratic asset" (Anglin herself, "while extremely attractive and beautiful," was "simply and handsomely gowned" and checked in quietly and without any fuss).[127] Nor could everyone enjoy the luxury of permanent summer homes or the lengthy European vacations and other trips abroad that a number of them took to recover from their work (to be sure, Allen, Arthur, and Anglin all claimed that such trips were also spent researching). Moreover, the fact that these actresses' images were used to advertise a range of goods, such as cigarettes, shoes, tooth powder, playing cards, sheet music, and, in Arthur's case, a racehorse, reinforced their

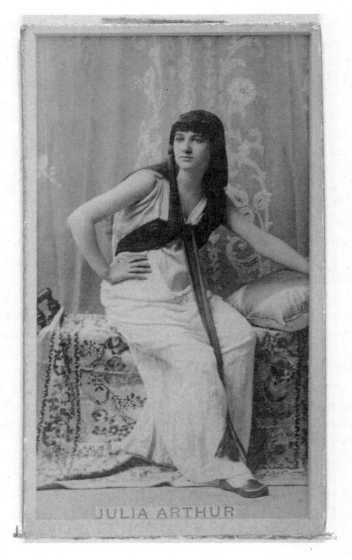

Fig. 4.4 Julia Arthur advertisement, Virginia Brights cigarettes, c. 1900s.

Fig. 4.5 (*opposite*) Margaret Mather cigarette card, c. 1888.

Fig. 4.6 (*overleaf*) Viola Allen, Virginia Brights cigarette card, c. 1888.

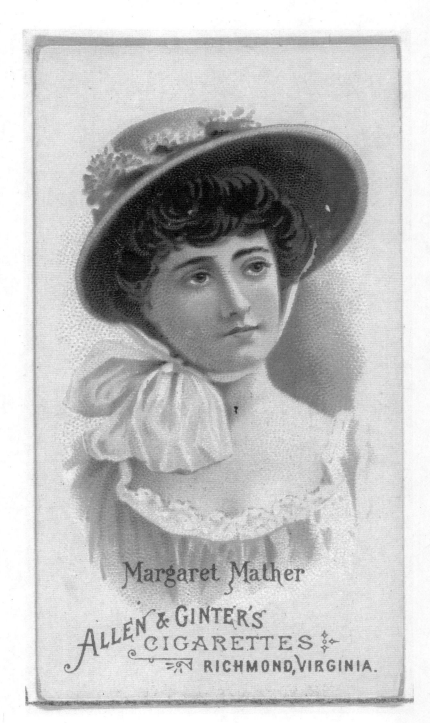

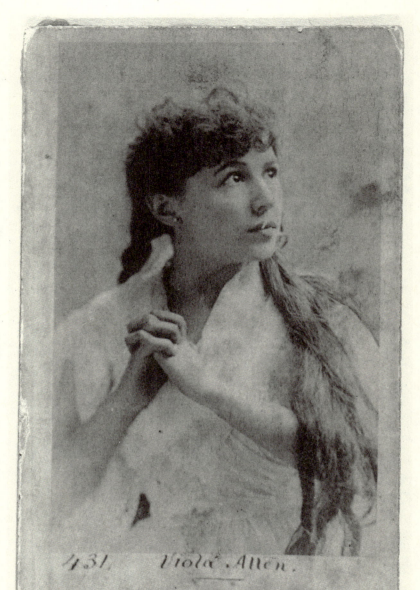

relationship to middle-class consumption but also belied their images as "ordinary" middle-class women.[128]

In particular, the very wealthy men that Allen and Arthur married made the image of the modest, unadorned lifestyle a difficult one to maintain, something that at least one reporter was quick to notice. Arthur, the *London Free Press* stated, had suffered a "state of nervous collapse," brought about by hard work and complicated by "grippe." This was not new, the paper added, since last year she had been said to have fainted every night after performances of *A Lady of Quality*. The real problem, though, was that as Mrs Cheney, "of Boston," Arthur was "very wealthy and has no need to continue at work."[129] Snipes at Arthur's marital status aside, the paper was correct about her husband's fortune. Arthur's husband, Benjamin P. Cheney, was one of the "brightest and keenest, as well as one of the richest, young men in Boston," said the *New York Herald*, which went on to tell readers that his father had made a fortune of $25,000,000 from railroads and his son was said to have $10,000,000. The twenty-nine-year-old Cheney had been the head of the family company since he was twenty-five, now ran the Santa Fe railroad, and was a director for six banks. He also, though, was a leading amateur actor in Boston, had three sisters who were well-known in city society, and had bankrolled a number of plays.[130] Arthur's retirement shortly after her marriage made it easier to reconcile her luxurious lifestyle with earlier accounts of her humble existence. Although Arthur's was not quite a "rags to riches" story, in the early years of her marriage Arthur lived part of the year in a "mansion" on Calf Island in Boston Harbour; the couple divided the rest of their time between the city's grand Parker House Hotel and travelling.[131] While in Boston Arthur could be spotted, "exquisitely and elegantly gowned," in their private box at opening nights; Cheney also bought her a rare and very expensive blue diamond for a Christmas present.[132] Once Arthur returned to acting because of Cheney's business losses, the press emphasized that she had lived a quiet life during her absence from the stage, reading, thinking, and keeping up with new developments in theatre; her erstwhile wealth notwithstanding, Arthur's artistic dedication remained unchanged.[133] Allen's husband, Peter Duryea, was also a wealthy businessman whose wedding present to Allen was a house in Manhattan.[134] However, unlike Cheney, who appears to have been influential in Arthur's decision to

leave acting, Duryea seemed quite happy with Allen continuing to work after their marriage. For those who dreamed of a career onstage, such articles suggested that for a hard-working, talented, and unpretentious young woman, such luxury might be hers someday.

What was more, even if marrying a millionaire was out of many young women's reach, an aspiring actress – and, probably even more importantly, her family – could be reassured that marriage and the stage were not mutually exclusive, since actresses' weddings were covered by the press.[135] While most of these reports confined themselves to the bare facts, the press might whip up excitement by the suggestion of a "secret" wedding. Margaret Mather's 1887 marriage to Emil Haberkorn, the conductor of the Union Square Orchestra, took place while Mather was supposedly resting from her current production. However, Mather travelled to Buffalo and "did something besides resting," *The New York Times* reported. Curate Ballard at St John's Free Church had been called upon by a "handsome," well-dressed gentleman with a "heavily veiled" young woman resting on his arm; the man asked that they be married as quickly as possible and that "for matters purely professional" the ceremony be kept secret. Ballard found witnesses whose discretion could be guaranteed – the church organist and a young woman who simply happened to be in the church parlour – and the bride "removed her veil. appearing very lovely and betraying no little agitation." After the ceremony, the couple left quietly; nevertheless, despite the secrecy, a number of people in Buffalo knew (and in New York, since "Manager Hill" was rumoured to have travelled to Buffalo with the intent of stopping the marriage).[136] Excitement over the wedding did not end there, though, since the next day the paper interviewed Ann Finlayson, Mather's mother, who professed great surprise at her daughter's getting married: "'I knew nothing whatever about it,'" she told the reporter, and had never seen "'the man she is married to.'" Mather had come to her mother's house "'with her maid,'" travelled to Toronto to "'fetch her sister from the convent,'" and left her with their mother so she could attend school in Buffalo. Mather's mother emphasized that her daughter had settled in a "comfortable cottage" in Buffalo, but if she had known of her wedding plans, she would not have agreed to have moved from Toronto. "'I expected she would marry some very rich man, but I suppose she wanted to be taken care of. I suppose she would come here in the Summer, but I don't know.'"[137] The secrecy

surrounding Mather's marriage may well have been a means of gaining some added publicity for her, since ostensibly there were no reasons why she could not marry.

Allen, too, married "in secret," although in her case it might have been because Duryea was being sued for breach of promise by another actress, Sarah Madden, and did not wish to encounter any legal complications. The couple were wed in Louisville, in a ceremony witnessed by Allen's African-American maid America Wagner and Sarah Allen, the bride's mother.[138] Ashwell's second marriage, to physician Henry Simson, was a "secret well kept," declared *The Daily Mirror*. Only a few close friends knew of the couple's impending wedding; Ashwell's company members were astonished when she gathered them onstage to break the news (unlike Anglin's transatlantic honeymoon trip, Ashwell took only a weekend break to Dover).[139] According to the press, Ashwell had only received her final divorce decree a few days before the wedding; according to her memoirs, Simson's position as a prominent and respectable doctor made too much publicity unwise. Whatever the underlying reasons, though, a "secret" marriage, which — at least ostensibly — was being held in order to give the couple privacy, seems to have led to the opposite effect once they had spoken the vows and signed the register.

Not all marriages lasted, though. Although Chicago's *The Daily Inter Ocean* believed that respectability was extremely important to actresses and that the most popular ones were "honourable, modest," and had never been connected to scandal or divorce, Russell, Ashwell, and Mather all divorced and remarried.[140] In Russell's and Mather's cases, their second marriages also ended in divorce. Yet except for Mather, who at times seems to have been followed by controversy, the press reported on these divorces in a straightforward manner, stating the facts of the divorce without moralizing or casting aspersions upon the wife. According to both her lawyer's account and Ashwell's own memoir, Ashwell's marriage to fellow actor Arthur W. Playfair had been ruined by his alcoholism; when drunk, Playfair threatened Ashwell verbally and on one occasion physically, running at her with a carving knife. Although Ashwell left him, she returned after his brother entreated with her, whereupon Playfair continued to terrorize her, threatened to kill her, and locked her out of her home, at which point Ashwell left him and moved in with her sister.[141] (In what seems to have been an act of revenge against his

Fig. 4.7 Amelia Summerville (rightmost) with fellow cast members in *The Merry World*, c. 1896.

wife, in 1903 Playfair attempted to divorce her on the grounds of her alleged adultery with actor Robert Tabor; the suit was dropped for lack of any basis for his charges.[142]) A husband's cruelty, then, cast an actress as an innocent victim and simultaneously made salacious copy. In Ashwell's case, her plight might remind the paper's readers of the victimized women she portrayed onstage, such as Deborah in *The Shulamite*.

Although some writers made fun of those husbands who were not as well-known (or possibly well-paid) as their wives, in general the press had only kind things to say about husbands who remained in the background, content to support their more famous spouses.[143] Few of these women had children, a fact lamented by at least one theatrical publication.[144] Isabel Irving, though, wished to set the record straight, pointing out in an interview just how many leading actresses headed "happy households" and were the mothers of "splendid, well-trained children." Irving included Amelia Summerville, whose "boy and girl are as well-trained a pair of youngsters as one would wish to see in the theatre or out."[145] Children were interpreted as proof of an actress's commitment to heterosexuality and to a disciplined family life; however, other family members also caught the media's attention. Anglin's sister Eileen accompanied her to Australia and, the press noted, stayed with her on and

off throughout her career. Their coverage of Eileen's marriage included her connection to her famous sister.[146]

Moreover, reporters also were interested in family members who were performers. Articles about Allen's history invariably discussed her parents, particularly her father.[147] Annie Russell's sister Marion and her brothers Tommy and Henry were the subjects of a number of articles, whether of their careers or sensational events in their personal lives.[148] Moreover, Russell's early support of Tommy's career as a child actor and her travels to the West Indies with the E.A. McDowell Company as his informal guardian appeared in a number of accounts of her career.[149] It was Arthur's family, though, that garnered the greatest amount of attention. Not only was it very large, but all her siblings also had, in the words of the *New England Home Magazine*, "displayed talent of a high order," either in music or drama. Better still, the Lewis children "are not offensive 'infant prodigies' ... but are healthy, wholesome, attractive, and normal."[150] To have ties to one's birth family helped reassure audiences, and possibly the women themselves, that no matter how peripatetic their lifestyles, they were grounded in an institution seen as the backbone of Western society. Conversely, articles about marriage and family implicitly pointed out that, unlike other forms of middle-class women's work, an actress did not have to relinquish her career when she married.

Stalkers and Scandals

Yet for all the emphasis on respectability, there were moments when cracks appeared in this image, and when the press hinted at whiffs of scandal or, at least, glimpses of less-than-ideal behaviour. Not all of these controversies were of the actresses' making. Others, though, caught the newspapers' attention precisely because they featured these women acting in ways that controverted the norms of well-behaved middle-class femininity.

Although the image of the fan so obsessed that they became a dangerous stalker was, as Marcus has argued, more media stereotype than reality, at times it was the latter.[151] In 1905 Anglin found herself quite troubled by the attention of a young man, Alfred Freund. The son of a wealthy executive of a St Louis department store, Freund was in the audience for all of Anglin's New York performances, sitting in the same seat

and gazing at her fixedly. After Anglin had him banned from the theatre, he then sent her numerous letters, photographs, and love poems, which she turned over to the theatre's security. Freund also began camping out on the stage door steps to the Princess Theatre and, after being evicted from there, sitting on Central Park's stone wall near Anglin's home on West 59th Street. At that point Anglin had him charged with "'haunting and besetting.'" At Freund's trial he stated he wished to marry Anglin and had received encouraging signs of her affection for him. To his dismay, he believed he had been thwarted by Henry Miller, who had interfered on behalf of a friend who was also in love with her. Although clearly unnerved by Freund's attention, Anglin asked the court to be lenient with him. Freund, who had already been in Bellevue's "Psychopathic" Ward, was returned to the hospital for examination.[152] Freund was not the only one with an obsession for her. In 1907 Mrs James Stevenson, the widow of a Boston millionaire, decided that Anglin was her missing daughter, Grace, who had vanished from their home in 1897. Grace's parents had searched endlessly for her, according to the press, but without success. In 1905 Stevenson saw a photograph of Anglin and decided she was in fact Grace; she sent a note backstage, signed "'Mother,'" which Anglin apparently refused to accept. Stevenson took the case to the press since her husband's estate could not be settled while Grace was still missing. If Anglin would acknowledge that she was her long-lost child, Stevenson claimed, she would be entitled to her share of the family's wealth, something that Anglin steadfastly refused to do. According to her biographer, after Anglin returned from her 1908 tour of Australia she had herself declared legally dead in Massachusetts so that Stevenson would desist in her pursuit of Anglin and, too, so that she could settle her husband's estate.[153]

Following on the heels of the Stevenson affair, Arthur O'Connell wrote to Anglin from Syracuse, declaring his "sincere appreciation" for the kindness she and her company had shown him, a "young man who had become a *true* Christian," one who had overcome his vices (an account of which, he reassured her, could be found in the local paper), had never drank or smoked, and who "shunned cakes, cookies, and pies." O'Connell, it seems, was looking for "a girl who will live exactly as I do and become a *true* Christian and become my wife and rear me a minister son." Given that "you stage girls know what honor is," he felt that he had

found an ideal candidate in Anglin. If she felt the same, he suggested, why not meet him "this evening in the east reading room of the Carnegie Library and I will be there near that time and sit down amid the solitude of the books and have quiet, sensible talk with you in this regard."[154] It seems unlikely that she accepted his invitation to meet, but this would not be the end of such matters for Anglin. In November 1911 an anonymous author wrote to her about their (most likely, his) close study of her work onstage and of recently published profiles of Anglin. The writer then proceeded to describe how they would then meet Anglin in New York "in the conventional way" and how they would take motor car rides together; however, she would still not know the letter-writer's identity.[155] An even more unsettling missive was sent by an anonymous author who signed themselves "Macduff," and, in nineteen pages, advised "Peggy Anglin" to "'get thee to a nunnery'" and suggested (amongst other things) that "Jesus Christ the Eternal God still telephoning micro phoning radio toning whispering yelling shouting talking breathing knocking wrecking and waiting for Maggie Peggy Sweet Peggy Anglin to wake up."[156] Much of the letter resembles stream-of-consciousness writing, with constant references to "Peggy Anglin," religious imagery, and Shakespeare. Anglin did not appear overly worried by such communications: she placed them in a file labelled, at her request, "Freak Letters" and it does not appear that she took any action to find their authors.

At the same time that Freund was causing Anglin such unease, May Tully claimed that she, too, had a stalker, a man whose identity was unknown to her. Tully, said Rochester's *Democrat and Chronicle*, "has never met the man, and hasn't even a remote idea of who he is or what he looks like. She knows he's after her. That's all." The anonymous admirer had been sending her copious love letters detailing his attraction to her, telling her that he attended every one of her performances and was tempted to leap over the footlights to be with her. The letters, Tully told the Rochester police, were "of the soft, 'mushy' sort," and demonstrated that he was infatuated with her, as he had sent them from Chicago, Detroit, Cleveland, Cincinnati, Buffalo, and Syracuse, and was "unable to control his mental faculties." Not wishing to be the focus "of a sensation," which she feared the man might create, Tully had gone to police headquarters to ask for protection, including permission to carry a gun while in Rochester. Although Rochester's Captain Zimmerman told Tully that

he could not grant the latter, the city's police sent an officer to watch over the theatre, but the admirer did not materialize. Tully was much relieved by the police protection and it also may have served to warn off her pursuer, since there is no further mention in the press of his stalking Tully.[157] While it's possible that all of this was a publicity stunt, designed to stir up interest in Tully and depict her as a vulnerable – albeit courageous – young performer, it may not have been, given Anglin's experiences and Tully's popularity at the time of the incident.

In a more poignant reversal of the stalker-stalkee relationship, Kate E. Anderson accused Julia Arthur of being "her nemesis." In a New York court on 5 January 1907, the seventy-year-old Anderson claimed that Arthur had been following her incessantly for four years. She had called the police every few days "to put them wise" to Arthur's behaviour, claiming that on the previous evening the actress had drugged her and stolen four gold watches and $100. Yet Anderson was in court not to bring Arthur to account but, rather, to answer charges of public intoxication on a Brooklyn street. She had been married to a prominent businessman, Archibald C. Anderson, the press reported, but the couple had been separated for thirty-five years; Kate worked as a maid and companion for a wealthy Manhattan family. The court detained Anderson for a "sanity examination" and, like Freund, she too might have been sent to Bellevue Hospital.[158]

Celebrity thus made actresses vulnerable; moreover, the women could not be accused of behaving badly or in ways that would attract unwholesome attention. The same could not be said of other matters that ended up either in the press or in court (or both), whether over professional or personal affairs (or some combination of both). In the 1880s reporters seem to have regarded Margaret Mather's battles with her manager, J.M. Hill, as good fun for their readers. In the next decade Mather was once again in the news, this time for her second divorce. After divorcing Haberkorn in 1892 on the grounds of non-support and desertion, Mather then married Gustav Pabst, heir to the Milwaukee brewing family's fortunes.[159] By 1895, though, the couple's marriage was ending. Although normally that would not have attracted too much attention from the press, the circumstances of its demise did.[160] Some newspapers were coy, mentioning only "incompatibility of temper" or "trouble" between the couple on a Milwaukee street.[161] Others, though, decided a more

Fig. 4.8 Margaret Mather, studio portrait, 1883.

Figs. 4.9a and 4.9b Margaret Mather's studio portraits, c. 1880s.

detailed and sensational story would be more interesting. At first the couple, who had married secretly in order to ward off his family's objections, lived happily in Terre Haute, but once the Pabsts forgave their son for his marriage, they moved to his hometown of Milwaukee into a "handsome" home. Gustav became secretary to the family company and he and Margaret were the epitome of loving, doting spouses. Yet, according to one source, not all members of the family treated Mather well. Out in their carriage one day, a quarrel broke out when Pabst asked her to accompany him to a family function. During their argument Mather supposedly struck Pabst with the buggy whip. He leaped from the carriage and walked away but she followed him for four blocks, hitting him with the whip and then punching him in the face. Both parties vehemently denied that any of this had taken place, with Mather calling it a "'cruel falsehood.'"[162] Nevertheless, the press was more than happy to run the story about, in the words of one cheeky reporter, "Margaret of the Horsewhip."[163]

Other dramas took place not in courtrooms but in the theatre itself. On 8 November 1899, according to the New York press, Julia Arthur stopped a production of *More than Queen* to demand that the occupants of a box be ejected from the Broadway Theatre, ostensibly for making too much noise and distracting the performers.[164] Reporters were not having it, though, and insisted that one of the troublesome audience members was the actress Florence Crosby, who had been involved with Arthur's husband before their marriage. When asked who the woman in the box was, "Miss Arthur's flashing eyes glittered with something far more bitter than mere annoyance over persuasive [sic] whisperings."[165] To make matters worse (or better, if one wanted to sell newspapers), the next week Cheney tried to have Crosby barred from the theatre, although accounts conflicted as to whether he was successful.[166] Arthur countered these pieces by claiming that Crosby meant her harm and had been writing her threatening letters (a charge that Crosby vehemently denied), and thus Arthur was now being guarded by detectives.[167] While the matter blew over, during the late fall of 1899 the supposed feud between the two women dominated coverage of Arthur's career. Instead of being a serious and focused actress, she was portrayed as behaving out of pique and jealousy: "'You cannot have my husband and you cannot see me act,' is the tenor of feeling of JA toward Miss Florence Crosby."[168]

Conclusion

For these women, then, offstage celebrity was a multilayered phenomenon. It was tied to notions of national and, at the same time, transnational or imperial identity. They also were lauded by the press for *not* acting in ways associated with fame (or the characters they portrayed onstage), since, for the most part, they did not throw tantrums, behave scandalously in their private lives, lounge about with lap dogs and boxes of expensive chocolates, or dress extravagantly. Instead, these "sweet Canadian girls" represented wholesomeness and a lack of pretension. To be sure, reporters were not above seizing, sometimes gleefully, on times when these lines were crossed: witness, for example, the images of Margaret Mather horsewhipping her wealthy husband in the street. Too, there were always contradictions that hovered around the edge of these representations, not least the reminder that women such as Arthur, Anglin, Allen, and Russell possessed wealth, resources, and connections far beyond the reach of the white, middle-class women in their audiences. Yet in general the celebrity these actresses enjoyed was one that confirmed the values of Anglo-American middle-class culture, including the possibility of social mobility through a theatrical career. While certainly consumption was integral to their images, it was a consumption that had been earned through hard work, diligence, application of both body and mind, and responsibility towards others. So far as their public image was concerned, then, in many ways these women epitomized liberal values of order, self-control, and rationality. Even coverage that hinted at romance and passion in their lives was quick to demonstrate how these emotions had been channelled into respectable domesticity.

Such representations were not the only aspects of their public personae, though. Like their non-theatrical counterparts, these actresses also participated in the civic realms of society – charity work, the campaign for woman's suffrage, and support for Britain, Canada, and the United States in World War I – on both sides of the Atlantic, the subject of chapter 5.

CHAPTER FIVE

Citizenship

Introduction

Over the last few decades, feminist scholarship has debated the gendered dimensions of citizenship, work that includes its meanings in nineteenth- and early-twentieth-century Western societies. Such work has alerted us to the many ways in which citizenship – or, in the case of Britain and its colonies, the status of being a British subject, and its complex relationship to citizenship – was contingent on relationships and categories that intersected with gender, such as race, ethnicity, class, and marital status, and the interrelated dynamics of inclusion and exclusion that underpinned them.[1] Actresses, though, rarely figure in such discussions, even though their lives might be marked by constant movement across national borders that left them either without an obvious nation-state to claim or, for the privileged, freer to make such claims than other mobile women. Just as the lives of the actresses studied here provide us with the opportunity to explore transnationalism's relationship to childhood, work, performance, and celebrity, they also open up questions about citizenship and belonging. What did transnational mobility mean to these actresses' conceptions of citizenship? How did their movement across geographic and cultural borders affect their relationship to the multiple articulations of national identity and civic belonging that existed in the late-Victorian and Edwardian eras? These women were claimed by the international media in discourses shaped by concepts of national belonging; they themselves staked out national affiliations and subjectivities. There were other lenses, though, through which they saw themselves and asserted their respective places in the societies in which they lived and worked, lenses that might be inflected by concepts of nationalism, transnational affiliations, and social ways of belonging. These took multiple, sometimes interlinked, forms:

working for charity, whether for the theatre or for other worthy causes; supporting the struggle for woman's suffrage, either wholeheartedly or somewhat reluctantly; assisting the Allies' efforts in World War I; and engaging with postwar political developments. Just as other middle-class women participated in these enterprises and movements, becoming involved in charity, suffrage, and support for the war effort allowed these actresses to claim membership in the public realm as part of civil – and civic-minded – society.

Looking After One's Own

By the mid-nineteenth century the theatrical profession had a century-long history of organizing benefit performances for its members who were facing difficult times because of age, illness, or disasters (fire, flood, accident): those onstage would donate their time and the box office revenues would be given to the recipient.[2] Annie Russell, for example, received a very large testimonial performance at New York's Palmer's Theatre in 1891, organized by a committee of fellow actresses, "ladies" who were friends of hers, a list that included May Robson. Supported by prominent theatre managers such as A.M. Palmer and Charles Frohman, the committee brought together many New York performers for Russell, "the excellent actress who was such a favorite at the Madison Square Theatre until sickness forced a long retirement from the stage, which her friends still hope is to be but temporary." *The New York Times* remarked that such was the ladies' committee's devotion to Russell that they managed to get both the Lyceum and Twenty-Third Street Companies to rehearse two new plays for the performance, instead of staging familiar pieces. "When actors and actresses give their services, and in addition study new parts to add to the attractions of a benefit," the paper mused, "it is safe to assert that the cause appeals to them with more than ordinary force."[3] One hundred performers showed up on 10 February at Palmer's. Over the course of the afternoon and early evening they presented a program that included a trial scene about a breach-of-promise case and two one-act plays, one a historical romance, the other a Henry Arthur Jones comedy. Although a few prominent performers originally on the playbill did not appear – Lillian Russell's recitation was replaced

by the song and dance of Little Tuesday — the benefit was a success. Between box office receipts and souvenir programs (sold in the lobby by members of the ladies' committee), it raised over $3,000 for the very ill Russell, whose "touching telegram" of thanks was read at the end of the show.[4]

In the case of Russell's benefit and in others, a number of themes emerge. For many of those onstage, it was an opportunity to try out new work and, particularly for theatre managers, to tantalize future audiences with it. The benefit also highlighted the activism and organizational skills of the "ladies' committee," a phrase often seen in accounts of middle-class women's voluntary charitable activity but, in this case, applied to women working in a professional capacity. Like many other descriptions of benefits, the language of sentiment and affect, such as references to Russell's grateful telegram and her lengthy illness, overlay the harsh realities of illness and unemployment in an occupation in which, despite the celebrity of many of its members, such conditions were all too common. In Russell's testimonial, as in many others held for performers in such straits, members of the stage proclaimed their determination to look after their own. Theatrical networks thus functioned in a similar manner to fraternal and artisanal organizations that provided life, health, and unemployment insurance for their members. Benefits also allowed the theatrical profession to garner publicity on two fronts: the talents of its members and its charitable and giving nature. Too, given that some of those involved either had worked with Russell or were her friends, they were quite likely genuinely concerned for Russell's welfare and probably realized that they too might need a benefit or testimonial someday.

Performers also might hold benefits to celebrate a fellow actor, whether during a successful run, on the eve of their departure from the city for other venues, or as recognition of their contributions to the stage. In 1916 Viola Allen helped organize a testimonial for critic William Winter, an important advisor to Allen in her staging of Shakespeare. Allen had suggested the testimonial and, as *The New York Times* reported, her idea had been very well-received, the event "an unmistakable success," with an audience of 3,000. The organizers staged a "Masque of Shakespeare" to open the performance, featuring a procession of notable characters

backed by a chorus; it was followed by short scenes from the plays acted by many prominent performers, including Russell, Allen, and Julia Arthur. The city's mayor sent a greeting, well-known cultural figures read poetry and sang, and Ruth St Denis danced, although the paper noted acerbically, "the imagination swoons at the prospect of finding a more incongruous number for a Winter testimonial."[5] As Allen's correspondence with her colleagues demonstrates, such an undertaking was very much a "labour of love." While being associated with the event may have enhanced Allen's own cultural capital, it also involved considerable letter-writing and cajoling of her busy peers.[6] Although she could not attend, Clara Morris wrote to Winter to express her "pleasure in the big, beautiful wholly deserved honour that is coming to you so soon," concluding, "as one of the 'old guard' let me congratulate you! That you may long bask in the sunlight of your fellow creatures' love, respect, and admiration is the sincere wish of your's respectfully and sincerely."[7]

But when the time came for a similar event in Morris's honour, she wrote to William Quaid, the manager of New York's Proctor's Theatre, begging off appearing at a "Clara Morris" night planned to commemorate her headlining appearance at the theatre in 1875. While she professed to have been "licking the cream off her whiskers" at the prospect of "an amazing and delightful surprise – a beautiful, thrill surprise," she felt Quaid was being overly optimistic that such an event would attract an audience. "Is not Clara Morris pretty much of a legend now, a sort of Cinderella fable based on that amazing Fifth avenue opening night in 1875? Think of the year, think how the ranks of my beloved public are thinned." Few men would remember her, she told Quaid, but those few who did "would remember vehemently, with impetuosity of feeling." While their applause would be "the sweetest sound this side of heaven" for her, for the past eight years Morris's rheumatism had prevented her from leaving her house; she would have to be "shouldered like a bag of oats or dolled in a roller chair, but pride forbids." Despite her great disappointment that a "Clara Morris" night was not to be, she was warmed by Quaid's kindness in remembering her.[8] Morris was no stranger to benefits, though. In 1903, as her eyesight deteriorated badly and she was threatened with losing her home, she had received an outpouring of support and care with a benefit that raised $6,000 for her.[9] However,

later in her life, age, disability, and, quite likely, the fear that even those few with memories of her might not materialize were all good reasons to remain off the benefit stage.

Benefits for particular performers had their limits, though. They focused on individuals and were probably most effective when the recipient was famous or well-beloved. They also could not address the structural economic problems faced by all theatre workers. As early as the 1830s, British performers began to look at more collective and systematic solutions, such as officially sanctioned charities with corporate structures, regular meetings, and fund-raising events. By the late nineteenth century, the theatrical profession increasingly turned its attention to supporting other forms of charitable work, a shift motivated by its own increasing drive for respectability and by developments in British charity at the broader level.[10] While there is no comprehensive study of North American theatre's engagement in philanthropy, developments in the United States appear to have been similar to and yet different from Britain, particularly so far as timing was concerned. While, as Russell's example suggests, benefits did not die off or dwindle,[11] like their counterparts across the Atlantic many North American actors agreed that more structural efforts were needed to address poverty and dislocation within the ranks of theatre workers, particularly as theatre and performance grew increasingly industrialized and theatre management became dominated by large corporations. Collective efforts to provide for theatre workers began in 1861, with the formation of New York's Theatrical Workmen's Council, a body affiliated with the Knights of Labor; in 1886 it became the Theatrical Protective Union and then Local One of the International Alliance of Theatre and Stage Employees.[12] By the early 1880s various prominent members of the New York stage, led by *New York Dramatic Mirror* critic Harrison Fiske, had begun to call for a body to assist the acting profession. Although Fiske's demand that actors and managers end their practice of giving benefits for charities and instead focus on the theatre's structural needs was unsuccessful, he helped create the momentum needed for the foundation of the Actors' Fund in 1882. Despite its name, the fund was created to help all those who worked in the industry. Its 1889 annual report listed not just performers but also stage managers, stagehands, scenic artists, properties and wardrobe builders, machinists, doorkeepers, agents, authors, and managers.[13]

Work for the fund also garnered considerable publicity for the profession. Its fairs, held at prominent locations in New York from 1892 to 1917, were elaborately staged spectacles that bore a strong resemblance to the World's Fairs and imperial exhibitions of the period, and received extensive coverage in the American press.[14] Actresses from across the profession were extensively involved in this work; indeed, historian Albert Auster claims that the success of the 1892 Fair was largely the result of women's skills in fundraising and organizing.[15] A number of the women of this study lent their time and their names to these events. Viola Allen appeared at the 1892 Fair with other prominent female performers and was the president of the fair's furniture display, while Julia Arthur assisted with the toys booth.[16] In 1910 Margaret Anglin sat for a portrait painted by Thomas W. Dowing, part of the fair's fundraising efforts; it, along with four other portraits of famous American actresses, was auctioned at the fair's close.[17] A 1916 cookbook put together to raise money for the fund featured Julia Arthur's recipe for fruit salad, while in 1917, Amelia Summerville chaired its "Shamrock Booth" for an event that promised to be a "record breaker.[18] That year the fair also featured a Canadian booth. Catherine Proctor was happy to report that Sir John Eaton had donated $1,000 worth of goods to it, Toronto's mayor presented her with a Union Jack, and her cousin, businessman Len Proctor, had given a "handsome set of silver" to be sold for the fund.[19] While their work for the fund's fairs reinforced images of respectable white femininity exercised from positions of prosperity, Clara Morris's tribute to the fund reminded its members of the professional and economic struggles that older actresses might face. Morris spoke at the second anniversary commemoration of the fund-sponsored Actors' Home, a speech that celebrated growing old and — somewhat paradoxically — the comforts the Home offered, which were necessary for women facing poverty and potential destitution.[20]

But despite women's work being crucial to the fairs' and fund's success, the latter's leadership was dominated by actors and male managers, a gendered division of roles that resembled other mixed-sex charitable organizations of the nineteenth century.[21] Actresses created other organizations that, while they shared the fund's overall goals and often were represented by booths at the fairs, sought to address their members' specific needs. The Twelfth Night Club, founded in the late

1880s, was a social and benefits club for actresses, which, amongst its other activities, organized testimonials for those facing hardship. In the early 1900s Allen was elected president of the club, whose all-female membership, declared the *Albany Argus*, "represents the most intelligent, charming and characterful women of the New York stage."[22] Although little information has survived about her presidency, in 1901 Allen appeared in a scene from *The Christian* as part of the Club's testimonial at Wallack's Theatre for Mme Janauschek, who had been ill for some time and was currently in Saratoga, presumably to recuperate; the event raised almost $5,000 for her.[23] As well as the club, the Professional Women's League, inaugurated in 1893, was a self-help organization with a membership that consisted primarily of actresses and which focused on teaching skills such as dressmaking, language, art, music, business law, and debating. While dressmaking might have seemed merely to reinforce stereotypical female traits, Elizabeth Jane Phillips's complaints about the constant cost and worry of buying costumes suggests that learning to cut and sew them would have been a practical solution for a cash-strapped actress. Moreover, such skills could be put to use making costumes for fellow performers if work onstage was scarce. The league also organized bazaars and exhibits: its 1897 display of dolls dressed as prominent actresses included one modelled on Julia Arthur wearing the costume of her character Clorinda Wildaires from *A Lady of Quality*.[24] In 1902 Arthur and Amelia Summerville sat on two of the league's advisory committees, while Annie Russell allowed the league to use her portrait for its *Souvenir Book*, issued for the league's 1902 Madison Square Gardens exhibit.[25] In 1911 Summerville ran the "beauty booth" for the league's seventeenth annual bazaar, held at the Waldorf. Fellow performer Marie Dressler, "in a tight-fitting tailor-made gown," was the bazaar's "official 'capper.' Trying to buy things at three booths at once, and talking at the rate of at least a hundred words a minute, Miss Dressler advised everyone to take as many chances as possible in all the bazaar's lotteries." After all, she had spent a "'season's earnings'" in one afternoon and expected to "'mortgage'" her next two that night.[26] However, this appears to be the extent of these women's active engagement with these two organizations; many of them might not have had the time or inclination to become directly involved with running a group.

This is not to suggest that they were unsympathetic to or uninterested in the problems faced by their fellow performers. In 1922 Anita Clarendon contacted Margaret Anglin about a program, the National Stage Woman's Exchange, that she and two other actresses were starting. Inspired by the Woman's Exchange and having produced domestic goods (jam, cakes, candies) and sewn dresses in their own homes, Clarendon and her friends wished to set up their work in a more formal (and, they hoped, lucrative) manner. They planned to set up a sewing shop that could handle mending, dressmaking, and interior decoration with a tea room attached to help cover their overhead, and hoped that Anglin, as an "important woman of the stage," would sit on their advisory board. To protect their participants' reputation, "no one need know who does the work ... it'll help many a one over the rough road," she thought. Clarendon had also heard that Anglin had admired other dresses that she had made, and offered to sew some for Anglin at a cost of fifteen dollars per dress, either in chambray or "little figured chintz." Moreover, some of the women in Anglin's company might be interested in joining the Exchange: "I think the actress is the most versatile women in the world, and I am sure could design and make more attractive things than the average woman." After all, Fanny Davenport's niece Kate had been making jam for Clarendon's group and was now supplying the Ritz and the Waldorf hotels.[27] Anglin replied that she would be happy to provide any service she could by sitting on the Board, although she confessed her "familiarity with anything more than finished work is rather meagre." Nevertheless, she encouraged Clarendon to visit her at her apartment to discuss things further, would be delighted if Clarendon would make her another dress, and promised to take her letter to the women in her company.[28] The correspondence ends with Clarendon thanking Anglin for the order of a chintz dress ("it was sweet of you") and telling her that her group had rented a small shop at 62 West 47th Street.[29] It is not clear if Clarendon was successful in her enterprise; however, her exchange with Anglin suggests that the ethos of self-help represented by the rural-based Woman's Exchange movement had inspired at least some women in Broadway's urban theatrical milieu.[30]

They also supported their fellow actors in other ways. Ashwell appeared in Ellen Terry's 1909 benefit for the Queen Alexandra Sanatorium

in Davos; some of the funds were to go towards beds for performers who, in Terry's words, "'can no longer make us laugh and cry – tragedians at last!'" Terry also reminded the audience how fervently members of the profession "give our services frequently and freely, and we are always glad and proud to do all that we can for those who are needy and distressed.'"[31] Moreover, in 1911 Ashwell founded the Three Arts Club, citing the need for a place for young actresses, musicians, and artists; the club held a large restaurant, bedrooms, reception rooms, lounges, and rooms for reading, writing, and music practice. The spaces were subsidized and the club stood out in the context of London's theatrical charities because the profession itself founded and ran it. Its two boards included a large number of actresses who also were involved in the Actresses' Franchise League and the Theatrical Ladies' Guild; they also, though, included women who did not openly support suffrage or who did not contribute to the Guild.[32] On the other side of the Atlantic, Summerville, along with other "prominent women of the stage," helped organize an entertainment for the "children of the stage," an annual event put on at New York's Tammany Hall that included dinner and a gift for each child who attended, followed by a performance at Pastor's Theatre by several children's acts.[33]

Anglin also helped out amateur and school drama groups. She donated a gold bracelet as a prize to Canada's Earl Grey Dramatic Competition, a gesture noted in the press.[34] At least one of its recipients remembered the award fondly. Toronto's Patti Newton wrote to "Miss Anglin" to tell her how superb she found her in *Henry VIII*: "your voice well, it was beyond thrilling to describe. I never heard anything like it." Newton was more than a regular fan, though, since she had met Anglin in London, Ontario, and "was fortunate in winning your beautiful gold bracelet in 1910 ages ago isn't it. I feel so happy and proud to have met you, how I longed to go on the stage – but always something kept me back." Now married, she hoped that if Anglin visited Toronto again she would come and see her.[35] Judging from the number of letters sent to Anglin from the organizers of the Canadian Drama Award, she also assisted the group as a judge, work that, in the words of L. Bullock Webster, kept her "constantly in the thoughts of her British Columbia admirers."[36] What was more, in the early 1920s Fay S. Goodfellow, a member of Cotrell's Ferry College Theatre Club, thanked Anglin for writing personally to Samuel French

for a reduction of the royalty fee on *Green Stockings*, which the club had just mounted. Goodfellow was thrilled that Anglin would do that for her organization, not least because "this year has been in many respects, for me, one of disappointments. You see, I had hoped and I have tried to find some little place in the actual theatre — in fact, I am still hoping and trying. But in the meantime to be busy working in the art I love so well, even tho' as an *amateur* — that is some compensation," especially since she was able to play Celia Faraday (Anglin's part). Goodfellow reiterated her and the club's personal gratitude and hoped that perhaps one day she could meet Anglin. Until then, she promised to try not to miss any one of her new plays, and to listen and watch "with greater interest than ever before, if that's possible!"[37]

Moreover, in keeping with these women's overall images of humility and empathy discussed in chapter 4, the press enjoyed running stories that illustrated their generosity to fellow performers on an individual level. One such anecdote featured Russell's acts of kindness to a young "chorus girl" who was appearing with Russell in *The New Woman* at Palmer's theatre. The "very pretty and somewhat sentimental scene was acted behind the curtain" when the young woman approached Russell to show her a framed five-dollar bill, her first wage as an actress. This "sacred souvenir," which would only be exchanged in the "prospect of absolute starvation ... was part of her life history, the monument that marked the adoption of her life work." With the young woman's consent, Russell showed it around the company and was struck by the idea of getting all the cast to sign the frame before returning it to its owner. In conclusion, the reporter noted, "the memento of her début is now doubly valuable to the young woman, bearing, as it does, the testimonials of encouragement from a notable company of players."[38] While a tale of small kindness, the sentimental story both drew heavily on many of the tropes of popular nineteenth-century culture and suggested that actresses such as Russell were not adversaries engaged in cut-throat competition for roles, pay cheques, and fame. Instead, they were warm, nurturing, maternal figures who took their responsibilities for encouraging the next generation of performers seriously. The press told a similar tale in 1901 when Julia Arthur gave Henrietta Crosman the costumes, scenery, and properties of *As You Like It*, which had been valued at $20,000. Although Crosman, who had not met Arthur, hesitated at accepting this "unusual

and rich gift," Arthur persuaded her by pointing out that despite having retired, she wished to see "Shakespeare perpetuated on the stage." The paper also pointed out, a little unkindly and with a tinge of sexism, that since she had married a millionaire Arthur could afford to make "such a rich present to her sister actress."[39]

Matters were more serious for Margaret Anglin when in 1908 Thomas Whiffen beseeched her for a loan. The son of Blanche Whiffen, who had played Anglin's mother in *The Great Divide*, Thomas told Anglin that the matter was "strictly private and confidential. I have appealed to all my friends without result and am forced to try every means. I stand a good chance of going to jail – a result of an action of my partner in the vaudeville act we had last year – unless I get at once $225.00. If you can by any means spare me this it will release a sum of $100, which I will at once send you, and the balance of $125 I can easily pay in a short time as I start work next week" at the Broadway Theatre in Camden, New Jersey. It was impossible for him to raise the amount, he confided to Anglin, and he knew his mother did not have the funds, adding, "and in any case you know what it would cause her tho' as a fact the mess is not of my making." Please, Whiffen begged her, "kindly keep the matter between ourselves no matter how you act," as she would understand how humiliating this was to him.[40] Anglin decided to help him but she may have regretted her generosity, since further correspondence suggests that Whiffen either did not pay her or was late sending the money.[41] By the end of April she may have become exasperated, since Whiffen wrote to her that he had just seen Mr Nethersole "and he tells me you are very angry with me. I do not blame you in the least but want to say I have only had twelve weeks' work in two seasons and have been absolute 'flat broke.'" Whiffen had arranged with Louis Nethersole to send his payments to Anglin, telling her that he would have sent them directly but she was "hard to reach" in her "wanderings." What was more, "I have delayed as every week something has come and I have waited to enclose a payment and then it has fallen through. Believe me I am grateful for your kindness. I would have written to or seen you on your arrival here ... From Mr. Nethersole I gather that you accuse me of treating you as 'an easy mark,' etc. It has not been so. The hundred dollars was practically stolen from me – the amount I wrote to you about and at the time I borrowed from you I was booked for a long route in vaudeville a week after my partner missed the

train and everything was lost. Again I must say I am very sorry and I will repay everything, with interest added out of the first money I earn." His letter was accompanied by a note stating that he would pay Anglin $25 per week, starting 1 October and continuing until the full amount, plus 6 per cent interest, had been discharged.[42] Why Whiffen did not turn to the Actors' Fund for help is unclear. It may well have been, as he told Anglin, that he was ashamed to tell his peers about his financial troubles. He also might not have been honest with Anglin about the matter and may not have been entirely the innocent victim that he claimed to be, thinking that it might be easier to hide less-than-flattering details from her as opposed to a committee of his peers.

As well as voluntary work for the profession and private acts of charity, these women also lent their names and, in some cases, considerable amounts of time and labour to causes outside the theatre. When the Boston Museum reopened after a fire, Allen's company, which was playing *The Christian* at the time, staged a benefit performance for the city's Firemen's Relief Fund, raising $500 for it (the goodwill may well have contributed to the production's success, as its run was extended by a week).[43] Others helped raise funds for hospitals, orphanages, and widows and their children. Carolyn Miskel Hoyt appeared in Augustus Thomas's one-act play *The Overcoat* as a fund-raiser for the New York Orthopaedic Hospital and Dispensary. Part of a dramatic tea held at the Waldorf Astoria Hotel and arranged by "society ladies," the play was staged alongside other one-acts and scenes from other plays.[44] Amelia Summerville performed in a benefit for the Monmouth Memorial Hospital, staged at the Norwood Casino in Long Branch.[45] Summerville seems to have been particularly civic-minded: two years later she volunteered with a group of performers to appear at Keith's Union Square Theatre, the proceeds to go to the New York Home for Destitute and Crippled Children. (This was an annual event organized by vaudeville producer B.F. Keith, who donated both services and the box office receipts to the Home.[46]) She also organized the entertainment for Brooklyn's Rest-a-While Club's Christmas party for 150 disabled children from the area's hospitals and private homes.[47] "Viola Allen's Greatest Achievement," insisted Margaret Bell in *Maclean's*, was not her wonderful work on stage but, rather, her providing a Christmas dinner of "real turkey and real plum pudding, and raisins and oranges, and nuts, and all the other delicious things which

makes Christmas such a sweet anticipation for every child in every land." These were children dressed in torn dresses or threadbare knickers but that did not matter, since the feast Allen provided made them forget their worn and shabby clothing. Moreover, lest any cynic think that Allen did this merely as "an advertisement for the world to look upon and commend," Bell reminded them that other actresses, once successful, had picked "up their skirts ... and march haughtily by, lest the hem of their garments become besmirched by one-time associations." Moreover, after her dinner with the children was finished, Allen would rush off to a "grimy dressing room" to prepare for the matinee that she would perform for them. After all, Bell noted, as a small child in Toronto Allen had been allowed to go to the Grand Opera House for the Christmas matinee, a special treat that allowed her to "dream dreams of some day being a really great star, who would invite a lot of boys and girls to see her, who could not buy tickets for themselves."[48]

Viola Allen also came to the media's attention for her individual acts of beneficence. "Visited by Viola Allen. Roses Taken to Pearl Van Gundy — Relatives Have Not Appeared," related the adventures of nineteen-year-old Pearl Van Gundy from Louisville, Kentucky. Van Gundy appeared to have run away from home a number of times; this particular escape was motivated by her mother's threats to put her in a reform school or convent.[49] She had been arrested in Lexington for "bad conduct" on the train, detained by the local police at her mother's request, and, when her mother did not come to fetch her, placed under the care of the local Charities Agent. Van Gundy then escaped from the agent's custody and was rearrested by the police, "confined like a felon," and nothing had been done about her release: her parents had been notified and though they promised to come for her, neither had shown up. Allen, who was appearing in Lexington, had heard of Van Gundy's plight, and decided to visit her in the town jail just before Allen's company left the city. "Moved to pity by [Van Gundy's] forlorn appearance," Allen presented her with a bunch of American beauty roses. The paper noted approvingly that "the young girl seemed to appreciate the act of kindness highly, and placed them in a jar of water which was given her."[50] Van Gundy may well have welcomed a friendly gesture, but she also refused to be a victim in this narrative, which the press treated as a story of adventure and derring-do. She continued to escape from both the authorities and her parents,

picking the lock of the room where she was held, and, once placed in a convent, scaling the building's ten-foot wall. Perhaps fed up and admitting defeat, the authorities decided to leave Pearl to her fate.[51] While this story of the young female ne'er-do-well and the actress augmented Allen's reputation for being kind-hearted, it also pointed to the great differences in these women's lives, ones based on age and social status. Allen's movements about the country were seen as normal and legitimate, whereas Pearl Gundy's desire to leave home and family landed her in a jail cell.

The most civic-minded of these women, though, was Lena Ashwell, who donated her time and labour to a range of organizations, many of them focused on alleviating poverty in London. As early as 1896, when Ashwell had only been on the London stage for five years, she sang at a concert at the Kensington Town Hall to aid the Cowley Mission; five years later she recited at a benefit staged at London's Wyndham Theatre for the poor of Holy Cross parish in the borough of St Pancras.[52] Along with other prominent performers, Ashwell appeared at a matinee put on at London's Criterion Theatre to help the city's Poor Children's Boot Fund; in 1911 she was part of a benefit matinee for the Miller General Hospital in southeast London.[53] She also sang at a fundraiser for the Tweedale Work Guild: organized by Julia Monson, Marchioness of Tweedale, and held at the Carlton Place home of Viscount and Viscountess Ridley, the event was aimed at providing work for women in Stepney and the East End.[54] Although much of Ashwell's charitable work involved performing, in 1908 she, along with sixteen other well-known London actresses, pledged to donate a Christmas pudding to the *Daily Mirror*'s children's Christmas parcels (the drive included members of the aristocracy, business leaders, and professionals).[55] She also lent her celebrity to the Women's Imperial Health Association of Great Britain caravan, which was sent throughout the Thames Valley to provide "lectures and demonstrations to the mothers of England."[56] Of course, providing Christmas treats, boots for poor children, and funds for hospitals and orphanages were gestures commonly found in the late-nineteenth- and early-twentieth-century landscapes of charity and philanthropy. Moreover, by the late nineteenth century the East End of London was providing fertile ground for middle- and upper-class reformers and philanthropists, intent on both "rescuing" the poor and surveilling them.[57] Ashwell's celebrity status made her

stand out from the ranks of reformers and informal social workers, but there is no denying that her benevolence was part of this larger context. In turn, though, some of those involved in that movement then may have been attracted to come and see her in a drama such as *Diana of Dobson's*, which addressed questions of social inequality and working women's struggles to earn a decent living.

Actresses' involvement did not stop at domestic charities, though. They often were asked (or volunteered; it is not always possible to determine which was the case) to lend their names and skills to fundraising for international charities and humanitarian causes. In 1905, for example, Anglin and her company performed an excerpt from *Zira* at a benefit at New York's Casino Theatre for Russian Jews in Odessa who had been persecuted in pogroms; the event raised around $2,500 and featured Sarah Bernhardt in a one-act play. Apparently, Bernhardt was so thrilled with Anglin's performance that she ran to her, kissed both her cheeks, and told her how "'superb'" she had been as Zira, an anecdote that suggested how such events could augment a performer's celebrity.[58] Anglin's identification as a Canadian of Irish descent also caught the eye of those fundraising for various causes in Ireland. In 1916, Ishbel Aberdeen, the wife of Canada's former governor-general who was extremely active in several voluntary organizations and causes, thanked Anglin for being willing to help promote Irish textiles in the United States.[59] Other international causes drew in Summerville (destitute women and children in Europe) and Allen (Hungarian children affected by World War I).[60] Ashwell too was no stranger to international or transatlantic relief. In 1900 she recited at a London matinee set up to raise funds for "the sufferers" of a devastating fire in Ottawa and Hull in which thousands of residents lost their homes. Organized by Canadian actor James McLeay and held at Drury Lane, with Queen Victoria as its patron and the Prince of Wales in the audience, the six-hour performance featured London's theatrical stars and raised $15,000 (although by that point the funds were not needed).[61] Eleven years later Ashwell also helped both the "French sufferers" and fellow performer Gabrielle Réjane (thus being doubly charitable) at a performance held at the Hippodrome, on a bill that included Sir Herbert Tree, Oscar Asche, Dion Boucicault, Cecilia Loftus, Marie Tempest, and Irene Vanbrugh.[62]

There are a host of reasons, some touched on above, that can help us understand why busy, hardworking performers might become involved in charitable causes. The appeal of organizing and fundraising for groups such as the Actors' Fund, the Twelfth Night Club, or the Professional Woman's League is probably the easiest to comprehend, on both practical and ideological grounds. In a period when on both sides of the English-speaking Atlantic state-supported welfare was either nonexistent or available for only certain specific causes (widows' pensions, for example), and when North American theatre was becoming industrialized and more hierarchical, finding more collective solutions and pooling resources to combat the chronic insecurity of theatre work would have seemed logical; nineteenth-century fraternal organizations and early unions provided a useful template. At the ideological level, despite celebrity culture's vaunting of individual performers and their "genius," theatre workers also subscribed to the ethos of working together as a team, a value often coupled with the metaphor of theatre as a family endeavour. Looking after one's own, whether that "own" was defined by occupation, religion, or ethnicity, was part of the terrain of nineteenth-century fraternalism and self-help, so it is not surprising that those who worked in performance should turn to their profession's needs. Moreover, performers' relationship to existing charities had been a tense one. Religious charities' hospitals and homes for the aged, for example, often denied assistance to actors on the grounds of their "vagrant" status, while nineteenth-century charitable and philanthropic organizations frequently made distinctions about the deserving vs. undeserving poor: it is not hard to imagine that theatre workers might well have fallen into the latter category.[63] The Actors' Fund, in contrast, does not have appear to have discriminated against recipients on the basis of character, and unlike craft-based unions, it also did not discriminate based on the type of work performed. Instead, it welcomed all who had worked in live performance. Moreover, those who appeared in benefits for fellow performers did so to assist fellow workers: the latter were not objects of pity or subjects to be reformed, removed from them by virtue of class, ethnicity, race, or geography. Furthermore, the growing number of young women entering the acting profession who constantly sought out their more seasoned counterparts' advice about their

prospects may well have reminded the latter that they could not afford to take their own status for granted.

To be sure, charity bazaars and fairs, held by both the League and other organizations in settings that echoed the décor of the middle-class home, drew on the language and images of white middle-class women's benevolence. Such work helped prove their members' respectability and elicited support from sectors outside the theatre. Actresses' engagement with other causes, such as orphanages, hospitals, maternal health, and relief for victims of overseas conflicts, also made use of those tropes. It is difficult to move beyond the media representations of these women, since they rarely discussed the reasons for the actresses' involvement, instead treating it as something natural, to be expected. Moreover, the women themselves rarely provided any explanation for their actions. While benevolence, then, for non-theatrical organizations became a performance of white middle-class womanhood for them, it was one with motivations that were seldom examined explicitly. Even those with personal archives treated it in a matter-of-fact manner, their correspondence lacking any reflection as to why they agreed to recite, staff booths, or cut ribbons.

Perhaps most obviously, giving speeches at charitable events for institutions such as orphanages gave publicity to these women, guaranteeing that they would receive extra coverage in the press. Yet it is also possible to imagine how dispensing charity might be entangled with their own needs and desires. For one, many of these women, particularly Allen, Anglin, and Ashwell, sincerely believed that theatre could be a beacon of morality for modern audiences. Even when the plays they appeared in dealt with unsettling topics, their messages were serious, often meant to improve their audiences' moral well-being.[64] Furthermore, many had grown up in middle-class homes, educated by nuns or a religiously inclined parent, and would have been told from an early age that it was their duty to help those less fortunate. Using their celebrity not merely for self-aggrandizement but for "nobler" purposes might have assuaged any twinges of conscience about the extent to which actresses needed to be focused, even self-absorbed and selfish, in order to succeed in their work. Being involved in charity work, after all, was an important marker of civic engagement and citizenship, particularly by the late nineteenth century. Even though they might be formally excluded from

other markers of citizenship and national belonging, such as suffrage, they thus could demonstrate their desire to claim such a status and make a commitment to the civic sphere in their society, one composed of those voluntary institutions that occupied an increasingly important and significant role in North America and Britain.[65] As well, charity work linked them to a larger community of benevolence and humanitarian sympathies. Like the plays of emotion and affect in which they appeared, such a community had spread across both the Atlantic and North America; actresses were able to tap into larger networks that reached beyond those of the theatre, forging friendships that were often hard to create outside of theatrical circles. It is worth remembering, though, that unlike their middle-class counterparts who were not performers, actresses who recited for the orphans' home or performed for poor children's Christmas entertainment donated not just their time but also their labour and professional expertise. Although we should not overlook the eagerness of charitable organizations to exploit those skills, it may be that these women took great pleasure and delight in demonstrating that they were polished speakers and performers on- and offstage.[66] These skills could also be put to use in support of the woman's suffrage movement.

Reluctant Suffragists?

"The dramatic night scene in the beautiful Court of Abundance at the Panama-Pacific Exposition which closed the Convention of Women Voters spread both symbolically and literally the western women voters' campaign for the voteless women of the east and south. It was witnessed by 10,000 people gathered under the deep blue, be-starred California sky. The throng gave Miss Anglin an ovation when she appeared at 11 o'clock to deliver to Miss France Joliffe and Mrs. Sara Bard Field the resolutions they are to hear in Congress and to the President, and cheered the envoys as they set forth with their burden." The account, published in the American newspaper *The Suffragist* on 2 October 1915, went on to tell readers of the large international chorus of women who were gathered "like a brilliant flower bed [and] filled the terraced stage from end to end." After singing English writer and composer Cecily Hamilton and Ethel Smythe's "The Women's March," the gathering cheered speeches from Joliffe and Field, who spoke of going forth through American

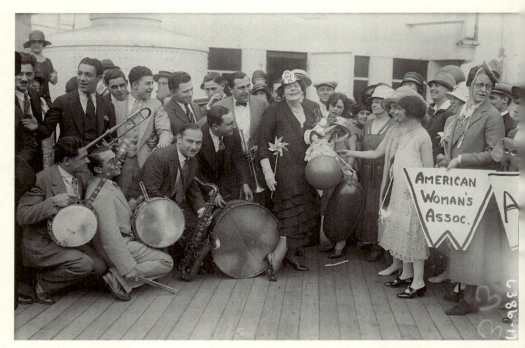

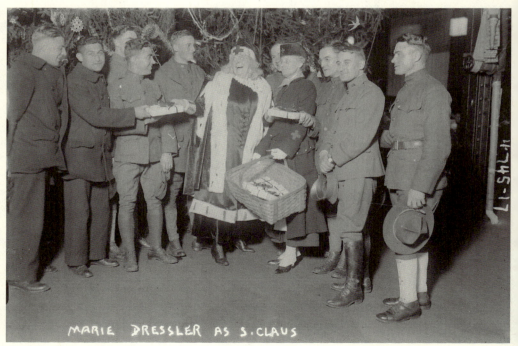

MARIE DRESSLER AS S. CLAUS

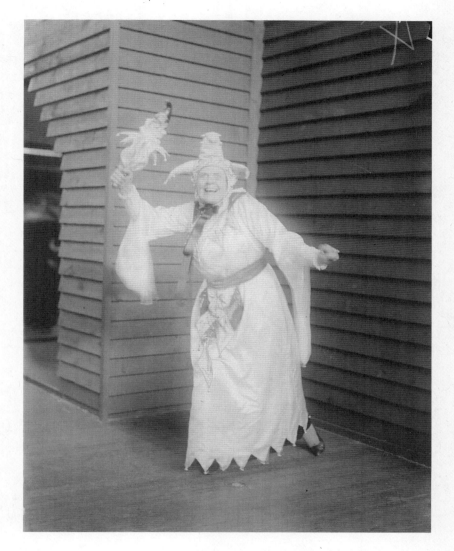

Fig. 5.1 (*opposite top*) Marie Dressler appearing in support of the American Woman's Association, c. 1920s.

Fig. 5.2 (*opposite bottom*) Marie Dressler, dressed as Santa Claus for the Red Cross, c. 1915–1920.

Fig. 5.3 Marie Dressler at the Russian Bazaar fundraiser, 71st Regiment Armory, New York City, 4–6 Dec. 1916. Figs. 5.1–5.3 suggest the playful elements that Marie Dressler brought to her advocacy and charity work, most likely representing an extension of her onstage work in comedy.

states where voteless, voiceless women were "enslaved in the factories and mills." "Then one of the country's greatest actresses, Miss Margaret Anglin, spoke a few fitting words to them in the name of the women of the world." Standing in front of the Fountain of Energy, Anglin told her audience, "'I am not saying words alone ... [as] the hopes and hearts of 1000s of women go with you.'" Her address concluded, the "masses of women" formed a procession to escort the delegates to the Exposition's gates. With orange lanterns swaying in the breeze, purple, white, and gold draperies fluttering, and a band blaring, they were met by the two women who had bought the car that would drive Joliffe and Field across the country. To the crowd's cheers, the gates opened and "the big car swung through, ending the most dramatic and significant suffrage convention that has probably ever been held in the history of the world."[67]

The reporter's hyperbole aside, this account of Anglin's appearance at the Convention both suggested and obscured certain things. For one, it pointed to, in historian Lisa Tickner's words, the "spectacle of suffrage," the movement's self-conscious theatricality in its use of pageantry and parades, highlighted by music, colour, and motion. It also suggests the ways in which actresses were engaged in the movement. Among the diverse groups and individuals in the transnational suffrage movement of the late nineteenth and twentieth centuries, actresses occupied a distinct place in the struggle for the vote. As a highly visible group of women in the paid labour force, they lent their skills in performance and bodily display in suffrage pageantry, speech-making, and plays dedicated to the question of suffrage, most notably British playwright Cecily Hamilton's *How the Vote Was Won*.[68] Motivated by a range of feminist ideologies and personal experiences of discrimination within their profession, these women performed a particularly theatrical type of activism in the suffrage movement.[69]

Along with a number of other prominent actresses who were out of town and could not attend in person, Annie Russell sent her support and best wishes to the National Woman Suffrage Association's Dramatic Tea and Fête, held at the Hotel Biltmore in February 1914 to celebrate the birthdays of Anna Howard Shaw and Susan B. Anthony.[70] This was not, it seems, a perfunctory gesture on Russell's part, since three months later she joined her fellow actresses in a detachment that was part of the large suffrage parade in Washington, DC, and that ended with a presentation

of 581 resolutions to Congress.[71] Russell also, it is worth noting, hired Grace Olmstead Clarke, heralded by The New York Times as the "only woman scene painter in the world," to design and paint her Shakespearean productions; as well admiring Clarke's work, she may have wished to promote other women in the theatre.[72] Along with her extensive charitable work, Summerville walked in New York City's first suffrage parade; she was also interested in old age pensions for performers, mothers' pensions, and labour rights.[73] May Irwin's support for suffrage in the 1910s went even further. Irwin marched in a number of parades, spoke at the 1916 Republican National Convention in favour of woman's suffrage, and, as her biographer notes, used her play *33 Washington Square* to support the cause, featuring pro-suffrage speakers between its acts and donating part of the box office income to the Empire State Campaign Committee.[74]

Like her support for charity, though, Ashwell's commitment to suffrage stood out. Of the actresses who marched as part of the London procession to the Royal Albert Hall in 1910, the press singled out Ashwell, as well as pointing out that the actresses were "the best-dressed section of the pageant." (Ashwell wore a black silk dress and a black picture hat, and carried an armful of pink and white peonies.[75]) In her memoirs Ashwell spoke of suffrage as a cause that encompassed a range of issues. After her very happy marriage to Henry Simson, she became aware of a world in which revolutionary movements were beginning to germinate: "There was much in the world that needed to be put right," Ashwell wrote, including suffrage and women's position more generally. Life in Britain had been an eye-opener for her, accustomed as she had been to the more egalitarian treatment of girls and women in Canada and the United States.[76] In Britain suffragists were deeply scorned and resented, even in the world of theatre. Ashwell recounted a tale of Beerbohm Tree who, on finding her copy of *The Soul of a Suffragette*, responded "with a magnificent gesture of contempt" by hurling the book across the room.[77] As the Actresses' Franchise League representative for theatre managers, Ashwell accompanied the Women's Suffrage Deputation to Downing Street. There "flunkeys" treated the women as though they were strange-smelling animals from the London Zoo and Prime Minister Asquith was uninterested in their arguments, receiving them with a face that made Ashwell think "of that iron curtain which descends in the

theatre" to cut off the stage from the auditorium.[78] Ashwell also visited the Treasury as part of a group to protest the unfair treatment of married women's tax status. She was particularly galled that although she ran her own theatre and her husband had nothing to do with it – indeed, he knew nothing about the stage – nevertheless she could not even file her taxes without Simson's signature.[79] What was more, the gala that celebrated the coronation of George V and Queen Mary did not include actresses on the same terms or in the same number as their male counterparts. Although her colleagues refused to redress this inequality, Ashwell took the initiative and produced (on twenty-four hours' notice, she remarked) a Ben Jonson masque which featured actresses. She was particularly proud of her participation in the 1910 suffrage procession, explaining that she wore a black dress, not the white dress she was supposed to wear, because she had no time to change after work.[80] Moreover, while on tour in the United States Ashwell walked in a Boston suffrage parade. Although the event was much smaller than London's event, the crowd was polite and sympathetic; the parade concluded at the town hall and was received by the city's mayor and corporation.[81] Ashwell concluded her discussion of suffrage with some blunt remarks about the "stupidity" that greeted the movement, which, fortunately for Britain, was overcome. Not only did the fight for suffrage help prepare British women for war work, it also provided a bulwark against the gendered effects of fascism. From Ashwell's vantage point of 1936, if British women had not fought so hard in order to obtain the vote they might have ended up like their German counterparts, banned from universities and other "avenues to freedom." "But then," she commented sardonically, "Hitler is a bachelor as well as a dictator."[82] For Ashwell, then, suffrage was necessary to challenge the gendered inequities of her profession and the world beyond the stage; equally importantly, it was fundamental to questions of national defense and the fight against a fascist government.

But despite the obvious importance of "the cause" to Ashwell (and vice versa), there was no natural or inevitable link between the suffrage movement and female performers.[83] For one, not all actresses openly advocated female suffrage. There is little evidence that Viola Allen, Julia Arthur, May Tully, Clara Morris, or May Waldron Robson publicly supported it,[84] and the Professional Woman's League, for example, did not

endorse suffrage.[85] Many who joined the movement in the United States did so much later in the campaign, when it had gained a degree of public legitimacy and had become far less controversial than in the 1880s or '90s: by the 1910s, supporting suffrage might garner some welcome publicity.[86] In 1913 Marie Dressler was publicly opposed to suffrage but by 1916 she had changed her mind and performed in pro-suffrage plays to raise money for suffrage activists.[87] As Leslie Goddard points out, the reasons for these women being relative latecomers to the cause are multiple and complicated. Being dependent on public opinion (and the opinion of theatre managers) for their livelihood, they were cautious about being associated with a potentially unpopular movement.[88] Despite suffrage becoming less contentious, Ashwell's memoirs, as well as studies of anti-suffrage activism, should caution us against seeing suffrage as a popular or mainstream cause. After being rejected by Asquith, Ashwell writes, "the ugly war went on. And it was a very ugly war."[89]

Notwithstanding her speech to the women delegates, Anglin was quiet on the subject until 1915. This did not mean, though, that she lacked opinions about white, middle-class women's position in North American society. As we have seen, she had plenty to say about the need for actresses to be well-educated. She also believed that women in general benefited from the mental discipline of higher education; cultivating their intellectual capacities prevented them from descending into artificial sentimentality, taught self-control, and would lead to the expression of authentic feeling.[90] Moreover, less than one month before she bade farewell to the suffrage delegation, Anglin, described as a "noted feminist" and "brilliant suffragist," decried the lack of female drama critics. Lauding the impressive work of San Francisco's Josephine Hart Phelps, Anglin contrasted her work with that of male critics who were "totally unable to bring into the theatre a critical vision unspotted of personal flyspecks," a swipe at those who believed women were too partial and lacked objectivity (in many matters, not just drama criticism). While she did not believe that women should "supplant" the men, she wished to see the ranks of the few competent critics "increased by a score of women all over the country, studying the drama, writing of the theatre and bringing to the work all the fine qualities of perception, judgment and feeling – for in no other sphere does the ability to feel and to

gauge the emotions count for as much as in the theatre." Women would bring a "balance and proportion," Anglin believed, "which is implied in the term 'equal rights.'" While she was under no illusions that society would ever be equal, nonetheless women would "enjoy their new opportunities of speaking for themselves."[91]

Equally importantly, women such as Anglin became more closely aligned with suffrage as the movement itself became ideologically tied to notions of gender difference, a stance that, as Goddard points out, suffused the feminism of prominent actress-suffragist Lillian Russell and, in a similar vein, that of May Irwin, whose support emanated from a maternal feminist perspective.[92] It was also grounded in the notion of white women's need for the vote as a "means of preserv[ing] the exclusionary white national identity that had characterized American racial identity since the mid nineteenth-century."[93] As Goddard argues, the questions of "difference" vs. "equality" were extremely complicated ones for actresses. In the eyes of the press and for some of the women themselves, they were women professionals who had achieved equality. Their pay was not kept artificially low because of their sex, they did not suffer sex discrimination because they did not compete with men for work, and they demonstrated a high level of independence and self-sufficiency in their day-to-day affairs, particularly those who ran their own companies. As we have seen, the press lauded actresses for intellectual accomplishments that in other women might have been the source of scorn, condescension, or accusations of being unwomanly. Yet as Goddard also suggests, actresses also were exposed to discriminatory treatment. They might encounter not just casual sexism but also abuse at the hands of directors, managers, and fellow actors (not to mention male stalkers), and they were exposed to sexual dangers when travelling alone from city to city.[94] When the United States suffrage movement began highlighting gender difference as a reason for the vote and granted it a more central place in its conceptions of American society, suffrage, it seems, resonated more clearly with these women.

Whatever they thought of suffrage, though, actresses almost unanimously agreed that the fight against Germany merited their support. Wartime activism drew them in on both sides of the Atlantic and on both sides of the United States–Canada border.

Performing for War, Hoping for Peace

It opened with several trumpet calls, followed by the boom of cannons. Then the curtain rose and the central attraction of the vaudeville production *Liberty Aflame* was revealed: Julia Arthur, dressed as the Statue of Liberty. According to reviewer Alan Dale, "Miss Arthur stood, as all stars love to stand, in the absolute centre of the stage, and on high. Flowing robes encircled her, her brow bore Liberty's crown, and she had a torch in uplifted hand. No other star could have reveled in anything more stellar. The storm raged around her. Glimpses of Manhattan, illuminated, might be seen in the background, but Liberty on her pedestal, a loquacious and very chatty Liberty, confronted the audience."[95] As Arthur spoke, a stereopticon show was displayed on the statue's base. Featuring patriotic actors from American history — the Minute Men, George Washington, and Abraham Lincoln — it then proceeded to show the audience the sinking of the *Lusitania*, described by Arthur as a "needless sacrifice." The next photograph was that of Woodrow Wilson, who explained his aims in taking the United States into World War I and asked for his nation's help, an appeal Arthur underscored with her call for the country's young, strong, and healthy male citizens to represent liberty and win the battle. As she told readers, all of this was met with "great cheering" from the audience. After all, "Julia Arthur's name means much to vaudeville, but her present vehicle means much to the country and its producers are doing a valuable service to Uncle Sam."[96] Throughout the late winter and spring of 1917, *Liberty Aflame* played in vaudeville houses across the United States; judging from the many reviews, it was deemed a great success. While some felt it was unseemly to imitate the voices of the dying *Lusitania* passengers and crew on a vaudeville stage, they also recognized the "majestic dignity," sincerity, and intensity with which Arthur endowed her character.[97]

Liberty Aflame was a particularly spectacular example of actresses' promotion of wartime patriotism. Yet it was by no means an isolated event, as a number of these actresses, along with other members of the profession, showed support for Canada's, Britain's, and the United States' participation in World War I.[98] Furthermore, performances such as Arthur's, which appealed to emotions such as outrage and anger, also must

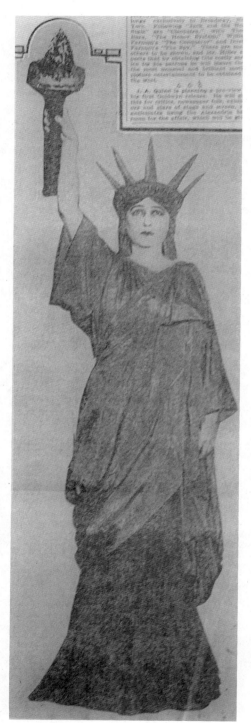

Fig. 5.4 Julia Arthur, *Liberty Aflame*, 1917.

be seen as part of a larger propaganda campaign waged by the American government, one it felt necessary to conduct because of the war's unpopularity and its geographic distance from the United States.[99]

Like charitable fundraising, support for the army and navy was not a new phenomenon for the theatre. While we lack a comprehensive study of the complex relationship between war, the armed services, and theatre over the course of the nineteenth and early twentieth centuries, more specialized studies suggest that it was a reciprocal one. British imperial regiments were often among the first to mount English-language plays, particularly those of Shakespeare, in colonies that ranged from India and New South Wales to the Caribbean and British North America, while during the Napoleonic Wars London's public spaces, including its theatres, were suffused with military performances.[100] Colonial melodramas highlighting feats of military, equestrian, and naval strength were popular in early-nineteenth-century Britain; nautical melodrama both celebrated naval heroics and dealt with pressing questions such as abolition and naval reform.[101] During the Second Anglo-Boer War, London's performers appeared in pro-British plays, ballets, and poetry recitations and held fund-raising events for the troops.[102] In the United States, amateur productions by Civil War veterans (Union and Confederate) proliferated in the decades after the war's end, part of a panoply of commemorative acts that helped both actors and audiences to create, in theatre historian Bethany D. Holmstrom's words, a "whitewashed space of nostalgia innocence" about the Civil War.[103] Similar to British productions celebrating the Anglo-Boer War, late-nineteenth-century American melodrama promoted the need to free Cuba from the evils of Spanish domination and glorified American troops as noble and self-sacrificing, while frontier dramas also celebrated the vanquishing of Native Americans and Mexicans.[104]

Actresses in Britain could demonstrate their patriotic zeal in multiple ways. For one, in urban centres – particularly London – soldiers on leave and civilians who had migrated to cities' wartime industries constituted ever-growing audiences, men and women who were looking for entertainment. They flocked to see revues and pantomimes and also might have been entertained by the sight of Edwardian music-hall performers, such as Vesta Tilley, who dressed as soldiers and sang patriotic songs.[105] Toronto-born Margaret Bannerman (1896–1976), for example, whose

family moved to England just as the war broke out, started her career in London's West End. Young, talented, and very beautiful, Bannerman appeared primarily in revues and comedies and became quite popular with servicemen enjoying a night out in the capital: so much so that her photograph was featured regularly in the pages of the *Canadian Daily Record*, a newspaper distributed to Canadian troops serving overseas.[106] While Bannerman did not leave any personal papers that would shed light on these appearances, it seems reasonable that as a youthful "colonial" performer struggling to carve out a career in the highly competitive world of English theatre she would have welcomed the publicity and exposure that the *Record* gave her.

Yet if the use of Bannerman's girlish glamour to boost morale amongst her countrymen was a matter of serendipity, in other cases it was the result of more organized and thought-out efforts, ones that capitalized on a performer's status, visibility, and commitment to the war. Ashwell, who had been involved in socially engaged theatre and had managed her own theatre, organized singers', musicians', and actors' tours of France very deliberately. Like many of her counterparts in the Actresses' Franchise League and suffrage activists in general, Ashwell put the struggle for the vote aside once war was declared. With fellow actresses Decima and Eva Moore and May Whitty, she established the Women's Emergency Corps. This organization, as Claire Hirschfield points out, grew from a single organization into a "vast network," supplying food, clothing, toys, housing, and hospital transport for the refugees who were entering London in droves.[107] She was not alone: as well as organizing charitable fundraising, prominent individuals – Harry Lauder, George Bernard Shaw, and J.M. Barrie, for example – either appeared in benefits or donated funds to wartime causes.[108] Members of the profession gathered goods, both daily necessities and sheet music and instruments, to be sent to British prisoners of war, and provided hospital entertainment in Britain; by August 1915, artists had raised over £1 million.[109] Moreover, actors enlisted voluntarily. By 1918 the Artists' Rifles had supplied 10,000 officers to the army, eight of whom won the Victoria Cross.[110]

Ashwell wished to go further in her war work, though. She first tried to persuade the government to provide a theatre for every military camp but was not successful. Using her contacts within both the theatrical and musical worlds and those of the military and the Church of England,

Ashwell invited a group of performers, generals, and bishops to call on the War Office to ask the Red Cross to organize troop entertainment. Although their request was rejected and Ashwell "had quite lost hope that the drama and music of the country could be recognised as anything but useless," she then was asked by Lady Rodney, on behalf of Princess Helena Victoria, chairman of the Women's Auxiliary Committee of the Young Men's Christian Association, to organize a concert party to Havre. According to Ashwell, the Princess had been able to negotiate arrangements with the War Office to provide entertainment for men in camp who were resting and preparing to return to the front; Ashwell's responsibilities included selecting the artists and meeting their expenses.[111] Over the course of the war Ashwell helped organize 6,000 concerts in France, Egypt, and Malta, as well as those held in camps in southern England and London hospitals. Her work had employed 400 artists, '"some of whom might have fared ill during the war but for her efforts."' (In fact, with the advent of conscription in 1916 they might have become the troops Ashwell entertained, rather than being the entertainers.[112]) She also made extensive fund-raising tours of England, Scotland, and Wales, raising money and also locating artists for the concert tours and theatrical performances.[113]

Ashwell had various motivations for spearheading these tours. For one, her own deeply held beliefs about the power of art to provide spiritual succour, coupled with her compassion for the soldiers, cannot be discounted. Her account of the tours, *Modern Troubadours*, is filled with anecdotes of the warm welcome her companies received; she also included tales of badly wounded and in some cases dying soldiers whose suffering had been alleviated by listening to music. "On one occasion there was a man in very great pain; his tense face strained and weary; he was waiting for the music to start. When the violinist passed him he said, 'Give us something nippy, Miss.' She went up to the top of the room and played the gayest tune she knew, but when she looked at his face at the end of it, she saw that he had passed on to the Great Unknown while she was playing."[114] Ashwell was sincere in her compassion for these men and eager to help them as best she could. Elsewhere in her account she discusses the terrible effects of gassing, "the sight of scores of men gasping for their very life-breath, some of them blue in the face as in the agonies of drowning," and the "most pathetic sight" of those who had been

Fig. 5.5 Lena Ashwell concert party program.

"severely wounded" by lyddite explosion, their faces and hands swathed in layers of bandages, with only their eyes exposed.[115]

She was not solely inspired by humanitarianism, though. Ashwell also wished to demonstrate the centrality and significance of art in general

and, in particular, the importance of theatre and musical performance to British society. The tours allowed her to defend her profession and prove that it too was necessary to war work. "I had always longed that artists might have their proper recognition as a great arm of National Service," she wrote. "In our professional capacity we might be of as much use and as real a necessity as the Red Cross or St. John's Ambulance, for does not the soul of man need help as much as his body?" She went on to ponder the curious stance of the English public vis-à-vis theatre, their unwarranted suspicions of actors as "wicked creatures." "I used to be glad that my hair was white, and that I have achieved a certain measure of solidity of figure, because when arriving at a Y.M.C.A. meeting, I could feel the sigh of relief and security. Here was no '*Siren come to tempt St. Anthony*,' but a Mrs. Grundy in whom they might perhaps place confidence."[116] This was not a random sentiment, as Ashwell made numerous references to British society's lack of appreciation for artists' work and the perception that actors were of dubious morals. "To them we are a class of terribly wicked people who drink champagne all day long, and lie on sofas, receiving bouquets from rows of admirers who patiently wait in queues to prevent these tokens of rather unsavoury regard. I rather think some expected us to land in France in tights, with peroxided hair, and altogether to be a difficult thing for a religious organization to camouflage."[117] Furthermore, when war broke out, "'two patriotic sections of the nation,'" women and artists, were made to feel irrelevant and useless. "'Women were advised to stay at home and knit ... members of musical and theatrical professions were told they were a peace-time luxury, only useful if famous enough to attract philanthropists and millionaires to charity matinees.'"[118] Given her experiences within both theatre and the suffrage movement, it was no accident that Ashwell provided a particularly gendered analysis of the situation faced by artists and women, one in which the performing arts were seen as decadent, feminized, and potentially leading to promiscuity, and in which women were stigmatized as capable of making only trivial contributions to the national effort. She was optimistic, though, that as a result of their wartime experiences the barriers between performers and the members of the YMCA were breached. Through their exposure to Ashwell and her colleagues, the latter had been persuaded that theatre meant more than dyed hair, loose women, and day-long champagne-quaffing. Instead, they had had a

conversion experience and demanded "some of the most splendid works ... for sound and wholesome recreation for the people."[119]

In 1917 Ashwell, along with eleven other women and the queen, was awarded the newly created Order of the British Empire. Her contributions, along with those of thirty other women, appeared in the book *Women of the War*, which was introduced by former British prime minister Herbert Asquith. In a newspaper interview, Asquith also paid tribute to British women's patriotism and predicted that their wartime achievements would result in both politicians and economists reevaluating women's "power and functions" in the postwar world.[120] If Ashwell grimaced when reading this tribute from the politician who had refused to discuss women's suffrage, her diplomacy prevented her from doing so publicly.

Although the United States did not enter the war until 1917, it too sent companies of performers overseas to boost troop morale.[121] Unlike Ashwell, however, Julia Arthur did not tour France during the war; her appearances in *Liberty Aflame* were targeted at home front support. As well as dressing as the Statue, Arthur posed in military uniform for newspaper articles promoting the pageant and played a Red Cross nurse in J. Hartley Manners's *Out There*, a fundraiser for the Red Cross that also featured prominent stage actors. The production toured cities on the eastern seaboard's circuit — Washington, Baltimore, Manhattan, Brooklyn, and Boston — and the mid-Atlantic and mid-western cities of Buffalo, Cleveland, Cincinnati, Louisville, and St Louis.[122] *Vanity Fair* was pleased to report that for the past twelve months Arthur had devoted her "dramatic activities" almost exclusively "to appearing, and working for, war benefits." Moreover, it was "very like her" to take on a role in which she had only four lines. Unfortunately, though, the stage was about to lose her once again, as "the lure of the moving pictures" was tempting her.[123] One of the moving pictures that would lure Arthur from the stage, albeit only temporarily, was *Edith Cavell or, the Woman the Germans Shot*. As Katie Pickles has argued, the transnational memorialization of the English nurse Cavell, shot in Belgium by German occupying forces in 1915 on charges of spying, included films that featured Cavell's patriotic self-sacrifice in the face of German barbarism.[124] Arthur's depiction of the doomed martyr was very positively received by the press. Well-known movie reporter Louella Parsons, who interviewed Arthur about

Fig. 5.6 Julia Arthur in nurse's costume, *Out There*, Sept. 1918.

the role, declared that Arthur had "won a triumph" as Cavell, while Frank Crane, writing for New York's *Globe and Commercial Advertiser*, thought that whoever had cast Arthur as Cavell "had a sense of the fitness of things" as she was well-suited for the part.[125]

Not only did the film garner Arthur additional publicity in the United States, but she also travelled with it to Canada, where it was shown in Montreal, Toronto, Ottawa, London, and her hometown of Hamilton. Arthur made speeches at the film's screenings, attended receptions in her honour given by the Imperial Order Daughters of the Empire (IODE) and the Women's Canadian Club, and was interviewed by the press. The film thus gave her the opportunity to publicly affirm and reiterate her affection for Canada. At the IODE reception, Arthur, dressed in a gown of "soft, clinging French grey satin, fashioned on long lines, a small black hat covered with cerise roses and touches of blue velvet," spoke of the work that both Canadian and American women had done in support of the war effort, discussed the "noble and martyred" Cavell, and expressed her "heartfelt pleasure" in coming back to Hamilton. Although the United States had been kind to her and she loved Americans, Arthur proclaimed that "'once a Canadian, always a Canadian.'"[126] In another interview Arthur also praised Canadian women for their "splendid work" in support of the war; she believed there were many "fine heroines" among them who were like Jeanne d'Arc. While the whole world had praised the bravery of Canadian men fighting in France and also their "cousins" the Australians, "brave as these men were, they were not a whit braver than their women at home, who had carried on through the long years of their absence." While her husband was an American, "all the years of her home-life" had been spent in United States, and most of her friends were there, "her heart had thrilled" at the prospect of returning to Canada, even for a brief visit.[127] (Arthur had just appeared in Toronto with *The Eternal Magdalene*; during its run she also performed in a benefit for the 170th Battalion.[128]) *Edith Cavell* thus offered Arthur an opportunity to build upon her ties to her birthplace and to do so in gendered ways that, even if subtly, suggested that Cavell's love of country and patriotic spirit were something Arthur shared with her character. In the pages of the Canadian press, Arthur suggested that these were forms of sentiment and belonging that not even a lengthy career and marriage to an American citizen – with the subsequent loss of her own Canadian citizenship – could dislodge.

Performance was one way of demonstrating patriotism but, like their contemporaries in Britain, actresses on the other side of the ocean worked in a variety of ways to support the war. Although May Irwin

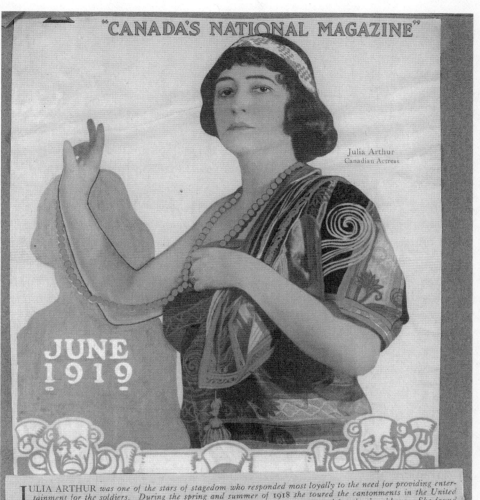

Fig. 5.7 Julia Arthur claimed by Canada, *Maclean's*, June 1919.

maintained her belief in pacifism, as her biographer notes, she worked with the Red Cross after the United States entered the conflict; she also contacted Woodrow Wilson to offer her home to recuperating soldiers.[129] Actresses also united to form the Stage Women's War Relief, a group formed in 1914 to coordinate women's volunteer efforts in the theatre. The Relief gathered hospital supplies and clothing for soldiers, organized Liberty Loan Drives, put on entertainments and stage performances for troops, and in 1918 set up a canteen for soldiers and sailors in New York City.[130] "Here are faces," proclaimed *The Billboard*, "framed in the white cap and apron of the organization, that have looked out from the pages of magazines, names that have been blazoned in electric lights on Broadway. Of these sincere women one of the most constant is Amelia Summerville, The Merry Little Maid, of Adonis fame." Summerville had appeared in the Relief's first program at the Army's Camp Upton on Long Island and had given much of her time to camp entertainment. What was more, she had recently donated ten volumes of *The Masterpieces of English Literature*, which had belonged to her late son, telling the Relief's Service House that her son had loved the books "'and would want me to give them for the use of our soldiers and sailors.'"[131] She was not alone: Anglin had just started a campaign to purchase "Smileage Tickets" for the soldiers in training camps, having bought $100 of the tickets herself.[132] Their work did not end with the war's conclusion. Along with other celebrities, Arthur helped sell victory bonds at an entertainment at New York's Forum that featured "children of the stage," army, navy, and police bands, and the Police Glee Club; the reporter stated that the Relief held the record for selling the bonds.[133]

Like their work in philanthropy and suffrage, then, these actresses' engagement with the war can be juxtaposed with our understanding of other women's support for it; to date, historians have tended to focus on "home-front" voluntary activities, women's work in agricultural production or factory work, and nursing.[134] To be sure, these actresses' wartime work intersects with that of their non-theatrical sisters, as it deployed images of domesticity and femininity that owed not a little to Victorian conceptions of feminine self-sacrifice and built on women's experience in fundraising for philanthropic and charitable organizations. Yet it also was shaped by these women's celebrity status, their geographic and cultural mobility, and, too, the theatre's own history of supporting

Fig. 5.8 Poster for Margaret Anglin in *Billeted*, c. 1918.

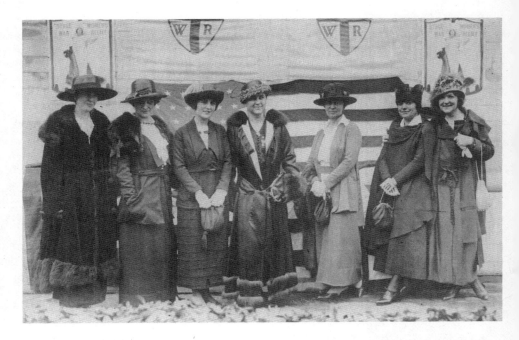

Fig. 5.9 Julia Arthur posing for Stage Women's War Relief photograph, 1919. Arthur is in the centre, wearing a fur-trimmed coat.

philanthropic and charitable enterprises.[135] Moreover, actresses' participation in wartime service drew on a repertoire of images of feminine self-sacrifice that many of them had portrayed onstage but that also co-existed with these women's public visibility, managerial acumen, and deployment of forms of early-twentieth-century technology, not least that of silent film. There are other considerations, too. Ashwell and Arthur claimed that their work for the war effort was aimed, ultimately, at securing peace. A defeat for Germany would represent a triumph for civilization – in their eyes, a civilization defined by its respect for the arts and artists.[136] While arguments that the war was a crusade for civilization were, of course, frequently heard in Britain and North America, Ashwell's and Arthur's wartime service reminds us that conceptions of culture figured in such a discourse. As historians of the commemoration of World War I have pointed out, the war's image was created in a raft of cultural forms – prose, poetry, drama, film, music, sculpture, and paint-

ing — as well as in the language of official commendations and regimental histories.[137] Actresses' wartime work gave them yet another forum in which to claim a citizenship that was not solely politically or nationally grounded but that also had strong ties to Anglo-American culture, ones that might transcend national borders. Moreover, as Pierre-Yves Saunier has pointed out, while war normally is seen as ending exchanges and circulations between nations, that is not always the case: for performers, it might intensify such traffic.[138]

The War's Aftermath

Actresses' participation in charitable causes continued into the interwar decades, and once war with Germany began again, so too did their patriotic work. Some also became involved in the debates over unionization of the profession, struggles that continued into the 1920s, and that saw them taking sides both for and against the formation of Actors' Equity.[139] Amelia Summerville ventured into formal politics. In 1920 she was appointed the chairman of the Stage Women's State Democratic Committee by theatrical and literary agent Elisabeth Marbury, "woman member" of New York's Democratic National Committee.[140] An ardent supporter of Woodrow Wilson because of his commitment to the League of Nations, Summerville spoke publicly in favour of James Cox, governor of Ohio and the Democratic nominee in the 1920 presidential race against Republican candidate Warren G. Harding. She lambasted fellow performer Al Jolson and others who had "'performed on Senator Harding's front porch,'" stating that they did not represent the profession in general, adding, "'I think I can say that the Democratic party can bank on getting the votes of most of them who stay long enough in one place to have votes.'" While generally performers were not politicians, since "'the very qualities of idealism and spirituality that makes us good actors or actresses, would make us poor politicians,'" nevertheless Cox's promise to carry out Wilson's ideals drew Summerville and her like to him. Summerville conceded that there were actors, as in any profession, who were "'materialistic and selfish in their aspirations'" and who would oppose the League; nevertheless, she was sure that such a group was a minority "'among stage people.'"[141]

Summerville would be disappointed by Harding's success in the election. While she lived to see the League of Nations established, it was without America's participation. However, she also witnessed the ongoing careers of her contemporaries, most notably Margaret Anglin and Julia Arthur. Their lives and work in the 1920s and '30s suggest how these women, their careers forged in the late nineteenth and early twentieth centuries, negotiated the challenges and opportunities afforded by both change and continuity in the interwar decades.

CHAPTER SIX

The Interwar Decades: Retaining Old Patterns, Facing New Challenges

Introduction

The interwar years ushered in significant new developments, as a host of technological, cultural, and political changes came to Canada, Britain, and the United States: the advent of radio, the rapid growth of the film industry, new patterns of consumption, shifts in fashion, women's enfranchisement (albeit restricted by race and age), and postwar reconstruction efforts.[1] These actresses' careers provide a lens through which we can see some elements of those changes: the growth of radio, for example, which provided Margaret Anglin with an important new outlet for her work. Moreover, as chapter 7 will explore, popular culture increasingly linked femininity to youth, a phenomenon that produced images of the "Modern Girl" on an international scale but tended to marginalize the women who did not fit within those parameters.[2]

But not all change occurred dramatically. Rising hemlines and shorter hairstyles did not mean that all the patterns of the pre-war years were abandoned. For one, movement both within North America and across the ocean continued to mark an actress's life, as the experiences of Anglin and Arthur, along with their contemporaries Lucille Watson, Catherine Proctor, and Mae Edwards, demonstrate. While touring did not become easier, these women's careers show that, despite popular culture's fascination with youth (particularly youthful women) and the allure of film and radio, live theatre still offered opportunities for women in their forties and fifties. Furthermore, Anglin's personal correspondence suggests that while at times her plays might have struggled at the box office, during the interwar decades she was well-respected by

both individuals and a range of organizations across North America and beyond, including the Roman Catholic Church, an institution with a long history of transnationalism. Although theatre and performance historians treat the decades of 1880–1918 as a discrete and distinct period (as do many other historians), individual lives do not always fit within scholarly frameworks. "Finishing the story" of Arthur's and Anglin's lives within their specific historical contexts necessitates exploring the interwar decades.

Shakespeare and Shaw: Julia Arthur's "Comeback"

"Julia Arthur to Act," read the headline of a short article in *The New York Times*, followed by "Returns to the Stage Following Husband's Loss of Fortune." Benjamin Pierce Cheney had once been one of the wealthiest men in Boston but had suffered "reverses" in business, and thus Arthur was "forced" to take up her profession again. To underscore how dire the Cheneys' finances were, interested buyers were going through the "personal art treasures, furniture and knickknacks which once furnished Miss Arthur's palatial home on Calf Island."[3] New York's *Evening Telegram* ran a photograph of Arthur seated at a small table and signing a document (perhaps relinquishing her property to Cheney's creditors). However, even though "curious persons" were wandering around one of Boston's auction houses pricing her possessions, Arthur did not look particularly poverty-stricken in her large hat that matched her dress, white gloves on her lap, and fur stole.[4] Like other media stories concerning great wealth and its disappearance, this tale of the couple's financial ruin did not capture the entire story. Arthur and Cheney, it is true, lost much of their fortune; one wonders what Arthur, who supposedly had given up acting to make Cheney happy, said to her husband in private about his financial situation. Her income appears to have been their main support in the 1920s. But as we have seen, Arthur had already "returned" to the stage in 1916 with *The Eternal Magdalene*, *Seremonda*, and her work in vaudeville and film for the war. Moreover, according to a 1917 newspaper report, Arthur's Calf Island property had already been requisitioned by the federal government to improve defence in Boston Harbour and torn down, a destruction that Arthur was said to have borne bravely as a necessary sacrifice.[5]

Fig 6.1 Julia Arthur at home, c. 1920s. Despite her financial troubles, this photo depicts Arthur in middle-class comfort.

Arthur's next major appearance was as Lady Macbeth at New York's Apollo Theatre in 1921. Co-starring Lionel Barrymore, the production was described by critics as "handsome" yet also "queer and bizarre," "strange and striking."[6] Critic Heywood Brown was not impressed with Arthur, feeling that in only one scene "did any tongue of fire dance around her shoulders." While legend had it that when Charlotte Cushman asked for the daggers women would faint, here the effect was that of a "determined and tidy woman" who wished to set a "guest room to order."[7] He seems to have been in a minority, though. Alan Dale wrote that Arthur was "memorable" and that others' (from Mrs Siddons's to Viola Allen's) interpretations paled before hers. Arthur was not a monster, dangerous, or evil, Dale insisted, but rather a woman who needs to get her own way by using her femininity and who thus is captivating, fascinating, and dangerous.[8] Arthur appears to have had her own doubts about the production. Producer Daniel Frohman wrote to Arthur one month after it opened to tell her that even though he knew she was upset about it, the fault was not hers but rather that of the "grotesque scenery which produced the wrong effect in the imagination of the audience and the restrained and somewhat diminutive methods of your associates." "Nobody," Frohman hastened to reassure her, questioned her abilities, her eloquent expressions, or "the big force" she showed in her work.[9]

Her next foray into Shakespeare was as Hamlet in vaudeville, a choice that M. Alison Kibler interprets as made strictly out of financial necessity.[10] Restoring her family's finances to a level close to what she and Cheney had enjoyed may well have been an important motivation for choosing vaudeville in 1923, with its higher salaries, well-defined and regulated circuits, and (almost) guaranteed audiences – not to mention that vaudeville producers wished to appeal to middle- and upper-middle-class patrons, precisely the kinds of audiences for Arthur's previous work.[11] Furthermore, through her appearances in *Liberty Aflame* Arthur would have been familiar with the structure and circuits of vaudeville; as well, choosing to perform a fifteen-minute scene was safer than risking the cost of mounting a full production of the play. But Arthur's own creative desires might well have been at work, too. In 1900 she had told the press she wished to play Hamlet, albeit on the legitimate (not vaudeville) stage; moreover, by 1923 female Hamlets were – if still somewhat of a novelty – certainly not unknown to critics and audiences.[12] *The*

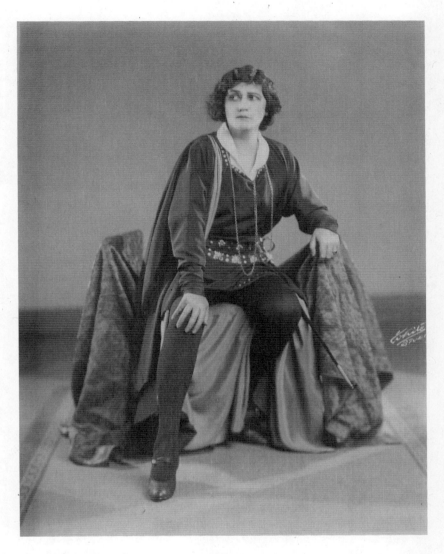

Fig. 6.2 Julia Arthur as Hamlet, c. 1923.

Pittsburgh Press reminded its readers that "Women Have Scored in the Role of Hamlet," going back to Sarah Siddons in 1785 Edinburgh, continuing with Charlotte Cushman, and extending to a number of "lesser-known" female Hamlets in New York and London theatres from the 1820s to the 1870s, a roll call that included Canada's Julia Tremayne in

an 1870s production in Southampton.[13] Hamlet, the paper proclaimed, was a role that "foremost actresses" had taken on in "every generation, every nation" with "varying degrees of success." While Bernhardt's performance had inspired a new generation of actresses on both sides of the Atlantic; none had brought Arthur's "equipment" to the role. The latter included her knowledge of both Shakespeare and the literature of the English-speaking stage, as well as her "physical endowments, the temperament, imagination, and poise, [and] the high ideals of the great actress."[14]

Overall, many agreed with the Pittsburgh reporter. Writing for *The Cleveland News*, Archie Bell thought she was keeping the legitimate theatre's "dramatic flame alight," since in that city it had either closed its doors or given its stages over to musical comedy. "Thus vaudeville steps in and accomplishes something quite unexpected." Bell went on to argue that the role is so "tremendous and all-embracing that the matter of the sex of the impersonator does not matter. What counts is the acting – and the audience." And in this case Miss Arthur "performs splendidly ... [and] makes H a manly chap – much more so than some of the actors." Like other reviewers, Bell pointed to Arthur's "excellent" reading of lines, her "intelligent conception" of them, and her "Diction. Ah, here we have another actress of the older school, who learned to act when thespians were not permitted to mouth their words and be so 'natural' that they were not acting at all."[15] A number of writers agreed with Bell. One such reviewer believed that Arthur had created a fifteen-minute Hamlet for her audience that would "stay in memory longer than some three-hour Hamlets. For readers having only book acquaintance with Shakespeare it is well worth meeting such acting as Julia Arthur's that makes every line pulse with the anguished soul of Hamlet ... [this] artist of impassioned experience" made the text vital with great feeling. Famous for her Portia and Rosalind, Arthur "justifies her brief entry into the masculine field."[16]

While not doubting Arthur's talent, others were more critical. One claimed that it was a "daring adventure for the woman who has been called 'America's charming romantic heroine'" since the atmosphere in vaudeville conflicted with "dignified artistic effort." Perhaps that was why Arthur began on "too high and vehement a pitch," although she redeemed herself later in the scene with "genuine emotion."[17] Yet others were snide: Burns Mantle stated that Hamlet would help "a lot of worthy

folk. First, it will help Miss Arthur to a profitable salary, plus a pleasant adventure, for several weeks. Second, it will help Mr. Albee, who loves to point with pride to what has been done for vaudeville and through vaudeville, for the people who support what Mr. Kingsley quaintly calls the two-a-day. Third, it will remind vaudeville folk that there is a Shakespearean stir in the theatre and that 'Hamlet' is a play they might have enjoyed if John Barrymore had not tired of playing it so soon, or if the prices had not held so high. But it will not do much for Shakespeare, nor for 'Hamlet,' nor for those potential students of the drama who take their entertainment in tabloid form." For one, there was "too little of it ... and because a female 'Hamlet' is still a female and capable of convincing her audience of nothing more than that she is in earnest and that she has a pleasant voice." Quoting Samuel Johnson, Mantle felt the wonder was not that she did it well but that she did it at all, and concluded his review with the patronizing comment: "Miss Arthur, admirable lady, worthy custodian of an honourable stage past, reads Hamlet's portion of the so-called closet scene in a pleasant, even voice, with intelligent emphasis and careful diction."[18]

In Baltimore, matters became heated when the city's papers published cutting reviews of Arthur's performance. Julia Arthur, wrote Robert Garland, "came back to town as Hamlet. Supported, as it were, by Trixie Friganza and a trained seal, the more or less celebrated actress projected the more or less celebrated 'closet scene' while a croupy and slightly bewildered audience looked on. Clad in pants and poniard, Miss A was not so good — as the fellow says. Had Miss Friganza been the Dane's mother and horse-voiced seal the ghost of H's father, we would have been happier by far." Garland continued with "We have heard H spoken of as a grouch, a nut, and an unmitigated bore, but we have never heard him spoken of as a perfect lady ... Considering her sex and everything, Miss A's performance was interesting. But unsuccessful ... We'd love to say nice things about Julia Arthur's venture into vaudeville, but it can't be done. Although it happened before our day and generation, Miss Arthur's career on the legitimate stage was doubtless a long and honourable one. Our mother has pleasant recollections of her charm as the heroine of *A Lady of Quality*. But nonetheless and notwithstanding, Frances Hodgson Burnett's heroine and Shakespeare's Hamlet are miles and miles apart, as yesterday's performance went far to prove." Garland was

not convinced that the historical precedents for female Hamlets cited in Arthur's program had any merit, and Julia Arthur's "rendition is more a recital than anything, a noisy recitation." After it was over, the melancholy Dane seemed to have cast a spell over every bill, since everybody but the Clown Seal was depressed.[19] Although his review was less snarky, Norman Clark called her Hamlet "not something over which to enthuse. She seemed merely to be shouting the lines of the Bard. Her voice was harsh and colorless. This perhaps was due to her desire to give her tones a masculine quality" (Clark felt that Arthur's voice in her curtain speech was excellent and that she should use it instead). What was more, it had "never been recorded whether Hamlet's father's ghost made a baby cry but we record it here and now," since a baby began wailing during the scene. Although the audience seemed interested, they clapped harder for the trained seal.[20]

Arthur was, to say the least, unimpressed. Not only were the Baltimore critics the rudest that she had encountered, one critic "'violates every canon of an honest dramatic critic. He is positively insulting. He attempts to display his facetiousness by mingling the comments on my Hamlet with his opinion of one trained seal on the Maryland program. I understand, however, that he is but a child, almost.'" In contrast, Baltimore's audiences had been "'courteous and appreciative.'" While some "'slight tittering'" happened once, Arthur claimed it came from the upper gallery (which housed cheaper seats and a more working-class audience). If Baltimore's critics treated their profession seriously she would not object, "'but to have a piece, such as Hamlet, a character of serious appeal, treated in such light manner by all the critics here is inexcusable.'"[21] In general, though, Arthur (at least publicly) seems to have been pleased with her reception, praising her audiences for receiving Hamlet "'with the most respectful ... attention ... [they] have given us splendid encouragement ... thus doing much to dispose of the snobbish notion that vaudeville audiences are different from others. They have a full understanding of diversified entertainment and a fine appreciation of the best in the theatre.'"[22]

Despite historical precedent and the merits of Arthur's work, these reviews, whether positive or negative, shared the assumption that at its heart Hamlet was a male role. As Shaw's *Saint Joan*, though, there could be no doubt that Arthur was playing a woman, no matter how often she

appeared onstage in soldier's clothing. Arthur, said the *Boston Evening Transcript*, portrayed Joan of Arc as a "full-bodied, full-blooded, full-voiced, upstanding woman of the people, mature, believably enough, beyond her years. No sooner had the actress entered upon the scene than the audience felt the directness, the honesty, the homeliness of The Maid – her 'common sense' as Mr. Shaw likes to repeat – while underneath beat the faith and the fervors." Arthur continued to impress, demonstrating "eagerness, faith, devotion, [and] honest humility," and matched Shaw in the third act "with crescendos of bewilderment, endurance, and her cry in trial 'How shall I be judged except by my own judgment?' flamed across the theater."[23] When Arthur took *Saint Joan* to Canada, she was warmly received as a daughter returning home. "Emerging from a retirement of nearly twenty years," *The Montreal Gazette* declared, "Miss Julia Arthur in the role of Joan proves anew the right to stand with Miss Margaret Anglin as Canada's two chief contributions to the ranks of the serious drama." Arthur's "splendid voice, the music of her diction, her illuminative ratings of lines, and the naturalness and mingled dignity and fire of her acting, combine to make her Joan a memorable creation." What's more, this was a "truly wonderful performance" for a fifty-five-year-old woman, "to convey so truthful and convincing a picture of innocent girlhood and heaven-inspired heroism."[24] Writing in *The Montreal Daily Star*, S. Morgan-Powell thought that Arthur "visualizes the very spirit of France." Despite her long retirement and her age, she never lost the illusion of youth, "physical, facial, and vocal ... Her Joan is one of the outstanding triumphs of modern stage portraiture, and it will go down in the annals of our drama as one of the most beautiful and inspiring achievements of any actress of our time." While admitting this was "high praise," Morgan-Powell had a rich body of experience to draw upon, having seen the work of North America's principal actresses for over twenty-five years, adding, "here is the art of histrionism carried to a point at which it is sustained by genius and the incommunicable fire of the inspirational moment."[25] Toronto's *Mail and Empire* also noted Arthur's "fine contralto voice" that contained the "dramatic fire" the role needed, resulting in an "eloquent and moving" performance."[26]

Her hometown of Hamilton was even more effusive in its praise for Arthur. Such a "gala occasion" had not been seen in the city for many years, the local press noted, with the theatre beautifully decorated by the

city's chapters of the Imperial Order Daughters of the Empire, which also sent Arthur a basket of lovely flowers at the end of the performance. Her art was "never more poignant, more finished, more flawless ... one that defies criticism and leaves one amazed ... she was Joan and on the wings of her own creative genius she carried her people with her." Not just a "gifted actress," Arthur was also a gracious woman in her curtain speech, one "characteristic of the warm womanliness" that marked her creative work. The reviewer also saw in Shaw's play a plea for tolerance, something desperately needed in a time when churches were being torn apart by the question of union, society was riven by struggles between workers and those with money, and creeds such as Bolshevism and anarchy, racial prejudice, religious bigotry, and orthodoxy threatened Canadian society.[27] As Craig Hamilton has argued, *Saint Joan* "quickly became a play without a passport," its appeal both transcending national borders and simultaneously resonating with those struggling over nationalism in the aftermath of the War.[28] Moreover, while no doubt local boosterism in Hamilton accounts for Arthur's warm welcome in that city, she may also have benefited from the surge of English-Canadian nationalism in the early 1920s.[29]

Although all these topics may have been relevant to audiences, they were not at the forefront of reporter Jennie Wren's interview with Arthur in Hamilton. While lively and in the midst of selecting new dresses and hats from Toronto (she was particularly fond of plaids for her frocks), Arthur admitted to being worn out by the demands of the role, telling Wren, "'If I could play the part like some do, by walking through it and not caring particularly about it, why, it wouldn't take so much out of myself; but I can't do that. I've got to give it my best, and the consequent strain is terrible.'" Their conversation turned to matters psychic and spiritual. While Arthur had no "'use for fads and fancies along forbidden lines,'" she did believe that some people had highly developed psychic abilities, Joan among them. A "'crude peasant girl'" she might have been, but Arthur also thought she was "'frank, loyal and utterly sincere,'" unable to understand the deceitfulness and evil of the powerful. Arthur also had been deeply touched by the appreciation of the previous night's audience and spoke of Hamilton's "'loyalty, their friendship and their love.'" Many years had elapsed since she had appeared in *A Lady of Quality* in the city, playing a "'selfish hoyden who romped in boy's clothes. Now I come back

... playing the role of a girl, also clad in boys' clothes, who is entirely selfless, and the two roles are poles apart. Joan is a terror to play, but I love her.'" Continuing with the theme of selflessness, Arthur only wished that her mother could have lived to see her play Joan. Wren thought that such a sentiment was "typical of the woman who, like Bernard Shaw himself, has realized that from loneliness and isolation is born strength, the strength that carries on and wins to its ultimate end."[30]

Producing and Performing: Margaret Anglin in the Interwar Decades

Like Julia Arthur – and maybe Joan of Arc – Margaret Anglin knew about the need to carry on through a number of changes in the 1920s and '30s. It was not that Anglin was isolated or lonely, though: her personal and professional correspondence attests to a constant round of work, planning, and keeping abreast of developments in a changing theatrical landscape. Her archival record also testifies to the status that Anglin had achieved by the early 1920s, noted both by her peers and by organizations outside of theatre. Her career, then, was marked as much by continuity as by rupture.

While Arthur's post–World War I work was seen as a "comeback" by both her and the press, Anglin continued to work steadily throughout the 1910s in a range of productions: the 1916 St Louis Shakespeare pageant, for example, her starring role in the wartime comedy *Billeted*, and her ongoing productions of Greek plays at Berkeley and in New York. In 1919 Anglin appeared in Paul Kester's *The Woman of Bronze*, the tale of Vivian Hunt whose sculptor husband Leonard betrays her with a younger friend. While the play's themes – love, marriage, and deception – were ones familiar to pre-war audiences, Kester also brought the play into the postwar period by having Hunt participate in an international competition for a World War I memorial to American soldiers. His model for this sculpture is Vivian, "a woman of bronze, whose face is to express victory, a victory that is the realization of a great end, gained through just so great a sorrow" (the play also opened with the rehearsal of a musical for a babies' milk fund). His affair with young violinist Sylvia Morton having come to light, Hunt ends up destroying his creation and runs away with Sylvia; he then, though, realizes his error and returns to Vivian, begging her forgiveness and working to make things up to her by returning to

his sculpture.[31] The play toured across the United States and opened in New York's Frazee Theatre in 1920 to a mixture of reviews. One Los Angeles critic thought it was not a great play or high art, not least because it had been crafted around one star (as were so many American plays, they admitted): in this case, Anglin. While she certainly achieved great heights and deserved much praise for doing so, "Miss Anglin, after all these years, should go before the American public in plays worthy of her interpretation and with faultless support" (the critic found the majority of her cast weak).[32] Others, though, were more impressed and were pleased that Anglin had returned to such an "emotional" role after her work in light comedy. "What she gave Albany was ART," enthused one review, while in Seattle *The Woman of Bronze* was "a play of intense emotional power, beautifully staged and capably acted," not least by Anglin, who was given "an opportunity for sheer emotional acting that is most gratifying to the theatre-goer, tired of the weak and inane dramas in which many capable actresses appear."[33] Whatever the critics made of *The Woman of Bronze*, though, audience members were touched by its themes and by Anglin's work. According to one writer, the women who came to see it in New York gathered in the lobby afterwards, debating the realism of Vivian Hunt's attempts to keep her husband. Some felt it was out of step with modern mores, declaring that women were "'no longer parasitic creatures'" and any wife would tell Hunt to "'follow the path he had selected.'" Others, though, declared that her great love for him made her decision to try and get him back completely understandable. According to Anglin, Hunt's "'domestic tragedy'" was one with which many women empathized: more women had written to her about their experiences of a husband's infidelity than about any other play she had performed.[34]

It is difficult to verify her claim since most of Anglin's surviving correspondence dates from 1911. The letters she received about *The Woman of Bronze*, though, are heartfelt in their appreciation for it and her portrayal of Vivian Hunt. Writing to Anglin from Forest Park, Illinois, Edith Heileman had interviewed Anglin at the dedication ceremonies of the Edward Hines Memorial Hospital and had just seen her in *The Woman of Bronze*. "What a Crusader you are," thought Heileman, as Anglin's cry in the play "'We can't hold your heart with our naked hands'" was also echoed in many women's hearts, not just in those of their lovers, husbands, or children. "To me you stand out as the most wonderful women [sic] artist

Fig. 6.3 Margaret Anglin in *The Woman of Bronze*, c. 1920.

of the day," Heileman said, adding that she had pasted "school girl fashion" a photograph of Anglin from the *Chicago Tribune* onto a cardboard mount and hung it above her desk, but, alas, someone had stolen it.[35] Corinne Heaser told Anglin that her performances in a number of plays,

including *The Woman of Bronze*, had given her "a richer desire to live and love better and more universally – with a great sense of the shallowness of most mortal existence but with a great appreciation of the beauteous influence of a life consecrated to one's highest ideas of good. This seems so much more worthwhile than merely to have afforded an afternoon or evening of amusement!" Anglin, Heaser told her, was "surely helping to prove the theatre rightly a powerful influence in uplifting and purifying the affections and aims of mankind."[36] It was not just women, though, who wrote to Anglin about the play. Writing on behalf of the 47 Workshop and Harvard Dramatic Club, George Baker asked her to give his group an informal talk about success achieved through hard work; he had seen her in *The Woman of Bronze* and would like to see it again.[37] On an even more enthusiastic note, George Bishop wanted to let Anglin know that he had seen her *The Woman of Bronze* in Ann Arbor and had "lived that night again and again! It is one of the most memorable events of my life." He hoped Anglin would not think him "bold" but needed to tell her how "wonderful I think you are." "Living in a small town as I do [Poland, Ohio], you cannot imagine what a thing like that means to me, it is the breath of my life."[38]

Anglin's next major theatrical venture was in Emile Moreau's *The Trial of Joan of Arc*, which opened at New York's Shubert Theatre in 1921. Like *The Woman of Bronze*, *The Trial* allowed Anglin the opportunity to play a part that called for dramatic intensity and passion. Those who might have visualized Joan as the "trim and boyish" figure preferred by sculptors and artists would be disappointed, stated one reviewer, since Anglin played her as a "typical peasant woman of France with all the finesse of character and spirit in that race." They would not, though, have been let down by Anglin's "dramatic outbursts ... her acting is not only thrilling but possesses also a beauty that cannot be dimmed." What was more, the play had both "beauty and pageantry" but also moments of "horror," particularly in the last act when those watching Joan at the stake were forced by the smoke and their own remorse to move away from the window.[39] Another reviewer was relieved to see that Anglin had abandoned her "sleazy play" (*The Woman of Bronze*) in favour of *The Trial*: while the translation was awkward, nevertheless the play captured the excitement of Joan's story and Anglin played her part "with an eloquence and force she has never surpassed." This reviewer also was struck by Joan not being a

"slim, frail, dauntless girl," an image promoted so successfully by Geraldine Farrar in her film role as Joan and by the "emaciated Joan" of Boutet de Monvel's art that society had forgotten that "really the Maid was just such a broad-shouldered, husky peasant girl" of a type found still today on the roads around Domremy. "Which is worth mentioning because, ten minutes after Miss Anglin has walked, chain-laden and head high, into the hostile court at Rouen, you surrender and accept her as Joan. And this is not because of your docile acquiescence in any make-believe, but because, by some inner power she possesses, an actual transformation takes place. She changes in appearance before your very eyes. She becomes the wide-eyed, mystical girl of the plays. There is magic in it."[40]

Like her work in *The Woman of Bronze*, members of Anglin's audiences for *The Trial* agreed that her portrayal of Joan helped them transcend their daily lives. Mary McCall wrote to thank Anglin for such a "very wonderful afternoon." "Should I live to be as old as Methuselah, I shall never forget the pleasure of seeing you act before," McCall raved. "Being a 'tired business girl,'" she admitted that her taste ran to musicals and comedies, but she found Anglin "marvelous. You made my beloved little Joan exactly as I would wish her to be." She asked Anglin to "please pardon her boldness" as she had not written to someone she did not know before, confiding in her that "though I have many favourites among the people of the stage, in common with most girls, I have never before been even tempted to send a word of thanks or appreciation to one of them but I was so carried away with 'Joan' I feel I had to write that."[41] Even the prominent theatrical and literary agent Elisabeth Marbury sent Anglin words of praise: "as I told Maud Adams yesterday – to see your Joan reduces the same effect on my soul as do the glorious stained glass windows in Chartres Cathedral."[42] Virginia Madigan wished Anglin great success "in a rôle that I, too, have had the honour of essaying" (Madigan had portrayed Joan of Arc in a large pageant held at Fordham University to commemorate her canonization).[43] And, on behalf of the International Federation of Catholic Alumnae, Mrs Thomas McGoldrich congratulated Anglin, both for her "artistic triumph" as Clytemnestra in *Iphigenia* and for the joy she had given the group's members as Joan of Arc. Its Literary Department has been watching her "constructive and splendid work in the drama, with keen interest" and would like to interview her for their *Quarterly Bulletin*'s June issue. It would reach a large audience, she reassured Anglin,

since the federation had 55,000 active members and their publication went to every Catholic college, academy, and seminary in the United States, as well as Catholic educational institutions in Belgium, England, Ireland, and Canada. If an interview was out of the question, "do you think in the busy whirl of your days you could find the time to send a message on your Joan of Arc to these Catholic women, who are looking up to you with love and gratitude for your efforts which are bearing such wonderful fruit?" They were eager, she reassured Anglin, to hear from her directly "some of the dreams, the thoughts, the hopes, that you wove into that *Joan of Arc*."[44]

McGoldrich's request was not an unusual one. Throughout the 1920s and '30s Anglin received many similar appeals from fellow Catholics to support the church's educational and social work, both within the United States and beyond. Catholic societies, educational institutions, and publications asked her to speak, lend her name to their causes, be interviewed, and write articles. Corinne Roche wrote on behalf of the New York Circle of the International Federation of Catholic Alumnae to invite Anglin to their November breakfast, held at the Hotel Plaza after mass at St Patrick's Cathedral. The breakfast would feature Catholic women who had received honorary degrees from Catholic colleges in past year, and Anglin was "preeminent in this group."[45] Sadie Wing, the corresponding secretary of the Catholic Study Club of Detroit, told Anglin how thrilled that group had been to be her guests at the recent performance of *The Woman from the Sea* (most likely *The Sea Woman*).[46] In a few cases, connections with Catholicism overlapped directly with Anglin's professional life. Charles Phillips, the author of *The Divine Friend*, a 1915 play about Mary Magdalene that starred Anglin, passed on inquiries from Catholic organizations interested in interviewing her, relayed enthusiastic feedback from his colleagues about her work (Phillips was based at the University of Notre Dame), and acted as an informal agent, contacting groups that he thought should publicize "the great Catholic actress."[47]

It was not only members of the laity, though, who felt a connection to Anglin. In 1921 Reverend Joseph P. Herbert, the curate of St Patrick's Church in Brooklyn, introduced himself to Anglin. Being very interested in literature and drama and the author of nine plays (all produced "under Church auspices," he hastened to assure her), for two years Herbert had

been working on a play called *The Two Marys*, about the Blessed Virgin and Mary Magdalene. Having completed it just before Lent, he would like to see it produced and wondered if Anglin would read it. "I am writing to you, first of all, because I look upon you as a true type of what a Catholic actress should be – a shining example of what is noblest and purest in dramatic art and a devout and loyal adherent of religion." Herbert was aware he might be overstepping the "bounds of propriety" but he took courage in the fact that Anglin was known "as a patroness of all those who strive to 'uplift' by means of the drama." A longstanding fan of Anglin's work, he wished her continued success, telling her he had been following her career since *Zira* and had seen everything she had done in New York, except for *The Woman of Bronze* (which he planned to see soon).[48] Anglin was also contacted by Sister M. Dominic at San Rafael's Dominican College, who sent her the program of her students' adaptation of the *Dream of Gerontius*. Having heard from one of the cathedral fathers that Anglin was interested in school plays, she invited her for a visit to discuss with her students "the importance of dramatic work in the development of the young woman's life." As an additional enticement, Anglin would enjoy the convent's beautiful setting and would be given a very "cordial and sincere" California welcome "from your Dominican friends who have long admired your splendid work." Could Sister Dominic telephone her after Holy Week?[49] Other Catholic individuals, clergy or lay, asked her to advise young women about an acting career or read scripts.[50]

In 1927 Anglin was awarded the Laetare Medal, an honour given by the University of Notre Dame to an American Catholic who had provided outstanding service to the Catholic Church and society and "whose genius has ennobled the arts and sciences, illustrated the ideals of the church and enriched the heritage of humanity." Anglin was not the first member of the theatrical profession to receive the Laetare; it had been awarded to Augustin Daly in 1894. Nor was she the first woman, since in 1885 it was given to art critic Eliza Allen Starr. She was, though, the first actress to receive it; the next was Irene Dunne Griffin in 1949.[51] As Anglin herself acknowledged, her audience members – at least in certain cities – were Catholics, their attendance sufficiently important to her box office success that there was little point performing after Ash Wednesday (and certainly not during Holy Week).[52]

To be sure, it was not just the Catholic Church that acknowledged Anglin's work or asked for her help. In 1927 Mrs Beatrice S. Spitzer of the National Council of Jewish Women, Brooklyn Section, asked Anglin if she would be the "artist of the afternoon" and perform a reading for their February program. The council wished to provide Brooklyn women "an afternoon of artistic merit" and also fundraise for their group for Immigrant Aid and Education, and Personal Service to the handicapped (whom Spitzer defined as the "blind, the crippled, and the mental defective"). She asked Anglin to please bear their charitable purposes in mind in coming up with a fee, "for we want you with us so much, but cannot afford the prohibition." Although Anglin could not predict where she might be in February, she reassured the Council that she would do her best to assist, since "[i]t is a well-known fact that at no time has Miss Anglin failed to lend whatever her gifts or talents may be, to Jewish causes." If she was in New York she would make "every effort ... to do everything that she reasonably can."[53] Anglin was also asked to lend her name and time to a number of secular organizations and philanthropic causes. In 1931 she gave a speech on behalf of the Women's Division of the Emergency Unemployment Relief Committee. Broadcast on New York's WOR radio station, Anglin's talk described the important work of the Committee in putting money into the pockets of the city's destitute, related a touching anecdote of the generosity of a young girl and a policeman on the Lower East Side, and urged New Yorkers to donate.[54]

Secular schools, universities, and groups affiliated with them also wrote to her with various requests, often meant to celebrate her and her work. In 1923 Anglin was invited to attend an event held in her honour at the University of Southern California's College of Liberal Arts, where she would be presented to the faculty and to members of the Drama League.[55] Ten years later the Heads of Department Association in Brooklyn hoped that she might speak at their lunch. The group, composed of three hundred assistant principals in New York's elementary schools, had a history of inviting women "outstanding" in their professional life and ideals who had inspired the group's members, who between them supervised thousands of children.[56] Such requests became almost routine, while others were a little more unusual. In March of 1923 Tufts College student Ruth Earle sought Anglin's expertise on the subject of "ethics in acting,"

a topic she had chosen for her ethics thesis. What, she asked Anglin, was an actor's duty towards the audience, towards his fellow actors, and towards his manager, producer, and author? And if the actor is a star does her/his opinion carry more weight than that of a director? If Anglin could not answer all Earle's questions, she would "consider it a great favour" if she replied to even one of them. Anglin was baffled by Earle's request, pencilling "What do you know about this???" at the bottom of Earle's letter and asking her secretary to reply to Earle that she was taken up all day and night with a new play so, much to her regret, she did not have time to answer these queries.[57]

She also received numerous letters in the 1920s from Catholic and Protestant admirers who wrote to tell her how much they deplored the increasingly popular plays that dealt with crime and sexuality and valued her work for its moral seriousness. Carlton Dinsmoor asked her "for an autographed portrait" on behalf of Indiana's Culver Military Academy Dramatic Club (set up to "stimulate" the cadets' desire "for the highest type of drama") as the Club wished to have their own room decorated with photographs "of the truly *artistic* and *good* actors and actresses of the legitimate stage."[58] Fellow actress Margaret Leigh had seen Anglin in *A Woman of No Importance* and felt compelled to tell her how much she admired her: "YOU are doing the *big thing* in the theatre, it seems to me, upholding the bigger, finer things in the play. And that is the thing we most need – we who live in the audience and we who live on the stage."[59] What was more, playwrights, both established and aspiring, flooded Anglin's mailbox with requests that she consider the scripts they sent her. Some dealt with serious topics: Arthur Cleveland wanted Anglin to appear in his play that dealt with the subject of women's emancipation. Fifty years ago, he informed her, women were men's chattels yet despite the great changes that had occurred, "*women today are still nothing more than CHATTELS OF MEN*," and his play would "stir the world of women from one end of the country to the other as they've never been stirred before."[60] K.W. Das Gupta, who thought Anglin's acting was a "feast," sent her his play and also asked her to perform a short play by Rabindranath Tagore at his Society's next meeting.[61] An unnamed correspondent told her about his play, a comedy that nevertheless dealt with the "serious subject" of youth's attitudes toward parents: "I have long felt that there is

a silent wave of revolt against the follies of the 'flappers' and 'rounders' who seem to hold the limelight at present. I have felt that a play showing them up in their true colours would meet with a hearty response."[62]

Other scenarios were more lighthearted. John M. French, who worked for *The Journal of Commerce and Commercial Bulletin* and who had met her some years ago, informed Anglin that he had written a Canadian play set in Moose Factory, Ottawa, and Gatineau. The story was of a voyageur who "by jugglery of fortune" becomes an English peer and, in love with the factor's daughter, leaves the bush for Ottawa and elite society. However, "higher civilization is not to his liking and, after winning the girl, without disclosing his identity, he returns with her to the wilderness." French thought the plot was "unique" and that he had a strong play, "teeming with human interest and dramatic situations, with plenty of light and shadow." Equally important, "quaint Canadian folks songs" were interwoven throughout the script.[63] Hearing that Anglin was considering working in vaudeville, Jerry Cargill (who also wanted to be her booker) wondered if his sketch about an Englishman who has returned home from twenty years in India, proposes to a woman who had rejected him before he initially left England, and then panics when she accepts his proposal "out of sheer deviltry" since she is married, would interest Anglin.[64] No doubt the steady stream of requests that spoke to her stature as an actress and her reputation for integrity were flattering to Anglin, not least because they suggested that, despite a culture increasingly oriented to youth and (in the minds of some) frivolity that often celebrated moral and social transgressions, a more mature, serious, and principled performer could still have considerable public sway.

They also, though, probably were a much-needed ego boost at a time when, despite continuing professional successes, she also encountered a range of challenges. The growing strength of Actors' Equity in 1920s American theatre was not welcomed by Anglin. She initially refused to join the union, instead preferring to affiliate herself with the pro-management Actors' Fidelity League, an organization founded by George M. Cohan and the Producing Managers' Association.[65] Although theatre historians and Anglin's biographer have claimed that her opposition to Equity stemmed from its refusal to allow her to hire her husband, Howard Hull, as a member of her company, her correspondence suggests a number of reasons why she felt it was unnecessary and intrusive.[66] For

one, Anglin's objections to Equity were shared by a number of other prominent, well-established performers. In 1921 Minnie Maddern Fiske sent words of encouragement to Anglin about her stance, telling her, "you and you alone – during the past year – have kept the banner of the theatre in its most distinguished sense aloft." If like-minded performers did not strengthen the League, "in the not so far distant future we will be in the humiliating position of 'taking orders.'"[67] Anglin complained (often quite bitterly) to her colleagues that, in the words of one letter, "the Actors' Equity has denied me the right to act with my own company."[68] From Anglin's perspective, Equity demanded that she either cede control of her company to another manager and appear with Equity members onstage with special permission from the union or stop acting and act only as a manager. Was this true, Anglin asked Frank Gillmore, Equity's executive secretary? If so, it denied her "the right to realize her very large investments and to employ the only means I possess to accomplish this end." It also meant that she would not be able to meet her responsibilities towards those authors who were expecting fees from her New York season.[69] In reply, Gillmore asked her to meet with him, since he felt sure "you would desire complete information, which at the moment I am fairly confident you do not yet possess," and reassured Anglin that he would be honoured to meet.[70] She was not pleased with his reply and demanded an answer to her question, although she (rather haughtily) agreed that they might meet.[71]

Control over her finances and, equally importantly, the way in which she ran her company appear to have been at the heart of Anglin's vexation with Equity. Coming from a privileged background and having achieved considerable wealth as an actress-manager, Anglin was loath to be associated with, as she put it in the press, "bricklayers." Eschewing both the Taylorite principles of scientific management that had permeated Broadway's theatrical culture[72] and the protection that Equity's rules afforded performers, Anglin publicly declared that actors could not work according to a strict timetable: "'if a whistle were blown in the middle of rehearsal it would be difficult to return on the next while and pick up actions like a bed of bricks." She had no difficulties working with the stagehands' union, the International Alliance of Theatre Stage Employees, and she had also hired and "'made happy'" Equity members. However, for Anglin the art of acting was "'spontaneous and free-flowing'"

and those who practised it could not be curbed or treated like "'the ordinary professions or trades in life.'"[73] At least one of Anglin's colleagues felt obliged to reply, suggesting that it was unfortunate she felt that way but that many other actors (Ethel Barrymore, for example) belonged to Equity and did not feel "cramped, confined or bound in." Moreover, American theatre was marked by greater artistic achievements than ever before, even though 95 per cent of its performers were Equity members, and Anglin's claims were "pure bunk."[74] Eventually, though, Anglin was reconciled to Equity. By 1930 she was a member and later that year the union represented her in a dispute with the manager of the Davidson Theatre, Sherman Brown, winning an arbitration award for her (although Brown asked for patience, as he had only recently regained control of his theatre, something that might have resonated with Anglin).[75]

Equity was not the only source of Anglin's troubles. During performances of *The Woman of Bronze* in Chicago, Anglin seems to have been struggling with several personal problems. Her advance press agent, Thoda Cocroft, confessed to Elsa Marbury that "My dear things are awful — Believe me the combination of too much alcohol and 9 performances a week are not adding to M.A.'s good temper — She is in a terrible state and fat as a *pig*. She is driving me simply mad." Cocroft had told Howard, "I would *not* be able to stand it any longer and asked him to let me *out* — He begged me to stay till the end of the run in March — all this is strictly 'entre nous' — Be sure and tear this up."[76] Fortunately matters improved; she wrote Marbury, "business is great and everybody's happy."[77] In 1924, though, Anglin admitted to deep exhaustion. Negotiations with the Shubert organization over a play she wished to appear in had fizzled out; her current performances in St Louis had been rushed and the opening night audience had felt hostile. A backstage visit by several men and women who were connected to the St Louis Theatre Guild "or whatever the movement there is called" had left her bewildered, since "these people could not find a word to say in approval of the play." Moreover, she was unhappy with the play and was discussing rewriting the last act, but "I think you must know how very weary I am of rewriting plays," she told Alice Kauser. "I am so desperately tired of the whole business of this struggle that I may close up in 10 days or 2 weeks from now and leave the play for future production until next season. It is possible that if I could find a very strong, exciting, 1-act play, to go ahead with it, in which

I could to put it simply, raise Cain emotionally, I might be able to make a tour of 1 night stands with profit." As well as being dispirited, Anglin was also sleep-deprived. She had just begun to get six hours' sleep and for three months had managed only two to three hours a night. Anglin was optimistic, though, telling Kauser, "if this good luck of the return of natural rest will only continue I will be quite myself in a short time."[78] The context of the 1920s, in which performers found it increasingly difficult to make a decent living touring, would have played its own part, adding levels of stress and anxiety to her life and work. Letters sent by Anglin to her New York producer George C. Tyler, while she was touring the American South and the Midwest, testify to her distress and feelings of mistreatment: uncomfortable train journeys, poor hotels, filthy dressing rooms, and incompetent production staff convinced her she needed to eschew touring and return to New York.[79]

The interwar decades were not entirely fraught or bleak, though. Anglin continued to act, direct, and produce; in the early 1930s she also launched a new career as a radio performer, which continued into the 1940s. She was no stranger to the medium, since in 1927 Canadian prime minister Mackenzie King had invited her to read an ode to Confederation, written by Canadian poet Bliss Carman, as part of her home country's Diamond Jubilee of Confederation, a recital that was broadcast from the Parliament Buildings in her birthplace of Ottawa.[80] Although biographical sketches of Anglin tend to gloss over this aspect of her career, moving from the 1920s to her last theatrical performance, *Watch on the Rhine*, judging from the volume of mail she received about her radio work it was far from being inconsequential. Colleagues and friends from the theatre told her how much they enjoyed her readings of poetry and fiction.[81] Equally importantly, Anglin's listeners sent volumes of mail to express their delight and gratitude to her. Many of them had watched her onstage and were thrilled to hear her voice again. Florence Rothert wrote to her from Brooklyn to tell her that she had seen her in many productions and would always remember her in *The Woman of Bronze*. Rothert had heard Anglin on the radio and had enjoyed it "so much" that she decided to tell her so. To be sure, Rothert had other reasons for contacting Anglin. An actress and teacher of theatre, she wished to move into radio and wondered if it might be possible to "do some things together on the air," adding, "please don't think me a silly

stage-struck young girl, because I'm not. I have studied and worked hard and have won much commendation within my own little circle." Telling Anglin that she had a large classical and modern repertoire, Rothert invited her to visit her studio in Brooklyn "or at any place and time that will be convenient for you."[82] Radio work thus represented a form of continuity in Anglin's career, as it maintained ties with the affective and professional communities originally created by her stage work. It might also help bring new family members to her attention. Bertha Byrnes loved hearing Anglin on the radio, she wrote. What was more, Byrnes's late mother had told her they were distant relatives of the famous actress and had related stories about bidding farewell to Anglin when she left Canada to start her career and then seeing her on her visits home.[83] Radio also provided Anglin with a forum for her other concerns. In 1931 she broadcast her thoughts on "The Christian Theatre," in which she spoke out against the sensationalism of much contemporary theatre, the lack of support for theatre from those who were all too happy to subsidize music, opera, and museums, and the need for a better and more sensible division of managerial labour within the profession.[84]

Personal relationships also may have helped sustain Anglin, particularly in the years after Howard's death in 1937. Howard's sister-in-law, actress Josephine Hull, wrote regularly to her from the 1920s until the 1940s, sharing stories of mutual friends, details of her tours, her own illnesses, and her worries about the war, as well as letting Anglin know how much she appreciated her work and her great affection for her.[85] Anglin also benefited from her ongoing friendship with Carrie Jacobs-Bond, the singer and songwriter. Although Jacobs-Bond was fourteen years older than Anglin and by the 1930s lived in Hollywood, the two wrote to each other frequently. They exchanged professional gossip, plans for future projects, discussions of the progress of World War II, and other, more personal news: a tooth that had been pulled, a bout of shingles, accidents, a granddaughter's time at Vassar, and the death of a beloved pet (Jacobs-Bond's letters, in particular, have much to say about her struggles with aging, particularly as she continued to work).[86] Anglin's relationships with other women involved in similar work suggest that, far from the competitiveness and jealousy that the press sometimes attributed to them, they could be a source of support and encouragement to persevere with the business of performance and, too, life in general.

Lucille Watson, Catherine Proctor, and Mae Edwards: Working Lives in the Twentieth Century

Arthur and Anglin were by no means exceptions. While Lucille Watson, Catherine Proctor, and Mae Edwards may not have been as well-known as other Canadian actresses, nevertheless their lives demonstrate the ways that transnational currents and networks shaped actresses' lives after World War I, lives that ranged from transatlantic movement to transcontinental touring, as well as working in film and television.

Watson, who had performed in Charles Frohman's New York productions prior to World War I, appeared in the Theatre Guild's productions in the postwar years, as well as acting for the Shuberts and the Actors' Theatre.[87] Her career took a transatlantic turn in 1925 when she appeared at London's Queen's Theatre in Edgar Selwyn and Edmund Goulding's comedy *Dancing Mothers*. Directed by the Queen's manager, Alfred Butt, the influential music-hall impresario, Conservative politician, and (by then) baronet, *Dancing Mothers* tells the story of a modern Manhattan daughter's escapades and misbehaviour, drinking cocktails and chasing men. Rather than correct her, her father "aids and abets" her and then proceeds to misbehave himself, while her neglected mother decides to follow in her child's footsteps and ends up running off to Europe with an "amorous bachelor" whom her daughter had pursued.[88] Although *The Times* was scathing in its review (dismissing it as "one of those crude and obvious American plays, wherein robustness of tone is more conspicuous than delicacy of feeling"), the play suggests how representations of American culture crossed the Atlantic to London.[89] Three years later Watson was living in France with her husband, playwright Louis Evan Shipman; she was associated with the dramatic section of the American Women's Club, staging and performing in their productions of J.M. Barrie's *Rosalind* and Strindberg's *The Stronger*.[90] Upon her return to the United States in 1934 after Shipman's death, Watson continued to build the film career she had started in 1916, performing in movies such as *The Garden of Allah*, *Waterloo Bridge*, and *The Women*.[91] She also resumed her stage work and her association with the Shuberts, appearing in their production of *Home James*; her other roles included *Pride and Prejudice* and *Yes, My Darling Daughter* (which also toured to Toronto).[92] According to her biographer, though, her "best-known and most acclaimed role"

Fig. 6.4 Lucile Watson portrait, c. 1910s–20s.

Fig. 6.5 (*opposite*) Lucile Watson (seated, centre) in *Heartbreak House*, 1920.

was as Mrs Fanny Farrelly in Lillian Hellman's *Watch on the Rhine*, a performance described by *The New York Times* as being "enormously witty" and full of conflicting emotions.[93] Watson also continued her predecessors' practices of wartime service. In 1939 she spoke at an event to support the Red Cross and boost membership in the organization; she also became a board member of the American Theatre Wing War Service, serving alongside fellow performers Josephine Hull, Antoinette Perry, and Gertrude Lawrence.[94] Watson was quite active in the organization, chairing its workroom committee, helping to sell war bonds, organizing troop entertainment, and collecting food and clothing.[95] Her commitment to the war effort may have been shaped by her time in France, as well as by the theatre community's more general support for it.

After playing Farrelly in the 1943 film version of *Watch on the Rhine*, Watson worked in Hollywood until the early 1950s, performing in films such as *Song of the South* (1946), *The Razor's Edge* (1946), and *Little Women*

(1949). She returned to New York in 1950 and continued to act in theatre until her retirement in 1953. Interviewed by Canadian journalist Lotta Dempsey in 1950, Watson impressed Dempsey by the fact that at age seventy-one she was still performing and displaying the "flowing gestures which seem to be the hallmark of most women who have grown in state and in years with the unmoving tempo of the legitimate stage." Her voice was also remarkable. It could fall to a whisper when discussing her friends (who included Ethel and Lionel Barrymore, Dempsey noted) but also could "boom out her denunciation of bad actors in both the world of make-believe and the world of nations at daggers drawn." Watson was far from being a "gentle old lady" but instead was as commanding as she had been in her youth. She had much advice to offer those who aspired to greatness as an actress: study, show commitment, and cultivate a love of music, poetry, and art.[96]

Like Watson, Catherine Proctor represented degrees of continuity in Canadian performers' relationships with transnational theatre. For one, like so many of the women who began their careers in the late nineteenth century, Proctor attributed much of her desire to become a performer to her mother, who spotted her talent when she was only six and taught her to recite. Proctor went on to attend Jarvis Street's Toronto Collegiate Institute and studied drama at the Toronto College of Music, where she was advised to become an actress. After seeing Minnie Maddern Fiske and Julia Arthur perform in Toronto, Proctor decided that she must follow in their footsteps and persuaded her mother to take her to New York, where she was hired by Maude Adams for a few seasons. Proctor's "'thrilling joy'" came with the part of Hermia in Annie Russell's production of *A Midsummer Night's Dream*, her opening in it made even more special because of her mother's presence in the audience. Yet despite her success with Russell, Proctor found that it did not open doors as easily as she had hoped. The next few years saw her cast in smaller roles, albeit alongside famous performers from whom she claimed to have learned much about the theatre.[97] Proctor's career included work for Jessie Bonstelle's Stock Company; during World War I their tours brought her back to Toronto in *The Girl of the Golden West* and *The Darling of the Gods*.[98] Hired by David Belasco, she toured in a number of his productions and then returned to play exclusively in New York, including a leading role in *Out There* (although she found herself replaced by Julia Arthur when

Fig. 6.6 Catherine Proctor as Hermia, c. 1912.

Fig. 6.7 (*opposite*) Catherine Proctor, studio portrait, c. 1910s.

Fig. 6.8 Catherine Proctor as Mrs Lincoln in *If Booth Had Missed*, 1932.

the play was staged for benefits).[99] As well as being inspired (and then replaced) by Arthur and working for Russell, Proctor's career also was linked to Anglin's. She played Ruth Jordan in a 1922 revival of *The Great Divide* and volunteered to be a member of the chorus in Anglin's 1927 *Electra* at the Metropolitan Opera House.[100] In 1922 Proctor appeared in

the New York production of Somerset Maugham's *East of Suez*, described by prominent New York reviewer Alexander Woollcott as a "sultry Oriental melodrama, with much Manchu mischief" and a heroine who is a "seductive and ruthless half-caste."[101]

As Canadian theatre critic Herbert Whittaker pointed out in his obituary of Proctor, while she might not have achieved the kind of stardom in theatre enjoyed by Anglin and Arthur, from the interwar decades on she gained recognition as an important and talented character actress. Proctor played Lily in Eugene O'Neill's *Ah Wilderness*, as well as appearing in *Arsenic and Old Lace*; her fellow performers included George M. Cohan, Boris Karloff, and Leo J. Carroll.[102] In 1931 Proctor also performed with the Rochester-based Lyceum Players, a stock company that combined elements of a community-based summer theatre with aspects of New York cosmopolitanism (the company was also used to try out Broadway-bound productions) and "little theatre artiness."[103] Moreover, Proctor maintained ties to Canada through her tours with the Bonstelle Players, her appearance in *Declasseé* at Toronto's Uptown Theatre, and a tour of *Arsenic and Old Lace*.[104] During the 1950s and '60s she came back to Canada for longer stretches of time, performing in *Jalna* for the New Play Society and in a CBC drama, *Mrs. Taylor*, which was seen in England and Australia. Proctor's family also kept her linked to Canada, since she returned frequently to Toronto to visit her siblings.[105]

For Mae Edwards, the 1920s were spent primarily on the road. Born in the eastern Ontario town of Lindsay in 1878 and a graduate of its Collegiate Institute, Edwards went on to work with various stock companies, including the "all-English" Passers By, which crossed Canada.[106] In 1917 Edwards created a theatrical partnership with her husband, musician and vaudevillian Charlie Smith. During the war years the Mae Edwards Players toured Ontario; in the 1920s they expanded to the Maritimes, New England, Newfoundland, and into the American Midwest, reaching as far as the Dakotas (the latter tour featured the "sensational melodrama" *Dope*, an anti-narcotics play).[107] Although, like Watson and Proctor, Edwards does not appear to have left any personal papers, newspaper coverage of her career suggests the Players' great popularity during their years on the road. At Halifax's Strand Theatre, Edwards was greeted with "vociferous applause ... With her pretty face, striking presence, magnetism and charm of manner, and, wearing beautiful and

becoming gowns, no wonder all were so enamoured with her."[108] Judging from other surviving reviews of the Players' work at the Strand, this was not an anomaly. While critics praised the entire company and noted the audiences' enthusiasm, Edwards was a particularly popular performer, noted for her talent and polished appearance.[109] Her repertoire included one hundred plays; she was said to be equally adapt in comedic or emotional roles, never overacting but always performing naturally and with great clarity and articulation. A "tall, good looking," and well-dressed performer, Edwards's stage presence was "striking," and offstage "she has a refined charming manner and is a most pleasant conversationalist."[110] Although not as extensively interviewed as other actresses, Edwards shared her thoughts on living a healthy life with the women of Quincy, Massachusetts, during her company's run at the Quincy Theatre. "Moderation" in diet, rest, and work, Edwards thought, coupled with plenty of fresh-air walks, was the key to health: a "busy day in the office, a rushed trip home, and a hurried meal eaten too fast to be digested ... [and] four hours of prancing around a modern dance floor, six nights a week, is enough to rob the vitality of any woman." According to Edwards, her daily walks and swims helped her meet the demands of constant rehearsals and playing leading roles in a "modern company of today." However, the founder of that "modern company" was pleased that the "much talked of 'flapper' seemed to be absent from the minds of girls of this city."[111]

Edwards and Smith lived in Portland, Maine, during the company's lifetime; when the Players disbanded in 1935, they, along with their son Valmore (who at the age of twelve had played drums in his parents' orchestra), moved from Portland back to Lindsay. During her retirement, Edwards joined those voluntary organizations popular with middle-class women in small-town and rural Ontario: the Imperial Order Daughters of the Empire, the Order of the Eastern Star, the Kiwanis' Ladies Organization, and (perhaps as a way of keeping up her walks) the Lindsay Golf Club.[112] Just after her death, Edwards and fellow stock player Marjorie Adams were remembered rather patronizingly by Toronto writer Roly Young. Young claimed that despite their somewhat crude acting, shabby scenery, and mixture of vaudeville with so-called "serious" drama, Edwards and her ilk endured "noisy trains, slat-seated railways stations, musty little hotels and boarding houses, and dirty ill-equipped theatres"

to bring much-needed entertainment to isolated towns that were starved for amusement.[113] One wonders what the residents of Halifax, a city tied into long-standing theatrical (and other) networks along the eastern seaboard and across the Atlantic, and who would not have been so "starved of entertainment" as to put up with poor acting and shoddy scenery, would have made of this characterization — let alone what Mae Edwards might have thought.

Conclusion

As the careers of Arthur, Anglin, Watson, Proctor, and Edwards demonstrate, in the interwar years, work as an actress, along with the transnational mobility it entailed, remained a legitimate and valid choice: the patterns described in the previous chapters were not anomalies of the late Victorian and Edwardian era. Moreover, even in the era of the flapper and the Modern Girl, women who did not fit neatly into those categories as performers — for reasons related to age or their choice of genre (or both) — were still able to find meaningful employment, garner public respect, and make ongoing contributions to theatrical culture in the twentieth century. Further research might uncover more such women.

Yet the ranks of English-Canadian actresses in the interwar years also included Margaret Bannerman, Beatrice Lillie, and their contemporary Frances Doble. Their work, in Britain and beyond, represented developments in theatre, performance, and celebrity culture that were intertwined with new forms of the interwar decades' modernity but that also reflected the contradictions that surrounded earlier representations of "sweet Canadian girls."

CHAPTER SEVEN

The Modern – and Transnational – Sweet Canadian Girl Onstage in London ... and New York ... and Sydney ... and Auckland

Introduction

"She began at the Alhambra. A quaint little thing sixteen years old; almost a marionette run on many wires," was London theatre critic and promoter J.T. Grein's description of Beatrice Lillie's London debut. Grein remembered her early work as "amateurish" but nonetheless "immensely attractive": that Lillie stood out from the crowd could not be denied. "One could not help looking at that sweet little face, with an Alice in Wonderland look in the eyes, with the movements of a Pierrot, with a glad-eye smile that found magnetic response from our lips." Although Grein knew then she had a future, he confessed he could not have foretold her great success, both in London and America where, he felt, her great comedic gifts had been recognized and appreciated. He very much hoped that producer André Charlot would create a revue dedicated solely to Lillie, her "indescribable sex appeal intensifying the charm of all she does."[1] Grein was not exaggerating: Lillie's reputation grew substantially during the 1920s and '30s as she became a star of the London revue stage and then in the United States. She went on to work in radio and film on both sides of the Atlantic, with a career that lasted well into the post–World War II years, resulting in a 1953 Tony Award for her revue, *An Evening with Beatrice Lillie*. Lillie died in 1989 at the age of ninety-four at Henley-on-Thames.[2]

Lillie was joined in Charlot's companies by Margaret Bannerman (1896–1979). Born Marguerite Grande in Toronto, like Lena Ashwell

Margaret Bannerman was educated at Bishop Strachan School and then went to Mount Saint Vincent University in Halifax. Like Lillie, Bannerman crossed the Atlantic with her parents and sister in 1914. She began her professional career in Charlot's *Revue of 1915* and played alongside Gertrude Lawrence in his *Buzz Buzz*.[3] Charlot's revues drew managers' attention to Bannerman's comedic talents (and her blonde beauty). She then went on to perform in several comedies, toured Australia and New Zealand, and, after moving to the United States in 1937, continued to act in both film and theatre.[4]

Like those discussed in chapter 6, Lillie's and Bannerman's careers point to the continued importance of transatlantic and transnational mobility for English-Canadian actresses. While they point to significant shifts from the late-Victorian and Edwardian eras, both in the types of careers these women crafted and the intersection of their images with interwar discourses around femininity, popular culture, and modernity, they also suggest degrees of continuity. For one, both women were perceived by the press as embodying Canada's membership in the British Empire; moreover, they came not from a dependent colony but from one of those "white" Dominions that had unequivocally demonstrated its support of Britain during World War I. Furthermore, while their celebrity status was crafted in ways that emphasized youth, freedom from convention, and glamour, it also relied heavily on the tropes of innocence, authenticity, and lack of artifice that had characterized their predecessors' images. The contradictions, then, that surrounded earlier representations of these "sweet Canadian girls" persisted into the interwar decades.

Lillie, Bannerman, and English Musical Revue in the 1920s and 1930s

In their work for André Charlot, both women performed in the genre of English intimate revue, entertainment that offered all-female small-scale choruses, comic sketches, and song-and-dance routines by featured performers. The revue's development during the war shaped its form; forced to work in smaller theatres, Charlot was unable to fit large numbers of chorus members on his stages, and the war also reduced the number of available young male actors.[5] During the postwar

period, intimate revues still owed much to the music hall, yet revue producers sought to distinguish their productions from variety or music-hall shows, not least by seeking to attract a theatre-going audience.[6] Moreover, although contemporaries who were engaged in new forms of modernist theatre (such as Lena Ashwell and Shaw) condemned such entertainment as meaningless fluff, these productions both reflected and channelled the "post-war neuroses of a decadent Mayfair society as well as the ambitions of the aspirational middle classes," particularly those written by Noel Coward.[7] Despite their playfulness and seeming frivolity, Coward's revues "displayed an abundance of distinctive versions of class and national identities, providing idiosyncratic depictions of class conflict and engaging and critiquing British social life."[8] Along with fellow performers Gertrude Lawrence and Florence Mills, Lillie's comedic talents were thus at the heart of these critiques, helping to place revues "at the forefront of contemporary British culture."[9]

Charlot had hired Lillie prior to developing his revues, including for an appearance as a farmhand singing Irving Berlin's "I Want to Go Back to Michigan."[10] However, it was in Charlot's revues, along with fellow performers Gertrude Lawrence, Jack Buchanan, and (by 1918) Noel Coward, that Lillie developed both her repertoire and her reputation.[11] Some critics suggested that the nuances of Lillie's sketches were best suited to smaller theatres. One critic, reviewing her 1923 appearance at London's Little Theatre, stated that Lillie was at her best in such a venue: "She has a happy knack of making the audience feel that she is thoroughly at home in every new part that she plays, and in *The Nine O'Clock Revue* she tears through half a dozen parts at top speed, and is diverting in them all – but as a descendent of William the Conqueror she is immense."[12] Yet no matter where Lillie appeared, critics thought she occupied "the front rank of British commédiennes [sic]," although simultaneously they left the impression of a performer whose work was hard to encapsulate neatly.[13] As early as 1916, when Lillie appeared in Harry Grattan's revue *Samples*, *The Times* singled her out for her comic playing of either "boy or girl ... with a delightful neatness and elegance."[14] In its review of *Pot Luck*, a "'cabaret entertainment'" at London's Vaudeville Theatre, the paper's critic attributed its success to the skill and hard work of Lillie and co-star Jack Hulbert but admitted that Lillie was "one of the mysteries of the stage." Her dancing was not "brilliant," and her singing

Fig. 7.1 Beatrice Lillie in revue skit, c. 1920s.

was unremarkable, "yet in everything she has to do in this entertainment she scores heavily — because she is one of the few *revue* artists who are richly endowed with personality." Lillie's versatility and almost chameleon-like qualities made her memorable: "From impersonating a ridiculous lawyer to making herself almost unrecognizable as an elderly

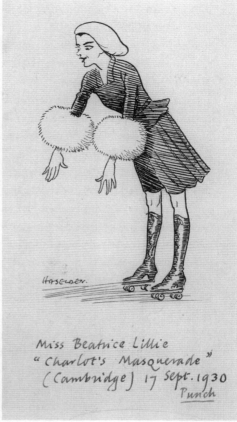

Fig. 7.2 Beatrice Lillie publicity photograph.

Fig. 7.3 Beatrice Lillie caricature, *Punch*, 17 Sept. 1930.

street singer who howls down all her competitors; or from playing a burlesque Peter Pan to singing a number as an immaculate young man about town. In every item there is that special touch of genius which has made her work so acceptable." She would be perfect, this writer thought, but for her "annoying habit" of forgetting some of the words of her choruses "and extemporizing with anything that happens to come into her head."[15]

Grein's exploration of Lillie's stage career provides even more valuable insights into the details of her performance and, too, the reasons why she was so compelling to watch. "She is an artist so accomplished

THE MODERN SWEET CANADIAN GIRL 253

that, except Miss Cecily Courtneidge, there is none to vie with her in the portrayal of satirical characters culled from life." He went on: "See her as Frisco Jenny, the *fille de joie* posing as a histrionic heroine, and you think of Jack London's tale; listen to her as she sings and poses in 'a study in porcelain'; behold how, in a witty skit, she visits a fellow-actress and heaps acidulated compliments on her rival in a devastating manner, and you are amazed not only by the swift, chameleonic changes. Each type has an individuality of its own. Satire and reality go hand and hand and make an exquisite blend." Lillie's ability to evoke this range of personalities, ones drawn from both her own milieu and transatlantic culture, such as London's gold-rush tales, owed much to her physical gifts as a comic. "Her greatest and most peculiar gift," Grein added, "is the *gaucherie* of certain sudden movements, remnants of her former inexperience, which are now irresistible in their effects. She jerks, she twists, she lets her lithesome body stumble in clumsiness, she utters malapropisms, or naughty casual remarks with a childish nonchalance. She attempts to sing with a little voice still hoarse, yet attractive – and she revels with an innocent air in these would-be shortcomings, because she knows full well that these are idiosyncrasies of which she holds the sole patent and monopoly. If a lesser actress practiced these one would chide her as an 'amateur,' but in Beatrice Lillie's joyful work it is the condiment that adds to the piquancy of her performances." While Lillie was onstage, she naturally – through no intent of her own – overshadowed her fellow performers: "it is simply," Grein thought, "the outstanding flamboyancy of her art that makes her the cynosure of all eyes, the pivot of humour, the will o' the wisp that sheds sparks here, there, and everywhere."[16]

In her cross-dressing and mocking of gendered stereotypes, some of which were rooted in theatre (the "histrionic heroine" or the sharp-tongued actress), Lillie's comedy also played with forms of knowingness that had a long history in British comedy, most notably music hall. Grein's article, for example, featured a photograph of Lillie as a barmaid, a figure who would be very familiar to London's music-hall audiences: although in her case she was one of "great 'refeenement.'"[17] But, as *The Times* critic observed, Lillie's work also evoked characters and situations drawn from the contexts of 1920s urban modernity: the "romantic teashop waitress," who in all likelihood was based on the young women who

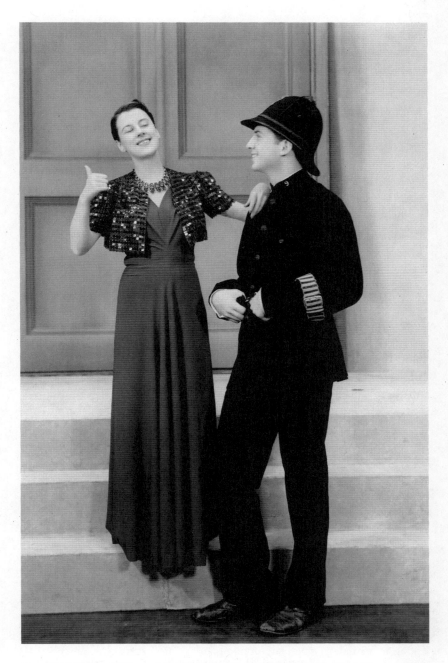

Fig. 7.4 Beatrice Lillie and Sanders Draper in "bobbie" skit, *Set to Music*, Noel Coward, 1939.

worked in the popular Lyons' Tea Shops, close to the theatres in which Lillie appeared, or Charlie Chaplin's Little Tramp, a figure much imitated in transatlantic popular culture.[18] Moreover, while Grein did not hesitate to describe Lillie as a figure who embodied heterosexual desire, her depictions of femininity had a malleable quality to them that played with the gendered ambiguities of 1920s modernity. Her slim figure, cropped hair, and boyish looks onstage were frequently remarked upon in the press, sometimes with references to Maude Adams's Peter Pan. While the subject matter of the skits in which Lillie appeared was part of the interwar decades' conservative modernism, their gendered dynamics also fed into the vivacious nature of 1920s London, its possibilities for instability, and the fragmented nature of the modernity that revue provided.[19] It is difficult to know precisely how Lillie's audiences received this aspect of her performances, as Lillie's personal papers do not include fan mail from this period. However, audience members from London's queer communities may have identified with the tropes of gendered and sexual instability she embodied.[20]

In contrast, Bannerman's performances – and critics' reviews of them – emphasized her heterosexual appeal: her blonde beauty was considered as compelling as her comic talents. In *Under Cover* at London's The Strand, a play that dealt with "society smugglers and the American Customs," Bannerman was "the most amusing figure" as a "pretty girl with a coming-on disposition," a role she played "most cleverly."[21] Four years later Bannerman, "the brilliant actress," played Lady Audley in the Queen's Theatre's production of *Lady Audley's Secret*.[22] It was her work in Somerset Maugham's 1923 *Our Betters*, though, that marked Bannerman as a more "serious" actress.[23] "Mr. Maugham's new comedy is like its heroine, clever, cynical, and shameless," proclaimed the *Times* review of *Our Betters*, which had just opened at London's Globe Theatre. A satire of the "American ladies who barter their dollars for English and French and Italian titles" and of their wealthy compatriots "who expatriate themselves to live idle lives in Europe," *Our Betters* was notable for, amongst other things, one of its two female leads, Lady George Grayston, played by Bannerman. Although Grayston is married, her husband does not appear onstage; instead, she lives in an "almost public" liaison with a "mature, bald-headed, but rich lover." If such amoral behaviour was not enough, Grayston also takes another lover, a man being kept by her

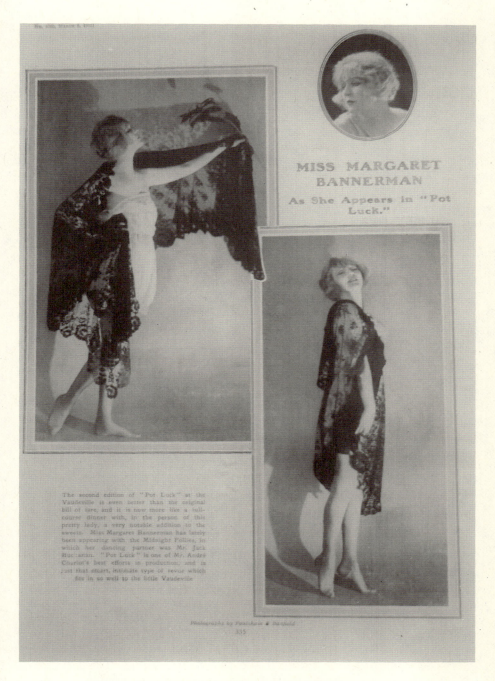

Fig. 7.5 Margaret Bannerman featured in *Pot Luck*, 1922.

Fig 7.6 Margaret Bannerman featured in *Just Fancy* and *Beauty*, 1920.

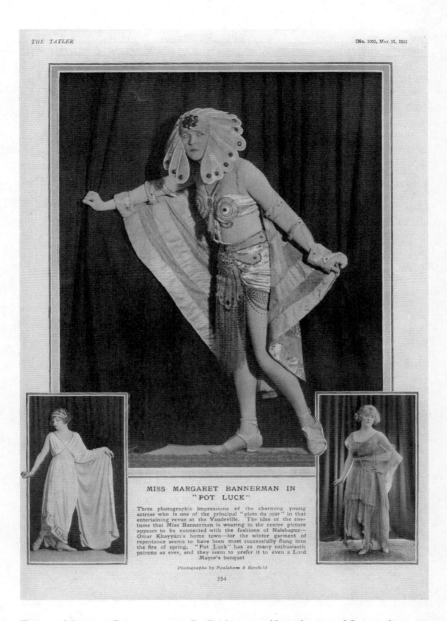

Fig. 7.7 Margaret Bannerman in *Pot Luck*, 1932. Note the use of Orientalist clothing in the centre photograph, the Grecian costume bottom left, and the Western evening dress bottom right. They suggest her ability to move fluidly between these forms of cultural representation and, by extension, the panorama of cultures presented in the revue.

Fig. 7.8 Margaret Bannerman and Reginald Owen in the London production of *Our Betters*.

counterpart, the American-French Duchesse de Sureness. Calculating, cajoling, and deceptive, Grayston '"vanquishes" the Duchesse in a competition for the young man's affections marked by its "rich vocabulary of vituperation" and underpinned by financial considerations. Bannerman, the reviewer thought, "gave you a slight shiver, she was so naturally and so consistently wicked."[24] Writing for *The Daily Express*, "The Dragoman" was "delighted" to see the notable improvement in Bannerman:

"this young Canadian girl, once one of our poorest actresses, gives a performance than which there is perhaps no finer piece of comedy acting to be seen today."[25] George Godwin, covering Bannerman's career in an article for *Maclean's*, agreed. Bannerman had made "giant strides" since her first appearance at the Adelphi: "she has established herself as an actress of real ability," Godwin told his fellow Canadians. With *Our Betters* Bannerman had "'arrived' in the artistic sense of the word with her interpretation of the very difficult part of the unmoral ultra-modern woman in Somerset Maugham's play 'Our Betters.' Her career is full of indefinite possibilities." Godwin found Bannerman offstage to be "very sophisticated ... with a streak of hardness beneath her charm."[26] To be sure, not all critics could see "what all the pother had been about," in the words of the *Daily Mail*'s critic, who found the play to be too artificial, cynical, and containing no characters "worth troubling about." Bannerman, though, looked "very pretty" as Grayston, a woman lacking "morals or conscience, who, we are told, 'has half the Cabinet in her pocket.'"[27]

After *Our Betters* closed, Bannerman continued to work on the London stage. The *Daily Mail*'s William Pollock devoted an article to her career, believing that it was "difficult" — in fact, impossible — to determine where she would find herself in the theatre. Bannerman had had an "extraordinary rise," Pollock believed, since 1923, "and it is now quite clear that she is only at the beginning of a brilliant future." Calling Bannerman "one of our greatest hopes among young dramatic actresses," Pollock stated she was known both to her friends and to "that host of faithful, fervent gallery girls who always acclaim her on first nights" as "'Bunny.'" Toronto-born, Bannerman had become a very popular revue star in her early days onstage, when "men back from the war were particularly pleased with her fair-haired freshness, her dainty ways, her touch of wistfulness." She was not unlike Mary Pickford or Peter Pan, "the kind of girl you saw looking at you from magazine covers." Now, though, Bannerman's persona had migrated from the popular periodical: she more closely resembled the young women who populated the pages of modern novels. In *Our Betters* Bannerman was wonderful as Grayston, a woman from "a certain immoral section of society." Although the part had been written for an older actress, "her performances astonished the critical theatrical world. People went around saying quite frankly, 'I didn't think Margaret Bannerman could do it'; critics from abroad asked 'Who is

this actress? We have never heard of her.'" Bannerman, in Pollock's estimation, was "teachable" but also had an "innate understanding," one that might be "intuition," "keen observation," or possibly both. He concluded with high praise for her current work. "That what she did in 'Our Betters' was not a fluke had been demonstrated by what she has done since. Playing a different sort of woman she has won just as much, if not more, approval from connoisseurs of fine acting. She has grip, personality, ease, and — noteworthy in these days of vocal affectations on the part of so many young people of the theatre — an uncommonly right way of speaking English."[28]

Bannerman put her "uncommonly right way of speaking English" primarily to use in contemporary West End comedies, although in 1926 she also appeared as Rose Trelawney in a revival of Pinero's *Trelawney of the Wells*.[29] While London's critics found her still charming, very attractive, and, on occasion, powerful, the tone of their reviews suggests that a part with the power and depth of Lady George Grayston did not come her way in the mid-1920s.[30] Yet Pollock's remarks about the "gallery girls," as well as a comment by another critic that Bannerman's gowns in *The Golden Calf* were "of the kind that win applause from envious girls in the gallery," should give us pause. It is quite likely that Bannerman's real audience was not so much the critics (most of them older men), who in other writings registered their distaste with supposedly all-female London audiences, but rather young, urban women, the British equivalent of America's matinee girls.[31] Bannerman may have been the materialization of their own fantasies and desires around modernity. Although they were not, strictly speaking, "girls," in their performances on West End stages both Bannerman and Lillie represented the promises of the "modern girl" of the 1920s: pleasure and fun, consumption, independence, and mobility.[32] While their performances relied as much on sensory appeal as those of the "emotional actresses" of the late Victorian and Edwardian years, it was to a different manifestation of the senses.

Across the Atlantic, Across the Pacific: Lillie and Bannerman on "Other" Stages

Much has been written about the flow of American culture across the Atlantic to Britain in the 1920s and '30s, not least in the form of Hollywood

films that helped spread American forms of music, fashion, hairstyles, and dance.[33] However, Bannerman and Lillie's careers suggest that in the interwar years such cultural traffic was not one-way. Late-Victorian and Edwardian transatlantic theatrical networks between Britain and the United States continued to operate after World War I, representing a series of exchanges in which British plays, actors, directors, and theatrical material culture were sent across the ocean to New York and to tour the continent.[34] Despite the popularity of American popular culture in major European centres, the revue was part of a "complex transnational space" marked by interactions between a number of genres and players. Charlot's revues combined "the local and the global, [the] contemporary and the old." His 1924 presentation in New York was meant to represent the West End as the "embodiment of wit, sophistication and cool."[35]

The press on both sides of the Atlantic took note. Britain's *Daily Mail* was happy to report that the 1924 revue "scored a decided hit" on its opening. "American critics pronounce it bright, snappy, and full of fun. They express horror at some of the English jokes, but concede that the revue contains many good ones. The principal performers, Miss Beatrice Lillie, Miss Gertrude Lawrence, and Mr. Jack Buchanan, all enjoy an excellent Press."[36] In 1928 the *Daily Mail Atlantic Edition* enthused about those "Plays and Players on the New York Stage." While the paper saw Broadway's offerings that year as particularly strong, since they included *Show Boat*, Oscar Hammerstein's *New Moon* (with a cast of 150), and the Marx Brothers' *Animal Crackers*, it declared that the "palm must be handed, all the same, to the English production *This Year of Grace*." The cast included Beatrice Lillie, Noel Coward, and a "bevy of English young ladies," with a book, lyrics, and music written by Coward, "a full share of work for this young man!" Furthermore, "'B' Lillie has made a furor this time. Critics have gone wild about the entire show."[37]

Two years later the *Daily Mail* reported that "New York at the moment has more English actors and actresses than there are American artists in London," so much so that they seemed to have formed their own social group. Upon Viola Tree's arrival in the city, "a party was at once given for her by Ivor Novello in Beatrice Lillie's flat, which he has leased. (Miss Lillie, by the way, is going to St. Moritz with her small son Bobbie for the Christmas holidays. I would like to see her on skis)." As well as the Welsh writer and performer Novello, the party also included the

well-known American actor Alfred Lunt and British-born actress Lynn Fontanne, the husband-and-wife team who were currently playing in *Elizabeth the Queen* ("yet another angle on Elizabeth and Essex," the reporter noted somewhat dryly).[38] Readers thus were reminded of a range of transatlantic theatrical exchanges: English actors mingled with their American counterparts who represented English history for American audiences.[39] Eight years later, the *Daily Mail* announced, "A Star Comes Home," since "Beatrice Lillie, who for some years has reigned over Broadway as New York's favourite London actress — is to return to the West End stage." Producer Charles B. Cochran told the paper that Lillie's "own material in the production will include some of her best numbers from her last two New York stage successes — numbers which will be entirely new to London." The article ended by reminding readers that in recent years Lillie rarely had appeared in England, as "her services have been in continual demand by New York — and, more recently, Hollywood — producers."[40]

American press coverage of Lillie was, in general, equally enthusiastic. *The New York Times* described the 1924 *Revue* as "thoroughly English ... frequently brilliant in idea, less rich than American revue, and yet sufficiently attractive to the eye, and particularly fortunate in having Beatrice Lillie and Gertrude Lawrence in its cast." The reporter went on to praise Lillie and Lawrence as "the mainstays of this English revue — comediennes in two distinct and separate fields, and each excellent. Something of their fame had already been brought to this shore by returning travelers, but no amount of advance description can take the edge off the entertainment that is to be had from seeing and hearing" them. Lillie's sketches included a "fifty-year-old soubrette, still bent upon singing the giddy ballades [sic] of her youth," and a patriotic number. Eager, it seems, to explain this "English" production to American audiences, the reporter thought it "a far more literate entertainment than any American revue — perhaps (terrible thought) it is a bit too literate for the general public." Yet while Charlot himself could be described as "London's Mr. Ziegfeld," the revue did not quite live up to Florenz Ziegfeld's visual standards, as the chorus ("like the principals") "is all English, and a little below the Ziegfeld-Music Box standard in appearance."[41] Lillie's "English" form of performance also was remarked upon during her 1927 vaudeville tour. In an interview with *Los Angeles Times* reporter Alma Whittaker, Lillie was

quizzed about her modesty, notably the fact that she didn't take all the curtain calls or "bows" that her audience wished to give her. However, Whittaker also found it "rather marvellous," given that "her burlesque is of such a very British female type," that the audience was so appreciative, remarking that "the only time I ever saw the breed [female British burlesque] over here was during the war when the British Daughters were putting on pageants for Red Cross funds." Whittaker attempted to explain the differences between British and American burlesque for her readers, arguing that caricatures were delivered with subtlety and nuance, not the broad-based strokes of American performances.[42]

Theatre critic Percy Hammond went even further, arguing that Lillie and her like might smooth over tense moments in Anglo-American political and economic relations. Writing in 1932, Hammond listed Lillie as one of those "amiable British actors on Broadway" who had done much to "offset cruel darts from the House of Commons." Along with her fellow British actors and playwrights, Lillie was doing much to help Americans "forget and forgive the cruel darts thrust into our breasts by British patriots and journalists ... Whenever I am made indignant by the warlike sneers of Lord Beaverbrook, the *Saturday Review*, or *Punch*, for instance, I visit a Times Square playhouse and there, under the influence of the drama's envoys, I am mollified." Hammond ended his article with the plea, "Give the stage a chance and it will link us again in bonds of amity with our former pal and ally."[43] To what extent Hammond was writing tongue-in-cheek is difficult to know; he was not, though, the only observer to point to a British wave of performers on American stages in the interwar years. One year later Gilbert Swan's "In New York" column discussed the Senate bill aimed at barring foreign performers from American stages "unless [they were] great established stars." "Who'd Be Left?" Swan asked, since "Broadway would be barren of key players but for dear old London and way points." Lillie was among his list of theatrical and film stars and "has been practically adopted" by the United States.[44] Lillie's status as an honorary American was underpinned by an announcement that the "Stage Star Returns Home," arriving in New York after visiting abroad.[45]

During the interwar years Bannerman was known primarily to American audiences for her private life and as a fashionable beauty, rather than for her work onstage. She did not make her American theatre debut until

1937 when she starred in *Three Waltzes*, a musical produced by the Shubert organization; she left less than one month after it opened, though, declaring it did not meet her artistic expectations.[46] However, Bannerman's name and image travelled across the Atlantic in 1922 when she replaced the American actress Willette Kershaw as Princess Perdita in the Drury Lane production of *Decameron Nights*. A dramatization of Giovanni Boccaccio's *Tales of the Decameron*, the script calls for Perdita to be found naked, cast up on a rock after a storm at sea. According to the press, Kershaw insisted that she should wear both tights and a long blonde wig, a decision that both the London critics and Drury Lane's management found unrealistic. "American Girl Fails as Perdita," reported the *Los Angeles Times*, and would be replaced by Margaret Bannerman, "a Canadian."[47] The *St. Louis Star and Times* went even further in its coverage and saw the controversy as a clash of cultures, telling its readers that London critics declared, "Princesses who were cast up naked by the sea did not wear tights," and, according to Drury Lane's management, "'the name of the play is Decameron Nights – not Decameron Tights!'" When Kershaw refused to relinquish her tights she was replaced by Bannerman, "an English beauty and stage star," who kept the wig and discarded the tights. According to the paper, London critics portrayed Kershaw as a "'prude with the narrow prejudices of a provincial schoolteacher. Miss Bannerman is a heroine who sacrifices modesty – if indeed modesty is sacrificed at all – on the high altar of classic art. Americans have no respect for classics or traditions anyway.'"[48] American reformers answered that not only did their country respect "classics and traditions" but that "'we are proud of Miss Kershaw as an American girl and if she had to go naked on the stage to compete with brazen English actresses, she did quite right to resign the role. Besides, the *Decameron* is an immoral book and ought to be suppressed, and never was a classic.'" Bannerman herself entered the fray, although she refrained from turning the matter into an international incident. She told the press that while her wig was not as long as Kershaw's, she was placed on the rock by her maid who arranged the wig around her, "furnishing sufficient covering," and, furthermore, that the scene was very brief and ended with her being covered with a cloak by the monk who discovered her. "'There is no suggestiveness in the part as I play it – it is simply naturalism in art.'"[49] The *Times* of London said only that Bannerman had taken on Kershaw's part

and her "performance is very pleasing, and she succeeds making of the rather artificial character she is called on to act a thoroughly natural young woman."[50]

The international press paid even more attention to Bannerman's performances when she toured Australia and New Zealand in 1928–29. Managed by fellow performer (and future husband) Anthony Prinsep, Bannerman took the comedies *Other Men's Wives*, *Diplomacy*, *Sixes and Sevens*, *The Marionettes*, and *Our Betters* to Sydney and Melbourne and, in New Zealand, to Wellington, Auckland, and smaller centres.[51] She would not have been a stranger to audiences in many of these cities: for one, the press in both Australia and New Zealand had covered her career, including her British films, prior to her arrival.[52] Moreover, in Australia the tour was well-publicized by Sir George Tallis, managing director of the Australian-based J.C. Williamson firm (which had helped bring Anglin to Australia in 1908), even before Bannerman boarded her ship. Not only did Tallis alert the press that the "famous," "'handsome ... young and talented,'" and "brilliant Canadian actress," was coming, he added to her desirability by telling the press it was only after two years of negotiations that he had induced her to come.[53] Even better, when Bannerman appeared in Melbourne, she would do so in a brand new building, the Comedy Theatre.[54] Bannerman was waved off, readers of Brisbane's *Telegraph* were told, by Australians in London with a farewell party at Claridge's, an event that further linked Bannerman, Australia, and England.[55] As she sailed closer to Australia, the press told readers that she was known to her friends as "Bunny" and that, although she had had more than her share of failures, she still was a "triumphant favourite" of the London stage: "in the right part, she is the most scintillating of them all, and her beauty is classic. Her method is hard and brilliant, and in smart repartee she touches the bulls-eye every time."[56]

Out of all the productions in which Bannerman appeared, *Our Betters* drew the most attention – and sometimes contention. Was the play's production in Australia a sign of the country's sophistication or lack of prudery? wondered Adelaide's *News*. That sophistication supposedly varied from city to city, since it was rumoured that Bannerman would open in more worldly Sydney with *Our Betters* and in less-urbane Melbourne with *Diplomacy*, leaving Adelaide to wonder where it stood on the scale of cultural maturity.[57] Bannerman herself was hopeful that Australians

would like the play, as she loved the "cynical, calculating" character of Grayston, had liked the Australians she had met in England, and "'hope [Australians in Australia] will like me.'"[58] Even before Bannerman arrived, newspapers ran synopses of the plot, letting audiences know that despite Maugham's reputation for lighter work, this was a "stinging commentary" on society, most notably American-British relations: so much so that the Lord Chamberlain had refused its performance in 1917, fearing that it might affect the United States' imminent entry into World War I.[59] The *Sydney Mail* thought that while *Our Betters* was not a "pleasant play," Bannerman was warmly welcomed by her audience, justified their high expectations of her, and was particularly powerful in the play's last act.[60] Although coverage of *Our Betters* was not as extensive in New Zealand, nevertheless Wellington's *Evening Post* review thought she was "artistic in every sense of the word," her performance greeted with much applause and laughter.[61] In contrast to these glowing appraisals of both *Our Betters* and Bannerman, Melbourne's *Advocate*'s review appears to have been one of the few unenthusiastic accounts. Calling the play "neither edifying nor particularly amusing," the reviewer believed that while its subject matter might have great relevance in England, where the social circles it satirized were widely known about, "it has no point here." *Our Betters* "is an ugly play, written frivolously," the reviewer concluded, and it was unlikely that it would have a good run in Melbourne. Of Bannerman's performance, the reviewer had little to say, except that the part of Grayston fit her "like a glove."[62]

Bannerman's other productions found mixed favour with Antipodean critics. *Diplomacy*, declared Melbourne's *Age*, was a "triumph in comedy of action," one in which Bannerman and her company shone; in the third act's highly emotional scene she took "possession of the audience" and reached "artistic heights."[63] Others, while appreciating Bannerman's beauty onstage, found the emotional passages of the script too much for her.[64] And a number of critics thought that some of Bannerman's scripts were notable only for their value as frivolous entertainment. A Wellington reporter decided that *Other Men's Wives* was a "dramatic cocktail compounded by a mixer who knows his business and what his people like … another instance of the truth that a good play and money-maker are not always the same thing." The writer admitted, though, that Bannerman was captivating, with her "good looks, personal charm, finished

Fig. 7.9 Margaret Bannerman, signed portrait for J.C. Williamson, c. 1928.

acting, and clear if sometimes rather rapid speech. To have seen her in this play quickened the desire to see her in the others to come." (The reviewer also was quite taken with Bannerman's "sparrow-leg blue silk pyjamas."[65]) Another writer was more enthusiastic, seeing Bannerman's work in the play as one of "consummate artistry": it was "little wonder" that Bannerman was "one of the greatest actresses of the present day."[66]

A Canadian or an English Actress ... or Both?

Although during their careers both women were frequently described as "English" or "British" actresses, the press also reminded its readers on both sides of the Atlantic that Bannerman and Lillie were born in Toronto and had moved to London with their families just as World War I broke out. Being a "Canadian" formed part of these women's identities as public figures; like those of their predecessors, though, it was a mutable form of identification, one that could be invoked when it suited both them and the press. Bannerman's and Lillie's Canadian origins may well have been deployed strategically and for good reasons, not least in an English context that saw a range of anxieties over the Americanization of British culture. Coming from a white settler colony that was the first to claim Dominion status and whose loyalty to the imperial tie had just been reaffirmed through its participation in World War I, Bannerman and Lillie could pass both as "British" and as highly respectable "colonials." Moreover, in the eyes of both the British and the Canadian press, there was little that was contradictory or contentious about a Canadian woman importing English culture to the United States (and, in turn, returning to England with a wealth of experiences that benefited her work on English stages). The media coverage of Lillie and Bannerman suggests how depictions of transnational movement could be intertwined with discourses of empire and imperial sentiment.

Bannerman's tours of Australia and New Zealand also demonstrate how being both English and Canadian might bolster a performer's image. She was welcomed as a "famous English actress" whose career in London had "imbued [her] with the highest traditions of English stage."[67] Yet Bannerman was also a "lovely Canadian, now one of the idols of London theatregoers."[68] Her trip to Australia even introduced her to a countrywoman, Winnipeg-born dramatic actress Gywneth Grahame, who (the

Fig. 7.10 Margaret Bannerman photographed reading in her Australian home, c. 1928.

press was pleased to announce) was eager to meet Bannerman. Currently starring in *The Trial of Mary Dugan* in Melbourne after appearing in New York productions, Grahame had wired Bannerman's ship to introduce herself and suggest the two meet.[69] (Bannerman and Grahame must have met at some point. At a murder trial, they were reported to have "gone to extraordinary lengths" to gain admission to the crowded spectators' gallery.[70]) Bannerman's dual identification was a useful form of promotion when she toured Australia, since during the 1920s certain cultural nationalists decried American influences as degrading and decadent, a threat to the British values that made up Australia's cultural heritage.[71]

The press (and, no doubt, the women's press agents) also depicted them as down-to-earth. In Australia and New Zealand Bannerman was seen as friendly, very likeable, and always willing to help and offer advice, whether the matter was acting, clothing, or hair and beauty tips. "And has lovely Margaret ever been found in an off-colour mood?" one reporter asked. "No, never – always smiling, always charming."[72] One writer went so far as to analyze Bannerman's handwriting, which, they claimed, told readers much about her professionally and personally. Perhaps not surprisingly, her handwriting demonstrated a high level of musical talent, an ability to lose herself in any character and to be a "quick study," possessing a highly developed sense of rhythm and "fluidity," and a fondness for new challenges and new worlds to conquer. It also showed that she was bright, cheerful, logical, intelligent, generous, and warm-hearted; that she loved beauty, aesthetics, and animals; and that she was a "home-loving" person "when free from her profession," and a "splendid hostess" to boot.[73] One reporter, reflecting on the fact that "unlike many other stage stars Bannerman does not look for a maid to wait upon her hand and foot" but looked after herself, speculated that perhaps "this is the 'colonial' coming out in her. She comes from Canada."[74] "Real-life" snaps of her taken with her company, reading at home, with her new husband (fellow actor Antony Prinsep), and with her beloved dogs (which included a "prize Alsatian" given to her by a New Zealand admirer) underscored just how unpretentious and approachable Bannerman was.[75] Far from being aloof, moody, temperamental, or demanding, which for some might have been the hallmarks of the successful female artist, Bannerman was a young woman who could easily be a reader's ideal daughter, sister, or – possibly – future wife, welcome

both in one's theatre and in one's home. All these likeable qualities could be traced to her Canadian origins. And, although the American press did not always ascribe Lillie's character and behaviour in Manhattan society to her birthplace, they went to great lengths to construct an image of her that was fun-loving, often fearless, and unfazed by social pretentions: a type of offstage performance that closely resembled her professional work.[76]

Just as their predecessors had written about aspects of the countries they travelled to, these actresses could serve as popular ethnographers of the societies they visited. Interviewed in 1932 by Harry Goldberg for *The Minneapolis Star*, Lillie was asked about her impressions of the United States and provided a commentary that ranged across class relations, social customs, gender relations, and child-rearing. She told Goldberg that in the United States money was "the magic word that opens doors," whereas in Britain brains and intellectual "reclaim" were key to social advancement. However, despite the changes brought about by World War I, British class lines still held firm, and formality ruled social gatherings, something Lillie thought admirable. "'In England living is a business,'" she declared, "'but in the United States business is living.'" While an Englishman's dressing for dinner might be "'a pose ... there is the same kind of boyishness in the American's carelessness and indifference in dress. Too busy with such very important matters to let myself be annoyed with the mere matter of clothes, yes, yes,'" Lillie declared, accompanying her comment with a "sly shrug." Moreover, higher divorce rates in the United States suggested its stability was more declared than real. English marriage "'is so much more solid'" and English youth worked harder at their marriages, perhaps because they married later and had more "settled personalities.'" Lillie also noted a distinct gendered difference in matters of dress. While American men were distinctly dowdy, their female counterparts were much better turned out than English women. All these trends were beginning to affect British women but, nevertheless, they were still far behind their American sisters, whom she praised for their spirit of "'get-up-and-go'" and their youthful appearance.

Lillie was not, however, entirely in favour of all aspects of American society. She believed English children were better disciplined and that American notions of independence led to more "'extravagant attitudes'"

and a taste for speakeasies. Lillie was uneasy with the ubiquity of liquor at American social gatherings (one could have just as much fun at British tea, she thought) and American patterns of hard drinking, particularly among the young. She admitted, though, that when it came to the question of well-off men's employment, upper-class American men did not "'lose caste'" if they entered a trade or profession, unlike their Oxbridge-trained British counterparts who saw such careers as beneath them. Although she refused to rank the handsomeness of either group of men, she admitted that because of their love of sport British men tended to have "'neater, trimmer, figures,'" while their American counterparts were so tied to business that they often forgot to enjoy themselves. Goldberg admitted, though, that she answered his questions with "that famous twinkle in her eye which one interprets to mean that society and all measure exactly nothing to the famous comedienne." Moreover, although Goldberg thought that Lillie's liking of the United States (a curious statement that suggests that he glossed over her critiques of the country) might suggest she was an "English girl who has sold out her caste and adopted America," such a position was not tenable or stable. Lillie "really belongs to North America," originating from a small Canadian town. Like reporters of the late-Victorian and Edwardian years, Goldberg assimilated Canada into a continent-wide formation.[77]

Glamour and Beauty in the Interwar Years

Like their predecessors, Bannerman's and Lillie's likeability extended to other realms, most notably their sympathies towards less fortunate others. Both women supported many charitable causes on both sides of the Atlantic (and, in Bannerman's case, Australia): invalid and poverty-stricken children, settlement houses, hospitals, orphanages, veterans, and the Actor's Fund.[78] Like her predecessors, Lillie also received more personal appeals for help. From Palmerston, Ontario, the Reverend Allen Leslie Howard wrote to ask "Lady Peel" (then staying at Toronto's Royal York Hotel) if she might contribute to the reforestation and beautification of the forest near the home of her grandparents, a place that was her "girlhood haunts." While their old log house had been torn down, the little church was still standing and Howard, an early student missionary in Muskoka, was helping to plant trees in the area. He was

"sorry that I dwell so distant from Toronto that I am unable to attend to your entertaining art this week. But my great incentive in life come to you by means of the pleasures you afford your fellow Canadians by your esteemed visit to Canada."[79]

Generosity, as well as a lack of artifice, thus were part of Bannerman's and Lillie's attractive personalities: they also, though, were matched by attractive faces and figures. Reporters judged both women to be fashionable and visually appealing, albeit in somewhat different ways. Lillie, one writer declared, was the first to have an Eton crop (and seemed "determined to be the last to have one"); at times the style was synonymous with her.[80] Some, though, were dubious about classifying her as a "beauty." William Pollock thought Lillie, along with Gertrude Lawrence, Cicely Courtneidge, and Gracie Fields, was abundantly talented but doubted that many would think of her as beautiful (only a handful of actresses, a group that included Bannerman, were both).[81] Julia Blanchard classified Lillie, along with other female performers such as Lawrence and Joan Crawford, as "distinguished," as opposed to the many "exotic" beauties of both Hollywood and on the stage. From Blanchard's perspective, a distinguished star was able to wear "million dollar clothes and gems without looking ostentatious."[82] No matter how critics assessed her, though, Lillie's slight, boyish figure, her Eton crop, and her air (at times) of careless glamour were very much in keeping with the image of the Modern Girl of the 1920s.[83] Lillie also shared the secrets to her slender, youthful look, telling Ida Jean Kain that she loved food but ate only two small meals a day and did not like desserts; stated she did not exercise but in fact walked three miles a day because she enjoyed it; and avoided crow's-feet because she spent all her weekends in the country, swimming, playing tennis, and having fun. Lillie, though, professed not to care about her appearance and thought that glamour was very much in the eyes of the beholder (particularly those of the press).[84]

Yet, while Lillie's carefree attitude may have suggested that she eschewed the glamorous look of a leading lady, there are many hints in the press that suggest otherwise. After a photography shoot in 1935 at a smart Fifth Avenue studio for which she had worn a $3,000 ermine wrap, Lillie was so taken with the coat that she bought it on the spot, columnist O.O. McIntyre told his readers.[85] One year later Lillie posed for the press wearing a silver mesh and green velvet evening wrap, one

Fig. 7.11 Beatrice Lillie, studio portrait, c. 1920s.

that could double for a southern resort as well as urban nightlife, that she told reporters had been inspired by Ethiopian emperor Haile Selassie's cape.[86] Los Angeles fashion reporter Sylvia Blythe used Lillie's wardrobe, offstage and on, as a way of demonstrating to her readers the

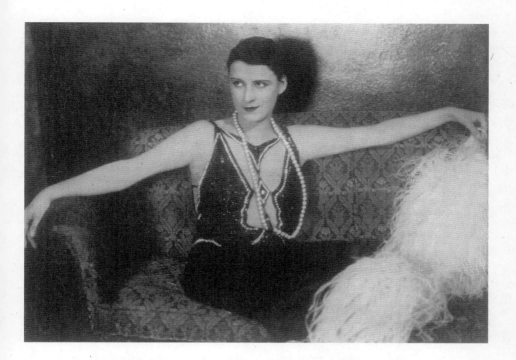

Fig. 7.12 Beatrice Lillie, *Illustrated London News*, c. 1920s.

value of harmony, simplicity, and good taste in dress. (This was very unlike her character Mrs Rowntree, a charity bazaar organizer, with her fancy heeled sandals, frilly, lacy dress, "fussy feather cape," and hairdo replete with curls and orchids: the epitome of how *not* to dress.) Lillie's sartorial advice included one "smart piece of costume jewelry," no corsages to be worn in the hat or hair, plain hairdos if one's gown was elaborate (and vice versa), and, above all, the right heel: no overly high heels but no flats, either, as they were unbecoming. Furthermore, foundation garments should be well-made, and above all, girdle-tugging should be avoided, along with jerky movements and fussing with hair and dress.[87] Although Lillie's long face and turned-up nose made her a favourite with caricaturists, she also posed for the camera wearing evening gowns, jewels, and glamorous shoes.[88] Lillie became so ubiquitous a figure in McIntyre's columns, being mentioned for her hair, clothing, nightclub appearances, choice of dinner menu, and even her presence on the city's streets with her husband, that readers might be forgiven

for assuming that she was a permanent resident of Manhattan; in those columns she appears not so much a "sweet Canadian girl" as a sophisticated cosmopolite.[89]

There was no doubt, though, that Bannerman was a model of fashionable beauty. Reviewers of her onstage appearances invariably commented on her looks, noting her lovely frocks and her ability to carry them off with style. Bannerman, claimed Toronto's *Saturday Night*, "gives me a shock because she is ... so shockingly well-dressed. Watching her in *Engaged*, it was hard to believe that there was not a man in the audience who, on seeing her hat, shoes, gown, and coiffure, did not suppress an involuntary, 'By George!'" Moreover, all the women would immediately have been taking mental notes of Bannerman's appearance. Even while Bannerman was "acting away," her lines fell on deaf ears, so stunning was her appearance: she combined being beautifully dressed with being beautiful.[90] The "succession of smart frocks" she wore in *A Hen upon a Steeple* were greatly admired by *The Times*, and the paper provided extremely detailed descriptions of them, their materials including pleated crêpe-de-Chine, black velvet and satin, gold lace and tissue, and diamond and emerald accessories.[91] In a photo spread shot by English photographer Dorothy Wilding (who also took a number of studio portraits of Bannerman) and shared with Tallulah Bankhead, Bannerman's dresses were described in great detail, ranging from an orchid-coloured crêpe-de-Chine tea-gown trimmed with ostrich feathers to an ivory georgette evening dress, embroidered with silver beads and crystals.[92] In *The Mouthpiece*, Bannerman wore a "delightful" lightweight spring suit of powder blue, with a matching handbag of wool lace; in the last act the skirt of her primrose yellow ensemble boasted almost five hundred small pin tucks, with a handbag that not only matched her dress but displayed her character's initials.[93]

Such lovingly detailed portraits of an actress's costumes were not new, nor was the relationship between fashion and the stage. In Bannerman's case, though, writers added an extra fillip of sophistication and glamour by emphasizing the Parisian origin of her wardrobe, on- and offstage. Even when she bought costumes from an unnamed English male dressmaker, the press underscored her ties to Parisian couture by reminding readers that she usually patronized French designers. Moreover, her shoes were French: "forty pairs!"[94] The *Daily Mail*'s "Editress"

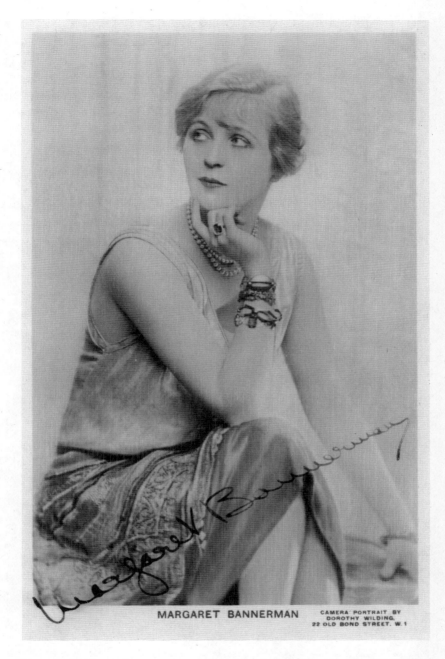

Fig. 7.13 Margaret Bannerman postcard, photographed by Dorothy Wilding, c. 1920s.

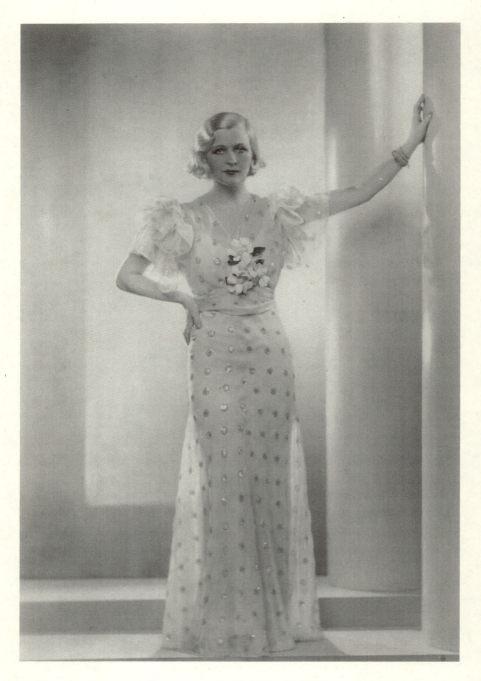

Fig. 7.14 Margaret Bannerman portrait by Dorothy Wilding, c. 1930s.

of its woman's page visited a Paris fashion house and was delighted to be shown some of the dresses that Bannerman would take on her tour of the Antipodes.[95] Prior to Bannerman's landing in Perth, the press in both countries went to great lengths to tell Australians and New Zealanders that with Bannerman would arrive the height of modern fashion. Article after article repeated the designation of her as the "best-dressed woman on the London stage" and told readers that Bannerman's Antipodean wardrobe, particularly her costumes, had been ordered specially by the actress herself in Paris.[96] Although when Margaret Anglin toured Australia her wardrobe had received much detailed attention from the reviewers,[97] in Bannerman's case fashionable, beautiful clothing became synonymous with the actress. Reviewers devoted part of their reviews to her wardrobe changes, while those who interviewed Bannerman or wrote columns about her inevitably discussed her clothing.[98] Bannerman's costumes in *Our Betters* and *Diplomacy* had made such a "stir" that women bombarded her with letters asking her about her wardrobe on- and offstage. One had written to ask if she could make a copy of Bannerman's "'wonderful'" silver dress from *Our Betters*; another, a dressmaker, asked if she could see Bannerman's dresses in *Diplomacy* privately, as she would like some tips about "'the latest from Paris.'"[99] Moreover, photographs of Bannerman were ubiquitous in the Australian newspapers: the press ran publicity stills of her in various costumes, head and shoulder portraits, and, as Figure 7.10 demonstrates, "at home" photographs that emphasized her fashionable clothes. After Bannerman returned from her tour she continued to shop in Paris for her clothing, buying dresses from noted couturier Paul Poiret.[100]

She was more than a clotheshorse, though. Bannerman, declared Canadian writer A. Beverley Baxter, was one of the three most beautiful woman on Britain's stages.[101] For her admirers, she was the epitome of English feminine beauty, her blonde hair and fair skin emblematic of a youthful, modern "Englishness," although she also could typify ideal "Canadian" or Anglo-American femininity.[102] Some went even further. According to the author of "Beautiful Women. Empire Contrasts," an article first run in London's *Daily Express* and then reprinted in the Australian press, Bannerman was one of the British Empire's great beauties, to be compared with the "famous English national beauty" Lady Diana Duff Cooper and Australia's Phyllis von Alwyn. With her "rose

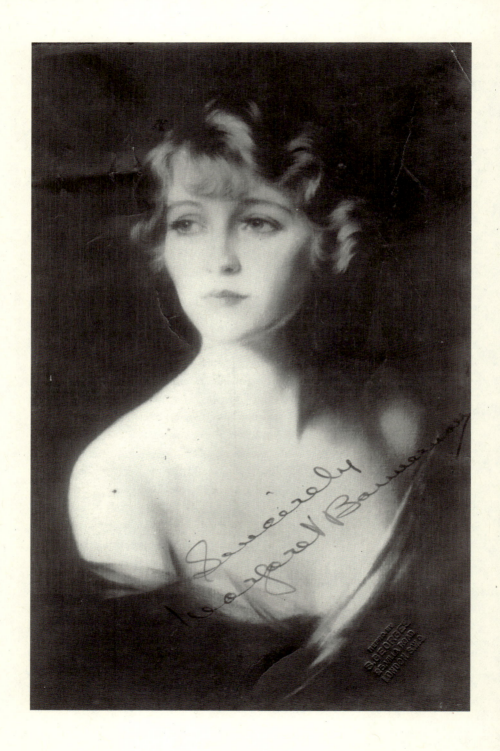

Fig. 7.15a and b Margaret Bannerman portraits, c. 1920s.

leaf complexion" and "pale golden hair that is almost the color of winter sunshine" (a feature all three women shared), Bannerman "represents a type that will become standardized beauty in the future."[103] At least one American newspaper picked up the story but tweaked it for its own purposes, stating that "Empire Can't Pick a 'Miss Britain;' Types of Beauty Too Numerous." The reporter felt that the three "Venuses of the realm" (Cooper, von Alwyn, and Bannerman) exemplified three very different styles of beauty, making it impossible to "reconcile accepted standards of British comeliness" and concluding, "not yet has Britain been able to agree upon a representative English beauty who represents national excellence as does Miss America in the United States."[104]

Despite the American reporter's reservations, Bannerman was to be greatly admired for epitomizing imperial white femininity. What was more, she could provide inspiration and advice to other women, augmenting her celebrity by acting in a public capacity as a fashion and beauty consultant. Interviewed for a 1923 article about hobble skirts, Bannerman declared they were "ugly and impossible. How can a woman walk well and have a decent carriage when she is held in by a yard of material or less? And the English girl of today walks so well and so gracefully."[105] Not only was Bannerman a wearer of Parisian frocks, she also could be trusted for an update about the current state of fashion in that city (very long, cut on the bias, mostly black, and – in the case of the one she bought – accessorized with mittens).[106] "Women," wrote an American reporter, go to see the "London stage beauty" for her clothing as well as her acting, making her a style-setter.[107] Her hair, too, was discussed by reporters. Bannerman voiced her opposition to the extreme form of "the shingle" (Lillie's Eton crop), arguing that the drive for originality now "'must be stopped,'" since women would have to either shave their heads or let their hair grow long again, adding, "'they must be guided toward the alternative before it is too late.'"[108] Bannerman's "fragile fairy fringe" (light, wispy bangs) added great charm to her look, one she shared with Gracie Fields, the Duchess of York, and Princess Elizabeth, declared the *Daily Mail*. What's more, it was a decidedly "womanly affair" and was best when paired with beautiful eyes and perfectly shaped eyebrows.[109]

Bannerman also weighed in on the means by which a woman could attain – and maintain – beauty. In an interview conducted in Australia, "There Are No Ugly Women! Margaret Bannerman Discourses

on Beauty," Bannerman stated that every woman had a good feature, but personality and character were the key elements in a woman's attractiveness and would outlast mere prettiness. Moreover, "Australian girls have no excuse not to be beautiful. Beauty is in the air. The very atmosphere radiates health and happiness, the best ingredients of good looks. The sunshine brightens the hair and brings a rosy glow to the palest cheeks, and the air is like wine to blood. I feel my own heart rise in joyous ecstasy every time I go out on the harbour." On her Sunday morning fishing tours with her husband, "we see girlhood at play – healthy, happy; the spoilt darlings of nature, sun-kissed, bubbling with the joy of life."[110] For those who could not travel to Australia, Bannerman offered them her own beauty tips for hair, skin, hands, and weight.[111] Taking care of one's looks, Bannerman proclaimed, was a "duty" and it could be done not by spending large amounts of money but instead by looking after one's complexion and hair on a daily basis, with a good diet – fresh fruit, milk, eggs, green vegetables, and fish – and plenty of water. Bannerman was not opposed to makeup, though, suggesting that it should be applied lightly in hot weather (a lesson she learned "in the East") and "of course" finished with a dusting of rice powder. Proper exercise and sensible clothing were equally important. In Australia and in the "tropics" she passed through on her journey there and back, she informed British readers that she learned the value of exercise, even in very hot weather: "it keeps you tuned up," she concluded.[112] But excessive dieting was to be avoided. Bannerman warned her audience about the dangers of "'slimming,'" telling them that it made her appear "'the world's most ancient woman,'" injuring her health and fraying her nerves.[113]

Like Lillie, who advertised products such as Lux soap, ginger ale, and cigarettes, Bannerman also lent her name to a number of goods.[114] She spoke at great length for Pond's Cold Cream, advertised Khaa Beauty Treatment, visited Wright Brothers store for its birthday celebrations, told readers that she kept her "lovely stockings beautiful" with Lux Soap, and endorsed the Evans' Electric waving comb at its booth in the 1930 *Daily Mail* Ideal Home Exhibition at Olympia.[115] Like a number of other actresses in the 1920s and '30s, she also appeared in a cigarette advertisement, posing seated in her dressing room waiting to go onstage, wearing a black velvet dress and holding up a hand with a cigarette to show off not just it but the cut of her full, draped sleeves.[116]

Fig. 7.16 Margaret Bannerman advertises Condor Hats, 1926.

The messages that Bannerman — and those who helped craft her celebrity — promoted were somewhat mixed, though. Her Paris frocks and her air of glamour and chic fashion made Bannerman an admirable (certainly a desirable) figure, a woman whose sartorial sophistication made the English stage and English society in general up-to-date and, especially, modern, while simultaneously upholding older patterns of transnational fashion in which Paris was the apex of cosmopolitan style. Her modernity, however, was in many ways a conservative one. So far as her glamorous style was concerned, Bannerman's image was that of upper-class luxury, her body clothed in dresses of silk, chiffon, and fine wools which featured hand-beading, hand-stitching, and delicate lace. What was more, the press made it clear that, just as she was constantly changing clothing while at work, much like those upper-class women that Bannerman often portrayed onstage, a good part of her offstage life would be spent shopping for and choosing clothes, then changing into and out of them from morning wear to afternoon dresses to evening gowns, none of which could be done without a substantial amount of domestic help and an ample income. The fact that Bannerman's images were so often found in conservative newspapers — *The Times*, *Daily Mail*, *Daily Express* — also would have underscored the class-based nature of her image.[117] Yet this reading might not have been the entire story. For one, through the medium of her advice columns, readers were meant to see Bannerman as wholesome and uncontrived, someone whose simple counsel — if properly followed — would result in a greater enjoyment of both their own appearance and possibly life in general. Moreover, the very detailed descriptions of Bannerman's clothing, while obviously emphasizing its costliness, also might have been an inspiration to her female audience members. Although few could afford hand-beaded or embroidered silk, they might have sought to emulate her style in cheaper, mass-produced fashion or by sewing their own clothing, a practice that by the 1920s had a long history in Europe.[118] As we have seen, the press made it clear that Bannerman had her share of "gallery girl" admirers. In London twenty young women named Dora formed a "Dora Club," said *The Daily Mirror*, named after Bannerman's character in *Diplomacy*. These young women came to see the play as a group; after the curtain they went to Bannerman's dressing room to introduce themselves, then followed up their visit by sending her a copy of *David Copperfield* (whose

heroine, of course, is Dora), which they had all autographed.[119] One year later Bannerman was reported to have been "thrilled" to have received a call at London's Streatham Theatre from a group of Sydney "gallery girls" who wished her a happy New Year.[120] These young women's attentiveness to Bannerman suggests a potentially more complex relationship of actor to audience than designating Bannerman as an emblem of conservatism can capture.

Private Lives in the Interwar Decades

Other aspects of Bannerman's and Lillie's personal lives intrigued the press, British, North American, and Antipodean. Although the late-Victorian and, particularly, Edwardian press scrutinized the intimate details of actresses' lives, during the 1920s such scrutiny appears to have intensified.[121] Bannerman's first marriage to fellow actor Pat Somerset evoked much curiosity. Described by reporters as a "romance of the theatre," as the two met while playing leading roles as lovers in the London production of *Three Wise Fools*, Bannerman and Somerset began their married life without a proper honeymoon, instead flying to Cowes for a weekend before returning to work.[122] Two years later, though, press coverage of their relationship no longer featured their romance but, rather, its unpleasant aspects, uncovered during their divorce. The marriage was dissolved on the grounds of his adultery with fellow performer Edith Day and his cruelty, charges that were fleshed out considerably in the newspapers. Almost immediately after their honeymoon, Somerset, Bannerman charged, had "begun a course of ill-treatment which ultimately broke down his wife's health."[123] He demanded money from her to cover his bad cheques, which she attempted to deal with by borrowing £500 from moneylenders, giving him half her salary, and selling her pearls. Her dresser, Eva Mary Gardiner, also testified that Bannerman had told her Somerset had threatened to throw vitriol in her face, "so that no other man should look at her." Somerset also bullied and swore at his wife, drank heavily, and told her that he had contracted a venereal disease before their marriage (on consulting a doctor, a fearful and frantic Bannerman found this to be a lie). To make matters worse, Somerset assaulted her several times: one harrowing incident involved his taking her to some "'particularly unpleasant, smelly, and noisy rooms in Frith

Street, Soho,'" where he accused her of being the lover of a man from whom she had borrowed money to cover Somerset's debts. When Bannerman attempted to phone a friend, Somerset knocked the phone out of her hand, "dragged her upstairs to her room, threw her on the bed, shook her violently, and locked her in," leaving her all night. He also caused a scene at the theatre, "'nagging'" at her onstage and bringing her to tears, at which point she fled to her dressing room, followed by Somerset, who continued to curse and shake her. After such a narrative of abuse, the revelation by Annie Gunn, actress Edith Day's dresser, that Day and Somerset had spent nights together and were now sharing a home in Torquay may well have seemed anticlimactic, almost beside the point.[124]

Unlike those young women whose trials were covered in the British press and registered concerns about modern English femininity in the 1920s, Bannerman was depicted as a victim of brutish (and brutal) masculinity.[125] There is no hint in the press coverage that she might somehow have "provoked" Somerset or that her success onstage had undermined him as the head of their domestic – and theatrical – union. It is highly likely that her youth, her growing popularity on the London stage, and her "blonde beauty" played a role in casting her as the innocent and injured party. Moreover, the press coverage of the divorce almost invariably mentioned that the "petitioner is a Canadian." While that phrase may have been formulaic, one wonders if Bannerman would have received such a sympathetic treatment had she not been from a settler Dominion. It is possible, though, that for some readers her divorce hearing served as a kind of morality tale about celebrity. Just as earlier "experts" had warned about the potential dangers a career might pose to an actress's health, Bannerman's private life might be a warning about the less pleasant consequences of being in the public eye even when one was the object of sympathy.

During her divorce Bannerman also became the object of an extortion attempt. A young engineering student, Oliver Harold Barron, was sentenced to nine months at the Old Bailey for sending a letter to her in May demanding £25 or he would send to the king's proctor information about her impending divorce. Bannerman responded, though, by contacting the police, who set up surveillance and, after Barron had sent her letters, intercepted him in her dressing room. Said to be of "previous good

character," Barron apologized to Bannerman and hoped for her forgiveness, hoping that he had not ruined his "prospects" for his upcoming exams at the East London College of Engineers. In his client's defence, Barron's lawyer claimed the attempted blackmail was a "'mad act' due to a temporarily deranged mind brought on by excessive study."[126] In this case, Bannerman appeared not as a battered and brutalized wife but, rather, as a sensible and plucky young woman who kept her head and called in the authorities.

American coverage of Bannerman's divorce, though, told a somewhat different story, albeit not one drawn from the court hearings. The *St. Louis Star and Times* covered it as "the most sensational stage divorce case in many years in London, involving members of British society." The sensation, though, could be attributed to the protagonists' social standing and the fact that Day was married, not to Somerset's treatment of his wife.[127] Later that year the paper ran an "exposé" of the matter and attributed the divorce not to Somerset's drinking, violence, or financial problems (in fact, the paper's full-page spread said nothing about those matters) but, rather, to the actions of the British aristocracy, most notably those of the Duke of Manchester, William Montagu. "If the high-stepping Duke," the paper claimed, "hadn't given that whizzy house party for his select London theatrical friends, the sun of love might still be shining on the respective households of the Somersets and the Carletons" (Edith Day had been married to the American theatrical producer and conductor Carl E. Carleton). Somerset, "champion girl-charmer of the British stage, might still be married to Margaret Bannerman, the beautiful Canadian actress." However, the duke, determined to have "one of those awfully jolly old jamborees at his historic diggings not far from London, don't you know," brought Day and Somerset together with, the paper felt, almost predictable results. But equal blame should be laid on the shoulders of Bannerman and Carleton. "Where, oh where, was the beautiful Margaret Bannerman that she could have permitted the partner of her 'perfect marriage' to encounter the starry eyes of Edith Day? Of what, oh, what could the fond Carl Carleton have been thinking to let business interfere with devotion when 'Beau' Somerset was on the love path?" While certainly male violence played a role in this narrative, it was not Somerset's but Carleton's, who gave his wife a black eye upon

discovering her liaison, something the paper dismissed breezily as his having forgotten that "knocking out ladies isn't done in the best society anymore" (although Day called the police and Carleton was charged with assault and battery). But while London "mourned even while it hashed over the racy details," with some blaming Somerset while "others laid it all to those fearful Americans," the paper concluded that "there were chappies who ventured the observation that his grace, the Duke of Manchester — and his jolly old jamboree of a house-party — were the cause of it all."[128] English aristocrats, with their decadent habits, not male violence, were to blame for the end of the "English" romance. In 1928 Bannerman married fellow actor and manager Anthony Prinsep during their tour of Australia; although that too ended in divorce, it appears to have been a much calmer and less fractious union.[129]

The public face of Lillie's marriage was a stark contrast to Bannerman's unhappiness. On 10 January 1920, Lillie married jazz musician Robert Peel, son of Sir Robert Peel, at St Paul's Church in Fazeley, Staffordshire. Although not a London society wedding, the event appears to have been more elaborate than Bannerman's. The local paper reported a large crowd gathered outside the church to watch the bridal party arrive, while inside a "full congregation included many members of the London theatrical profession who travelled from London by special train." Officiated by two vicars and the area's rural dean, the service included choral music and ended with Mendelssohn's "Wedding March." Lillie "was a charming figure in her beautiful dress of silver tissue, with silver-worked sleeves and underskirt, with bunch and streamer of orange blossom. The full court train was of brocaded satin, with a large bunch of ostrich feathers in the corners. Her veil was of white net, with Russian coronet wreath of orange blossoms. She carried an exquisite bouquet of lilies and lilies of the valley." The paper went on to provide details of the page boy's outfit (he was the son of one of Lillie's fellow performers) and bridesmaids' dresses "of exceptional taste and attractiveness." After the ceremony the couple drove slowly through the village, acknowledging the well-wishes of the residents, and under an archway erected at the entrance to Drayton Manor, at that point the Peel family home. Here a "large number of guests were entertained in first class style." The reception over, the couple left for a honeymoon in the south of France, for which Lillie

Fig. 7.17 Beatrice Lillie and Robert Peel. *Eve Magazine*, 10 Aug. 1927.

sported a "black velvet jacket, with white Eton collar, white shirt blouse, and plaid velvet skirt, bordered with a narrow band of Persian lamb, and hat to match."[130]

After Sir Robert Peel's death in 1925, the press in both the United States and Britain frequently worked in references to Lillie's new status, calling her "Lady Peel" as well as the more familiar "Beatrice Lillie."[131] Such references added a layer of celebrity and interest to her audiences, suggesting that she was both "stage royalty" and a member of the British social elite. Yet depicting Lillie as a "Lady" did not mean that the press adopted a more reverential or respectful tone in reviews of her work. The press (and quite likely Lillie, with the help of her press agent) continued to portray her as a loveable, highly talented, but somewhat madcap and irreverent performer.[132] Moreover, Lillie was said to dislike "society" and prefer the stage. Lillie herself did not see why she should try to be "'the character that novelists and playwrights would feel Lady Peel should be.'" After all, she had been born Beatrice Lillie, had taken the theatre as her profession, and "'that is the real me.'" There was no reason why she should "'drop my career and preside over the teacups in Mayfair.'" Her husband agreed with her; the only dissenter in their household was their son Bobbie, who, according to Lillie, disliked her dressing up in stage costumes "'that make me appear ugly.'"[133] Even Lillie's taste in food was simple, as she preferred dishes such as chicken salad, steak and kidney pudding, and Brussels sprouts to caviar and other exotic fare. Lillie's preference for plainly cooked and fresh food was the legacy of her childhood in Ontario, Canada, from which "she departed with her mother and sister to tour the Canadian mining towns as a concert trio."[134]

While Peel did not garner the same amount of attention as his wife, on occasion his name surfaced in the press. In 1926, for example, he was reported to have "rushed" to the United States when his wife was named in a suit by Mrs Timothy Whelan, a Hollywood screenwriter. Whelan claimed that Lillie had alienated her husband's affections and was asking £20,000 in damages. Peel expressed "his utmost indignation at the aspersions on his wife" and Whelan withdrew all her charges.[135] Very little was said, though, about Lillie's relationship with her husband, although on occasion the press hinted at the presence of tensions. On docking in New York in 1920, four months after her wedding, Lillie was said to have been relieved that America had prohibition. According to the *Finland's*

captain, Peel had been the "'life of the ship'" across the Atlantic, engaging in a number of "'hair-raising'" stunts.[136] Just under a year after Peel's death in 1934, a "sobbing, auburn-haired Mrs. Doris Draper" contended in a London courtroom that Peel had accepted responsibility "for her large dressmaker's bill," had lived with her for five years (during which time she was known as "'Lady Peel'"), and was going to divorce Lillie to marry her.[137]

The possibility that Lillie might have had affairs did not seem to have excited much speculation, although on a few occasions the press tied her to the Prince of Wales. Writing about his refusal to marry and his penchant for West End revues, *Chicago Tribune* reporter John Dickinson Sherman linked Lillie to the prince as one of his "gay companions" at post-theatre dinners.[138] On the prince's ascension to the throne, the *New York Post*'s Michel Mok pointed out that the new King Edward VIII preferred women who were beautiful, charming, spontaneous, glamorous, and spirited, all qualities that he was more likely to find in "actresses, dancers, follies girls, night club entertainers" than royal or well-born women. While quite fond of Gertrude Lawrence, he was also very taken with Lillie and had seen her Charlot Revue skit as a "burlesque Britannia" fifteen times. But when asked by a reporter about their "friendship," the prince joked that although he loved her, it was because "'she reminds me so much of my grandmother – Queen Alexandra.'"[139]

Although Peel's letters to his wife suggest considerable tensions in their relationship, and letters from the estate's manager also point to the dire financial situation that he left at his death, their problems did not make their way into the press.[140] Lillie's relationship with her son Bobbie received more public attention than her marriage. Most of this coverage focused on the logistics of Lillie maintaining a transatlantic relationship with Bobbie, as she was frequently in the United States during his childhood and adolescence. Lillie, the *Daily Mail* reported in 1929, was going to forgo a weekly salary of over £2,000 at New York's Palace Theatre to take Bobbie to a preparatory school in Switzerland.[141] Five years later the press noted that "Beatrice Lillie Journeys 3,000 Miles to Send Her Son to School," as she had travelled back to England from New York, "working as only 'Bee' Lillie knows how," to see Bobbie before he started at Harrow. Mother and son holidayed at Bourne End, her home in Buckinghamshire where Bobbie was staying with Lillie's mother, enjoying

vigorous canoeing expeditions but also frequent "mother and son" talks. "'We don't see as much of each other as we should like,'" Lillie confessed, "'for I am nearly always working in the United States, but we take it in turns to visit each other during the summer holidays.'" Although it had been Bobbie's "turn" to visit Lillie, she had been frightened by outbreaks of infantile paralysis in the United States that summer, so decided that she must make the trip across the ocean. She noted that although she had been offered a contract in Hollywood, it would only allow her to see Bobbie for three months, which was not long enough. Bobbie himself had been offered a Hollywood contract for a leading role in *David Copperfield* but his mother preferred that he attend school "and mind his own business."[142] While a few newspaper accounts portrayed Lillie as being a bit scatter-brained – one pointed out in 1932 that she had mixed up the dates of Bobbie's school vacation and therefore had turned down work she could have taken[143] – they did not hint that she was a negligent mother because of her long-distance parenting. For one, boarding school was the norm for English boys of Bobbie Peel's social status, so Lillie was simply providing the expected and desirable form of education for her son. As well, the press depicted Lillie as a very hard-working woman whose choice of career necessitated movement back and forth across the Atlantic: she was not an irresponsible or self-centred socialite. Furthermore, unlike the correspondence between Lillie and her husband, letters sent between Lillie and Bobbie suggest a happier relationship, one marked by great affection on both sides and Lillie's care for Bobbie's future.[144] Yet when Bobbie's plane went down over Sri Lanka during World War II and he was presumed dead, Lillie's stoicism impressed the press, who noted that despite receiving the news just before curtain, she insisted on carrying on with her New York show.[145]

Conclusion: Canadian Actresses, Modernity, and Interwar Conservatism

Margaret Bannerman and Beatrice Lillie were far from the only embodiments of interwar modernity on the London stage, of course. More to the point for our purposes, they were not the only Canadian actresses to encapsulate, on- and offstage, a femininity that suggested luxury and great beauty, coupled with a close relationship to elite society and the

aristocracy. Born in Montreal in 1902, Frances Doble came to England in the early 1920s and made her first professional appearance as Hélène in Seymour Hick's production *The Man in Dress Clothes*. She subsequently worked for the Birmingham Repertory Company for fifteen months, appearing in productions of Shaw and Wilde; in London she received very positive reviews for her work in the drama *The Goddess*, in which she moved audiences to tears with her portrayal of a wife whose young son contracts meningitis.[146] Doble went on to perform in the revue *Vaudeville Varieties* (and was "quite satisfactory in what must be rather an unfamiliar atmosphere," thought *The Times*); she also was a "very arch and fascinating rogue " in the "crook play" *The Black Spider*.[147] However, as Doble's obituary in *The Era* pointed out, it was her role as the female lead in Noel Coward's *Sirocco* that garnered Doble a great deal of publicity, although it would not be the kind most actresses desired.[148] On its opening night, the audience at *Sirocco* booed so heartily at the curtain call that Doble's short speech could not be heard. They were voicing their displeasure with the play and not with her performance, which *The Daily Mirror* called "charming" and which *The Daily Express* thought was the play's only saving grace; however, *Sirocco* closed after less than a month's run.[149]

Although her experience in *Sirocco* was no doubt upsetting, it was not the end of Doble's career. In *Young Woodley*, Doble played the young wife of a housemaster in a public school with whom one of the students falls in love, a role in which she was "gentle and charming."[150] She also appeared in *The Chinese Bungalow* as a young woman whose sister has married a wealthy Chinese man with rubber plantations in the "Far East." Doble's character Charlotte Merivale rivals her sister in looks and "creates havoc" with the affections of both her brother-in-law and the "only accessible Englishman planting rubber in the neighbourhood." Described by *The Times* as a "'melodrama of the far East,'" the production played on racial tropes such as Chinese cruelty towards white women and a battle between the Chinese husband and the Englishman over white women's virtue, not to mention a certain amount of "'yellow-face'" on the part of various actors. *The Times* scoffed at the play, pointing out that the wife, although dragged offstage screaming by servants, was not being taken away to be killed or tormented, her husband apparently contemplating "nothing worse than divorce, having pardonably lost interest in the

Fig. 7.18 Frances Doble and Ivor Novello in Noel Coward's *The Vortex*, *Eve Magazine*, 1928.

baggage." Doble's performance, though, was judged to be "creditable."[151] In 1932 Doble would go on to play the "dashing" Lady Cattering, a bored colonel's wife with sexual designs on a young soldier, in the comedy *While Parents Sleep*. Doble garnered publicity for a scene in which she tries to seduce the soldier which "leads to a daring display of *lingerie* in a scene which at times burlesques itself."[152] In 1933 Doble appeared with Lewis Casson and Anton Dolin in the production *Ballerina*. Based on the novel by Eleanor Smith, with whom Doble would collaborate later in the decade, *Ballerina* was a mixture of drama, ballet, and musical comedy that told the story of a famous ballerina's life. Although *The Times* was

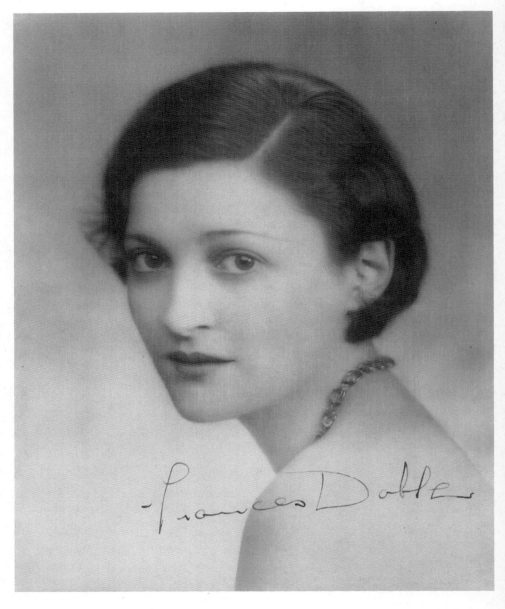

Fig. 7.19 Frances Doble portrait, c. 1920s.

scathing about it, calling "the concoction an unhappy one," other papers were kinder.[153] *The Daily Mirror* sidestepped the production's aesthetic merits and focused instead on the fact that Dolin had taught Doble her dance steps, was very proud of her, and had loaned her a crucifix given to him by Anna Pavlova for the play's run.[154]

R.B. Marriot, in his obituary of Doble published in *The Era*, may have been right that Doble was not a great actress and possessed only a limited range: she does not, for example, seem to have possessed the same dramatic gifts as Anglin or Arthur, nor was she as talented a comedian as Lillie or Bannerman. She did, though, resemble her Canadian contemporaries in other ways. Like Bannerman, Doble was celebrated as a fashionable and striking beauty, offstage and on.[155] Like Lillie, she also had ties to elite society. In 1925 her sister Georgia married Sacheverell Sitwell, the cultural critic and future baronet. Four years later Doble married Sir Anthony Lindsay-Hogg, who had succeeded to his father's baronetcy in 1923. In 1930 the couple had a son, William, but by 1932 they had separated, and divorced the following year. Doble cited Lindsay-Hogg's adultery and his "ill treatment" of her, which, according to Doble, included hitting her twice and neglect; she was granted custody of their son.[156]

Press coverage of Doble differed from that of Lillie, though, in that she was portrayed not as a down-to-earth "Canadian girl" but rather as a glamourous, upper-class beauty. But it was Doble's politics, though, that set her even further apart (at least openly) from her fellow Canadian performers. In 1938 she was said to have "exchanged the roar of theatre applause for the thunder of guns at the Spanish war front," having crossed the border between Portugal and Spain in an ambulance. Her mother told the press that Frances was "'among Franco supporters'" and had gone to Spain as a volunteer nurse, putting herself in "'some dangerous spots after fighting or a bombardment.'"[157] Doble seems to have been in Spain a year earlier, though. Biographers of the British spy Kim Philby state that she accompanied him during his tour there in 1937 and that Philby made conscious use of Doble's beauty, upper-class connections, and admiration for Hitler and Franco as a cover, so that he might demonstrate to Franco supporters that he was a conservative English gentlemen.[158] For her part, Doble claimed later that she knew nothing of Philby's politics: "he never breathed a word about socialism,

Fig. 7.20 Frances Doble and fiancé Anthony Lindsay-Hogg, *Illustrated London News*, 18 Dec. 1929.

Fig. 7.21 France Doble and Anthony Lindsay-Hogg wedding portrait, *Illustrated London News*, Dec. 1929.

communism, or anything like that."[159] Doble may have been influenced directly by her brother-in-law's politics, since Sitwell was an admirer of Oswald Mosley.[160] Her support for fascism may also have been part of the general undercurrent that permeated British aristocratic circles during the 1930s.

Doble may not have wanted her career onstage. She was supposedly pleased to have ceased acting and has been quoted as stating that whenever she passed a stage door, she was relieved not to have to enter it.[161] It's hard to imagine Lillie or Bannerman – or the other women this book has explored – making such a statement. But despite her differences from her Canadian contemporaries, Doble's life and political leanings are a stark reminder that transnational mobility should not always be celebrated. The white identity of this "sweet Canadian girl" did not just play out onstage, but was also implicated in one of the twentieth century's most dangerous movements, the growth of international fascism.

EPILOGUE

Upon retiring from the professional stage to teach at Florida's Rollins College, Annie Russell died in 1936. Her fellow performer Viola Allen, who died in 1948 in New York, was buried across the Hudson River from Russell's New Jersey grave, in Tarrytown's Sleepy Hollow Cemetery. After a lifetime spent working in the United States and travelling around Australia and Europe, in 1953 Margaret Anglin returned to Canada. Suffering from dementia, she died in a Toronto nursing home in 1958 and was buried in the Anglin family plot in Mount Hope's Catholic Cemetery. Anglin outlived a number of her contemporaries, although in some cases not by much. Julia Arthur died in Boston in 1950 and was buried in Cambridge's Mount Auburn Cemetery. Upon Lena Ashwell's death in 1957, her ashes were placed in Edinburgh's Dean Cemetery alongside those of her husband, Henry Simson. Margaret Bannerman, the beneficiary of her predecessors' efforts to support theatre workers, spent her retirement in the Actors' Fund home in Englewood, New Jersey, where she died 25 April 1976. Although Beatrice Lillie's career lasted into the 1960s, she began to show symptoms of Alzheimer's disease and underwent a stroke in the mid-1970s; in 1989 Lillie died in Henley-on-Thames.

The memories of their careers lingered in the pages of the press. Allen retired as one of "Broadway's most significant actresses," stated *The New York Times*,[1] while *The Times* dubbed Lillie the "comic genius of a theatre generation, a theatre legend"[2] and remembered Ashwell for her "emotional power and sincerity ... perhaps unique in English theatre."[3] *The New York Times* paid tribute to Anglin as "one of America's greatest actresses" of her time,[4] while *The Globe and Mail* described her as "the finest of North American actresses in Greek drama."[5] The author of Margaret Anglin's obituary in *The Windsor Star* raised questions beyond the actress's own significance. Having met Anglin when starting as a "cub reporter," they had been struck by her graciousness and generosity, so much so that the two began a "lasting, though long-distance friendship"

which continued until Anglin's retirement. Now, though, "Margaret Anglin is dead. Never heard of her? Margaret Anglin, in the estimation of many of us oldsters, was the greatest actress Canada ever contributed to the living stage. She was famous at a time when the stage was really living. Not represented almost exclusively by ambitious young ballet dancers and torch-bearing students."[6] This obituary mourned not only Anglin's passing but also the demise (at least from the writer's perspective) of a vibrant, professional theatre culture in which seasoned performers such as Anglin were valued.

Ghosts, Marvin Carlson tells us, with their tendency to appear repetitively and haunt plays, performers, performances, theatrical spaces, and audiences, are endemic to Western theatre. It is not possible, he argues, to be engaged in theatre and performance without being haunted by that which has gone before, to have one's understanding of theatrical experiences be molded by a consciousness of theatre's history and memory. Despite (or perhaps because of) its ephemerality, theatre does, as Carlson points out, work diligently to preserve and maintain a sense of its pasts, even if, like all histories, they are narratives that are told by particular narrators and are incomplete.[7] Carlson's insights resonate on a number of levels: for one, these women's performances and personae often were held up to the memories of those of their predecessors and even their contemporaries. In some cases, they too haunted those who came after them: witness, for example, Catherine Proctor's account of being inspired to act by Julia Arthur's performances. And yet ghosts may vanish over time, their presence no longer necessary as certain memories fade and particular stories about certain times and certain places are no longer needed and thus no longer told.[8] To no small extent, that has been the fate of many of these women: outside particular niches and with a few exceptions, their histories are not well known — if at all.

However, this book has sought to restore, retell, and recast their narratives. To return to the question that opened this book: why study these actresses? I hope that this research has offered proof that there is, indeed, something to be gained by digging through the archives for evidence of these women's lives. At a most basic level, this book demonstrates that a range of English-Canadian women chose to become actresses. A life as a performer was not the purview of a few, well-known exceptions but, rather, was work that encompassed both women who

achieved high levels of public visibility during their lifetimes and those who remained more obscure. Working as a performer could be a logical, not merely romantic, choice for women from a spectrum of backgrounds, both those of middle-class prosperity and security and those more economically marginal and unstable. Equally importantly, in their capacity as performers these women's lives became entangled with transnational networks, conveying them across both borders and oceans in multiple directions. But as well as their experiences of the mobility that becoming a performer entailed, these women also played important roles in those networks: as "sweet Canadian girls" they helped spread messages about gender, class, race and whiteness, and empire, and played a significant part in linking Canada to transnational worlds. While their onstage work was critically important in the ongoing exchanges of transnational theatre, so too was their offstage presence, whether as celebrities or at the level of various forms of social and political activism. In multiple ways, then, these women assisted in the spread of middle-class global modernity. While their ghosts might not be of much use to us, I hope their histories are.

DRAMATIS PERSONAE

(In order of appearance – roughly)

Clara Morris, b. 1849, Toronto, d. 1925, New Canaan, CT. Actress, theatre company manager, author.
Viola Allen, b. 1867, Alabama, d. 1948, New York. Actress, theatre company manager.
Margaret Mather, b. 1859, East Tilbury, ON, d. 1898, Baltimore (?). Actress, company manager.
Julia Arthur, b. 1869, Hamilton, ON, d. 1950, Boston. Actress, theatre company manager.
Margaret Anglin, b. 1878, Ottawa, d. 1958, Toronto. Actress, theatre company manager.
Annie Russell, b. 1864, Liverpool, d. 1936, Winter Park, FL. Child performer, actress, theatre company manager, college instructor.
Lena Ashwell, b. 1879, English Channel (on board ship), d. 1957, England. Actress, company manager, political activist.
Marie Dressler, b. 1868, Coburg, ON, d. 1934, New York. Actress, vaudeville performer and producer.
May Irwin, b. 1862, Whitby, ON, d. 1938, New York. Actress, vaudeville performer and producer.
May Tully, b. 1886 (?), Nanaimo, BC, d. 1924, New York. Actress, writer, vaudeville producer.
Mary Pickford (Gladys Louise Smith), b. 1892, Toronto, d. 1979, Santa Monica, CA. Child performer, actress, producer.
May Waldron Robson, b. 1868, Hamilton, ON, d. 1924, Louisville, KY. Actress.
Ethel Mollison Knight Kelly, b. 1875, Saint John, NB; d. 1949, Darlinghurst, NSW. Actress, author, pageant producer.
Lucille Watson, b. 1879, Quebec, d. 1962, New York. Actress.
Elizabeth Jane Phillips, b. 1830, Hamilton, ON, d. 1904, New York. Actress.
Amelia M. (Shaw) Summerville, b. 1862, Co. Kildare, Ireland, d. 1934, New York. Actress, author, political activist.
Catherine Proctor, b. 1896, Ottawa, d. 1967, Toronto. Actress.

Mae Edwards, b. 1878, Lindsay, ON, d. 1937, Lindsay, ON. Actress, theatre company manager.

Marjorie Guthrie White, b. 1904, Winnipeg, d. 1935, Hollywood, CA. Child performer, vaudeville entertainer.

Beatrice Lillie, b. 1894, Toronto, d. Henley-on-Thames, England, 1989. Actress, revue performer.

Margaret Bannerman (Marguerite Grande), b. 1896, Toronto, d. 1976, Englewood, NJ. Actress, theatre company manager.

Gywneth (Godfrey) Gordon/Grahame, b. ?, Winnipeg, d. ?. Actress.

Frances Doble, b. 1902, Montreal, d. 1970, London. Actress.

Please note that this list includes only women who are discussed in the text. I have identified around thirty-five women from Canada for the decades covered by my research. Future research may uncover more.

FIGURES

Fig. 1.1 Haverly's New York Juvenile Pinafore Company, c. 1879. Alamy Stock Photo. 36

Fig. 2.1 Margaret Mather as Juliet, c. 1880s. Houghton Library Theatre Collection, Harvard University. 67
Fig. 2.2 Viola Allen as Imogen in *Cymbeline*, c. 1906. By permission of the Folger Shakespeare Library. 69
Fig. 2.3 The Kingsway Theatre, 1956. London County Council Photography Library, London Metropolitan Archives. Courtesy London Pictures Archives, 72141. 75
Fig. 2.4 Margaret Anglin as Medea, c. 1912–16. Billy Rose Theatre Collection, The New York Public Library for the Performing Arts, 99934.u. 77
Fig. 2.5 Margaret Anglin as Rosalind in *As You Like It*, Wake Forest Theatre, St Louis, 1916. Missouri Museum, DSC00575. 80

Fig. 3.1 Clara Morris as Camille, c. 1870s. Billy Rose Theatre Collection, The New York Public Library for the Performing Arts, TH-38127. 85
Fig. 3.2 Annie Russell as Esmeralda, c. 1882. Billy Rose Theatre Collection, The New York Public Library for the Performing Arts, 99847. 87
Figs. 3.3 and 3.4 Annie Russell, scenes from *The Royal Family*, 1900. *The Royal Family* Souvenir Programme, 1900. Author's personal collection. 88–9
Fig. 3.5 Lena Ashwell as Mrs Dane, 1900. National Portrait Gallery, AX45881. 91
Fig. 3.6 Margaret Anglin as Zira, c. 1905. Author's personal collection. 93
Fig. 3.7 Lena Ashwell in *The Shulamite*, 1906. Lena Ashwell, *Myself a Player*. 96
Fig. 3.8 Viola Allen as Glory Quayle, c. 1898. Museum of the City of New York, M3Y59479. 98
Fig. 3.9 Viola Allen as Dolores in *In the Palace of the King*, c. 1900. Museum of the City of New York, 33646. 109
Fig. 3.10 Viola Allen in *The Winter's Tale*, 1903. By permission of the Folger Shakespeare Library. 109

Figs. 3.11 and 3.12 Viola Allen as Viola in *Twelfth Night*, 1903. By permission of the Folger Shakespeare Library. 110

Fig. 3.13 Julia Arthur as Mercedes, c. 1893. Julia Arthur Photo Book, Hamilton Public Library, Local History and Archives. 112

Fig. 3.14 Julia Arthur as Josephine in *More than Queen*, 1899. Julia Arthur Papers, Hamilton Public Library, Local History and Archives. 113

Fig. 3.15 Poster for Julia Arthur, *More than Queen*, 1899. Library of Congress, 2014637230. 114

Fig. 3.16 Julia Arthur as Clorinda Wildairs in *A Lady of Quality*, c. 1897–88. Julia Arthur Papers, Hamilton Public Library, Local History and Archives. 118

Fig. 3.17 Julia Arthur and her fencing instructor. Julia Arthur Papers, Houghton Library Theatre Collection, Harvard University. 119

Fig. 3.18 Viola Allen as the Empress Dowager in *The Daughter of Heaven*, 1912. Library of Congress. LC-B2-1404-7. 123

Fig. 3.19 May Waldron, *The Henrietta* program, 1887. Author's personal collection. 125

Fig. 4.1 Interior of His Majesty's Theatre, Ballarat, Australia. https://www.abc.net.au/news/2020-06-25/raked-stage-at-ballarat-her-majestys-theatre-ballarat/12364028. 142

Fig. 4.2 Julia Arthur as Mrs Erlynne in *Lady Windermere's Fan*, 1893. Billy Rose Theatre Collection, The New York Public Library for the Performing Arts, 65347u. 144

Fig. 4.3 Margaret Anglin in her drawing room, c. 1903. Library of Congress, 2004665714. 155

Fig. 4.4 Julia Arthur, advertisement, Virginia Brights cigarettes, c. 1900s. Author's personal collection. 158

Fig. 4.5 Margaret Mather cigarette card, c. 1888. Author's personal collection. 159

Fig. 4.6 Viola Allen, Virginia Brights cigarette card, c. 1888. https://commons.wikimedia.org/wiki/File:Julia_Arthur,_from_the_Actors_and_Actresses_series_(N45,_Type_8)_for_Virginia_Brights_Cigarettes_MET_DP831368.jpg. 160

Fig. 4.7 Amelia Summerville in *The Merry World*, c. 1896. Museum of the City of New York, MNY15808. 164

Fig. 4.8 Margaret Mather, studio portrait, 1883. Billy Rose Theatre Collection, The New York Public Library for the Performing Arts, TH-34302u. 169

Figs. 4.9a and 4.9b Margaret Mather's studio portraits, c. 1880s. Library of Congress 2001700500 and Billy Rose Theatre Collection, The New York Public Library for the Performing Arts, TH-34300u. 170–1

Fig. 5.1 Marie Dressler appearing in support of the American Woman's Association, c. 1920s. Library of Congress 38282u. 192

Fig. 5.2 Marie Dressler, dressed as Santa Claus for the Red Cross, c. 1915–1920. Library of Congress ggb2006003172. 192

Fig. 5.3 Marie Dressler at the Russian Bazaar fundraiser, 71st Regiment Armory, New York City, 4–6 Dec. 1916. Library of Congress ggb2005023337. 193

Fig. 5.4 Julia Arthur, *Liberty Aflame*, 1917. Julia Arthur Scrapbook, *Liberty Aflame*. Julia Arthur Papers, Houghton Library Theatre Collection, Harvard University. 200

Fig. 5.5 Lena Ashwell concert party program. Victoria and Albert Museum Theatre Collection. 204

Fig. 5.6 Julia Arthur in nurse's costume, *Out There*, Sept. 1918. Julia Arthur Scrapbook, *Liberty Aflame*, Julia Arthur Papers, Houghton Library Theatre Collection, Harvard University. 207

Fig. 5.7 Julia Arthur claimed by Canada, *Maclean's*, June 1919. Julia Arthur Papers and Scrapbooks, Houghton Library Theatre Collection, Harvard University. 209

Fig. 5.8 Poster for Margaret Anglin in *Billeted*, c. 1918. Author's personal collection. 211

Fig. 5.9 Julia Arthur posing for Stage Women's War Relief photograph, 1919. Julia Arthur Scrapbook, *Liberty Aflame*, Julia Arthur Papers and Scrapbooks, Houghton Library Theatre Collection, Harvard University. 212

Fig. 6.1 Julia Arthur at home, c. 1920s. Julia Arthur Papers and Scrapbooks, Houghton Library Theatre Collection, Harvard University. 217

Fig. 6.2 Julia Arthur as Hamlet, c. 1923. Julia Arthur Papers, Hamilton Public Library, Local History and Archives. 219

Fig. 6.3 Margaret Anglin in *The Woman of Bronze*, c. 1920. Author's personal collection. 227

Fig. 6.4 Lucile Watson portrait, c. 1910s–20s. Billy Rose Theatre Collection, The New York Public Library for the Performing Arts, TH-61708. 240

Fig. 6.5 Lucile Watson in *Heartbreak House*, 1920. Billy Rose Theatre Collection, The New York Public Library for the Performing Arts, 481316. 241

Fig. 6.6 Catherine Proctor as Hermia, c. 1912. Toronto Public Library. 243

Fig. 6.7 Catherine Proctor, studio portrait, c. 1910s. Billy Rose Theatre Collection, The New York Public Library for the Performing Arts, TH-44976. 244

Fig. 6.8 Catherine Proctor as Mrs Lincoln in *If Booth Had Missed*, 1932. Author's personal collection. 245

Fig. 7.1 Beatrice Lillie in revue skit, c. 1920s. Billy Rose Theatre Collection, The New York Public Library for the Performing Arts, TH29914u. 252

Fig. 7.2 Beatrice Lillie publicity photograph. Mary Evans Picture Library, 20095931. 253

Fig. 7.3 Beatrice Lillie caricature, *Punch*, 17 Sept. 1930. Victoria and Albert Museum, 2014GX6013.2500. 253

Fig. 7.4 Beatrice Lillie and Sanders Draper in "bobbie" skit, *Set to Music*, Noel Coward, 1939. Billy Rose Theatre Collection, The New York Public Library for the Performing Arts, 3994673u. 255

Fig. 7.5 Margaret Bannerman featured in *Pot Luck*, 1922. Author's personal collection. 257

Fig. 7.6 Margaret Bannerman featured in *Just Fancy* and *Beauty*, 1920. Author's personal collection. 258

Fig. 7.7 Margaret Bannerman in *Pot Luck*, 1932. Author's personal collection. 259

Fig. 7.8 Margaret Bannerman and Reginald Owen in the London production of *Our Betters*. Reproduced in *The Australasian*, 6 Aug. 1927, 51. 260

Fig. 7.9 Margaret Bannerman signed portrait for J.C. Williamson, c. 1928. National Library of Australia. 269

Fig. 7.10 Margaret Bannerman, c. 1928. National Library of Australia, vn6262175. 271

Fig. 7.11 Beatrice Lillie, studio portrait, c. 1920s. Billy Rose Theatre Collection, The New York Public Library for the Performing Arts, ps_the_2899. 276

Fig. 7.12 Beatrice Lillie, *Illustrated London News*, c. 1920s. Mary Evans Picture Library, 10269848. 277

Fig. 7.13 Margaret Bannerman postcard, photographed by Dorothy Wilding, c. 1920s. William Hustler and Georgina Hustler, National Portrait Gallery, London, AX160356. 279

Fig. 7.14 Margaret Bannerman portrait by Dorothy Wilding, c. 1930s. William Hustler and Georgina Hustler, National Portrait Gallery, London, x13696. 280

Figs. 7.15a and 7.15b Margaret Bannerman portraits, c. 1920s. Author's personal collection. 282–3

Fig. 7.16 Margaret Bannerman advertises Condor Hats, 1926. Author's personal collection. 286

Fig. 7.17 Beatrice Lillie and Robert Peel, *Eve Magazine*, 10 Aug. 1927. Mary Evans Picture Library, 10986614. 292

Fig. 7.18 Frances Doble and Ivor Novello in Noel Coward's *The Vortex*, *Eve Magazine*, 1928. Mary Evans Picture Library, 1098628. 297

Fig. 7.19 Frances Doble portrait, c. 1920s. © reserved; collection, National Portrait Gallery, London, x29910. 298

Fig. 7.20 Frances Doble and fiancé Anthony Lindsay-Hogg, *Illustrated London News*, 18 Dec. 1929. Mary Evans Picture Library, 11673319. 300

Fig. 7.21 Frances Doble and Anthony Lindsay-Hogg wedding portrait, *Illustrated London News*, Dec. 1929. Mary Evans Picture Library, 11677367. 301

NOTES

As mentioned in the introduction, the primary research base for this manuscript involved searching through many newspapers. In crafting my arguments, I have relied on multiple newspaper and periodical articles, so that I might obtain as representative a range of sources as possible. Moreover, articles that originated in one newspaper were often picked up by other publications and repeated in a range of geographic locations. However, for the sake of brevity, I have kept my citation of these articles to one or two of the most significant: most endnotes could in fact include many more references. I hope that this research might serve as a guide for other scholars; the digitized press, while not without its flaws, can be an invaluable tool for the study of nineteenth- and twentieth-century theatre and performance.

INTRODUCTION

1 Dudden's important work on American actresses from the late eighteenth century to 1870 alerted me to the possibilities of such research long before my project took anything like a coherent shape (*Women in the American Theatre*). See also Auster, *Actresses and Suffragists*, esp. ch. 3, "Women and the Growth of Show Business"; McArthur, *Actors and American Culture*; Kibler, *Rank Ladies*; Glenn, *Female Spectacle*; Brown, *Babylon Girls*; Powell, *Women in Victorian Theatre*; Davis, *Actresses as Working Women*; Gale, *West End Women*; Gale and Gardner, eds., *Women, Theatre, and Performance*; Bratton, *The Making of the West End Stage*.
2 See, for example, Glenn, *Female Spectacle*; Kibler, *Rank Ladies*.
3 Postlewait, "The Hieroglyphic Stage," 170–2; Auster, *Actresses and Suffragists*; Powell, *Women in Victorian Theatre*; Davis, *Actresses as Working Women*; Banta, *Imaging American Women*.
4 Davis, *Actresses as Working Women*.
5 Bratton, *The Making of the West End Stage*; Davis, "Female Managers, Lessees and Proprietors of the British Stage (to 1914)"; Davis and Ellen Donkins, eds., *Women and Playwriting in Late Victorian England*; Corbett, "Performing Identities."

6 Glenn, *Female Spectacle*; Byrd, *Redressing the Past*; Goddard, "'Women Know Her to Be a Real Woman'"; Hirshfield, "The Actress as Social Activist"; Hirshfield, "The Actresses' Franchise League"; Joannou, "'Hilda, Harnessed to a Purpose'"; John, *Elizabeth Robins*; Tilghman, "Staging Suffrage."

7 See, for example, Gardner, "Finlayson, Margaret, Margaret Bloomer, Margaret Mather"; "Nickinson, Charlotte"; "Scales, Caroline, Caroline Miskel, Caroline Miskel-Hoyt"; Barrière, "Horn, Kate M."; Salter, "At Home and Abroad"; Sperdakos, "Canada's Daughters, America's Sweethearts."

8 Overviews of the field can be found in Carstairs and Janovicek, eds., *Feminist History in Canada*; Janovicek and Nielson, eds., *Reading Canadian Women's and Gender History*.

9 For example, see Kovacs, "Beyond Shame and Blame in Pauline Johnson's Performance Historiographies"; Morgan, "'A Wigwam to Westminster'"; Morgan, "Performing for 'Imperial Eyes'"; Brown, "Frances Nickawa"; Sperdakos, *Dora Mavor Moore*; Ross, *Burlesque West*. It is my hope that this research will spur further work, such as studies of those who remained in Canada, or a gendered analysis of these women's male contemporaries who also became part of transnational theatre. For earlier work on these performers, see Brown, "Entertainers of the Road"; Scott, "Professional Performers and Companies."

10 Schweitzer, *Transatlantic Broadway*, xiii–xiv; Davis-Fisch, "Double Lives and Disappearing Acts," 14–17. For a discussion of trends in Canadian cultural history, see Nicholas, "On Display."

11 I have identified over thirty women from the 1870s to the 1930s; although not all are discussed directly in this book, see my "Dramatis Personae" list for brief biographical sketches. It's very possible that there were more who have not left traces of their lives in the archives: the letters sent to Margaret Anglin, for example, by would-be or young performers from Canada suggest this was the case.

12 "Interview with Margaret Anglin," *Theatre World*, Mar. 1902.

13 Filewod, "Named in Passing," 112.

14 For example, Alexander, *Guiding Modern Girls*; Flynn, *Moving beyond Borders*; Dubinsky, *Babies without Borders*; Dubinsky, Perry, and Yu, eds., *Within and Without the Nation*; Pickles, *Transnational Outrage*; McLean, "'The Necessity of Going.'"

15 Saunier, *Transnational History*, 4, 6.

16 Ibid., 8. On this point, see also Iriye, *Global and Transnational History*, 15; Rosenberg, "Transnational Currents in a Shrinking World," 819. See also Preston and Rossinow, *Outside In: The Transnational Circuitry of U.S. History*.

17 Saunier, *Transnational History*, 125.

18 Deacon, Russell, and Woollacott, "Introduction," in Deacon et al., eds., *Transnational Lives*, 3.
19 Wilmer, "On Writing National Theatre Histories," in Wilmer, ed., *Writing and Rewriting National Theatre Histories*, 19.
20 See, for example, Rosenberg, "Transnational Currents." Although see Saunier on the potential of culture, including theatre festivals (*Transnational History*, 109).
21 Filewod, "Named in Passing," 109. Although Filewod speaks specifically of English and French Canada, his point could apply to other contexts. For a critique of this practice in the United States, see McConachie, "Narrative Possibilities for U.S. Theatre Histories," in Wilmer, ed., *Writing and Rewriting National Theatre Histories*.
22 Wilmer, "Introduction," in Wilmer, ed., *Writing and Rewriting National Theatre Histories*, x.
23 Schweitzer, *Transatlantic Broadway*; Deacon, "Location! Location! Location!" 16, and "Becoming Cosmopolitan: Judith Anderson in Sydney, Australia, 1913–1918," in *Transnational Lives*; Kelly, "A Complementary Economy?"; Brown, "'Little Black Me': The Touring Picanniny Choruses," in *Babylon Girls*, 19–55, also 56–66.
24 Schweitzer, "Three Sentences: A Child Actress in Halifax, 1833," 296–7.
25 Postlewait, "The Hieroglyphic Stage," 107–8; Davis and Holland, "Introduction: The Performing Society," 2. Work on nineteenth- and twentieth-century Ontario points to the ubiquity and popularity of the stage in the colonial and provincial cultural landscape, whether that of the "legitimate" theatre, vaudeville, or other forms of performance (Saddlemyer, ed., *Early Stages*, and Saddlemyer and Plants, eds., *Later Stages*; also Tippett, *Making Culture*).
26 Bernard K. Sandwell, "The Annexation of Our Stage," *The Canadian Magazine*, Nov. 1911, 22–6; W.J. Thorold, "Canadian Successes on the Stage," *Massey's Magazine*, Oct. 1895, 235–40.
27 There is an extensive literature on English Canada's relationship to imperialism for these decades. For Canadian theatre, see Filewod, "Named in Passing"; Bretz, "An Effigy of Empire."
28 Dejung, Motadel, and Osterhammel, "Worlds of the Bourgeoisie," in Dejung et al., *The Global Bourgeoisie*, 2–6; also Young, *Middle-Class Culture in the Nineteenth Century*.
29 Dejung, Motedel, and Osterhammel, "Worlds of the Bourgeoisie," 3, 17, 27.
30 Ibid., 9–15.
31 López with Weinstein, "We Shall Be All: Towards a Transnational History of the Middle Class," 21–2.

32 For example: Ryan, *Cradle of the Middle Class*; Blumin, *Emergence of the Middle Class*; Davidoff and Hall, *Family Fortunes*. In Canada, a small number of community-based and family studies and work on late-Victorian social reform in English Canada have explored the material and discursive aspects of middle-class formation in Canada (Burley, *A Particular Condition in Life*; Holman, *A Sense of Their Duty*; Noel, *Family Life and Sociability*; Morgan, *Public Men and Virtuous Women*; Valverde, *The Age of Light, Soap and Water*).

33 Morgan, *"A Happy Holiday"*; Iacovetta, "The Gate Keepers," in López and Weinstein, *The Making of the Middle Class*.

34 There is a very large literature on the structural features of the middle class; see Dejung et al., "Worlds of the Bourgeoisie," 8, for a synthesis.

35 López and Weinstein, "We Shall Be All," 21.

36 They were not alone in such affiliations. As Schoch has noted, by the mid-nineteenth century much of British theatre reflected larger social concerns with respectability, that middle-class quest for decorum and propriety that dominated much of Victorian society in this period (although Schoch notes this quest for respectability was both "embraced and resisted" by the profession; see "Theatre and Mid-Victorian Society, 1851–1870," in Donohue, ed., *The Cambridge History of British Theatre vol. 2*, 331). Nor am I suggesting that there weren't other ways of being for actresses that either bypassed or skirted such forms of middle-class belonging, the best-known being Sarah Bernhardt's bohemianism (Marcus, *The Drama of Celebrity*).

37 That said, Indigenous Canadian performers appeared on lecture platforms and in private recitals, both in Canada and beyond: Kovacs, "Beyond Shame and Blame": Morgan, "'A Wigwam to Westminster'" and "Performing for 'Imperial Eyes'"; Brown, "Frances Nickawa."

38 There is now an extensive literature on race and its relation to the stage in this period. For the British context, see Bratton, ed., *Acts of Supremacy*; Hays, "Representing Empire: Class, Culture, and the Popular Theatre in the Nineteenth Century"; Gould, *Nineteenth-Century Theatre and the Imperial Encounter*; Richards, "Drury Lane Imperialism." Work on race in the American theatre is extensive. See, for example: Brooks, *Bodies in Dissent*; Brown, *Babylon Girls*, esp. 4–5; Hay, *African-American Theatre*; Young, ed., *The Cambridge Companion to African American Theatre*; Bank, *Theatre Culture in America, 1825–1860*, esp. ch. 1 and 2, "Spaces of Representation" and "Liminal Spaces"; Woods, "American Vaudeville, American Empire," in Mason and Gainor, eds., *Performing America*; Lott, *Love and Theft*; Kibler, *Rank Ladies*.

39 Levine, ch. 6, "Global Growth," in *The British Empire*; Hall and Rose, eds., *At Home with the Empire*.

40 Lake and Reynolds, *Drawing the Global Colour Line*.

41 Paisley and Scully, *Writing Transnational History*, 154.
42 Rosenberg, "Transnational Currents," 818.
43 Booth, "The Lessons of the Medusa," 259; Banner, "Biography as History," 583. See also Mackinnon, "Collective Biography: Reading Early University Women from Their Own Texts"; Banks, *Becoming a Feminist*; Weiner, "Olive Banks and the Collective Biography of British Feminism"; Ball, Seijas, and Snyder, eds., *As If She Were Free*.
44 Grossman, *A Spectacle of Suffering*; Kennedy, *Marie Dressler: A Biography*; Leask, *Lena Ashwell*; Ammen, *May Irwin*; LeVay, *Margaret Anglin: A Stage Life*.
45 Mackinnon, "Collective Biography," 101.
46 On this and related points in writing feminist biography see Margadant, ed., *The New Biography*.
47 Mackinnon, "Collective Biography," 101.
48 Saunier, *Transnational History*, 102. A wealth of studies explores transnational biography: for example, Deacon et al., *Transnational*; Deacon, Russell, and Woollacott, eds., *Transnational Ties: Australian Lives in the World*; McKenzie, *A Swindler's Progress*; Pybus, *Epic Journeys of Freedom*; Hodes, *The Sea Captain's Wife*.
49 Rosenfeld, "Transnational Currents," 819.
50 Paisley and Scully, *Writing Transnational History*, 196.
51 Matthew, "Modern Nomads and National Film History: The Multi-Continual Career of J.D. Williams," 167.
52 While it is possible that in Quebec the Catholic Church's disapproval of theatre limited its appeal to young women, Lajeunesse's career in opera was both highly successful and transnational. Valchon, "Lajeunesse, Emma (Marie-Louise-Cécile-Emma) (Gye), known as Emma Albani," in *Dictionary of Canadian Biography*, vol. 15.
53 Postlewait, "The Hieroglyphic Stage"; Frick, "A Changing Theatre"; Bank, *Theatre Culture in America*.
54 Auster, *Actresses and Suffragists*, esp. ch. 6 and 7; de Leon, *Self-Exposure*, 206–40; Marcus, *The Drama of Celebrity*.
55 Although from time to time the very successful vaudevillians May Irwin and Marie Dressler make their way into this book, I have chosen not to focus on them: partly because their stories have been told in other biographies and partly because of the differences between "legitimate" theatre and vaudeville. One of the reasons for including Summerville and Tully lies in the fact that they are not as well known.
56 For overviews of those developments, see Donohue, "The Theatre from 1800 to 1895"; Postlewait, "The London Stage, 1895–1918"; Postlewait, "George Edwardes and Musical Comedy," in *The Performing Century*, 80–102.

57 Donohue, "The Theatre from 1800 to 1895," 254.
58 N.a., "'Pros.' and Cons," *Reynold's Newspaper*, 29 July 1894.
59 Postlewait, "The London Stage, 1895–1918," in *The Cambridge History of British Theatre vol. 2*, 34–8.
60 N.a., "The Lost Paradise," *The Era*, 24 Dec. 1892. Fulda's play was adapted by Henry C. DeMille and its setting changed from Berlin to Boston. Balme, "Fulda, Ludwig (Luwig Salomon), 1862–1939," in Kennedy, ed., *The Oxford Encyclopedia of Theatre and Performance*; Woods, "DeMille, Henry C., 1850–93," in *The Oxford Encyclopedia of Theatre and Performance*.
61 For such cultural continuity, see Vance, *Death So Noble*; Winter, *Sites of Memory, Sites of Mourning*.
62 Discussions of both continuity and change in the postwar years can be found in Kennedy, "British Theatre, 1895–1946," in *The Cambridge History of British Theatre vol. 3: Since 1895*; Gale, "The London Stage, 1918–1945," in *The Cambridge History of British Theatre vol. 3: Since 1895*; Postlewait, "The Hieroglyphic Stage," 162–78.
63 Margadant, "The Duchesse de Berry and Royalist Political Culture in Postrevolutionary France," in Margadant, ed., *The New Biography*, 34–59, esp. 37.
64 For a very thoughtful discussion of the potentially problematic relationship between transnational history and digital sources, see Putnam, "The Transnational and the Text-Searchable." For the Canadian context, see Milligan, "Illusionary Order."
65 Osterhammel, *The Transformation of the World*, 29–36; also Ardis and Collier, eds., *Transatlantic Print Culture, 1880–1940*.
66 Saunier, *Transnational History*, 33. For a groundbreaking study of audiences in London, see Davis and Emeljanow, *Reflecting the Audience*.

CHAPTER ONE

1 Allen, "On the Making of an Actress," *Cosmopolitan*, Aug. 1901, Scrapbook 7607, Box 1, Viola Allen Scrapbooks 1867–1948.
2 Untitled clipping, ibid.
3 Arthur, "My Career," *Hearst*, Mar. 1916, 176–7, 222–4, 222. John Townsend's career is discussed in Gardner, "Townsend, John," in *Dictionary of Canadian Biography*, vol. 12.
4 This is a point also made by McArthur, "'Forbid Them Not,'" 65, and Davis, "The Employment of Children in Theatres," 123–4.
5 N.a., "Margaret Anglin in Sydney. A Sketch. A Celebrated Irish American Actress," *Catholic Press*, 18 Jun. 1908, 21. At Loretto, both Anglin and Caroline Miskel Hoyt (1873–1898) studied elocution with Jessie Alexander, who herself

would go on to perform professionally as an elocutionist (Alexander, *Jessie Alexander's Platform Sketches*, xvi).
6 Anglin, "My Career. A Canadian Girl's Achievements," *Everywoman's World*, Dec. 1916, 5, 43–6, 53, 55, 44, 46.
7 Ibid., 46.
8 Ibid.
9 Lindesmith, "Watson, Lucille," in Robinson et al., *Notable Women in the American Theatre*, 906.
10 Anglin, "My Career," 43; Lindesmith, "Watson, Lucille," 919.
11 Ashwell, *Myself a Player*, 32.
12 Smith, "Two Women of the Stage," *Donahoe's Magazine* 54 (1905): 197–205, 201.
13 For example, see Gidney and Millar, "From Voluntarism to State Schooling."
14 Ashwell, *Myself a Player*, 13–21.
15 "May Tully," *New York Times*, 11 Jun. 1916, x5; Cullen with Hackman and McNelly, "May Tully." Tully's precise birthdate is difficult to pin down: in the available sources it ranges from 1883 to 1886.
16 For the Arthur family tree, see https://www.ancestry.ca (accessed 26 Oct 2017).
17 Gordon, *Heroes of Their Own Lives*; Swain and Hillel, *Child, Nation, Race and Empire*.
18 Little information about Mather's family has survived that would allow me to trace the story of her brother; while there is an extensive collection of photographs and some clippings on ancestry.ca, the site holds almost no genealogical information about her relatives. For accounts of Mather's life, see Gardner, "Finlayson, Margaret, Margaret Bloomer, Margaret Mather," in *Dictionary of Canadian Biography*, vol. 12.
19 Kennedy, *Marie Dressler: A Biography*, 11–17.
20 The use of theatre within domestic settings in nineteenth-century Ontario warrants further investigation and analysis, not least because my examples are both small in scale and in many ways "self-selected." There is a growing historiography on nineteenth-century amateur theatre, although as Hawley and Isbell acknowledge, "amateur theatre has proved highly popular but is largely underrated and little studied" ("Editorial: Amateur Theatre in the Long Nineteenth Century," xvii). See: Cochrane, "The Pervasiveness of the Commonplace"; Meeuwis, "'The Theatre Royal Back Drawing-Room'"; Whittaker, "'Entirely Free of Any Amateurishness'"; Holmstrom, "Civil War Memories on the Nineteenth-Century Amateur Stage"; Walden, "Toronto Society's Response to Celebrity Performers"; Guiget, *The Ideal World of Mrs. Widder's Soirée Musicale*; Tippett, *Making Culture*, 3–16.

21 Wright, "Julia Arthur, 15 Years Off Stage, Comes Back to Boston," *Sunday Herald* [Boston], 19 Mar. 1916.
22 Price, "Memoir of Julia Arthur," *Boston Daily Globe*, 22 May 1950; n.a., "About Julia Arthur. Beautiful Actress Is of Irish Extraction. She Has 13 Brothers and Sisters – All of Them Quite Talented," *Toledo Blade*, 30 Sept. 1899.
23 Arthur, "My Career," 122.
24 Ibid., 5. Wilde visited Canada in 1882 and met John A. Macdonald, so it's not unthinkable that he would have also met the Anglins.
25 Ibid., 43. Although few parents appear to have disapproved of their offspring's desire to pursue a career on stage as vociferously as did Timothy Anglin, Carolyn Miskel-Hoyt's paternal grandfather, John Scales, apparently did. Scales, a Kentucky tobacco manufacturer who moved to Toronto after the Civil War, is said to have disowned Miskel-Hoyt and her sister Sarah (Sally) in 1891 because they had become actresses (Gardner, "Scales, Caroline, Caroline Miskel, Caroline Miskel-Hoyt," in *Dictionary of Canadian Biography*, vol. 12).
26 Hawley and Isbell, "Editorial," xviii.
27 Sánchez-Eppler, *Dependent States*; Steedman, *Strange Dislocations*; Bernstein, *Racial Innocence*. Many thanks to Kristine Alexander for drawing Bernstein's work to my attention.
28 Gubar, "Entertaining Children of All Ages"; Mullenneaux, "Our Genius, Goodness, and Gumption"; Klein, "Without Distinction of Age," 126; Bernstein, *Racial Innocence*, 113–33.
29 McArthur, "'Forbid Them Not,'" 66–8.
30 Vey, "Good Intentions and Fearsome Prejudice."
31 McArthur, "'Forbid Them Not,'" 69–70.
32 Ibid., 70.
33 Ibid., 74.
34 Ibid., 76.
35 Davis, "The Employment of Children in Theatres"; Davis, "Freaks, Prodigies, and Marvellous Mimicry"; Varty, "The Rise and Fall of the Victorian Stage Baby"; Varty, *Children and Theatre in Victorian Britain*; Colcough, *Child Labour in the British Victorian Entertainment Industry*; Brown, "'Little Black Me': The Touring Picaninny Chorus," ch. 1 in her *Babylon Girls*. For Australia, see Arrighi and Emeljanow, "Entertaining Children."
36 Davis, "The Employment of Children in Theatres," 117, 119. To be sure, children's work as performers was, as Davis points out, by no means a new phenomenon. During the late sixteenth century boys had been regularly employed in theatres, and the eighteenth century saw several children onstage as members of theatrical families (117–18).
37 Ibid., 124.

38 Horn, "English Theatre Children, 1880–1914: A Study in Ambivalence," 38–42.
39 Ibid., 45–7.
40 Ibid., 50.
41 Ibid., 47–8.
42 Ibid., 52–3.
43 Gubar, "Entertaining Children of All Ages," 6.
44 Ibid., 12–13.
45 Ibid., 10. Gubar makes a similar point in "Who Watched *The Children's Pinafore?*"
46 Allen, "My Beginnings," *Hearst's*, n.d., 1906, Scrapbook 7609, Box 2, Viola Allen Scrapbooks.
47 "Program for Rosedale, or, the Rifle Ball," and undated review, no title, Scrapbook 9122, Viola Allen Scrapbooks.
48 Allen, "My Beginnings," *Hearst's*, n.d., 1906.
49 Plotnicki, "Viola Allen," in her *Notable Women in the American Theatre*, 18. Both Ashwell and Allen would have attended Bishop Strachan in its Yonge and College location, Wykeham Hall, as the school's Forest Hill building was not erected until 1915.
50 Allen, "My Beginnings," *Hearst's*, n.d., 1906.
51 Kobbé, *Famous Actresses and Their Homes*, 101; also McHenry, "Russell, Annie," 360.
52 Eytinge's career is discussed in Bordman, "Eytinge, Rose," in *The Oxford Companion*.
53 Kobbé, *Famous Actresses*, 102.
54 "Stage Themes in Miniature," *New York Times*, 31 Jan. 1904, 22; also Kobbé, *Famous Actresses*, 102.
55 Bordman, "Russell, Annie."
56 Gubar, "Who Watched *The Children's Pinafore?*" 416–17.
57 Ibid., 411.
58 Kobbé, *Famous Actresses*, 103. Although Russell and her biographers are somewhat hazy about dates in this part of her life, it is likely that she worked for Booth in his 1879 season. Bordman, *American Theatre*, 128.
59 Fraser, "Theatre Management in the Nineteenth Century: Eugene A. McDowell in Canada, 1847–1891."
60 "Reported Marriage of Annie Russell," *The New York Times*, 28 Mar. 1904, 1.
61 "On the Tour," *The Daily Inter-Ocean* [Chicago], 15 Sept. 1889, 13. Arnold was the former manager of Montreal's Academy of Music; his career also took him to Winnipeg, where he claimed to have performed for Sitting Bull's nephew.

62 Kobbé, *Famous Actresses*, 104. Tommy Russell returned to New York and continued to perform but his career was not as long-lived as his sister's. Amongst other productions, he appeared in an 1888 production of *Little Lord Fauntleroy* as Lord Fauntleroy; while a "pretty child," he could not compete with the alternate performer, Elsie Leslie. Odell, *Annals of the New York Stage, vol. 14: 1888–1891*, 36.

63 Odell, *Annals*, 554.

64 The dates from Irwin's various online biographies give conflicting information about her father's death and her subsequent debut. It is clear, though, that she was a very young teenager when she began performing.

65 "Tony Pastor," *The Cincinnati Enquirer*, 6 Sept. 1878, 4; "Amusements: Haverly's!" *Chicago Tribune*, 10 Sept. 1879, 7.

66 Irwin's career in vaudeville is discussed in Kibler, *Rank Ladies*, esp. ch. 5, "The Corking Girls: White Women's Racial Masquerades in Vaudeville."

67 Morris, *Life on the Stage*, 2–15.

68 Grossman, *A Spectacle of Suffering*, 18–30.

69 Ibid., 35.

70 Fass, "Childhood and Memory"; Baena, "'Not Home but Here.'"

71 Pye, "'Irreproachable Women and Patient Workers,'" 75–82; Corbett, "Performing Identities"; Marshall, "Ellen Terry: Shakespearean Actress and Critic."

72 Mary Pickford interview with Arthur B. Friedman, 1 May 1958, 2654, Mary Pickford Papers, File 1338.

73 Pickford, *Sunshine and Shadow*, 68.

74 Ibid., 69–70.

75 Pickford interview, 2665.

76 Ibid., 2655–69.

77 Ibid., 2670.

78 Arthur, "My Career," 222.

79 Assuming adult roles was standard practice for a performer in a stock company; the wide repertoire meant that its members, particularly the junior ones, were called upon to play a range of parts. "Julia Arthur," *Philadelphia Record*, 1916, Arthur papers.

80 Whitfeld, *Pickford: The Woman Who Made Hollywood*, 22–4; "Julia Arthur," *Philadelphia Record* 1916, File 1, Box 2, Julia Arthur papers. Unfortunately reviews of these performances do not seem to have survived. Russell, as we have seen, appeared in a production of *Uncle Tom's Cabin*; Pickford and Julia Arthur appeared in productions of *East Lynne*, *The Silver King*, and *Uncle Tom's Cabin*.

81 Brown, "'Little Black Me,'" 21.

82 Arthur, "My Career," 223.

83 Price, "Memoir of Julia Arthur." It is not clear when Price interviewed Arthur. This interview may have been originally conducted in the early 1900s, as it ends with her career in stock.
84 For example, Arthur, "My Career," Mar. 1916.
85 There is an extensive literature on this topic. See, for example, Strange, *Toronto's Girl Problem*; Peiss, *Cheap Amusements*.
86 For example, "Beautiful Julia Arthur," *St. Louis Post*, 1 Jun. 1895; "In Detroit Theatres. Julia Arthur Begins Her Star's Career in Detroit," *Detroit Free Press*, 3 Oct. 1897.
87 Lewis Family Photograph, Copy Two, Archives File, Accession #782, Julia Arthur Collection. The handwritten note reads: "There were supposedly 16 members of the Lewis family but there were actually fifteen children born to Thomas and Ann." If this was the case, the child may or may not have been the result of a consensual relationship; there seems no way of verifying any of this, however.
88 Julia Arthur, "My Career, Part Two," *Hearst's*, Apr. 1916, 266–7, 322–3, 322.
89 Morris, *Life on the Stage*, 30.
90 Ibid., 14–15.
91 Ibid., 25–6.
92 Ibid., 23–4.
93 Ibid., 32–4.
94 For an insightful discussion of this question in the British context, see Davis, *Actresses as Working Women*, esp. ch. 3, "The Social Dynamic and Respectability."
95 Morris, *Life on the Stage*, 73.
96 Ibid., 74.
97 Ibid., 39–41.
98 Ibid., 50–6.
99 Ibid., 41–2.
100 Ibid., 44–5.
101 Ibid., 42–3.
102 Kennedy, *Marie Dressler: A Biography*, 11–17.
103 Pickford, *Sunshine and Shadow*, 50, 75–6.
104 Varty, *Children and Theatre in Britain*, 76.
105 Pickford, *Sunshine and Shadow*, 76.
106 Pickford interview, 2670.
107 Ibid., 2673–80.
108 Pickford's autobiography is shot through with admiration – frequently adoration – of her mother. The book is dedicated to her mother, whom she depicts as self-sacrificing, hard-working, and courageous in the face of constant adversity (*Sunshine and Shadow*, esp. ch. 1–6).

109 Christian Cassidy, "Kid Nearly Made It Big," *Winnipeg Free Press*, 27 Aug. 2016; "Dies in Hollywood. Marjorie Guthrie," *The Winnipeg Tribune*, 21 Aug. 1935, 1.
110 "Stage Favourite to Dance Tonight," *The Winnipeg Tribune*, 30 Nov. 1915, 6. Guthrie was to perform a solo in a YWCA concert.
111 Cassidy, "Kid Nearly Made It Big"; "Dies in Hollywood. Marjorie Guthrie."
112 Frey, "Singing and Dancing 'Their Bit' for the Nation," 58.
113 *Photographic Souvenir of the Winnipeg Kiddies*.
114 See Frey, "Singing and Dancing," 50, on this point; also Alexander on the difficulty of exploring children's agency ("Can the Girl Guide Speak?").
115 Cassidy, "Kid Nearly Made It Big."

CHAPTER TWO

1 "The Stage," *Detroit Free Press*, 25 Nov. 1906, 44; "Music and the Drama," *The Globe*, 18 Jan. 1908, 9.
2 Schweitzer, "Networking the Waves"; Potter, "Communication and Integration," in Bridge and Fedorowich, eds., *The British World*; Arceneaux, "News on the Air"; Codell, ed., *Imperial Co-histories*.
3 Postlewait, "The Hieroglyphic Stage," 150.
4 Ibid., 150–1.
5 Ibid., 152.
6 Ibid., 152–3.
7 Gardner, "Provincial Stages, 1900–1934: Touring and Early Repertory Theatre," in Kershaw, ed., *The Cambridge History of British Theatre vol. 3: Since 1895*, 60–85.
8 *Glasgow Herald*, 23 Oct. 1894; *Huddersfield Chronicle*, 25 Aug. 1894; *Freeman's Journal and Daily Commercial Advertiser*, 5 May 1896; *Aberdeen Weekly Journal*, 7 Apr. 1896 (no titles available for these articles).
9 "The Drama," *Saturday Night*, 4 Feb. 1893; W.J. Thorold, "Canadian Successes on the Stage," *Massey's Magazine* 2, 3 (Sept. 1895): 189–94, 193–4.
10 Ashwell, *Myself a Player*.
11 See, for example, Simmons and Biddle, eds., *The Oxford Companion to British Railway History*.
12 Postlewait, "The Hieroglyphic Stage," 154.
13 Brown, "Entertainers of the Road," 127.
14 Sandoval-Strauss, *Hotel: An American History*, 115. For a brief discussion of railways and imperialism, see Morgan, *Building Better Britains?* 79–80.
15 Little has been written about Phillips's career. O'Neill states that she had appeared in many amateur productions in Hamilton and became a professional during Nickinson's management of the Royal Lyceum Theatre ("A History of

Theatrical Activity in Toronto, Canada," 112n33). Her correspondence cited in this chapter originated from a now-defunct website, http://maryglenchitty.com/ejp.htm/. These letters have been downloaded and are in the author's personal collection.
16 These points will be explored further in ch. 4.
17 Phillips, correspondence, 29 July 1886.
18 Ibid., 31 July 1886.
19 Ibid., 21 Sept. 1886.
20 Ibid., 29 Sept. 1890.
21 Ibid., 2 Apr. 1886.
22 Phillips to Albert Nickinson, 13 Jun. 1886.
23 Ibid., 30 Jun. 1886.
24 Phillips to Penelope Nickinson, 29 Apr. 1890.
25 The Actors' Fund was established in 1882; despite its name, the fund was meant to assist all those who worked in live performance. Simon, *A History of the Actors' Fund of America*.
26 Phillips to Albert Nickinson, 9 July 1886.
27 Ibid., 19 Feb. 1886.
28 Ibid., 23 Feb. 1886; Morris, *Life on the Stage*, 23.
29 Phillips to Albert Nickinson, 23 Feb. 1886.
30 Ibid., 9 Jun. 1887.
31 Ibid., 5 and 9 July 1886.
32 Phillips to Albert Nickinson, 13 Jun. 1886.
33 Ibid., 30 Jun. 1886.
34 Ibid., 19 May 1896.
35 Ibid., 7 Sept. 1887.
36 Ibid., 21 Nov. 1888, also 2 Apr. 1886, 13 Nov. 1887, 20 Dec. 1887, 14 Jan. 1888.
37 Ibid., 9 Jan. 1887.
38 Schweitzer, *When Broadway Was the Runway*; Kaplan and Stowell, *Theatre and Fashion*.
39 Sandoval-Strauss, *Hotel*; Groth, *Living Downtown*; Berger, *Hotel Dreams*. Nineteenth-century hotels in Canada have not attracted the same kind of systematic analysis as in the United States; scholars focus mostly on their architecture and relationship to the Canadian Pacific Railway (Kalman, *The Railway Hotels and the Development of the Château Style in Canada*). See, though, Broadway, "Urban Tourist Development in the Nineteenth Century Canadian City."
40 See, for example, Margaret Anglin to Mr. Schmel, 14 Oct. 1922, File S–V 1920–24, Box 4, Margaret Anglin Papers (MAP); Anglin to George Emery, File. c. mid-1920s–1926, Box 1, MAP; Anglin to Harrison Fiske, 16 May 1926, Minnie Maddern Fiske File, Box 1, MAP.

41 Phillips to Albert and Penelope Nickinson, 30 Dec. 1892.
42 Phillips to Penelope Nickinson, 4 Jan. 1893. Phillips also noted that Peoria, Lafayette, and Evansville were noted for being "three miserable towns, hotels and theatres bad" (Phillips to Albert Nickinson, 17 Nov. 1893).
43 Phillips to Albert Nickinson, 27 Jun. 1892.
44 http://maryglenchitty.com/hotels.htm#strenuous.
45 Phillips to Albert Nickinson, 28 Sept. 1887.
46 Ibid., 29 Sept. 1887.
47 Ibid.
48 Ibid., 1 Oct. 1887.
49 Ibid., 4 Oct. 1887.
50 Ibid., 12 Apr. 1893.
51 Little has been written about actresses as tourists, but see Larson, "Across Oceans, Mountains, and Spaces."
52 Philips to Albert Nickinson, 19 Jun. 1890.
53 Phillips to Albert Nickinson and Harriet Nickinson Dolman, 15 Aug. 1896.
54 Phillips to Albert Nickinson, 28 July 1886.
55 Ibid., 19 Sept. 1896.
56 Ibid., 23 Jun. 1890. She may have been referring to the Puyallup Indian Reservation, which was created in 1854 and today is an urban reserve.
57 Ibid., 10 Aug. 1883.
58 There is a very large literature on this topic. For Canada, see Jasen, *Wild Things*.
59 "Miss Clara Morris at Santa Barbara," *The New York Times*, 28 Feb. 1875, 7.
60 Kelly, *Twelve Milestones*, 60–1.
61 The literature on women's travel and tourism and Orientalist gazes and practices is quite large but see Mills, *Discourses of Difference*.
62 Lydon, *Eye Contact*, esp. ch. 4, "Works Like a Clock."
63 As cited in LeVay, *Margaret Anglin*, 108. See also "Actress Tells of Park Trip," *Great Falls Tribune* [Montana], 5 Sept. 1910, 5. This article discusses Anglin's impressions of Yellowstone Park.
64 Woollacott, "'All This Is the Empire, I Told Myself.'"
65 LeVay, *Margaret Anglin*, 111–14.
66 For the role of tourism and tourists as transnational connectors, see Saunier, *Transnational History*, 37.
67 There is an extensive historiography on actor-managers that looks at multiple aspects of their careers: Richards, *Sir Henry Irving*; also his "Henry Irving: The Actor-Manager as Auteur"; Foulkes, ed., *Henry Irving*; Blum, "The Lyceum Theatre and Its Double"; Jackson, "Oscar Asche: An Edwardian in Transition"; Duncan, "Benson's *Dream*: Touring A 'Grand Production' to the Provinces"; Balme, "The Bandmann Circuit"; Schoch, ed., *Macready, Booth, Terry, Irving*.

68. Norwood, "Picturing Nineteenth-Century Female Theatre Managers."
69. Marra, *Strange Duets*, xix–xv. See also Schweitzer, *Transatlantic Broadway*; Schwartz, *Broadway and Corporate Capitalism*.
70. Bratton, *The Making of the West End Stage*, esp. ch. 5 and 6; Davis, "Female Managers, Lessees and Proprietors of the British Stage (to 1914)."
71. John, *Elizabeth*; Tilghman, "Staging Suffrage."
72. Curry, "Petticoat Governments," 13.
73. "Manager Hill and Miss Mather," *The New York Times*, 27 May 1888; "What Margaret Mather Earns," *The New York Times*, 30 May 1888.
74. "Miss Mather Testifies," *The New York Times*, 23 Jun. 1888; "The Legal Drama Closed," *The New York Times*, 28 Jun. 1888.
75. "Miss Mather Wins," *The New York Times*, 1 Sept. 1888; "Miss Mather Will Sue Again," *The New York Times*, 13 Sept. 1888.
76. "Margaret Mather Content," *The New York Times*, 12 Oct. 1888.
77. "Miss Mather's Management," *The New York Times*, 20 Dec. 1888.
78. "Miss Mather's Manager," *The New York Times*, 3 Jan. 1889; "In Favor of Margaret Mather," *The New York Times*, 10 July 1888.
79. "Miss Mather's Purchase," *The New York Times*, 2 Feb. 1890. Mather had visited Europe the previous summer with her husband, Emil Haberkorn, and one of her managers, Eugene Tompkins, to search for a new play: "Theatrical Gossip," *The New York Times*, 17 Jun. 1889.
80. "Miss Mather's Purchase," *The New York Times*, 2 Feb. 1890.
81. Gardner, "Finlayson, Margaret, Margaret Bloomer, Margaret Mather," in *Dictionary of Canadian Biography*, vol. 12.
82. Skinner, *Footlights and Spotlights*, 195.
83. Ibid.
84. Ibid., 196.
85. Ibid., 193.
86. Ibid., 194.
87. Ibid., 195.
88. "No 'Faked' Scenery for Her," *The New York Times*, 23 Sept. 1890; "Miss Mather Sustained," *The New York Times*, 24 Sept. 1890.
89. Mather's family life and marriages are discussed in more detail in ch. 4.
90. "Theatrical Gossip," *The New York Times*, 12 May 1897.
91. "Death of Margaret Mather," *The New York Times*, 8 Apr. 1898.
92. See, for example, Holroyd, *A Strange Eventful History*, 289.
93. Myers, "Allen, Viola Emily," in James et al., eds., *Notable American Women, 1607–1950*, vol. 1: A–F.

94 Allen to Winter, 9 Apr. 1905, Y.c. 29 (1–8), Folger Shakespeare Library. For Winter, see Bordman and Hischak, *The Oxford Companion to American Theatre*, 667.
95 Allen to Winter, 24 Nov. 1905. Two weeks later she was very concerned upon being sent an announcement of a New York production of *Cymbeline* but was reassured to find it was not accurate (6 Dec. 1905).
96 Ibid., 9 Feb. 1906.
97 Ibid., 7 Jan. and 27 May 1906.
98 "Mr. D" may have been John J. Donnelly, listed in Allen's 1906 program for *Cymbeline* as the company's acting manager.
99 Allen to Winter, 30 Sept. 1906.
100 Ibid., 29 Oct. 1906.
101 Winter, *Shakespeare on the Stage*, 64.
102 Allen to Winter, 12 Nov. 1907, 26 Jan., 17 Feb., and 30 Mar. 1910, 7 Jan. 1914, 1 Apr. 1916.
103 Ibid., 9 Mar. 1916; Allen to the Committee for William Winter's Testimonial, 8 Feb. 1916; David Bishpam to Allen, 29 Mar. 1916; Allen to Jefferson Winter, 9 Jun. 1916, 30 Aug. 1916, 22 Feb. 1917.
104 Plotnicki, "Allen, Viola," 19. *The Christian* had turned a profit of $500,000 in its two-year run. It's possible that Allen's 1905 marriage to well-off Kentucky horse breeder Peter Duryea helped her financially.
105 "New Theatre for Annie Russell," *The New York Times*, 5 Dec. 1908, 9.
106 "Princess Theatre for Annie Russell," *The New York Times*, 12 July 1912, 11.
107 "Annie Russell in Old English Comedy," *The New York Times*, 12 Nov. 1912, 13.
108 E.R. Parkhurst, "Music and the Drama," *The Globe*, 5 May 1913, 9.
109 Johnson, *Sisters in Sin*.
110 Salter, "At Home and Abroad."
111 Multiple newspapers ran the story. See, for example, "Ruin of Relentless Flames!" *Detroit Free Press*, 7 Oct. 1897; "Julia Arthur Burned Out This Morning," *San Francisco Bulletin*, 7 Oct. 1897.
112 Kelly, *Twelve Milestones*, 51.
113 "Thanks to Julia Arthur. Members of Her Company Tell How Well They Have Been Treated," *The New York Times*, 19 Oct. 1897.
114 Salter, "At Home and Abroad."
115 Ibid.; F.H. Cushman, "Miss Arthur Sees Few Changes," n.p., 15 Nov. 1915.
116 Geraldine Steinmetz, "Julia Arthur Comes Back," *Maclean's* 29, no. 3 (Jan. 1916): 18–19.
117 Leask, *Lena Ashwell*, 35.
118 Ibid., 37–54.

119 Ibid., 80.
120 Ashwell, *Myself a Player*, 147–8.
121 Ibid., 157.
122 Leask, *Lena Ashwell*, 64.
123 Ibid., 71.
124 "Miller, [John] Henry," in Bordman and Hischak, eds., *The Oxford Companion to the American Theatre*.
125 Anglin's artistic and intellectual achievements in her Greek productions are assessed by Foley, *Reimagining Greek Tragedy on the American Stage*, 47–61. Foley's analysis is based on extensive newspaper reviews and biographical accounts of Anglin's career but not her personal papers.
126 Anglin, "My Career," *Hearst's International Magazine* 28 (July 1915): 44.
127 Ibid.
128 William Armes to Louis Nethersole, 21 Apr. 1910, Antigone File, 1910, Box 20, Margaret Anglin Production Files (MAPF).
129 For example, see Foley, *Greek Tragedy*, 47.
130 See, for example, the contents of the *Antigone* Financial File and *Electra* Financial File, Box 20, MAPF. For a discussion of objects and the relationships in which they were embedded, see Schweitzer, *Transatlantic Broadway*.
131 "Toronto Actress to Revive Four Shakespearean Plays," *The Toronto Daily Star*, 7 Jun. 1913.
132 "Miss Anglin Brings Big Company for Reno Dates," *Reno Gazette-Journal*, 26 Aug. 1913, 3; "Miss Anglin Next Week," *The Globe*, 27 Dec. 1913.
133 "Faversham, Charles," in Bordman and Hischak, eds., *The Oxford Companion to the American Theatre*, 219; "Mr. Faversham Opens Tonight," *The Globe*, 29 Dec. 1913, 7.
134 William Faversham to Anglin, 24 Jan. and 5, 9, 16, 21, 22, 23, and 24 Feb. 1916, Faversham File, Box 1, MAP.
135 Faversham to Hull, 10 Mar. 1916.
136 Hull to Faversham, 23 Mar. 1916.
137 Anglin to George Tyler, 27 Feb. 1915, Tyler, George file, Box 2, MAP.
138 Such was the case with Minnie Maddern Fiske and Harrison Fiske. See Cecilia Morgan, "'My Dear Miss Anglin, My Dear Mrs. Fiske': Creativity and Conflict in American Theatre," paper delivered to the Emotions in Conflict Conference, University of Ottawa, Oct. 2019.
139 For a discussion of American pageantry in this period, see Glassberg, *American Historical Pageantry*.
140 "Miss Anglin in St. Louis," *The Springfield Sunday Republican*, 18 Jun. 1916, 8. Anglin's files do not specify how much she made from the celebration; at one

point she was offered 25 per cent of the box office gross (John H. Gundlach to Howard Hull, 4 Dec. 1915, St. Louis Pageant File, Box 3, MAP). However, several tickets were given away at one point ("Free Seats for Anglin, Mantell," *Stanberry* [MO] *Headlight*, 3 Aug. 1916, 30).

141 "Acts Rosalind in Open Air. Margaret Anglin Braves Rain at Shakespeare Celebration," *New York Times*, 8 Jun. 1916, 11.
142 "Miss Anglin in St. Louis."
143 "Platt, Livingston," in Bordman and Hischak, eds., *The Oxford Companion to American Theatre*; also Essin, *Stage Designers in Early Twentieth-Century America*, 41, 131.
144 Ammen, *May Irwin*, 38; Kennedy, *Marie Dressler*, 41, 55–7.
145 Bratton, *The Making of the West End Stage*, 157.

CHAPTER THREE

1 Conti, *Playing Sick*, 10. The phrase "cup and saucer" play is associated with the work of British playwright Thomas William Robertson (1829–1871), whose drawing-room comedies featured close attention to detail, ensemble playing, and sufficient rehearsal time.
2 Schweitzer points to the scramble by late-nineteenth- and early-twentieth-century Broadway managers for such scripts, brought about by changes to copyright legislation (Schweitzer, *Transatlantic Broadway*).
3 Marx, "Introduction: Cartographing the Long Nineteenth Century," in Marx, ed., *A Cultural History of Theatre in the Age of Empire*, 6. See also Wilmer, who points out that plays imported from abroad, whether as adaptations or translations, can be excluded by those seeking to trace national origins in a country's performance history, even though such plays may have outnumbered domestic drama (Wilmer, "On Writing National Theatre Histories," in Wilmer, ed., *Writing and Rewriting National Theatre Histories*, 24).
4 "Amusements. Clara Morris as Miss Multon," *Chicago Tribune*, 14 Aug. 1877, 5.
5 "Amusements. Miss Mather," *The New York Times*, 22 Dec. 1886.
6 "Amusements," *Chicago Tribune*, 5 Feb. 1874, 2.
7 Ashwell, *Myself a Player*, 122.
8 N.t., *The New York Times*, 11 Dec. 1904, SMA3.
9 "Serious Plays," *Daily Express*, 12 Jun. 1905, 3; "'Leah Kleschna' in London," *The New York Times*, 3 May 1905, 9.
10 "New York Gossip. Social and Theatrical Topics of the Hour," *Boston Daily Advertiser*, 7 Nov. 1881, 5; Burnett and Gillette, *Esmeralda*.

11 "'Esmeralda' at Haverly's," *The North American* [Philadelphia], 10 Apr. 1883; "Esmeralda at the Opera House Tomorrow Evening," *Rocky Mountain News* [Denver], 20 May 1883, 3.
12 "Plays and Actors," *The New York Times*, 18 Jun. 1882, 7; "Esmeralda," in Bordman and Hischak, eds., *The Oxford Companion to the American Theatre*.
13 "'A Royal Family' a Great Hit at the Lyceum Theatre," *The New York Times*, 6 Sept. 1900, 12.
14 "At the Princess," *The Toronto Daily Star*, 15 May 1914, 6; "Annie Russell at Princess," *The Globe*, 4 Jan. 1915, 6.
15 "The Princess Theatre," *The Toronto Daily Star*, 5 Jan. 1915, 4.
16 Ashwell, *Myself a Player*, 117–18.
17 "'Mrs. Dane's Defence.' Lena Ashwell's Triumph," *Daily Express*, 10 Oct. 1900, 3.
18 W.L. Hubbard, "News of the Theaters. Mrs. Dane's Defense," *Chicago Tribune*, 8 Jan. 1907, 8.
19 "Interesting Revival of 'Mrs. Dane's Defense,'" *The New York Times*, 16 Nov. 1906, 9.
20 "What One Week of Matinees Disclosed. The Rise of a Great English-Speaking Star. 'Mrs. Dane' as a Test of Comparative Merit," *The New York Times*, 18 Nov. 1906, X2; also W.L. Hubbard, "Nobody Knows Why Plays Fail," *Chicago Tribune*, 7 July 1907, 48. In an interview with Hubbard, Henry Arthur Jones refused to draw comparisons between Anglin's and Ashwell's performances ("American Stage as Seen by Henry Arthur Jones," *Chicago Tribune*, 23 Dec. 1906, 73).
21 Wilmer, "On Writing National Theatre Histories," 19. See also Fiona Gregory, who points out that Mrs Patrick Campbell "did not engage in grand displays of emotion that might offer the audience catharsis," unlike American actresses such as Minnie Maddern Fiske or Mrs Leslie Carter ("Mrs. Pat's Two Bodies," 221).
22 Saunier, *Transnational History*, 84.
23 Ashwell, *Myself a Player*, 120.
24 See, for example, Paisley and Scully, *Writing Transnational History*, in which the transnational and the imperial are closely connected; Marx, "Introduction," 3–6.
25 "Star – Zira," *The Buffalo Enquirer*, 7 Mar. 1905, 10.
26 "Theatre. Margaret Anglin," *Argus-Leader* [Sioux Falls], 27 Mar. 1912, 6.
27 "'Green Stockings' Very Entertaining. Margaret Anglin in Light Comedy Role," *Hartford Courant*, 15 Apr. 1911, 18.
28 "Successful Boer Play. Miss Lena Ashwell in 'The Shulamite' at the Savoy," *Daily Express*, 14 May 1906, 5. See also Hirshfield, "The Actress as Social Activist," 74–5.

29 "Successful Boer Play."
30 "Savoy Theatre. 'The Shulamite,'" *The Times*, 14 May 1906, 15. Later in the run the play was given a happy ending. Waring hears of his English wife's death and he and Deborah leave the Transvaal, presumably for England ("Savoy Theatre," *The Times*, 13 Jun. 1906, 14).
31 See, for example, Davis, "The 'Empire' Right or 'Wrong,'" in Hays and Nikolopoulos, eds., *Melodrama*; Condon, "Receiving News From the Seat of War"; Mackenzie, ed., *Imperialism and Popular Culture*.
32 These discourses are discussed in Stoler, *Along the Archival Grain*.
33 "Mr. Moody's 'The Great Divide,'" *The Sun* [New York], 4 Oct. 1906, 6; John E. Webber, "Plays of the Season," *The Canadian Magazine*, Dec. 1906, 171–8, 178.
34 "Belasco Theatre," *Evening Star*, 18 Sept. 1906, 16.
35 "Miss Margaret Anglin," *Muncie Evening Press*, 18 Sept. 1907, 5.
36 "Margaret Anglin's Plans," *The Daily Signal* [Crowley, LA], 12 Nov. 1907, 2. In 1916 Anglin repeated many of *The Great Divide*'s themes in another frontier drama, *The Vein of Gold*, set in Wyoming ("February Fancies For Local Theatregoers," *The Pittsburgh Gazette Times*, 13 Feb. 1916, 6).
37 Hall, *Performing the American Frontier*, 217; Wattenberg, *Early-Twentieth-Century Frontier Dramas on Broadway*, 170–87.
38 "*Great Divide* Is Here," *The Baltimore Sun*, 3 Mar. 1908, 9; "Strong Story Is That of Moody's *Great Divide*," *Albuquerque Journal*, 2 Jan. 1910, 10.
39 While Hall and Wattenberg point to the ways in which Jordan not only reconciles herself with the West but comes to love it, neither scholar explores Jordan's identity as a white woman and its implications for the frontier. For a discussion of these themes, see Gordon, *The Great Arizona Orphan Abduction*; Bederman, *Manliness and Civilization*; Pascoe, *Relations of Rescue*.
40 Ruff, *Edward Sheldon*, 1983.
41 "The Nigger Acted at the New Theatre," *The New York Times*, 5 Dec. 1909, C12.
42 Sheldon, *The Nigger: An American Play in Three Acts*.
43 Newman, *White Women's Rights*; Dowd Hall, *Sisters and Rebels*.
44 "Canadian Playwright Dies in New York," *The Globe*, 11 Mar. 1924, 2; Cullen, Hackman, and McNeilly, "May Tully," 1132.
45 "New Play from Shaw Story," *The New York Times*, 4 Jan. 1906, 6; "Society Actresses. May Tully of New York, and Lillian G. Barbour of Baltimore," *The Leavenworth Post* [KS], 16 Mar. 1906, 4; "May Tully, Literary Actress, Who Will Appear in a New Pinero Play," *News-Journal* [Mansfield, OH], 14 Apr. 1906, 12.
46 "The Stage," *Detroit Free Press*, 25 Nov. 1906, 44; "Music and the Drama," *The Globe*, 18 Jan. 1908.
47 See Frierson, "Christy Mathewson"; Lesch, "Chief Meyers"; n.a., "John 'Chief' Meyers." For other work on Native Americans in vaudeville, see Ware,

"Unexpected Cowboy, Unexpected Indian"; Bold, "Outside the Frontier Club," ch. 6 in her *The Frontier Club*.
48 "Woman Taught Ball Stars How to Become Actors," *Detroit Free Press*, 10 Sept. 1911, 43; "Baseball," *The Globe*, 17 Feb. 1911, 10.
49 "May Tully at the Big Game," *Los Angeles Times*, 7 Aug. 1912, 32; "Woman Fan Talks of Big Leagues," *Honolulu Advertiser*, 15 Aug. 1912, 3; Damon Runyon, "Baseball Loses Ardent Fan in Passing of May Tully," *The Akron Beacon* [OH], 12 Mar. 1924, 17.
50 Lesch, "Chief Myers."
51 Monod, *The Soul of Pleasure*.
52 See Grossman, *A Spectacle of Suffering*.
53 "Amusements. Clara Morris as Miss Multon," *Chicago Tribune*, 14 Aug. 1877, 5.
54 "Amusements. Clara Morris and the Play of 'Miss Multon,'" *Chicago Tribune*, 19 Aug. 1877, 10.
55 Ibid.
56 "Successful Boer Play. Miss Lena Ashwell in 'The Shulamite' at the Savoy," *Daily Express*, 14 May 1906, 5. See also Hirshfield, "The Actress as Social Activist," 74–5.
57 "Star – Zira," *The Buffalo Enquirer*, 7 Mar. 1905, 10.
58 "Zira at Albaugh's," *The Baltimore Sun*, 13 Feb. 1906, 12; John E. Webber, "Plays of the Season," *The Canadian Magazine*, Dec. 1906, 171–8, 178; Webber, "Canadians Prominent on the Stage," *Canadian Magazine*, Nov. 1908, 25–31, 27.
59 LeVay, *Margaret Anglin*, 166.
60 "The Nixon," *The Pittsburgh Press*, 11 Jan. 1910, 9.
61 "Miss Margaret Anglin," *Jackson Daily News* [MS], 8 Oct 1910, 12.
62 Marra, "Taming America as Actress," in Mason and Gainor, eds., *Performing America*, 60.
63 Ibid., 60–1.
64 At least in the first version of *The Shulamite* in which Ashwell appeared.
65 Wozniak, "The Play with a Past," 394.
66 "Glory Quayle and *The Christian*. Conversation with Viola Allen," n.p., c. 1898, Allen Scrapbook, 8-MWEZ-7607, 73; Arthur Brandeis, "Viola Allen as Glory Quayle," *The Dramatic Magazine*, Oct. 1899, Allen Scrapbook, 8-MWEZ-7607, 68.
67 See, for example, Wozniak, "The Play with a Past"; Eltis, "The Fallen Woman on Stage"; Gregory, "Mrs. Pat's Two Bodies"; McDonald, "New Women"; Guest, "The Subject of Money"; Johnson, *Sisters in Sin*.
68 Guest, "The Subject of Money," 636.
69 Ashwell, *Myself a Player*, 122.

70 Howard Hull to Alice Kauser, 8 July 1923. File Kauser, Alice, Box 2, Margaret Anglin Papers (MAP).
71 Ashwell, *Myself a Player*, 122.
72 Ashwell, *The Stage*, 15.
73 Barstow, "'Hedda Is All of Us,'" 405.
74 Those letters sent to Anglin by audience members date, for the most part, from the 1920s and '30s.
75 Harrison, *Separate Spheres*; Crozier-De Rosa, *Shame and the Anti-Feminist Backlash*.
76 Ahmed, "Collective Feelings," 27.
77 Ibid.
78 Kammen, *Mystic Chords of Memory*; Morgan, *Commemorating Canada*, esp. ch. 3, "The Heyday of Public Commemoration in Canada, 1870s–1920s"; Melman, *The Culture of History*.
79 "A New Play at the Empire. 'Sowing the Wind' Commands Respectful Attention," *The New York Times*, 3 Jan. 1894, 4; clipping, n.t., c. Jan. 1894, Viola Allen Scrapbook, 8-MWEZ-7607.
80 Arthur Hoeber, "'Under the Red Robe,'" in *Illustrated America*, 1897, Viola Allen Scrapbook, 8-MWEZ-7607.
81 Bordman, "In the Palace of the King," in *Oxford Companion to American Theatre*, 332.
82 Edward Freiberger, "'In the Palace of the King,'" *Saturday Evening Herald*, 27 Oct. 1900; also "Viola Allen's Splendid Art in 'In the Palace of the King,'" *Oakland Enquirer*, 18 Feb. 1902.
83 "Viola Allen in Romance," *Brooklyn Daily Eagle*, 3 Dec. 1901. Moreover, Allen's productions of *Twelfth Night* and *The Winter's Tale* tapped into the elaborate pictorial tradition of Shakespeare, which strove for a particular version of historical authenticity: "A Belated Ambition," *Massey's Magazine*, Nov. 1903, Book 7610, Viola Allen Scrapbooks. For the pictorial and historical in nineteenth-century theatre, see Kachur, "Shakespeare Politicized"; Richards, "Henry Irving: The Actor-Manager as Auteur."
84 "Play by a Native Poet. Julia Arthur Shows Genuine Talent in *Mercedes*," *The New York Times*, 2 May 1893.
85 "'More than Queen.' Julia Arthur's New Play a Notable Success. Thrilling Days of First Empire Represented. Piece Artistically Played and Finely Staged," *Journal* [Boston], 5 Oct. 1899; see also "More than Queen" clipping file, Box 6, Julia Arthur Papers.
86 Winter was certainly not one of those "idolators," writing in his review that Napoleon was "coarse, cruel, unprincipled, tyrannical, and obnoxious" ("The Drama. Julia Arthur in 'More than Queen,'" *New York Tribune*, 25 Oct. 1899, 9).

87 "A Great Play for Carpenters, Dressmakers and Burglars?" *Times* [Boston], 8 Oct. 1899.
88 "A New Stage Heroine. Julia Arthur as Clorinda Wildairs, a Strange and Vehement Young Lady of Long Ago," *The New York Times*, 2 Nov. 1897.
89 "Studying a Part. Miss Arthur Has No Sympathy with Clorinda," *Buffalo Express*, 22 Oct. 1898. "In New York" also pointed to Arthur's having "softened down" Wildairs's character (*The Theatre*, 1 Dec. 1897, 329).
90 "In the World of Amusement," William Winter as quoted in *The Duluth News-Tribune*, 7 Nov. 1897, 6.
91 Samuel Freedman, "Julia Arthur's Successes," *The Dramatic Magazine*, n.d. 1899, 5–11, 6.
92 "Sheriff Busy with Julia Arthur. Attached Bank Accounts of Her Husband, B.P. Cheney, in Mr. Moss' Suit for $10,000 Damages," New York Herald, n.d., c. 1897–98, File 1, Box 2, Julia Arthur Papers.
93 Hoganson, *Consumers' Imperium*, 71–80. Work on transatlantic tourism has pointed to Americans' fascination with France: Levenstein, *Seductive Journey*; Maureen E. Montgomery, "'Natural Distinction': The American Bourgeois Search for Distinctive Signs in Europe," in Beckert and Rosenbaum, eds., *The American Bourgeoisie*.
94 See King, *Henry Irving's Waterloo*, 112–13.
95 Lears, *No Place of Grace*, 186–7.
96 Melman, "Horror and Pleasure," 27–30.
97 "Viola Allen's Cloth of Gold Gown. Wonderfully Beautiful Dress of Ancient Fabric Worn by the Popular Star – Duplicate of Court Costume," n.p., 2 Apr. 1902, 7609, Viola Allen Scrapbooks.
98 Margaret McKenna, "Julia Arthur's Queenly Gowns. Fashioned Accurately, after Three of the Empress Josephine. They Are the Delight of Boston and New York Society Women Who Have Seen 'More than Queen,'" *Journal* [Boston], 3 Dec. 1899.
99 "She Does Not Like Encores. Peerless Viola Allen Says Acknowledgement Dispels the Illusion," *El Paso Daily News*, 28 Jan. 1902; Katharine Wright, "Julia Arthur, 15 Years Off Stage, Comes Back to Boston," *Sunday Herald* [Boston], 19 Mar. 1916.
100 For reviews that commented approvingly on her fencing during the play, see *A Lady of Quality* Clipping File, Box 6, Julia Arthur Papers.
101 "Fencing Makes Women Graceful," n.p., c. 1908, Scrapbook 7610, Viola Allen Scrapbooks.
102 Henri Dumay, "An Interview with Julia Arthur," *Criterion*, 18 Dec. 1897; Winter, "The Drama. Julia Arthur in 'More than Queen.'"
103 "Popular Theatres," *The Daily Illustrated Mirror*, 4 Apr. 1904, 2.

104 "Mr. Tree as a Jap. Staging 'The Darling of the Gods,'" *Daily Express*, 28 Dec. 1903. See also Lydia Edwards, "A Tale of Three Designers."
105 "Mr. Tree as a Jap," *Daily Express*.
106 Ashwell, *Myself a Player*, 126–7.
107 Archie Bell, "Viola Allen in Chinese Spectacle," *Plain Dealer* [Cleveland], 4 Apr. 1913, 6; Archie Bell, "Ming and Manchu in Drama," *Plain Dealer* [Cleveland], 29 Jan. 1913, 8. The production also toured to Chicago, Cleveland, and other mid-western cities.
108 "New Chinese Play Brings Artists of Rare Genius," *Morning Oregonian* [Portland], 22 Sept. 1912, 4.
109 "Longest and Strongest Part Ever Written for a Woman," *The Idaho Daily Statesman* [Boise], 15 Dec. 1912, 2.
110 "Late Play Is a Real Success," *The Duluth News Tribune*, 20 Oct. 1912, 5.
111 "About New Plays on Eastern Stage," *The Anaconda Standard* [MT], 22 Oct. 1912, 3.
112 "New Play Fails to Bring Praise," *Plain Dealer*, 13 Oct. 1912, 14; "Drama. Pierre Loti's New Play," *Macon Daily Telegraph*, 19 Oct. 1912, 6.
113 O. Terence, "The Human Procession," *Trenton Evening News*, 26 Oct. 1912, 7.
114 "Finds Fascination in a Chinese Role," *Washington Post*, 16 Mar. 1913, MT3. Allen ranked the play with the works of Sophocles, Euripedes, Shakespeare, and Milton.
115 Archie Bell, "Melodrama Is Here Again," *Plain Dealer* [Cleveland], 2 Dec. 1912, 6. It is not clear if Ashwell wore yellowface makeup for *Darling*, although a still photo in her memoir suggests that was the case (Ashwell, *Myself a Player*, 96).
116 Gardner, "Scales, Caroline, Caroline Miskel, Caroline Miskel-Hoyt," in *Dictionary of Canadian Biography*, vol. 12; also Morgan, "Mrs. Hoyt," in his *Types of Canadian Women vol. 1*, 167.
117 "Our Gallery of Players. CIV. May Waldron Robson," *The Illustrated American* vol. 14, 22 July 1893, 89–90, 89. She began her career in Chicago in a production of Gilbert and Sullivan's *Pinafore* and then moved to New York to work for Augustin Daly and then for Stuart Robson (her husband) and William Crane. In their company Robson also appeared in *A Comedy of Errors*, *The Merry Wives of Windsor*, and as Kate Hardcastle in *She Stoops to Conquer*.
118 "The Henrietta," in Bordman and Hischak, eds., *The Oxford Companion to the American Theatre*, 303; Smith, *American Drama: The Bastard Art*, 177. Not only was the play produced again in 1913 as *The New Henrietta*, but it was also revived in 2013 in an off-off-Broadway production (Ken Jaworoski, "'The Henrietta,' a Comedy Set in 1897, Resonates Today," *The New York Times*, 18 Jun. 2013). Howard was the first American playwright to make a profit at his work and

was instrumental in getting the 1891 Copyright Law passed (Smith, *American Drama*, 17).
119 Odell, *Annals of the New York Stage*, vol. 13, 436.
120 Annie Russell, "George Bernard Shaw at Rehearsals of 'Major Barbara,'" 73.
121 Ibid., 75.
122 Ibid., 80.
123 "'Major Barbara,'" *The Times*, 29 Nov. 1905, 10.
124 Russell, "George Bernard Shaw," 81.
125 Powell, "New Women, New Plays, and Shaw in the 1890s," in *The Cambridge Companion to George Bernard Shaw*, 76–7. See also Peters, "Shaw's Life: A Feminist in Spite of Himself," in *The Cambridge Companion to George Bernard Shaw*, 3–24; Hadfield, "What Runs (in) the Family"; Berg, "Structure and Philosophy in *Man and Superman* and *Major Barbara*," in *The Cambridge Companion to George Bernard Shaw*, 144–61.
126 Powell, "New Women," 87.
127 Leask, *Lena Ashwell*, 74–6.
128 Ashwell, *Myself a Player*, 152.
129 "Lena Ashwell Seen as 'Judith Zaraine,'" *The New York Times*, 17 Jan. 1911; "Astor. 'Judith Zaraine,'" *The Theatre* 13, 1911, xiii.
130 E.R. Parkhurst, "Music and Drama," *The Globe*, 3 Jan. 1911.
131 Ashwell, *Myself a Player*, 174.
132 The description of the Royal Alexandra comes from Filewod, *Committing Theatre*, 61; also Brockhouse, *The Royal Alexandra Theatre*, 75–86. For the left in Canada during this period see McKay, *Reasoning Otherwise*, esp. ch. 3, "The Class Question."

CHAPTER FOUR

1 Luckhurst and Moody, "Introduction: The Singularity of Theatrical Celebrity," in Luckhurst and Moody, eds., *Theatre and Celebrity in Britain*, 1, 3.
2 Auster, *Actresses and Suffragists*, esp. ch. 6 and 7; de Leon, "'There's No Business Like Show Business': Celebrity and the Popular Culture Industries," ch. 7 in his *Self-Exposure*; Marcus, *The Drama of Celebrity*, 20–2; Bonapfel, "Reading Publicity Photographs through the Elizabeth Robins Archive"; Kelly, "Beauty and the Market"; Hindson, *Female Performance Practice on the Fin-de-Siècle Stages of London and Paris*, esp. ch. 5; Eltis, "Private Lives and Public Spaces," in *Theatre and Celebrity in Britain*.
3 For discussions of Bernhardt, see Marcus, *The Drama of Celebrity*; Eltis, "Private Lives and Public Spaces"; Glenn, "The Bernhardt Effect: Self-Advertising and the Age of Spectacle," ch. 1 in her *Female Spectacle*. Being "French," though,

could mean a performer was accorded a certain latitude by the audience. As Monod points out in his analysis of the American career of French star Anna Held, "the fact that Held was French was undoubtedly crucial in overcoming discomfort with her eroticism" ("The Eyes of Anna Held," 300).

4 Woods, "American Vaudeville," in Mason and Gainor, eds., *Performing America*.
5 "In Detroit Theatres. Julia Arthur Begins Her Star's Career in Detroit," *Detroit Free Press*, 3 Oct. 1897; "Echoes from the Green Room," *The Theatre*, 1 May 1895, 313; A.B., "The Lyceum Recruits. II – Julia Arthur," *The Sketch*, 26 Jun. 1895, 477–8; n.t., *Standard*, 27 Nov. 1895, File 1, Box 2, Julia Arthur Papers.
6 "Viola Allen Talks to a New-Tribune Editor. Says That Plenty of Exercise Is the Best Medicine for a Pretty Complexion," *News Tribune*, n.d., c. 1905, Viola Allen Gift Scrapbook 9122, Viola Allen Scrapbooks 1867–1948.
7 "Viola Allen in Romance," *Brooklyn Daily Eagle*, 3 Dec. 1901.
8 M.A. Morehouse, "Women Here and There," *The New York Times*, 22 Dec. 1901, SM14. To be fair, Morehouse's point was to show how many "American" actresses had been born abroad; the list included Ada Rehan, May Robson, Mrs Whiffen, Rose Coghlan, Olga Nethersole, and Julia Marlowe.
9 "Stage Favourite Dies in Hospital," *The Evening Times* [Sayre, PA], 22 Jan. 1934.
10 N.t., *Herald*, 15 Dec. c. 1895–96, File 1, Box 2, Arthur Papers.
11 "One Dramatic Star," *Honolulu Advertiser*, 9 Feb. 1885, 4.
12 "Clara Morris's Start," *International Gazette* [Black Rock, NY], 27 July 1895, 2.
13 "Rise to Fame of Clara Morris," *The Sentinel* [Carlisle, PA], 11 Jun. 1910, 5.
14 "Pneumonia Is Fatal to Noted Stage Actress. Amelia Summerville Dies in New York," *Chicago Tribune*, 22 Jan. 1934, 20.
15 "May Tully Worked Hard to Get 'Curves,'" *The Pittsburgh Press*, 11 Dec. 1910, 25.
16 N.t., *Chicago Tribune*, 14 Oct. 1906, 95.
17 "Plain Little Girls Become Beautiful Women," *Chicago Tribune*, 9 Jan. 1907, 28.
18 Fannie M. Lothrop, "Famous People. Margaret Anglin. America's Brilliant Young Actress," *Star-Gazette* [Elmira, NY], 27 Nov. 1908, 6; Charles Henderson, "Some Few Facts and an Occasional Comment, Serious and Otherwise, Concerning Well-Known Actors Who Have Landed on Our Shores and Claimed Them," *Plain Dealer* [Cleveland], 8 Nov. 1914, 73–4. Henderson had little to say, though, about Dressler's early life in Canada, possibly because it was not as uplifting as Anglin's.
19 "Canadians Honor Margaret Anglin," *Salt Lake City Telegram*, 6 Jun. 1910, 14.
20 "Miss Julia Arthur," *Journal*, 7 Oct. 1893.
21 "Portraits. Miss Julia Arthur," *The Theatre*, 1 Aug. 1897, 56.
22 Bernard K. Sandwell, "The Annexation of Our Stage," *The Canadian Magazine*, Nov. 1911, 22–6, 22.
23 Ibid.

24 "Some Canadian Women Who Have Won Fame on the Stage in Other Countries," *The Ottawa Evening Journal*, 22 Mar. 1913, 17, 24.
25 W.J. Thorold, "Canadian Successes on the Stage," *Massey's Magazine*, Oct. 1895, 235–40, 235.
26 Ibid., 237. While Hoyt was born in Alabama, that did not prevent Thorold from claiming her as Canadian.
27 Ibid., 240.
28 Hammill, "'Astronomers Locate Her in the Latitude of Prince Edward Island': L.M. Montgomery, *Anne of Green Gables*, and Early Hollywood," ch. 4 in her *Women, Celebrity, and Literary Culture between the Wars*.
29 *Saturday Night*, 8 Apr. 1905; John E. Webber, "Plays of the Season," *Canadian Magazine*, Dec. 1906, 171–8; Margaret Bell, "May Irwin, Peeress of Stage Widows," *Maclean's*, 27 July 1914, 97–100; Margaret Bell, "Viola Allen's Greatest Achievement," *Maclean's*, 18 Feb. 1915, 47–8, 72.
30 John E. Webber, "Canadians Prominent on the Stage," *Canadian Magazine*, Nov. 1908, 25–31, 27.
31 Brennan, "Saturday Night," 566; Walden, "Toronto Society's Response to Celebrity Performers, 1887–1914."
32 N.a., n.t., *Saturday Night*: 15 and 29 Apr. 1911; 14 Nov. 1914; 28 Jun., 19 July, 20 Sept., and 27 Dec. 1913; 3 Jan. and 21 Nov. 1914; 13 May and 11 and 18 Nov. 1916; 24 May 1919.
33 "Plays, Players and Play Goers," *The Ottawa Journal*, 21 Nov. 1903, 14.
34 "News, Notes, and Comments of the Dramatic World," *The Winnipeg Tribune*, 5 July 1913, 19; "Margaret Anglin Again Scores at Walker Theatre," *The Winnipeg Tribune*, 10 Nov. 1915, 6; "Margaret Anglin in Effective Play," *Vancouver Daily World*, 10 Aug. 1910, 19.
35 Polly Peele, "Behind the Scenes with Margaret Anglin," *The Globe*, 17 Nov. 1914, 7.
36 "Music and the Drama," *The Globe*, 31 Aug. 1901, 19; "Miss Julia Arthur. The Canadian Actress Secretly Married to a Multi-Millionaire," *The Ottawa Journal*, 23 Apr. 1898, 11.
37 Arthur's performance in Shaw's *Saint Joan* was well-covered by the Canadian press and is discussed in ch. 6. Other coverage of Arthur in the late nineteenth and early twentieth centuries includes "An Accidental Actress," *Vancouver Daily World*, 9 Apr. 1892, 7; "A Hamilton Romance," *The Ottawa Journal*, 20 Apr. 1908, 8; "Big Blaze in Detroit … Julia Arthur Dramatic Company Lost Handsome Costumes and Stage Settings," *The Winnipeg Tribune*, 7 Oct. 1897, 1; "Julia Arthur's Rebuke. Canadian Actress Caused a Sensation at Hartford," *The Ottawa Journal*, 15 May 1899, 3.

38 "A Daughter of Canada. Miss Julia Arthur, of Hamilton, Is Among Real Friends," *Vancouver Daily World*, 19 Nov. 1895, 2.
39 "Canadian Actress in Unusual Drama. Miss Julia Arthur in 'The Eternal Magdalene' at the Grand. A Difficult Subject," *The Mail and Empire*, 21 Mar. 1916.
40 "Just Worry about Themselves That Makes Women Grow Old. Says Beautiful Julia Arthur, Whom War Has Given to an Admiring Public Once More," *The Evening Telegram*, 21 Mar. 1916.
41 "'The Eternal Magdalene,'" *Hamilton Spectator*, 22 Mar. 1916.
42 "Play Does Not Condone Sin, Declares Miss Arthur," *Telegram*, 25 Mar. 1916.
43 James M. Curley, "Letter," *Telegram*, n.d., Scrapbook Two: *The Eternal Magdalene*, Julia Arthur Papers.
44 "Julia Arthur Welcomed in 'The Eternal Magdalene' at Grand Opera House," *Toronto Daily Star*, 21 Mar. 1916.
45 E.R. Parkhurst, "At the Majestic," *The Globe*, 29 Mar. 1910, 9; "Music and the Drama," *The Globe*, 14 Sept. 1903, 10, and 10 Sept. 1903, 14; E.R. Parkhurst, "Music and the Drama. The Bonstelle Players," *The Globe*, 5 May 1913, 9; "'The Fortune Hunter' A Comedy Tid-Bit," *The Toronto Daily Star*, 4 Jun. 1913, 12; "Miss Catherine Proctor, a Clever Canadian Actress," *The Toronto Daily Star*, 2 May 1914, 6.
46 "Some Things about Canadian Actors and Actresses," *The Ottawa Journal*, 11 Oct. 1913, 13; "Annie Russell. The Talented Actress Who Will Be a Full Fledged Star Next Season," *The Winnipeg Tribune*, 17 May 1897, 6.
47 Cyrus Macmillan, "Some Canadians on the Stage," *The Globe*, 20 Apr. 1912, A2; also "Chit Chat," *The Globe*, 17 Dec. 1898, 23.
48 "Maria," "Lena Ashwell Who, as Daisy Pocock, Was a School Girl in Toronto," *The Globe*, 28 Dec. 1910, 5; E.R. Parkhurst, "Music and Drama," *The Globe*, 29 Dec. 1910, 7.
49 "Letters from a Canadian Woman in London," *Manitoba Morning Free Press*, 22 Dec. 1906, 35; also "The Social Round," *The Ottawa Evening Journal*, 11 Mar. 1903, 7.
50 "Lorgnette" and "Here and There," *The Globe*, 16 July 1909, 6.
51 Lanning, "Morgan, Henry James," in *Dictionary of Canadian Biography*, vol. 14.
52 See, respectively, Morgan, *Types of Canadian Women*, 11, 13, 37, 167, 172, 231, 241, 242, 289. In his first collection, *Men and Women of the Time: A Hand-book of Canadian Biography*, Morgan also included an entry on Mary Keegan (524).
53 Morgan, *Types of Canadian Women*, 23.
54 "Miss Prentice," in ibid., 276.
55 "Miss Mollison," in ibid., 236. For information on Mollison's subsequent life and career, see Rutledge, "Kelly, Ethel Knight [1875–1949]," in *Australian Dictionary of Biography*.

56 National Council of Women of Canada, *Women of Canada*, 238.
57 Ada Patterson, "Julia Arthur Cheney. The Story of a Beautiful and Once Famous Actress Who, Like Mary Anderson, Left the Stage Forever in the Middle of a Brilliant Career When Love Came," *Human Life*, Mar. 1907, 5–6.
58 "My Career by Julia Arthur," *Hearst's*, Mar. 1916, 176–7, 222–4; Margaret Anglin, "Domesticity and the Stage," *Good Housekeeping Magazine* 54, no. 1 (Jan. 1912): 41–8.
59 Eltis, "Private Lives and Public Spaces"; Sentilles, *Performing Menken*.
60 Wilmer, *Writing and Rewriting National Theatre Histories*.
61 "The Stage," *Detroit Free Press*, 24 Apr. 1896, n.t. The reporter noted that this "attack was not obstinate and it soon yielded to climactic influences."
62 "Empire Day Fetes. Thousands of Celebrations Arranged at Home and in the Colonies," *The Daily Mirror*, 23 May 1907, 4.
63 See, for example, "Margaret Anglin in Sydney. A Sketch. A Celebrated Irish American Actress," *Catholic Press*, 18 Jun. 1908, 21. An interview in Sydney's *Freeman* mentioned her father's newspaper (also called *Freeman*) but did not elaborate on his work ("Personal," *Freeman's Journal*, 2 July 1908, 25). For Timothy Anglin's career as a journalist and politician, see Baker, "Anglin, Timothy Warren," in *Dictionary of Canadian Biography*, vol. 12.
64 For a different kind of transnational cultural transmission that involved Irish communities, see Granshaw, "Performing Cultural Memory: The Travelling Hibernicon and the Transnational Irish Community in the United States and Australia."
65 To be sure, this too was not new; in the late eighteenth century, celebrity status shifted from being attained strictly through birth or connections to being achieved through hard work and accomplishments. These shifts are explored in Lockhurst and Moody, eds., *Theatre and Celebrity in Britain, 1660–2000*.
66 "Julia Arthur," *Dramatic Mirror*, 30 Nov. 1895; W.J. Thorold, "A Woman of Talent – A Lady of Quality," n.p., c. 1897–98, File 5, Box 2, Arthur Papers; Katharine Wright, "Julia Arthur, Fifteen Years Off Stage, Comes Back to Boston," *Sunday Herald* [Boston], 19 Mar. 1916; "'The Eternal Feminine.' Margaret Anglin Produces a New Play under Difficulties," *Public Ledger* [Philadelphia], 9 Nov. 1904; n.t., *Argus*, 17 Jan. 1905, Anglin Scrapbooks; "Miss Anglin, Worker," *The New York Times*, 25 Apr. 1916, x4; "A Chat with Viola Allen," n.p., Nov. 1895, 7, Allen Scrapbook 7607; "Miss Allen to Star," n.p., n.d. 1898, 23, Allen Scrapbook 7607.
67 Annie Russell, "What It Really Means to Be an Actress," *Ladies' Home Journal* 26, Jan. 1909, 11, 49.
68 N.t., *Milwaukee Free Press*, 9 Dec. 1904, Anglin Scrapbooks.
69 Unidentified clipping, Allen Scrapbook 7607, 3.

70 "Studying a Part. Miss Arthur Has No Sympathy with Clorinda," *Buffalo Express*, 22 Oct. 18.
71 "My Career by Julia Arthur," *Hearst's*, Mar. 1916, 176–7, 222–4, and Apr. 1916, 266–7, 322–4.
72 "Julia Arthur's Quiet Life," *World* [New York], 23 July 1893.
73 Fanny Enders, "Is It Beauty or Brains That Attract the Masses?" *Courier Journal* [Louisville], 4 Dec. 1898.
74 "Margaret Anglin, America's Brilliant Young Actress," *Star-Gazette* [Elmira, NY], 27 Nov. 1908, 6.
75 "Miss Anglin, Worker." This article was also a jab at "our actresses, who must have part of the season in the country and can't be bothered with the provinces."
76 J. Herman Thurman, "The Shakespearean Revival. Viola Allen in 'A Winter's Tale,'" *Men and Women*, Jan. 1905.
77 "Annie Russell in a New Play," *The New York Times*, 13 Nov. 1894, 4. The play in question was Sydney Grundy's *The New Woman*.
78 Viola Allen, "And Seen as Modern Types, People of Today. Lady Macbeth a Politician's Wife, Rosalind the Alert, Up-to-Date Girl," *The New York Times*, 5 Mar. 1916, ST3; Margaret Anglin, "The Heroines as Viewed from the Stage," *The New York Times*, 5 Mar. 1916, ST2.
79 "Stage Personality. Miss JA Expresses Her Views on the Subject – 'Schools of Acting' Defined," *Herald* [Rochester, NY], 22 Oct. 1898.
80 "The Stage of London. Miss Julia Arthur, the American Actress, Tells Her Experiences," *The Herald* [Boston], 7 Aug. 1897.
81 Viola Allen, "On the Making of an Actress," *The Cosmopolitan*, Aug. 1901; Viola Allen, "What It Means to Be an Actress," *The Ladies' Home Journal* 14, no. 6 (May 1899): 2.
82 "Actors as Speechmakers. Annie Russell and Kyrie Bellew Give Advice to Young Actors," *The New York Times*, 23 Mar. 1902, 15.
83 "The Stage as a Career for Women. What Margaret Anglin, the Clever Young Canadian Actress, Thinks," *Vancouver Daily World*, 28 Jun. 1902, 9.
84 Morris, *The Life of a Star*; *Stage Confidences*; *Life on the Stage*; *A Pasteboard Crown: A Story of the New York Stage*.
85 "Dramatic Notes," *Vancouver Daily World*, 1 Aug. 1908, 17.
86 de Leon, *Self-Exposure*.
87 "America Has Richest Actors," *Chicago Tribune*, 26 July 1908, 44.
88 Davidoff and Hall, **Family Fortunes**; Sklar, **Catherine Beecher**; Casper, **Constructing American Lives**.
89 Marcus, *The Drama of Celebrity*, 75–6, 85, 93–6, 108.
90 *Many* thanks to Nicole Neatby for reminding me of this point.

91 See, for example, "A Chat With Viola Allen," n.p., Nov. 1895, 7, and "Viola Allen Loves Horses," n.p., c. 1898, 45, Allen Scrapbook 7607; "Julia Arthur Talks on Health," *New York Morning Telegraph*, 27 Nov. 1898.

92 Grossman, *A Spectacle of Suffering*, 156–8; "The Sufferings of Clara Morris," *The Lake County Star* [Chase, MI], 23 Sept. 1875, 1; "Margaret Mather Very Ill," *The New York Times*, 25 Feb. 1883; "Death of Margaret Mather," *The New York Times*, 8 Apr. 1898; "Annie Russell's Long Illness," *The New York Times*, 26 Dec. 1890, 8; "Annie Russell to Act Again," *The New York Times*, 8 Nov. 1894, 9. Morris suffered from curvature of the spine; her use of morphine to control the pain contributed to her going almost completely blind later in life. Mather's early death from kidney disease is discussed in ch. 2. It is difficult to determine the cause of Russell's ill-health; it might have been a combination of overwork and the stress brought about by her abusive first marriage.

93 "Actress Who May Lose Voice," *Muncie Evening Press*, 18 Nov. 1910, 2; G.C.M. to Margaret Anglin, 15 Nov. 1910, Misc. L–W 1910–17, Box 4, MAP.

94 Roach, "Public Intimacy: The Prior History of 'It,'" in *Theatre and Celebrity in Britain*; Roberta Barker, "The Gallant Invalid: The Stage Consumptive and the Making of a Canadian Myth"; Conti, *Playing Sick*.

95 Auster, *Actresses and Suffragists*, 31; Davis, "The Socioeconomic Organization of the Theatre," ch. 1 in her *Actresses as Working Women*. We lack comparable statistics for Canada, although the number of women I have located suggests similar trends might have been at work, albeit complicated by performers' mobility outside the country.

96 Lillene Loeb to Margaret Anglin, 10 May 1921, File K–L 1920–24, Box 4, MAP.

97 Diana Bourbon to Anglin, 29 July, c. early 1920s, File Misc. A–B 1920–24, Box 4, MAP. Bourbon was not a neophyte. She had trained at the Academy of Dramatic Art in London and had performed professionally there and had gone on to work for Lee Shubert.

98 Cathie Cansdell to Anglin, 8 Aug. 1914, File Misc. A–H 1910–19, Box 4, MAP.

99 Schweitzer, "The Octopus and the Matinee Girl," ch. 1 in *When Broadway Was the Runway*; Butsch, "Bowery B'hoys and Matinee Ladies"; Barstow, "'Hedda Is All of Us.'" Although young women made up the bulk of those writing to Anglin for advice, see Samuel Baron to Anglin, 11 May 1921, File Misc. A–B 1920–24, Box 4, MAP.

100 Smith Livingston to Mrs Hull, 1 Apr. 1924, File K–L 1920–24, MAP.

101 Percival Chubb to Anglin, 10 Jan. 1916; Anglin to Chubb, 14 Jan. 1916, File Misc. A–H 1910–19, Box 4, MAP.

102 Anita Damrosch to Anglin, 10 Aug. 1922, and William Damrosch to Anglin, 25 Aug. 1922, File Damrosch, Walter, Box 1, MAP.

103 Katherine Kory to Howard Hull, 1 Apr. 1921, File K–L 1920–24, Box 4, MAP.
104 Earl Price to Anglin, 14 Aug. 1923, File P–R 1920–24, Box 4, MAP.
105 Polly Peele, "Behind the Scenes with Margaret Anglin," *The Globe*, 17 Nov. 1914, 7.
106 Kobbé, *Famous Actresses and Their Homes*, 165.
107 Ibid., 178–80.
108 Ibid., 181.
109 Young, *Middle-Class Culture in the Nineteenth Century*, 33–8; also Lawrence, *Genteel Women*; Moskowitz, "'Aren't We All?'"
110 Grace Drew, "Stars Seen by Day. Viola Allen at Home," *Every Month Magazine*, Jan. 1899.
111 "Glimpses of Viola Allen's Home Life," *Davenport Republican* [IA], 13 Apr. 1902.
112 Hoganson, *Consumers' Imperium*. See especially ch. 1, "Cosmopolitan Domesticity, Imperial Accessories: Importing the American Dream."
113 "Miss Viola Allen at Home," *Sunday Times-Herald* [Chicago], 24 Sept. 1901.
114 "Margaret Anglin – An Impression," *Maitland Daily Mercury*, 1 July 1908, 2; also "Frances" and "Sydney Social," *Punch* [Melbourne], 2 July 1908, 30.
115 "On and Off the Stage," *Table Talk* [Melbourne], 16 July 1908, 20.
116 "Stars of the Stage at Home. With Paint and Powder Off and the Make-Believe World Forgotten," n.p., Mar. 1917, Scrapbook S, Box 3, Arthur Scrapbooks. Obviously the second part of the title did not apply to either Anglin or Arthur.
117 Kobbé, *Actresses and Their Homes*, 119, 124–5.
118 Ibid., 124–5.
119 For beauty, see: "Our Gallery of Players. CIV. May Waldron Robson," *The Illustrated American*, vol. 14, 22 July 1893, 89–90; Storms, "Blanche Crozier," in Storms, ed., *The Players Blue Book*, 292; "American Theatrical Invasion," *Age* [Melbourne], 15 Jun. 1908, 8; "About Julia Arthur. Beautiful Actress Is of Irish Extraction. She Has 13 Brothers and Sisters – All of Them Quite Talented," *Toledo Blade*, 30 Sept. 1899, n.p.; "Viola Allen in the Beautiful Production of Shakespeare's 'Twelfth Night' at the Knickerbocker," *Broadway Weekly*, 18 Feb. 1904. For fashion: "Women Here and There – Their Frills and Fancies," *The New York Times*, 1 Oct. 1899, 22; Annie Russell, "Annie Russell Says American Fashions Are Here to Stay," *The New York Times*, 23 Feb. 1913, 87; "May Tully's New York Fashion Show," *The Oregon Daily Journal*, 20 Feb. 1916, 32; "Margaret Anglin – An Impression," *Maitland Daily Mercury*, 1 July 1908, 2.
120 Moskowitz, "'Aren't We All?'" 77.
121 Margaret Anglin, "Domesticity and the Stage. How Play-Acting and Housekeeping Work Together for Good," *Good Housekeeping Magazine* 54, no. 1 (Jan.

1912): 41–8, 41; "'Never Say Can't,' Advises Julia Arthur," *Boston Sunday Post*, 1 Apr. 1923.

122 According to the press, in Australia, Anglin developed a reputation with the stage hands at Her Majesty's Theatre for being "'a lady'" with "'no nonsense'" about her. Just before *The Thief* opened she decided that new set dressings were needed for a scene. Having taken the head of properties to the Sydney stores, Anglin insisted on carrying half of her purchases back to the theatre. "'Fancy Miss So-and-So doing that,' said the hands among themselves" (Frances, "Sydney Social," *Punch* [Melbourne], 2 July 1908, 30).

123 Anglin, "Domesticity and the Stage," 43.

124 Ibid., 43, 45.

125 Ibid., 45, 47–8.

126 Ibid., 48.

127 "A Real Maid," *The Daily Gazette* [Lawrence, KS], 19 Mar. 1912, 4.

128 "Advertisements – 'Six Persons,'" *The Illustrated London News*, 6 Jun. 1903, 872; "Selling Twice the Amount of Shoes at Half the Usual Profit," *Vancouver Daily World*, Nov. 1917, 4; "Elcy M Wins Race at the Minot Meet," *The Winnipeg Tribune*, 16 Jun. 1905; "Footlight Gossip," *The Philadelphia Inquirer*, 23 Jan 1898, 6; Wolf, "Margaret Anglin Waltzes," J.C. Williamson Papers, Box AJ, MS4573; https://immortalephemera.com/movie-collectibles/1908-playing-cards-actors-actresses/. To be sure, as Felicity Nussbaum has pointed out, actresses' relationship to consumerism was not new: "Actresses and the Economics of Celebrity, 1700–1800," in *Theatre and Celebrity in Britain*. See also Marcus, *The Drama of Celebrity*, 229.

129 "A Common Delusion," *The Ottawa Journal*, 31 Dec. 1898, 4 (originally published in *The London Free Press*).

130 "Julia Arthur Secretly Married," *New York Herald*, 12 Apr. 1898.

131 Ada Patterson, "Julia Arthur Cheney," *Human Life*, Mar. 1907, 5–6, 5; "Advertisements – 'Six Persons,'" *The Illustrated London News*, 6 Jun. 1903, 872; "Star Can Travel on Husband's Pass. Former Stage Favorite, Now Wife of Prominent Railroad Man, Is Here with Him," *LA Examiner*, n.d., c. 1902, File – Married Life, Box 6, Arthur Papers.

132 Patterson, "Julia Arthur Cheney," 5; "Blue Diamonds Bought by Americans, Former Actress Who Will Receive One," n.p., n.d., "File – Diamonds," Box 6, Arthur Papers.

133 Katharine Wright, "Julia Arthur, 15 Years Off Stage, Comes Back to Boston," *Sunday Herald* [Boston], 19 Mar. 1916.

134 "Viola Allen's New Home," *Dramatic Mirror*, 10 Feb. 1906; "Viola Allen Secretly Wedded to Peter Duryea," *Philadelphia Press*, 20 Jan. 1906.

135 "Local Dramatic Jottings," *The St. Louis Globe-Democrat*, 9 Nov. 1884, 11; "Margaret Anglin Weds Howard Hull," *The New York Times*, 9 May 1911, 1; "Reported Marriage of Annie Russell. Actress Is Said to Be the Bride of Oswald Yorke," *The New York Times*, 28 Mar. 1904, 1.
136 "Margaret Mather a Bride. A Quiet Wedding Ceremony in Buffalo," *The New York Times*, 4 Mar. 1887.
137 "Miss Mather's Marriage. Her Aged Mother Hoped to Have a Wealthy Son-in-Law," *The New York Times*, 5 Mar. 1887. When interviewed about Mather's wedding, "Manager Hill" claimed to have known in advance and stated he would not stand in the way of Mather's happiness.
138 "Viola Allen Secretly Wedded to Peter Duryea," *Philadelphia Press*, 20 Jan. 1906. A handwritten note in the Allen scrapbooks states that the breach-of-promise suit was dismissed by the magistrate (Scrapbook 7610). See also their wedding invitation for 19 Aug. 1905, Louisville, Kentucky.
139 "Marriage of Popular Actress. Miss Lena Ashwell Weds West End Doctor," *The Daily Mirror*, 2 Nov. 1908, 5; Ashwell, *Myself a Player*, 113–16.
140 The paper's list included Olga Nethersole, Maude Adams, Allen, and Russell (albeit before Russell's divorce from Presbrey); "Amusements," *The Daily Inter Ocean*, 15 Nov. 1895, 6.
141 "Divorce for Miss Lena Ashwell. Her Husband Guilty of Misconduct and Cruelty," *Daily Express*, 16 Apr. 1908, 1.
142 "Arthur Playfair Seeks Divorce," *The New York Times*, 13 Sept. 1903, 3.
143 *The Atlanta Constitution* published an article mocking Harriot's behaviour on a rail car, calling him "Mr. Clara Morris" (reprinted in "Dramatic News," *Chicago Tribune*, 16 Mar. 1879, 11). But see, for example, Logan, "Private Life of Clara Morris," for a more respectful treatment of Harriot.
144 "Race Suicide on the American Stage," *The Theatre Magazine*, Dec. 1905, 314–15.
145 "At the Grand," *The Daily Times* [Davenport, IA], 7 Oct. 1911, 14. Ashwell and her sister took in a cousin's young daughter when both her parents died, but it's not clear if Ashwell played a role in the child's upbringing (Ashwell, *Myself a Player*, 134).
146 "Browse," *Punch* [Melbourne], 5 Nov. 1908, 25; "Social News and Gossip," *Catholic Press* [Sydney], 6 Aug. 1908, 18. For Eileen Anglin's marriage to US navy officer Charles Hutchins, see "Wins Girl Wooed on World Voyage. Navy Officer to Wed Pretty Sister of Margaret Anglin," *The Detroit Free Press*, 3 July 1910, 1.
147 "Miss Allen Began at the Top," *The Scrapbook*, n.d., Scrapbook 7610, Allen Papers.
148 "Green Room Gossip," *The Milwaukee Sentinel*, 14 Sept. 1884, 10.

149 For example, see Kobbé, *Famous Actresses and Their Homes*, 103–5.
150 Claire Townsend, "A Family of the Stage. Julia Arthur's Sisters and Brothers," *New England Home Magazine*, 5 Feb. 1899; see also "Flora Fairchild Scrapbook – Sister of Julia Arthur," Arthur Papers, Houghton Library Theatre Collection. While the press painted a picture of a loving and devoted family, an anonymous inscription on the back of a family photo suggests otherwise: "And for one moment in time the Lewis siblings appear to be almost cheerful. I guess the hatchets, knives, poison and in-fighting were declared a '*cease-fire*' for the moment. How GOTHIC could these siblings get!" (Julia Arthur Collection, Accession #782).
151 Marcus, *The Drama of Celebrity*, 200–1.
152 "He Still Sighs for Miss Anglin," *New York Telegraph*, 14 Oct. 1906, as quoted in LeVay, *Margaret Anglin*, 100–1; "Margaret Anglin Pities Admirer," *The New York Times*, 14 Oct. 1906, 24.
153 "Wealthy Woman Claims Actress Is Her Child," *Great Falls Tribune* [MT], 22 Oct. 1907, 5. See also LeVay, *Margaret Anglin*, 98–9.
154 Arthur O'Connell to Anglin, 3 Mar. 1908, File Misc. A–W 1900–07, Box 4, MAP.
155 Anonymous to Anglin, 5 Nov. 1911, Freak Letters File, Box 8, MAP.
156 Macduff to Anglin, n.d., Freak Letters File, Box 8, MAP.
157 "Actress Fears Unknown Admirer. Says He Has Followed Her about Country," *Democrat and Chronicle* [Rochester], 15 Dec. 1906, 16.
158 "Julia Arthur Her Nemesis, She Says," *New York World*, 5 Jan. 1907; "Julia Arthur Her Nemesis," *Times* [Brooklyn], 4 Jan. 1907.
159 "Margaret Mather's Divorce Suit," *Times* [Brooklyn], 5 Apr. 1892.
160 "Mr. Pabst to Sue For a Divorce," *Times* [Brooklyn], 2 Dec. 1895.
161 "Pabst-Mather: The Once-Famous Actress Will Lose Her Hubby," *The Penny Press* [Minneapolis], 4 Nov. 1895, 2.
162 "Whipped Hubby. Full Story of the Trouble between Margaret Mather and Her Colonel," *Rocky Mountain News* [Denver], 11 Nov. 1895, 6.
163 "Pabst to Sue for Divorce," *Morning Oregonian* [Portland, OR], 3 Nov. 1895; "Pabst Goes to South Dakota," *The Emporia Daily Gazette* [Emporia, KS], 2 Dec. 1895. One writer claimed that disputes between Gustav and his father over the company's assets underpinned the incident ("Best-Pabst-Mather," *The Penny Press* [Minneapolis], 2 Dec. 1895, 4).
164 "Rialto Says Jealousy Rang Down the Curtain," *The World*, 11 Nov. 1899, File, "Lawsuits, Legal Problems, etc," Box 6, Arthur Papers.
165 "Rialto Says Jealousy Rang Down the Curtain."
166 "No Curtain Rung Down This Time. Comedy in Which Julia Arthur and Florence Crosby Play Leading Parts," *New York Evening Journal*, 17 Nov. 1899.

167 "Julia Arthur under Guard of Detectives,'" *Chronicle* [San Francisco], 18 Nov. 1899; "Why Julia Arthur Is Always Guarded. Thinks Another Young Woman Intends to Make Trouble for Her," *New York Morning Telegraph*, 17 Nov. 1899.
168 "Theatre Not Open to Miss Crosby. Julia Arthur Had Her Expelled from the Broadway. Didn't Wish to See the Woman Who Says She Was Engaged to Miss Arthur's Husband," n.p., 9 Nov. 1899, File, "Lawsuits, Legal Problems, etc.," Box 6, Arthur Papers.

CHAPTER FIVE

1 For an overview of US scholarship, see McKenzie, "Gender and United States Citizenship in Nation and Empire." See also Gardner, *The Qualities of a Citizen*; Cott, *Public Vows*; Glenn, *Unequal Freedom*. For Britain, see Baldwin, "Subject to Empire?"; Fletcher, Mayhall, and Levine, eds., *Women's Suffrage in the British Empire*. For Canada, see Strong-Boag, "'The Citizenship Debates': The 1885 Franchise Act," in Adamoski, Chunn, and Menzies, eds., *Contesting Canadian Citizenship*; Girard, "'If Two Ride a Horse, One Must Ride in Front'"; Price, "Naturalising Subjects, Creating Citizens."
2 Hindson, *London's West End Actresses and the Origins of Celebrity Charity*; Troubridge, *The Benefit System in the British Theatre*; Huff, "'That Benefit Racket.'"
3 "The Annie Russell Testimonial," *The New York Times*, 8 Feb. 1891, 13.
4 "Amusements. The Annie Russell Benefit," *The New York Times*, 11 Feb. 1891.
5 "Stage Pays Tribute to William Winter," *The New York Times*, 15 Mar. 1916, 9.
6 Viola Allen Correspondence, Y.C. 156 (1–2), Folger Shakespeare Library Letters.
7 Clara Morris to William Winter, 2 Mar. 1916, Y.C. 3924, Folger Shakespeare Library Letters.
8 "Clara Morris Goes No More to Broadway," *The Honolulu Advertiser*, 14 Dec. 1924, 49.
9 "Revivals and Novelties in the Week's Playbills," *The New York Times*, 12 Apr. 1903, 26; "Clara Morris's Property Saved," *The New York Times*, 28 Apr. 1903, 5.
10 Hindson, *London's West End Actresses*, 35.
11 My search of *The New York Times*'s database between 1851 and 1920 for "benefits" and "theater" in this period produced over 20,000 hits. While not all of these pertained to theatrical benefits and further research would be needed to see which of the latter were for the profession, a brief overview suggests many of them were.
12 Simon, *A History of the Actors' Fund of America*, 8. A related body, the Theatre Mutual Association, developed at the same time. The TMA functioned as an

independent welfare group that assisted ill or impoverished stagehands. See also McArthur, *Actors and American Culture*, 92–8.

13 Simon, *A History of The Actors' Fund*, 48–58.
14 Jean Loggie, "Notable Benefit Performances and Fund Raising Affairs," in Simon, *A History of The Actors' Fund*, 152–71.
15 Auster, *Actresses and Suffragists*, 71; McArthur, *Actors and American Culture*, 97, 125.
16 "The First of the Fair. Admiring Multitudes at the Garden," *New York Tribune*, 3 May 1892, 7.
17 "Portraits for Actors' Fair. Prominent American Artists to Paint Pictures of Leading Actresses," *The New York Times*, 16 Mar. 1910, 9.
18 "Favorite Recipes of Popular Actor Folk," *American* [Boston], 5 Nov. 1916; "Actors' Fund Fair Details Being Completed," *The Billboard*, 28 Apr. 1917, 18.
19 "Social Events," *The Globe*, 5 May 1917, 10.
20 "Old Age a Blessing, Says Clara Morris," *The New York Times*, 9 May 1904, 9.
21 See, for example, Gordon, *Bazaars and Fair Ladies*, 101; King, *Women, Welfare and Local Politics*, 17. Feminist historians of philanthropy debate the question of the extent of women's leadership within the field: see, for example, Geddes, *Philanthropy and the Construction of Victorian Women's Citizenship*, 6.
22 N.t., *Albany Argus*, n.d., c. 1900, p. 26, Viola Allen Scrapbook, 8-MWEZ-7607.
23 "Theatrical Gossip," *The Billboard*, 20 Apr. 1901, 10.
24 "Some of the Doll Gems at the Bazaar of the Professional Women's League," *New York World*, 17 Dec. 1897.
25 Professional Woman's League, *Souvenir Book Woman's Exhibition*, 84, 109.
26 "Stage Folk Run a Bazaar. Preside over Booths at Professional Women's League Sale," *The New York Times*, 16 Dec. 1911, 13.
27 Anita Clarendon to Margaret Anglin, 6 Jan. 1922, Anita Clarendon File, Box 1, MAP.
28 Margaret Anglin to Anita Clarendon, 19 Jan. 1922, MAP.
29 Anita Clarendon to Margaret Anglin, 26 Jan. 1922, MAP.
30 Sander, *The Business of Charity*.
31 "'Queen of Good Deeds.' Great Matinee for the Davos Sanitorium. Ellen Terry's Pathos," *Daily Express*, 12 May 1909, 3.
32 "Three Arts Club. Lena Ashwell on Need of London Home for Young Beginners," *Daily Mirror*, 11 May 1911; Hindson, *London's West End Actresses*, 112.
33 "Entertainment for Stage Children," *The New York Times*, 28 Dec. 1901, 7.
34 See, for example, "Edmonton and Winnipeg Winners of Earl Grey Dramatic Competition," *The Winnipeg Tribune*, 8 May 1911, 1.
35 Patti Newton to Anglin, 17 Oct., n.d., File A–M undated, Box 1, MAP.

36 L. Bullock Webster to Anglin, 29 Oct. 1938, File C–F 1935–39, MAP.
37 Fay S. Goodfellow to Anglin, 25 Jan., n.d., c. 1921, File E–G 1920–24, Box 4, MAP.
38 "Her First Earnings on the Stage. A Pretty Little Incident Behind the Scenes in Which Mr. Palmer's Company Were the Actors," *The New York Times*, 10 Dec. 1894, 3.
39 "Actress to Actress," *The Fort Worth Register*, 19 Sept. 1901, 2.
40 Thomas Whiffen to Margaret Anglin, 21 Feb. 1908, File Misc. A–W, Box 4, MAP. For Blanche Whiffen, see Bordman, *The Oxford Companion to the American Theatre*, 658.
41 Whiffen to Anglin, 29 Feb. and 24 Apr. 1908, MAP.
42 Ibid., 30 Apr. 1909.
43 "At the Museum," *Boston Herald*, 16 Apr. 1899.
44 "Second Dramatic Tea," *The New York Times*, 19 Mar. 1898, 7.
45 "Benefit Performance in Long Branch," *The New York Times*, 25 Aug. 1901, 9.
46 "Big Benefit at Keith's," *The New York Times*, 26 Apr. 1903, 11.
47 "Crippled Children Have a Party," *The New York Times*, 29 Dec. 1915, 17. As well as these examples, May Tully performed at a benefit for the Brookside home for the Wives and Children of Prisoners, while Marie Dressler raised funds for victims of the 1906 San Francisco earthquake: "Benefit at the Garden. Many Prominent Persons There to Aid the Brookside Home," *The New York Times*, 27 Apr. 1908, 7; "Actors Doing Good Work," *The New York Times*, 21 Apr. 1906, 9.
48 Margaret Bell, "Viola Allen's Greatest Achievement," *Maclean's*, 1 Feb. 1915, 47–8, 72, 47–8.
49 "Escaped From Cell. Pearl Van Gundy Received Outside Assistance – Recaptured and Held for Arrival of Mother," *The Lexington Herald*, 10 Dec. 1904, 8. See also "Runaway Rearrested. Pearl Van Gundy Again Caught," *The Lexington Herald*, 8 Dec. 1904, 2; "Letter From Georgetown Lady Who Tried to Befriend Pearl Van Gundy," *The Lexington Herald*, 12 Dec. 1904, 8.
50 "Visited by Viola Allen. Roses Taken to Pearl Van Gundy – Relatives Have Not Appeared," *The Lexington Herald*, 9 Dec. 1904.
51 "Climbed Convent Wall and Returned to Lexington – Pearl Van Gundy Adds Another Escapade to Record," *The Lexington Herald*, 21 Dec. 1904, 5.
52 "Cowley Mission," *The Church Times*, 6 Mar. 1896, 297; "A Charitable Matinee at Wyndham's," *Illustrated London News*, 15 Jun. 1901, 818.
53 "Last Night's News Items," *The Daily Mirror*, 10 Dec. 1908, 13; "The Grasso Thrill for London. Productions at Halls and Theatres," *Daily Express*, 24 Apr. 1911, 7.
54 "Tweedale Work Guild," *Daily Express*, 23 Apr. 1910, 4.

55 "Thousands of Puddings Wanted!" *Daily Mirror*, 17 Dec. 1908, 5.
56 "Miss Lena Ashwell Inaugurates a Health Tour," *Daily Express*, 22 Aug. 1910, 3.
57 See, for example, Prochaska, *Women and Philanthropy*; Koven, *Slumming* and *The Match Girl and the Heiress*; Ross, *Love and Toil*.
58 "Bernhardt and Mark Twain Appear Together at a Benefit for the Russian Jew Sufferers," *The Sun* [New York], 19 Dec. 1905, 9.
59 Ishbel Aberdeen to Margaret Anglin, 23 Mar. 1916, File Misc. L–W 1910–17, Box 4, MAP.
60 "Serbian Relief Work," *The New York Times*, 24 Oct. 1914, 4; n.t., *The New York Times*, 9 Apr. 1916, x8. The vaudeville entertainment appears to have been organized by the Red Cross.
61 "On and Off the Stage," *Daily Express*, 29 May 1900, 2. McLeay inserted a note in the program that stated the event was not for charity but rather an expression of sympathy with the Dominion. See Gardner, "McLeay, James Franklin," in *Dictionary of Canadian Biography*, vol. 12.
62 "For the French Sufferers," *Daily Mirror*, 29 Sept. 1911, 5.
63 Simon, *A History of the Actors' Fund*, 55.
64 Later in her life Anglin turned to the question of the need for a Christian theatre in North America: Anglin, "The Christian Theatre," Radio Address, 7 Jun. 1931, File Misc. D–G 1930–34, Box 6, MAP.
65 For a discussion of the links between philanthropy and citizenship, see Geddes, *Philanthropy and the Construction of Victorian Women's Citizenship*.
66 In turn, we should not forget that many voluntary organizations used highly theatrical genres in their fund-raising. Gordon, *Bazaars and Fair Ladies*, 72, 76; Ash, "'Panoramas' and 'Living Pictures.'"
67 "The Farewell to the Woman Voters' Envoys," *The Suffragist* 3, no. 40 (2 Oct. 1915): 5. For a discussion of displays of gender, imperialism, and whiteness at the Exposition, see Markwyn, "Queen of Joy Zone Meets Hercules."
68 Tickner, *The Spectacle of Women*, 24, 67, 131; Eltis, "Women's Suffrage and Theatricality," in Yeandle, Newey, and Richards, eds., *Politics, Performance and Popular Culture*; Woodworth, "The Company She Kept"; Hirshfield, "The Actresses' Franchise League"; Goddard, "'Women Know Her to Be a Real Woman.'"
69 See Glenn, "'The Eyes of the Enemy': Female Activism and the Paradox of Theatre," ch. 5 in her *Female Spectacle*.
70 "Stars Draw 1,500 to Suffrage Fête," *The New York Times*, 17 Feb. 1914, 6.
71 "Suffragists Ask Congress for Vote," *The New York Times*, 10 May 1914, C7.
72 "Only Woman Scene Painter," *The New York Times*, 22 Jun. 1913, X12.
73 Leonard, "Amelia Summerville," in Leonard, ed., *Woman's Who's Who of America*, 794–5.

74 Ammen, *May Irwin*, 150–4.
75 "Procession of 10,000 Women. Suffragists March through London. Picturesque Scene," *Daily Express*, 20 Jun. 1910, 5.
76 Ashwell, *Myself a Player*, 163–4.
77 Ibid., 164.
78 Ibid., 164–5. Ashwell is referring to the fire curtain.
79 Ibid., 166–7.
80 Ibid., 168.
81 Ibid., 169.
82 Ibid.
83 Goddard, "'Women Know Her to Be a Real Woman,'" 137–8.
84 To be sure, Morris's age and poor health in the 1910s may have been a factor.
85 Auster, *Actresses and Suffragists*, 73. Its stance may have been influenced by its president Amelia Bingham, who had been an outspoken supporter of the cause until she witnessed the militant campaign of British suffragists in 1910. In contrast, Mary Shaw, who was unsuccessful in her bid to become its president, was a supporter of suffrage (74).
86 Goddard, "'Women Know Her to Be a Real Woman,'" 148.
87 Ammen, *May Irwin*, 148.
88 Goddard, "'Women Know Her to Be a Real Woman,'" 139–41.
89 Ashwell, *Myself a Player*, 165. Although she does not provide many dates, Ashwell was in all likelihood referring to the militant campaign, the jailing of suffragists, and the Cat-and-Mouse Act.
90 "Actress Analyzes Emotion. Margaret Anglin Says Higher Learning Does Not Harden Women," *The Evening Statesman* [Walla Walla, WA], 7 Sept. 1906, 4.
91 Margaret Anglin, "Margaret Anglin Sees Defects in Work of Male Dramatic Critics," *The Bulletin* [San Francisco], 18 Sept. 1915.
92 Goddard, "'Women Know Her to Be a Real Woman,'" 145–7.
93 Ibid., 144.
94 Ibid., 149.
95 Alan Dale, "Alan Dale Likes Julia Arthur as Talking Statue of Liberty," *New York American*, 29 May 1917, File 1, Box 1, Arthur Papers.
96 S.L.P., "Julia Arthur," n.p., 30 May 1917, File 7, Box 2, Arthur Papers.
97 "'Liberty Aflame' Is Feature at Keith's. Julia Arthur, the Dramatic Star, Portrays Difficult Role with Sincerity and Spirit,'" *The Evening Bulletin – Philadelphia*, 15 May 1917, Scrapbook S, Box 3, Arthur Papers.
98 Bannerman (1896–1976) was born in Toronto; while she left Canada at the age of eighteen and spent her career in England, Australia, and the United States, she was frequently identified as Canadian by the press. Her life and work are discussed in ch. 7.

99 See Nagler, "The Mobilization of Emotions."
100 For the eighteenth-century British Empire see Wilson, "Rowe's *Fair Penitent* as Global History"; "The Lure of the Other: Sheridan, Identity and Performance in Kingston and Calcutta"; "Introduction: Three Theses on Performance and History." See also Mary Isbell, "When Ditchers and Jack Tars Collide"; O'Dell, "Amateurs of the Regiment, 1815–1870," in Saddlemyer, ed., *Early Stages*; Isbell, "Documents of Performance: Illustrated Reviews of Naval Theatricals"; Russell, *Theatres of War*. For Canada see Filewod, "Erect Sons and Dutiful Daughters," in Gainor, ed., *Imperialism and Theatre*; Bretz, "An Effigy of Empire."
101 Holder, "Melodrama, Realism, and Empire on the British Stage," in Bratton, ed., *Acts of Supremacy*, 132; Miles, "Characterising the Nation"; Burroughs, "Sailors and Slaves."
102 Hindson, "'Killing Kruger with Your Mouth': The Actress, Charity Recitations, and the Second Anglo Boer War," ch. 6 in *West End Women*.
103 Holmstrom, "Civil War Memories on the Nineteenth-Century Amateur Stage."
104 Polster, *Stages of Engagement*, 11–26.
105 *Theatre at War, 1914–1918*, 2–3. Collins points out, though, that as the war went on it became more difficult for theatres to operate: cheaper rail fare for touring companies was ended, baggage costs increased so scenery was cut, and a limited supply of paper affected companies' advertising (36–8). By 1916 the police and army started making regular visits to theatres and parks, inspecting men's papers and taking those without attestation papers to military barracks (25–6). See also Hendley, "Cultural Mobilization and British Responses to Cultural Transfer"; Fuller, *Troop Morale and Popular Culture in the British and Dominion Armies, 1914–18*.
106 O'Neill, "Margaret Bannerman," *The Canadian Encyclopedia*. I have not been able to locate the issue that featured Bannerman.
107 Hirshfield, "The Actresses' Franchise League," 148.
108 Collins, *Theatre at War*, 50–2.
109 Ibid., 58–64. Collins estimates that, if one accounts for fundraising by professionals, amateur dramatic societies, and the wages that the former forfeited in benefits, as well as the official amounts raised by theatrical societies, the arts in Britain contributed over £100 million in today's currency (70).
110 Ibid., 14. The Artists' Rifles was founded in 1859, originally as a regiment for painters, musicians, actors, and architects; by 1893 it also included other professions (Gregory, *A History of The Artists Rifles 1859–1947*).
111 Ashwell, *Myself a Player*, 195–6. The Princess was responsible for the artists' conduct and the YMCA handled their billeting and other work.

112 As Collins points out, theatre managers became very concerned about the loss of first young actors to the army and then, with the extension of conscription to include men up to forty, middle-aged performers (Collins, *Theatre at War*, 23–4).
113 Ashwell, *Myself a Player*, 203–5.
114 Ashwell, *Modern Troubadours*, 31. Ashwell's account of her tours, along with those of the United States' touring companies sponsored by the YMCA and that of American actress Margaret Mayo, have been reissued as *Entertaining the Boys "Over There."*
115 Ashwell, *Modern Troubadours*, 30.
116 Ibid., 15.
117 Ibid., 17.
118 Leask, *Lena Ashwell*, 152.
119 Ashwell, *Modern Troubadours*, 18.
120 Leask, *Lena Ashwell*, 146.
121 Durham, *Liberty Theatres*.
122 Charles Collins, "Red Cross Drama by Many Stars," *Chicago Evening Post*, 25 May 1918.
123 N.a., "Julia Arthur: Ardent War Worker," *Vanity Fair*, Sept. 1918.
124 Pickles, *Transnationalism Outrage*, 190.
125 Louella O. Parsons, "In and Out of Focus. Julia Arthur," *New York Morning Telegraph*, n.d., 1918, Scrapbook 1917–1920, Box 5, Arthur Papers.
126 "Julia Arthur at the Temple. Hamilton Warmly Welcomed Great Actress. Made a Touching Appeal for Fighting Men. Attended Reception by Daughters of the Empire," *Hamilton Spectator*, 25 Mar. 1919.
127 "Julia Arthur," *Hamilton Spectator*, 29 Mar. 1919; also "Answers Quickly Call of Canada. Julia Arthur Loves Land of Her Birth. Visiting in City Today. Greatest Portia to Ever Appear on Stage," *London Free Press*, n.d. Apr. 1919, Scrapbook 1917–20, Box 5, Arthur Papers.
128 "Julia Arthur in 'The Eternal Magdalene.' Brilliant Actress Greeted by a Large Audience at the Grand Opera House," *The Toronto World*, 24 Mar. 1916.
129 Ammen, *May Irwin*, 158.
130 Little has been written about the SWWR: see "Stage Women's War Relief Records," http://archives.nypl.org/mss/2856. The Relief was organized by Rachel Crothers, Josephine Hull, Dorothy Donnelly, and Louise Closser Hale. Fugate, "Crothers, Rachel," in *Notable Women in the American Theatre*, 180–5.
131 "Stage Women's War Relief," *The Billboard*, 14 Sept. 1918, 17.
132 Ibid. Smileage Tickets could be bought by family members to send to husbands, brothers, sons, or sweethearts who were in training; they then could exchange them for events at a Liberty Theater or YMCA Camp Auditorium

across the US. http://www.nationalmuseum.af.mil/Visit/Museum-Exhibits/Fact-Sheets/Display/Article/615639/smileage-book/. Anglin also sang at a 1917 service at Madison Square Gardens organized by the wives, mothers, and sisters of the 165th US Infantry and appeared in the comedy *Billeted*, a light-hearted tale of a young English wife who, pretending to be a widow, opens her home to two officers and is caught in her deception when she discovers that one of the officers is her supposedly dead husband. *Billeted* ran in New York and toured the United States and Canada. See "Margaret Anglin in Light War Play," *The New York Times*, 26 Dec. 1917, 6; "Margaret Anglin," *Vancouver Daily World*, 2 July 1918, 11.

133 "Stage Women to Take Over Entire Loan Work in Victory Way for Day," *New York Herald*, 20 Apr. 1919; "Stage Women Set New Loan Record. Raise More than $250,000 in Campaign Along Victory Way – Theda Bara Helps Sales. Julia Arthur Gives 5 Bonds. Presents Them to Wounded Men. Other Notes Stars of Stage and Screen Take Part," *The Morning Telegraph*, 26 Apr. 1919.

134 For example, Shaw and Glassford, eds., *A Sisterhood of Suffering and Sacrifice*; Hendley, *Organized Patriotism and the Crucible of War*.

135 Although the newspapers, performers' personal papers, biographies, and autobiographies are full of references to the profession's engagement in charitable enterprises and benefits, both for its members and other causes, little has been written about theatre and charity. An exception is Hindson, *London's West End Actresses*.

136 My thanks to Sarah Glassford for drawing my attention to this aspect of wartime discourse.

137 See, for example, Vance, *Death So Noble*; Winter, *Sites of Memory, Sites of Mourning*; Cook, *Clio's Warriors*.

138 Saunier, *Transnational History*, 110.

139 Holmes, "All the World's a Stage!"

140 "Democrats Name Miss Summerville," *The New York Times*, 1 Sept. 1920, 4.

141 Mabel Abbott, "Stage Folk Favor League of Nations," *The Times* [Shreveport, LA], 3 Oct. 1920, 22. It is not clear if Summerville knew about Wilson's attitudes towards race; today his support for the league may well be overshadowed by his racism.

CHAPTER SIX

1 See, for example, Carr and Hart, *The Global 1920s*; Daunton and Rieger, eds., *Meanings of Modernity*; McKibbin, *Classes and Cultures*; Grazia, *Irresistible Empire*; Bland, *Modern Women on Trial*.

2 The Modern Girl Around the World Research Group, *The Modern Girl Around the World*; Nicholas, *The Modern Girl*.
3 "Julia Arthur to Act," *The New York Times*, 25 Oct. 1920.
4 "Wealth Gone, Julia Arthur Will Return to the Stage," *The Evening Telegram* [New York], 24 Oct. 1920. According to the press, in 1917 Cheney had assigned his estate to his creditors after he had run up debts that he couldn't pay; his creditors had filed lawsuits and attachments against his property. See also "Julia Arthur's Romance Lives. White-Haired Lady Ill, with Devoted Husband, Now Almost Penniless, at Her Bedside," *Boston Post*, 20 Nov. 1932.
5 Katharine Wright, "Julia Arthur's Wind-Swept Home on Calf Island to Be Torn Down," *The Sunday Herald*, 5 Aug. 1917.
6 Alan Dale, "Barrymore and Julia Arthur in 'Macbeth.' Arthur Hopkins Presents Stars at Apollo Theatre — Honors Go to Miss Arthur for Interpretation That Departs from Convention," *New York Herald*, 18 Feb. 1921; Kenneth Macgowan, "The New Play. Lionel Barrymore Makes an Inadequate Macbeth and Julia Arthur a Splendid Lady Macbeth in a Strange and Striking Production," *The Globe and Commercial Advertiser* [New York], 18 Feb. 1921.
7 Heywood Brown, "'Macbeth' Seen Dimly through a Haze of Art," *New York Tribune*, 18 Feb. 1921.
8 Dale, "Barrymore and Julia Arthur in 'Macbeth'"; "Barrymore-Hopkins' Macbeth Keeps Audiences Guessing. Revolutionary Staging of Shakespeare's Tragedy Makes First-Nighters Sit Up and Rub Their Eyes — Nothing Like It Ever Seen Before," *New York Review*, 19 Feb. 1921.
9 Daniel Frohman to Arthur, 17 Mar. 1921, *Macbeth* Scrapbook, Box 5, Arthur Papers.
10 Kibler, "A Has Been Old Lady Star: Julia Arthur in Vaudeville," ch. 4 in her *Rank Ladies*.
11 DesRochers, *The New Humor in the Progressive Era*, 141.
12 Howard, *Women as Hamlet*.
13 Little is known about Tremayne, other than her appearances as Hamlet in England and Ireland. See "Southampton," *The Era*, 2 Dec. 1870, 1680; "Public Notices: Queen's Theatre," *Freeman's Journal and Daily Commercial Advertiser* [Dublin], 24 Feb. 1871; "The Queen's Royal Theatre," *Freeman's Journal and Daily Commercial Advertiser* [Dublin], 25 Feb. 1871; "Dublin. Queen's Royal," *The Era*, 26 Feb. 1871; "Some Women Players of Hamlet," *The Illustrated London News*, 17 Jun. 1899, 874.
14 "Women Have Scored in the Role of Hamlet," *The Pittsburgh Press*, 11 Mar. 1923.
15 Archie Bell, "Julia Arthur Scores as 'Hamlet,'" *The Cleveland News*, 6 Mar. 1923.
16 "Davis—Vaudeville," *The Pittsburgh Post*, 13 Mar. 1923; also J. Wilson Roy, "News of Stage and Screen. Albee's Elephant to Be Presented at Keith's Theatre. Julia

Arthur Seen as Gloomy Prince. Tragedienne Portrays Hamlet Superbly at B.F. Keith's Palace Theatre," *The Cleveland Times and Commercial Advertiser*, 6 Mar. 1923; File 5, "Clippings," Julia Arthur Papers, Houghton Library, Harvard.

17 "Julia Arthur and Co (3)," *Variety*, 8 Feb. 1923. See also Alexander Woolcott, "Good Night, Sweet Princess," *New York Herald*, 6 Feb. 1923.

18 Burns Mantle, "'Hamlet' in the 'Two-a-Day.' Julia Arthur Is an Earnest Lady Prince," *Daily News*, 6 Feb. 1923.

19 Robert Garland, "The Play. Seals, Shakespeare and Trixie Friganza Headliners on Maryland's Current Bill," *Baltimore American*, 27 Feb. 1923. For a discussion of the successful theatre and vaudeville performer Friganza, see Glenn, *Female Spectacle*, 59–63, 139–40.

20 Norman Clark, "Hamlet Gets Chance on Vaudeville Bill. Julia Arthur Portrays the Melancholy Dane at the Maryland," *The Baltimore News*, 27 Feb. 1923.

21 "Julia Arthur Complains Critics Are Insulting," *The Evening Sun*, 1 Mar. 1923.

22 "Julia Arthur," *The Morning Telegraph*, 1 Apr. 1923.

23 H.T.P., "'Saint Joan' – New Plays – Returning Plays. From Pages of Shaw Miss Arthur Acting the Maid of France," *Boston Evening Transcript*, 4 Nov. 1924.

24 "Shaw's 'St. Joan' Is Great Drama," *The Montreal Gazette*, 14 Oct. 1924.

25 S. Morgan-Powell, "Julia Arthur Makes Shaw's Saint Joan the Spirit of France," *The Montreal Daily Star*, 14 Oct. 1924.

26 "'Saint Joan' by G.B. Shaw, a Dramatic Masterpiece," *The Mail and Empire*, 7 Oct. 1924.

27 "Glorious Reception Accorded Brilliant Actress Last Night," *Hamilton Spectator*, 17 Apr. 1925; also E.J.R., "Julia Arthur in Shaw's New Drama. Hamilton's One Great Actress Gives Gripping Presentation of Joan of Arc as Pictured by Irish Dramatist," *Hamilton Spectator*, 11 Apr. 1924. For analyses of Shaw's *Saint Joan*, see Hamilton, "Constructing a Cultural Icon"; Stowell, "'Dame Joan, Saint Christabel'"; Waltonen, "*Saint Joan*: From Renaissance Witch to New Woman."

28 Hamilton, "Constructing a Cultural Icon," 359.

29 English-Canadian nationalism in the 1920s is discussed in Vance, *Death So Noble*; Wright, *The Professionalization of History in Canada*.

30 Jennie Wren, "Tete-a-tete with Julia Arthur, Most Charming of Ladies," *Hamilton Spectator*, 17 Apr. 1925.

31 "Ford's. Margaret Anglin in 'The Woman of Bronze,'" *The Baltimore Sun*, 7 Oct. 1919, 7.

32 "Miss Anglin in 'Bronze Woman,'" 9 May 1920, Anglin Scrapbooks.

33 "Margaret Anglin in 'The Woman of Bronze,'" n.t., c. 1920, Anglin Scrapbooks; Arthur Shannon, "Miss Anglin in 'The Woman of Bronze,'" *The Seattle Star*, 4 May 1920, 10.

34 "Margaret Anglin Talks on Controversies over Her Play, 'Woman in Bronze,'" *The Times Dispatch* [Richmond, VA], 28 Nov. 1920, 42. A number of papers used this (incorrect) title.

35 Edith Heileman to Margaret Anglin, 8 Jan. 1922, File Misc. H–J 1920–24, Box 4, MAP. Heileman's use of Anglin's photograph had its counterpart in the many theatrical scrapbooks of the late nineteenth and early twentieth century. See Marcus, "The Theatrical Scrapbook." Thanks to Roberta Barker for alerting me to Marcus's work.

36 Corinne Heaser to Margaret Anglin, 20 July 1923, File Misc. H–J 1920–24, Box 4, MAP.; see also Hazel Inez Email Benecke to Margaret Anglin, 12 Nov. 1923, File Misc. H–J 1920–24, Box 4, MAP.

37 George Baker to Margaret Anglin, 18 Oct. 1921, File Misc. A–B 1920–24, Box 4, MAP.

38 George Kirtland Bishop to Margaret Anglin, 4 May 1923, File Misc. A–B 1920–24, Box 4, MAP. See also Les E. Donehew to Margaret Anglin, 19 Oct. 1922, File Misc. C–D 1920–24, Box 4, MAP.

39 "Margaret Anglin Scores as Joan in Moreau Play," n.t., 20 Apr. 1921, Anglin Scrapbooks.

40 "Moreau's 'Joan,'" n.d., c. 1921, Anglin Scrapbooks.

41 Mary A. McCall to Margaret Anglin, 28 Mar. 1921, File Misc. M–O 1920–24, Box 5, MAP. McCall was probably making a play on words with the phrase "tired business girl," referring to the stereotype of the "tired businessman" who, lacking the intellectual energy for serious drama, made up the majority of audiences for Broadway's escapist productions of the 1920s (particularly musicals).

42 Elisabeth Marbury to Margaret Anglin, 26 Apr. c. 1921, File Elisabeth Marbury, Box 2, MAP.

43 Virginia Madigan to Margaret Anglin, c. 1921, File Misc. M–O 1920–24, Box 5, MAP.

44 Mrs Thomas McGoldrich to Margaret Anglin, 8 Apr. 1921, File Misc. H–J 1920–24, Box 4, MAP.

45 Corinne Roche to Margaret Anglin, 21 Oct. 1927, File N–S 1925–29, Box 6, MAP.

46 Sadie Wing to Margaret Anglin, 8 Mar. 1923, File C–D 1920–24, Box 5, MAP. Anglin appeared in Willard Robertson's *The Sea Woman* in 1923 ("Willard Robertson in 'Icebound,'" *The Standard Union* [Brooklyn], 16 Sept. 1923, 31).

47 Charles Phillips to Margaret Anglin, 19 Jan. 1927 and 18 Dec. 1929; Charles Phillips to Justin McGrath, 14 Feb. 1927, File Phillips Charles, Box 2, MAP. McGrath was the director of the National Catholic Welfare Conference New Service, a syndicate that reached over eighty papers and around one million

readers. For reviews of *The Divine Friend*, see "Margaret Anglin Again Scores at the Walker Theatre," *The Winnipeg Tribune*, 10 Nov. 1915, 6.

48 Joseph P. Herbert to Margaret Anglin, 2 Apr. 1921, File Misc. H–J 1920–24, Box 4, MAP.

49 Sister M. Dominic, S.D., to Margaret Anglin, n.d., c. 1922, File Misc. C–D 1920–24, Box 4, MAP.

50 See, for example, File C–F 1935–39, Box 4, MAP.

51 The only other actors to receive the Medal have been Helen Hayes (1979) and Martin Sheen (2008). A full list of the recipients can be found at http://archives.nd.edu/research/facts/laetare.html (accessed 20 Apr. 2018).

52 Margaret Anglin to George Tyler, 24 Mar. 1924, File George Tyler, Box 1, MAP. Anglin saw a dismal drop in ticket sales during the run of *The Great Lady Dedlock* in Chicago and saw no point in playing Baltimore or Philadelphia in the week before Easter.

53 Mrs Beatrice B. Spitzer to Margaret Anglin, 1 Dec. 1927, File N–S 1925–29, Box 6, MAP.

54 "Radio Address for Miss Anglin," 7 Dec. 1931, File Emergency Unemployment Relief Fund, 1931, Box 1, MAP. Anglin was also scheduled to speak at a meeting at the Hotel Astor but was not able to make it. See also Dorothea Blagden to Margaret Anglin, 27 Oct. 1931, 5 and 17 Nov. 1931; Grace Roosevelt to Margaret Anglin, 21 Nov. 1931, MAP.

55 Allison Gaw to Margaret Anglin, 18 Apr. 1923, File Misc. E–G 1920–24, Box 2, MAP.

56 Agnes Tallent to Margaret Anglin, 16 Nov. 1931, File Misc. Q–Z 1930–34, Box 7, MAP. Judging from the subsequent correspondence, Anglin accepted the invitation and was able to make the lunch (Margaret Anglin to Agnes Tallent, 12 Dec. 1931; Agnes Tallent to Margaret Anglin, 20 Jan. 1932, File Misc. Q–Z 1930–34, Box 7, MAP). See also Edna W. Unger, Alumni of Hunter College, to Margaret Anglin, 6 Apr. 1933, MAP.

57 Ruth Earle to Margaret Anglin, 10 Mar. 1923, File Misc. E–G 1920–24, Box 2, MAP.

58 Carlton Dinsmoor to Margaret Anglin, 21 Mar. 1924, File C–D 1920–24, Box 4, MAP.

59 Margaret Leigh to Margaret Anglin, 4 Mar. 1924, File K–L 1920–24, Box 4, MAP. See also Les. E. Donehew to Margaret Anglin, 19 Oct. 1922, File C–D 1920–24, Box 4, MAP; Enrique Gonzalez to Margaret Anglin, 9 May 1921, File E–G 1920–24, Box 4, MAP. Gonzalez introduced himself to her as a "Catholic gentleman."

60 Arthur Cleveland to Margaret Anglin, n.d. 1923, 24 July 1923; Margaret Anglin to Arthur Cleveland, 23 Aug. 1923, File C–D 1920–24, Box 4, MAP. Anglin had

read the play with great interest, she told him, but since her plans were very unsettled, she decided to return it to him. See also Forrest Bailey to Margaret Anglin, 23 May 1921, File A–B 1920–24, Box 4, MAP.

61 K.W. Das Gupta to Margaret Anglin, 21 Apr. 1921, File C–D 1920–24, Box 4, MAP. Anglin must have accepted his request to perform, since her secretary sent a request to Das Gupta 21 Apr. for $25 for rug and floor cloth cleaning and payment for her stagehands.

62 N.a. to Margaret Anglin, 12 Feb. 1924, File C–D 1920–24, Box 4, MAP. The unnamed playwright told Anglin that various prominent managers were considering the script seriously.

63 John M. French to Margaret Anglin, 8 Feb. 1921, File E–G 1920–24, Box 4, MAP.

64 Jerry Cargill to Margaret Anglin, 6 Jun. 1924, File C–D 1920–24, Box 4, MAP.

65 Bordman and Hischak, "Actors' Equity Association," in *The Oxford Companion to American Theatre*, 1.

66 See, for example, Plotnicki, "Anglin, Margaret," in Barranger, Roberts, and Robinson, eds., *Notable Women in the American Theatre*, 31.

67 Minnie Maddern Fiske to Anglin, 18 May 1921, File Minnie Maddern Fiske, Box 2, MAP.

68 Margaret Anglin to Edward Darling, 5 Jun. 1924, File C–D 1920–24, Box 4, MAP. Anglin had contacted Darling, the manager of New York's Palace Theatre, to see if he might help with her venture into vaudeville. See also Margaret Anglin to Mary Kirkpatrick, 7 Sept. 1924, File K–L 1920–24, Box 4, MAP; also Paul Kester to Margaret Anglin, 23 July 1924, File Paul Kester, Box 2, MAP.

69 Margaret Anglin to Frank Gillmore, 23 May 1924, File A–B 1920–24, Box 4, MAP.

70 Frank Gillmore to Margaret Anglin, 29 May 1924, File A–B 1920–24, Box 4, MAP.

71 Margaret Anglin to Frank Gillmore, 5 Jun. 1924, File A–B 1920–24, Box 4, MAP.

72 Schwartz, *Broadway and Corporate Capitalism*, 11.

73 "Dark Voices Tell of Coming Theatre War," *Chicago Tribune*, 27 May 1923; "Margaret Anglin Opposed to Union," n.p., 30 May 1923, Anglin Scrapbooks.

74 "Margaret Anglin's Remarks," n.p., Jun. 1925, Anglin Scrapbooks. The scrapbooks also contain many articles with headlines such as "Miss Anglin to Quit if Union Formed," "Margaret Anglin Talks of Retiring," "Margaret Anglin Threatens to Quit," from papers such as the *New York Telegraph* and *The New York Times*.

75 "Margaret Anglin Actors' Equity Association Membership Card," Emily Holt to Margaret Anglin, 6 May 1930, File A–C 1930–34, Box 6, MAP. Three years later

Anglin was partly in arrears, though (Paul Dullzell to Margaret Anglin, 8 Feb. 1933, MAP).

76 Thoda Cocroft to Elsa Marbury, 17 Jan. 1921, File Thoda Cocroft, Box 1, MAP. Cocroft was one of American theatre's first female advance agents. As well as representing Anglin, she worked for several prominent performers, including Eleanora Duse, Katharine Hepburn, Lillian Gish, Helen Hayes, Alfred Lunt and Lynn Fontanne, Laurence Olivier, and Vivian Leigh ("Cocroft, Thoda [1893–1943]," in Fisher and Londré, *Historical Dictionary of American Theatre: Modernism*, 145).

77 Thoda Cocroft to Elsa Marbury, n.d., c. 1921, File Thoda Cocroft, Box 1, MAP.

78 Margaret Anglin to Alice Kauser, 27 Jan. 1924, File Alice Kauser, Box 4, MAP.

79 Margaret Anglin to George Tyler, 14 Mar. and 5 and 15 Dec. 1924; George Tyler to Margaret Anglin, 14 and 16 Feb. 1925; Tyler, George File, Box 2, MAP. Tyler was a reporter and editor turned producer who worked on many well-known American plays (Bordman and Hischak, "Tyler, George Crouse," in their *The Oxford Companion to American Theatre*).

80 "Margaret Anglin Honored. Invited by Canadian Premier to Recite Confederation Ode," *The New York Times*, 26 Jun. 1927, 63.

81 See, for example, Josephine Hull to Margaret Anglin, c. 1943, File Josephine Hull, Box 2, MAP.

82 Florence Rothert to Margaret Anglin, 28 Aug. 1931, File Q–Z 1930–34, Box 7, MAP. As with many of these requests, it does not appear that Anglin was able to follow up Rothert's suggestion.

83 Bertha Byrnes to Margaret Anglin, 13 Mar. 1939, File A–B 1935–39, Box 7, MAP.

84 Margaret Anglin, "The Christian Theatre," Radio Address broadcast on Station WLRL, 7 Jun. 1931, File D–G 1930–34, Box 6, MAP.

85 File Josephine Hull, Box 2, MAP. Hull was married to Howard's brother Shelly. See Carson, *Dear Josephine, the Theatrical Career of Josephine Hull*.

86 File Carrie Jacobs-Bonds, Box 1, MAP; also https://www.radcliffe.harvard.edu/schlesinger-library/blog/carrie-jacobs-bond-forgotten-musical-entrepreneur (accessed 26 Apr. 2018).

87 The Theatre Guild was founded in 1919 to produce non-commercial plays by both American and international writers. Lotta Dempsey, "Person to Person," *The Globe and Mail*, 13 Dec. 1950, 13. See also Lindesmith, "Watson, Lucile," in Robinson, Roberts, and Barranger, eds., *Notable Women in the American Theatre*, 907. For Watson's family background, see "Rosina (Lucile) Watson," https://www.ancestry.ca (accessed 27 Apr. 2018).

88 "Queen's Theatre. 'Dancing Mothers,'" *The Times*, 18 Mar. 1925, 12. For Butt, see Crowhurst, "Butt, Sir Alfred, first baronet (1878–1962)," in *Oxford Dictionary of National Biography*.

89 "Queen's Theatre. 'Dancing Mothers.'"

90 "Rosina (Lucile) Watson"; "Shipman Estate $68,300," *The New York Times*, 16 Nov. 1934, 18. Her first marriage in 1906 was to fellow performer (and fellow Canadian) Rockliffe Fellowes, who would go on to have a career as a silent film actor. See "Rosina (Lucile) Watson"; "Rockliffe Fellowes," https://www.ancestry.ca (accessed 13 Feb. 2022); "Lucile Watson's Plans. Actress to Stage Plays in American Women's Club, Paris," *The New York Times*, 7 Aug. 1932, 23; "Paris Tries the Foreign Drama," *The New York Times*, 20 Nov. 1932, X2.

91 Lindesmith, "Watson, Lucile," 908.

92 "Rialto Gossip – News of the Shuberts' Far-Flung Front," *The New York Times*, 29 Oct. 1933, X1; "Theatrical Notes," *The New York Times*, 9 Jun. 1934, 18; "News of Stage," *The New York Times*, 14 Nov. 1936, 23; "Canadian Actress Is Serene Dresser," *The Globe and Mail*, 26 Mar. 1937, 3; Roly Young, "Rambling with Roly," *The Globe and Mail*, 28 Mar. 1938, 8.

93 "The Play. Lillian Hellman's 'Watch on the Rhine' Acted with Paul Lukas in the Leading Part," *The New York Times*, 2 Apr. 1941, 26.

94 "Mayor Asks Help for the Red Cross," *The New York Times*, 7 Nov. 1939, 24.

95 Lindesmith, "Watson, Lucile," 908.

96 Dempsey, "Person to Person."

97 "Second Thoughts on First Nights," *The New York Times*, 21 Nov. 1915, x8.

98 "Miss Catherine Proctor," *The Globe*, 8 May 1916, 7; "Toronto Actress Talks about Tears," *The Toronto Daily Star*, 23 May 1914.

99 Gertrude E.S. Pringle, "Catherine Proctor, Canadian Actress," *Maclean's* (Sept. 1922): 64–5, 65; Herbert Whittaker, "Catherine Proctor 70 Years of Theatre," *The Globe and Mail*, 39 Aug. 1967, 13.

100 "To Act with Miss Anglin," *The New York Times*, 26 Apr. 1927, 32.

101 Alexander Woollcott, "The Play. Modified Maugham," *The New York Times*, 22 Sept. 1922, 24. Proctor played Amah, with Florence Reed in the leading female role of Daisy.

102 Whittaker, "Catherine Proctor."

103 Fielder, "Lyceum Players," in *American Theatre Companies*, 272, 276.

104 "Coming Attractions," *The Globe*, 18 May 1922, 14.

105 Whittaker, "Catherine Proctor"; Mary Janks, "Theatre Back into Its Own, Says Catherine Proctor," *The Globe and Mail*, 14 July 1946, 11; Ralph Hicklin, "Grand Lady of Stage Pens Memoirs," *The Globe and Mail*, 26 Aug. 1961, 15. On at least one occasion Proctor stayed at the Bon Echo Inn, then owned by

Merrill Dennison, the playwright and Canadian nationalist who was the son of Canadian feminist Flora MacDonald Denison. MacDonald Denison had turned the inn into a wilderness retreat for avant-garde artists, poets, and playwrights. Proctor won first prize at the Inn's Bal Masque for dressing as Ophelia ("Bal Masque at Bon Echo," *The Globe*, 30 July 1921, 15). For Bon Echo see http://ontarioplaques.com/Plaques/Plaque_Lennox24.html (accessed 30 Apr. 2018).

106 "Portland Couple Win Success at Head of Touring Stock Co.," n.p., c. 1928, Envelope 7, Mae Edwards Collection (1923–67), Toronto Reference Library; also "Footlight Flashback: When Mae Edwards Played Winter Stock in Halifax," *The Mail-Star* [Halifax], 16 Oct. 1967, 33; "Mae Edwards Stock Co. New England's Last," *Lewiston Journal Magazine Section* [Lewiston-Auburn, ME], 21 Oct. 1967, 1.

107 Scott, "Professional Performers and Companies," 29.

108 "Strand Not Large Enough," n.p., Halifax, c. 1922–26, Envelope 7, Mae Edwards Collection. Built in 1915, the Strand burned down in 1926; it then reopened in 1928 as the Garrick Theatre but closed one year later, becoming a movie theatre in 1930 (as the Garrick). In 1962 Oland Breweries bought the theatre and it became the Neptune Theatre ("Alterations to the Existing Garrick Theatre Building blueprints," Retrieval code: 102-39H-1, 1947, City of Halifax fonds, Halifax Municipal Archives).

109 See, for example, "Strand Patrons Liked New Show," *The Mail-Star* [Halifax], 28 Dec. c. 1925; "Closing Shows of Players at Strand"; "At the Strand. Mae Edwards Players Present 'A Woman's Honour'"; "Intensive Mystery Thrills At Strand"; "Novel Bills at Strand by Mae Edwards Company." All clippings from Envelope 7, Mae Edwards Collection.

110 "Is a Canadian. Miss Mae Edwards, Leading Lady of Dramatic Company, Comes from Ontario," *The Acadian Recorder*, 28 Jan. 1926.

111 "Mae Edwards Gives Advice to Quincy Women," *Quincy Evening Telegram*, n.d., c. 1925–27, Envelope 1, Mae Edwards Collection.

112 Scott, "Professional Performers," 29; "Portland Couple Win Success"; "Footlight Flashback"; "Mae Edwards Stock Co."; "Ontario Deaths. Mrs. Charles T. Smith," *The Globe and Mail*, 4 Mar. 1937, 4.

113 Roly Young, "Rambling With Roly," *The Globe and Mail*, 31 May 1937, 8.

CHAPTER SEVEN

1 J.T. Grein, "Will-O'-the-Wisp: Miss Beatrice Lillie," *The Illustrated London News*, 9 Dec. 1933, 932. Grein was referring to the American performer and dramatist Ruth Draper, whose forte was monologues.

2. Despite her popularity, her ongoing success in both live performance and film, and her longevity, Lillie has not attracted much sustained attention from theatre historians of this period. There is one full-length popular biography but it lacks footnotes (Laffey, *Beatrice Lillie*), as well as Lillie's own co-authored memoir with James Brough, *Every Other Inch a Lady*.
3. "Theatres," *The Times*, 26 Apr. 1918, 6; "'Buzz, Buzz,'" *The Times*, 21 Dec. 1918, 5; "The Theatres," *The Times*, 11 Nov. 1920, 12; M.G., "Nameless Revue," *Daily Mail*, 21 Dec. 1918, 3.
4. For coverage of Bannerman's other appearances, see the following in *The Times*: "'Three Wise Fools,'" 14 July 1919, 14; "'Just Fancy,'" 27 Mar. 1920, 18; "'The Little Girl in Red,'" 12 Dec. 1921, 8; "'Isabel, Edward, and Anne,'" 2 Apr. 1923, 6.
5. Moore, *André Charlot*, 50.
6. Linton, "English West End Revue: The First World War and After," 159. See also Nield, "Popular Theatre, 1895–1940," in Kershaw, ed., *The Cambridge History of British Theatre*; Moore, "Girl Crazy: Musicals and Revue between the Wars," in Barker and Gale, eds., *British Theatre between the Wars 1919–1939*; Macpherson, "Peace: Nostalgia and Nationhood," ch. 7 in his *Cultural Identity in British Musical Theatre*.
7. Linton, "English West End Revue," 158–9.
8. Ibid., 160.
9. Ibid., 158.
10. Moore, *André Charlot*, 48–9.
11. Ibid., 53–8.
12. "Little Theatre. The Nine O'Clock Revue," *The Times*, 26 Oct. 1923, 10; "The Variety Theatres. 'The Knees of the Gods,'" *The Times*, 21 Nov. 1923, 10.
13. "The London Variety Theatres," *The Times*, 24 Oct. 1923, 12.
14. "'Samples' at the Vaudeville," *The Times*, 22 Mar. 1916, 5.
15. "'Pot Luck' at the Vaudeville. Miss Beatrice Lillie's Success," *The Times*, 27 Dec. 1921, 6. See also "Brilliant New Revue. 'Bran Pie' Fun and Frolic," *Daily Mail*, 29 Aug. 1919, 3.
16. Grein, "Will-O'-the-Wisp: Miss Beatrice Lillie." Green was referring to the very popular Australian-born comedian, actress, and singer Cecily Courtneidge, who also was married to Jack Hulbert, one of Lillie's fellow Charlot performers.
17. For representations of the barmaid, see Bailey, "Parasexuality and Glamour," in Bailey, *Popular Culture and Performance*. It also may have been shaped by the work of female performers such as Scottish actress, singer, and mimic Cecilia Loftus whose work, as theatre historian Catherine Hindson has argued, relied

heavily on physicality (*Female Performance Practice on the Fin-de-Siècle Popular Stages of London and Paris*).
18 The Lyons' workers are discussed in Walkowitz, *Nights Out*, 194–207.
19 Linton, "English West-End Revue," 162–3; Light, *Forever England*.
20 For gay men's communities, see Houlbrook, *Queer London*; Chauncey, *Gay New York*.
21 "'Under Cover.' American 'Crook' Comedy at the Strand Theatre," *Daily Mail*, 18 Jan. 1917, 3. The critic drily noted that despite its vaunted American origins, "a considerable amount of property belonging to Sardou and earlier Victorians seemed to have passed duty free."
22 "The Queen's," *Evening Post*, 30 Jun. 1921.
23 O'Neill, "Bannerman, Margaret."
24 "'Our Betters.' Mr. Maugham's Play at The Globe," *The Times*, 13 Sept. 1923, 8. *Our Betters* was first produced in 1917 in New York, since Britain's Lord Chamberlain refused to license it in London. For the "public furore" raised by *Our Betters*, see Eltis, *Acts of Desire*, 223–4. See also n.a., "The Early Days of *Our Betters*," *The New York Times*, 26 Feb. 1928, 106; "At the Play. 'Our Betters' (Globe)," *Punch*, 19 Sept. 1923, 282–3.
25 The Dragoman, "'Betters' and Better!" *The Daily Express*, 8 July 1924, 5. "The Dragoman" was one of the few reviewers to be so scathing about Bannerman's earlier work.
26 George Godwin, "Canadian Genius in the Old World," *Maclean's*, 1 Nov. 1925, 24–5.
27 "'Our Betters.' Mr. Somerset Maugham's New Play," *Daily Mail*, 13 Sept. 1923, 8.
28 William Pollock, "Brilliant Miss Bannerman," *Daily Mail*, 26 Jan. 1925, 8. This article was reprinted as "A Canadian Actress," *Saturday Night*, 21 Feb. 1925, 27.
29 "About Plays and Players. 'Beginner's Luck,'" *Daily Mail Atlantic Edition*, 31 Aug. 1925, 9; "'The World of the Theatre. 'A Hen Upon a Steeple,'" *Illustrated London News*, 9 Apr. 1927, 650; "'There's No Fool.' Miss Margaret Bannerman in a New Play," *Daily Mail*, 30 Jun. 1926, 10.
30 See, for example, "Globe Theatre. 'By-Ways,'" *The Times*, 7 Apr. 1926, 10; n.t., *Saturday Night*, 14 Feb. 1925, 26; "'The Golden Calf.' Miss Bannerman in Strong Part," *Daily Mail*, 15 Sept. 1927, 7.
31 Gale, "Errant Nymphs," 114–16.
32 For a discussion of the "modern girl" in the Canadian context, see Nicholas, *The Modern Girl*.
33 McKibbin, *Classes and Cultures*, esp. ch. 10, "The Cinema and the English"; de Grazia, *Irresistible Empire*; Ward, "Music, Musical Theater, and the Imagined South in Interwar Britain"; Double, "Teddy Brown and the Art of Performing

for the British Variety Stage"; Walkowitz, *Nights Out*. See also the articles in *Cultural and Social History* 4, no. 4 (2007) by Chris Waters, Siân Nicholas, Laura Mayhall, Peter Bailey, Roger Fagge, and Andrew Davies. For revue's transatlantic nature in the prewar period, see Bailey, "'Hullo Ragtime!'"

34 For discussions of such exchanges, see Schweitzer and Zerdy, eds., *Performing Objects and Theatrical Things*; Woods, *Transatlantic Stage Stars*; Moore, *André Charlot*. While my research looks at the phenomenon of transatlantic exchange through the lenses of these two performers' careers, based on newspaper coverage a great deal more research on this cultural traffic could be done. Lillie's Hollywood film career suggests how an "English" star was then sent back to Britain.

35 Linton, "English West End Revue," 160–1.

36 "London of 1924. From Our Own Correspondent," *Daily Mail*, 11 Jan. 1924, 5.

37 "Plays & Players on the New York Stage," *Daily Mail Atlantic Edition*, 30 Dec. 1928, 3.

38 Onlooker, "Looking at Life," *Daily Mail*, 10 Dec. 1930, 8.

39 See Davies, "The Scottish Chicago?"

40 "A Star Comes Home," *Daily Mail*, 4 Mar. 1938, 8.

41 "Comediennes Star in Charlot's Revue: Production at the Times Square Is Enlightened by Miss Lillie and Miss Lawrence," *The New York Times*, 10 Jan 1924, 18.

42 Alma Whittaker, "Vaudeville Is Happy Venture. Says Beatrice Lillie, Now on Her First Tour," *Los Angeles Times*, 18 Sept. 1927, 66.

43 Percy Hammond, "Amiable British Actors on Broadway Offset Cruel Darts from House of Commons," *The Los Angeles Times*, 10 Jan. 1932, 42.

44 Gilbert Swan, "Who'd Be Left," *The Longview Daily News* [TX], 16 Jan. 1933, 4.

45 "Stage Star Returns Home," *The Morning News* [Wilmington, DE], 13 Nov. 1933, 20.

46 "*Three Waltzes* Opens. Margaret Bannerman, English Star, Makes U.S. Debut in Boston," *The New York Times*, 15 Nov. 1937, 15.

47 "American Girl Fails as Perdita. 'Too Modest for Role in Decameron Nights,' Is Verdict of Londoners," *Los Angeles Times*, 2 Jun. 1922, 1.

48 "How an American Girl Started a World-Wide Squabble over Boccaccio," *St. Louis Star and Times*, 13 Aug. 1922, 42.

49 Ibid.

50 "Miss Margaret Bannerman's New Part," *The Times*, 10 Jun. 1922, 10. I have not been able to find much evidence of the controversy in the British press that the St Louis paper claimed occurred.

51 "Margaret Bannerman," *Evening Post*, 13 Oct. 1928, 18.

52 See, for example, "Plays – Players – Pictures," *Evening Post* 104, no. 138 (13 Aug. 1927): 25; 104, no. 140 (10 Dec. 1927): 25; 105, no. 17 (21 Jan. 1928): 25; "Music and the Stage," *Register* [Adelaide], 14 Feb. 1920, 5; "A Good Judge," *World's News* [Sydney], 7 July 1923, 4; "The Actress and the Naughty Role," *Advertiser* [Adelaide], 23 Apr. 1924; "'Strictly Limited,'" *Geelong Advertiser*, 20 Jun. 1924, 9; Margaret Bannerman, "The Art of Flirtation," *Daily News* [Perth], orig. pub. *Daily Express*, 23 Jun. 1924, 5; "'Camilla States Her Case,'" *Daily Mail* [Brisbane], 22 Mar. 1925, 11; "A Notable Selection," "Music and Drama. Notes From London," *Sydney Morning Herald*, 2 Apr. 1927, 10; "Britannia," *Ballarat Star*, 7 Aug. 1924, 5; "City Pictures," *National Advocate* [Bathurst, NSW], 2 Aug. 1924, 2.

53 The advance coverage of Bannerman's arrival in the Australian press was extensive. See: "New Plays for Australian Season," *Daily News* [Perth], 16 July 1927, 2; "Canadian Actress Coming to Australia," *Daily News* [Perth], 29 July 1927, 11; "Miss Bannerman's Tour," *Sydney Morning Herald*, 12 Nov. 1927, 10; "Across the Footlights," *Western Mail* [Perth], 17 Nov. 1927, 10; "'Our Betters,'" *Table Talk* [Melbourne], 8 Dec. 1927, 26; "Footlight Fancies," *Saturday Journal* [Adelaide], 10 Dec. 1927, 24; "For Theatregoers. Attractions from England. Return of Sir George Tallis," *Register* [Adelaide], 14 Dec. 1927, 12.

54 "Music and the Drama," *Telegraph* [Brisbane], 24 Dec. 1927, 14; "The New Comedy Theatre," *Table Talk* [Melbourne], 2 Feb. 1928, 20; "The Mainland Day by Day. New Theatre Opened," *Mercury* [Hobart], 30 Apr. 1928, 8; "Gossip of the Theatres," *Sydney Mail*, 2 May 1929, 22; "New Melbourne Theatre. Charm of Margaret Bannerman," *News* [Adelaide], 2 May 1928, 6. The Comedy Theatre is still in operation in downtown Melbourne.

55 "Tours of Australia. Theatrical Attractions," *Telegraph* [Brisbane], 23 Feb. 1928, 12; "Plays for Australia. Margaret Bannerman's Tour. London Farewell," *Daily News* [Perth], 22 Feb. 1928, 7.

56 "'Bunny' Bannerman," *Sun* [Sydney], 1 Apr. 1928, 44.

57 "Sydney Sophisticated," *News* [Adelaide], 3 Apr. 1928, 8.

58 "Colonel Bell Here. Producer of 'Our Betters,'" *Daily News* [Perth], 3 Apr. 1928, 1. See also "Miss Margaret Bannerman," *Sydney Morning Herald*, 14 Apr. 1928, 12; "Plays of the Day," *Argus* [Melbourne], 14 Apr. 1928, 10.

59 "Theatre and Screen. 'Our Betters,'" *Age* [Melbourne], 26 Feb 1926, 1; also "The Screen and Stage. New Melbourne Theatre," *Chronicle* [Adelaide], 21 Apr. 1928, 64; "Plays and Players. The Worst of 'Our Betters,'" *Sunday Times* [Sydney], 1 Mar. 1925, 6; "Melbourne's New Theatre," *Daily News* [Perth], 27 Apr. 1928, 8.

60 "'Our Betters,'" *Sydney Mail*, 20 Jun. 1928, 20. For more enthusiastic reviews, see "Great Play. Bannerman Triumph," *Truth* [Sydney], 17 Jun. 1928, 11. See

also "'Our Betters.' Miss Margaret Bannerman. Brilliant Actress," *Sydney Morning Herald*, 18 Jun. 1928, 8.
61 "Grand Opera House," *Evening Post* 106, no. 99 (5 Nov. 1928): 5.
62 "Women's World," *Advocate* [Melbourne], 17 May 1928, 32.
63 "'Diplomacy.' A Triumph in Comedy of Action," *Age* [Melbourne], 28 May 1928, 10; "'Diplomacy.' A Fine Play, a Fine Cast," *Evening Post* 106, no. 101 (10 Nov. 1928): 19.
64 "Stage and Screen. Modern Lightening," *Australasian* [Melbourne], 2 Jun. 1928, 20; "'Diplomacy,'" *Table Talk* [Melbourne], 31 May 1928, 1.
65 "Margaret Bannerman. 'Other Men's Wives,'" *Evening Post* [Wellington], 29 Oct. 1928, 5.
66 "Grand Opera House," *Evening Post* [Wellington], 30 Oct. 1928, 5. See also "Ladies' Letter," *Muswellbrook Chronicle* [NSW], 29 Jun. 1928, 5; "Theatres Full," *Brisbane Courier*, 5 July 1928, 5; "Margaret Bannerman's Voice," *Weekly Times* [Melbourne], 16 Feb. 1929, 78.
67 "Grand Opera House," *Evening Post*, 30 Oct. 1928, 5.
68 "Women in Print," *Evening Post*, 15 Dec. 1928, 25.
69 "The Screen and Stage," *Chronicle* [Adelaide], 14 Apr. 1928, 64. Born Gwyneth Godfrey, Grahame's stage name was Gordon; while appearing in Australia, at J.C. Williamson's suggestion she had changed it to Grahame (at times spelled Graham) to avoid confusion with fellow actor Leon Gordon ("Across the Footlights," *Western Mail*, 26 Jan. 1928, 10). Other coverage of Grahame's Australia tour can be found in: "Work, Not Luck, Brings Success. Gwyneth Graham Tells Her Experiences," *Table Talk* [Melbourne], 19 Apr. 1928, 14; "Gywneth Graham," *Brisbane Courier*, 12 Dec. 1932, 14. Grahame left Australia in June 1928, first for London and then New York, where she appeared in *The Jade God* (J. Brooks Atkinson, "The Play. One of the Vernal Mysteries," *The New York Times*, 14 May 1929, 26). In 1929 she married Abner Kingman Jr, also from Montreal ("Marriage Announcement 3," *The New York Times*, 20 Oct. 1929).
70 "Omeo Murder Case. Griggs Found Not Guilty," *Sunday Times* [Perth], 22 Apr. 1928, 1.
71 Deacon, "Celebrity, Empire, and American Morals in 1927."
72 N.a., "Margaret Bannerman Season Finishes Soon," *Arrow* [Sydney], 14 Sept. 1928, 15; n.a., "The Theatre and Its People. Margaret Bannerman," *Table Talk* [Melbourne], 20 Dec. 1928, 18.
73 "What Margaret Bannerman's Handwriting Tells Us," *Sunday Times* [Sydney], 8 July 1928, 25.
74 N.t., *News* [Adelaide], 18 Apr. 1928, 6.
75 "Margaret Bannerman and Her Dog," *Table Talk* [Melbourne], 13 Dec. 1928, 21.

76 "Looking at Life: An Actress's Lot," *Daily Mail*, 5 Aug. 1930, 6; Julia Blanshard, "In New York," *The Longview Daily News* [TX], 11 May 1933, 4; "Cholly Knickerbocker Says: New York Society Raises High-Jinks at Fantastically Successful Costume Party at Which Elsa Maxwell Was Hostess Recently," *The Tennessean* [Nashville], 23 Dec. 1929, 8; O.O. McIntyre, "Some of This and That," *The Greenville News* [SC], 27 Dec. 1931, 5; "Miss Beatrice Lillie's Surprise. Gangster Calls to Apologise," *Daily Mail*, 23 Feb. 1931, 11; "Capone Winks at Actress in Court, She Winks Back," *St. Louis Star and Times*, 19 Oct. 1931, 4.

77 Harry Goldberg, "English and American Cousins. But How Different!" *The Minneapolis Star*, 2 Apr. 1932, 27.

78 "Star Company in the 'Screen' Scene," *The Times*, 26 Nov. 1919, 16; "Opportunity Shops Aids Poor Patients," *The New York Times*, 29 Nov. 1925, E8; "A Dance for Charity," *The New York Times*, 2 Mar. 1926, 25; "Berengaria Concert for Charity," *Daily Mail Atlantic Edition*, 4 Aug. 1927, 6; "Waiting on the Men," *The Daily Mirror*, 7 Jan. 1932, 9; "Court Circular," *The Times*, 13 Dec. 1933, 17; "The 'Garden Party' Ball," *The Times*, 9 Dec. 1920, 15; "A Printer's War Charity," *The Times*, 29 Oct. 1918, 13; "St. George's Jewish Settlement," *The Times*, 21 Mar. 1936, 17; "Margaret Bannerman at University Sports," *Age* [Melbourne], 14 Apr. 1928, 17; "Limbless Soldiers' Gift to Miss Margaret Bannerman," *Sunday Times* [Sydney], 2 Sept. 1928, 24.

79 Rev. Allen Leslie Howard to Lady Peel, 2 Apr. 1936, Folder 3 Correspondence – Personal – BL G–J 1933–85, Box 1, Beatrice Lillie Papers.

80 "Looking at Life," *Daily Mail*, 13 Apr. 1931, 8; "A Woman about Town," *Daily Mail*, 8 Sept. 1930, 19; Alma Whittaker, "Battling Barberism," *The Los Angeles Times*, 17 Apr. 1927, 170.

81 William Pollock, "How Many Beauties?" *Daily Mail*, 29 Nov. 1929, 12.

82 Julia Blanchard, "Beauty of 1932 Must Be Either Exotic or Distinguished; 'It' Girl Passes," *The St. Louis Star and Times*, 27 Jan. 1932, 8.

83 Roberts, "Making the Modern Girl French," in The Modern Girl Around the World Research Group, eds., *The Modern Girl Around the World*, 92; The Modern Girl Around the World Research Group, "The Modern Girl Around the World: Cosmetics Advertising and the Politics of Race and Style," 31.

84 Ida Jean Kain, "Beatrice Lillie on Figure; Copy Rules She Disclaims," *The Philadelphia Inquirer*, 19 May 1939, 16.

85 O.O. McIntrye, "New York, Day by Day," *The St. Louis Star and Times*, 18 Apr. 1935, 13.

86 "War Influence," *Longview News-Journal* [TX], 24 Jan. 1936, 8.

87 Sylvia Blythe, "Too Many Doodads Spoil Your Charm," *This Week Magazine The Los Angeles Times*, 28 May 1939.

88 O.O. McIntrye, "New York, Day by Day," *The Longview Daily News* [TX], 1 May 1937, 4.

89 For example, O.O. McIntrye, "A New Yorker at Large," *The Burlington Free Press* [Vermont], 17 May 1930, 15; O.O. McIntrye, "New York, Day by Day," *The Morning News* [Wilmington, DE], 21 Jan. 1928; *The Longview Daily News* [TX], 18 Feb. 1936, 8; 21 July 1936, 4. See also Alice Hughes, "A Woman's New York," *The Tennessean* [Nashville], 2 Jan. 1938, 38.

90 "Here and There in the Old Land," *Saturday Night*, 3 July 1926, 27.

91 "London Fashions. At the Theatres," *The Times*, 13 Apr. 1927, 17; also "Beauty on the Stage – and Off," *Dundee Courier and Advertiser*, 26 Nov. 1926, 12; "'The Golden Calf.' Miss Bannerman in Strong Part," *Daily Mail*, 15 Sept. 1927, 7; "Belles of Old Drury. Lovely Women Who Have Adorned London's Most Historic Stage," *Daily Mail*, 12 Mar. 1930, 8; "A Pinero Revival. 'Trelawney of the Wells,'" *Daily Mail*, 24 Nov. 1926, 12; M. Willson Disher, "Glamour of Miss Margaret Bannerman," *Daily Mail*, 29 May 1933, 6.

92 "Fashions as the Stage Shows Them. Famous Stars in Lovely Dresses," *Illustrated London News*, 24 Oct. 1925.

93 "A Woman about Town. Featuring Spring Fashions," *Daily Mail*, 28 Nov. 1930, 19.

94 "Today's Gossip. Beautifully Dressed 'Bunny,'" *The Daily Mirror*, 30 Jun. 1926, 9; also "Today's Gossip. Paris Shingle," *The Daily Mirror*, 17 Feb. 1933, 9.

95 "The New Styles Make for Comfort. Outstanding Features of the Paris Dress Collections," *Daily Mail*, 16 Feb. 1928, 19.

96 Margaret Bannerman, "My Lady's Garters," *Chronicle* [Adelaide], 1 July 1922, 51; "Theatres and Fashions," *Chronicle* [Adelaide], 19 Mar. 1928; "Paris Fashions. Approach of Spring," *Sydney Morning Herald*, 4 Apr. 1927, 5; "The Shingle in Paris," *Chronicle* [Adelaide], 30 Apr. 1927, 68; "For Women. Survey of Fashions," *Sydney Morning Herald*, 3 Nov. 1927, 4; "Christine," "Post From Paris," *Brisbane Courier*, 8 Dec. 1927, 23; "For Women. Margaret Bannerman. Clothes for Australia," *Sydney Morning Herald*, 7 Apr. 1928, 5.

97 For example, "Margaret Anglin – An Impression," *Maitland Daily Mercury*, 1 July 1908, 2.

98 "Miss Margaret Bannerman Arrives," *Western Mail* [Perth], 5 Apr. 1928, 23; "Women's Realm," *The Australasian* [Melbourne], 21 Apr. 1928, 14; "Fashion Notes," *Chronicle* [Adelaide], 5 May 1928, 71; "Fashion Notes," *Cairns Post*, 7 May 1928, 12; "Straight from Paris. Miss Margaret Bannerman in Some Beautiful Frocks She Will Wear in 'Diplomacy,'" *Table Talk* [Melbourne], 24 May 1928, 33; "Fashion Notes," *Cairns Post*, 7 Jun. 1928, 14; n.t., *Truth* [Sydney], 10 Jun. 1928, 11; "Margaret Bannerman," *Referee* [Sydney], 13 Jun. 1928, 17; "The New Dinner Suit," *Telegraph* [Brisbane], 6 Oct. 1928.

99 "Stage, Film and Vaudeville Topics," *Saturday Journal* [Adelaide], 26 May 1928, 24.
100 "Paris Designs for Morning, Afternoon and Evening Wear. Three Models Made for Miss Margaret Bannerman," *Daily Mail*, 17 July 1929, 18.
101 "Beautiful Women," *The Courier and Argus* [Dundee], 30 Mar. 1923, 8. The other two were Marie Lohr and Gladys Cooper; other famous beauties in London were Maxine Elliott, Lady Diana Duff Cooper, Catherine Calvert, and Justine Johnson.
102 See, for example, "Beauty On the Stage and Off," *Dundee Courier and Advertiser*, 26 Nov. 1926, 12; "Beautiful Women," *The Courier and Argus* [Dundee], 30 Mar. 1923, 8; William Pollock, "Brilliant Miss Bannerman," *Daily Mail*, 26 Jan. 1925, 8.
103 "Beautiful Women. Empire Contrasts," *Daily Express*, 15 Sept. 1927, 9; *Daily Mercury* [Mackay, QLD], 30 Nov. 1927, 3; also "England's Ideal," *Shamokin News-Dispatch* [PA], 15 Dec. 1928, 1.
104 "Empire Can't Pick a 'Miss Britain;' Types of Beauty Too Numerous," *Clarion-Ledger* [Jackson, MS], 23 Dec. 1927, 7.
105 "Hobble Skirt Ban. Useless for Business Girls. 'Ugly and Impossible,'" *The Daily Mirror*, 26 Sept. 1923, 2. See also "A Successful Canadian Actress in London Discusses the Secret of Good Dressing," *Saturday Night*, 2 May 1925, 34.
106 "Today's Gossip. Mittens Arrive," *The Daily Mirror*, 26 Feb. 1931, 11.
107 "Woman Attracted by Actresses' Costumes," *The Burlington Free Press* [VT], 22 Apr. 1927, 13.
108 "Freak Fashions Revolt. The 'Prison Crop' More than Women Will Endure," *Daily Mail Atlantic Edition*, 28 May 1925, 21. There is a distinctly conservative tone to the article, with many actresses and prominent women voicing their opinion that an Eton crop could only be worn with masculine-looking clothing and boyish figures and that "feminine" hair was much longer (and preferably curly).
109 "Milady Goes Back to the Fringe," *Daily Mail Atlantic Edition*, 1 May 1930, 14. See also "Chatty Paragraphs," *Mirror* [Perth], 18 Apr. 1925, 5; "Letters to Marigold," *Sunday Times* [Sydney], 20 Dec. 1925, 14; "Shingled – Could No Longer Resist," *Register* [Adelaide], 27 July 1926, 5; "Change Your Hair – Change Your Personality," *The Daily Express*, 28 Apr. 1933, 5; "Support for Women Candidates," *News*, 25 Apr. 1928, 4. This article contained a short interview with Bannerman about women dyeing their hair.
110 N.a., "There Are No Ugly Women! Margaret Bannerman Discourses on Beauty," *Sunday Mail* [Brisbane], 9 Sept. 1928, 19; "The Care of the Complexion," *Sunday Times* [Sydney], 17 Mar. 1929, 16; Bannerman, "Beautiful Hair," *Advertiser* [Adelaide], 13 Dec. 1927, 9. For a discussion of the attractive, healthy

femininity that could be found on Australia's beaches, see Angela Woollacott, *To Try Her Fortune in London*.
111 Bannerman, "The Lemon Way to Beauty," *The Daily Mirror*, 3 Aug. 1929, 14.
112 Bannerman, "Beauty as a Duty," *Daily Mail*, 8 Aug. 1929, 4.
113 "The Dangers of 'Slimming.' Margaret Bannerman Reveals Her Own Experience," *Daily Mail*, 5 Apr. 1930, 9.
114 For example, see the following advertisements: Lillie for Old Gold Cigarettes, *The Burlington Free Press* [VT], 14 Mar. 1929, 4; Lillie for Clicquot Club Ginger Ale, *The Los Angeles Times*, 9 Aug. 1926, 7; "Broadway Stars Pass Merciless Close-Up Test," *The Anniston Star* [AL], 28 Jan. 1930, 5.
115 "The Dignity of Wonderful Womanhood. An Interview with Miss Margaret Bannerman," *The Daily Express*, 25 July 1926, 3, and *Daily Mail*, 29 July 1926, 14; "Khaa, the New 20/30 Minute Beauty Treatment," *Daily Mail*, 26 Jan. 1937, 19; "Birthday Week and Festival of Fashion, Wright Bros. Ltd., Richmond, Surrey," *The Daily Mirror*, 30 Apr. 1934, 8; "Margaret Bannerman's Lovely Stockings Are Kept Beautiful with Lux," *Daily Mail*, 24 Sept. 1929, 15; "Miss Margaret Bannerman Selects an Evans' Electric Waving Comb at Olympia," *Daily Mail*, 12 Apr. 1930, 10.
116 "Ten Minutes to Wait before the Call-Boy Knocks – Says Margaret Bannerman," *The Daily Mirror*, 19 Mar. 1937, 24, and *Daily Mail*, 15 Mar. 1937, 7.
117 Bingham, *Family Newspapers?*
118 Oldenziel and Hård, "Poaching from Paris," ch. 1 in their *Consumers, Tinkerers, Rebels*.
119 "The Dora Club," *The Daily Mirror*, 3 July 1933, 9.
120 "Today's Gossip. Australia Calling!" *The Daily Mirror*, 9 Jan. 1934, 9.
121 For a discussion of celebrity coverage in the interwar decades, see Bingham, *Family Newspapers?* 231–5.
122 "'Romance of the Theatre. Stage Lovers to Wed in Reality. Honeymoon Trip by Air," *The Courier and Argus* [Dundee], 1 Aug. 1919, 4. Born Patrick Holmes-Summer, Somerset's father was a captain in the Royal Navy; according to the press, Somerset began acting after attending Harrow ("Actor Threatened with Expulsion from U.S.," *Daily Mail*, 20 Oct. 1922, 7).
123 "Probate, Divorce and Admiralty Division. Decree Granted to an Actress Holme-Summer v. Holme-Summer," *The Times*, 5 May 1921, 5.
124 Ibid. The court proceedings were repeated in various papers. See, for example, "Actress Gets Divorce. Miss Bannerman and 'Brutal Husband,'" *Aberdeen Daily Journal*, 5 May 1921, 5; "Always Wanting Money," *Citizen*, 4 May 1921, 6; "Actor and Wife. Degree Nisi for Miss Bannerman. Petitioner a Canadian," *The Western Times*, 5 May 1921, 4; "Stage Stars in Divorce. Mr. Pat Somerset and Miss

Edith Day. Decree for Miss Bannerman," *Daily Mail*, 5 May 1921, 5; "Forced to Sell Her Pearls. Actresses' Pitiful Story in Court. Miss Bannerman Granted a Divorce," *The Evening Telegraph and Post*, 4 May 1921, 1.
125 Bland, *Modern Women on Trial*.
126 "Far and Near. News by Wire and Air," *Daily Mail*, 4 Jun. 1921, 3; "Letters to an Actress," *The Times*, 26 May 1921, 7.
127 "American Actress Named in London Divorce Case," *St. Louis Star and Times*, 26 May 1921, 11.
128 "How the Duke's 'Quiet Little Party' Ruined Two 'Perfect' Romances," *St. Louis Star and Times*, 27 Nov. 1921, 51; also "A $2500-a-Week Star – and How It Turned Out," 11 Dec. 1921, 91. The latter article emphasized that each couple had been given a bottle of champagne and two straws. Somerset's subsequent marital troubles and propensity for violence – he went on to another marriage and divorce after divorcing Day – fascinated the American press, far more than his theatrical career. See, for example, "Pretty Edith Day Gets Rid of Her Promiscuous Sheik," *Pittsburgh Press*, 26 Dec. 1926, 75; "Saucy Mr. Somerset's Glum Honeymoon – in Jail," *Ogden Standard-Examiner* [UT], 15 Jan. 1928, 28; "Pat Somerset's Bride of Four Months Says He Beat Her and Broke Ribs," *St. Louis Star and Times*, 19 Apr. 1928, 1.
129 "Miss Bannerman Married," *Daily Mail*, 1 May 1928, 5. They were divorced in 1938, on the grounds of her desertion ("Probate, Divorce, and Admiralty Division. Degree Nisi against Miss Margaret Bannerman: Desertion," *The Times*, 15 Jun. 1938, 4).
130 "Wedding at Fazeley. Mr. Robert Peel and Miss Beatrice Lillie," *The Tamworth Herald*, 10 Jan. 1920, 3.
131 "Beatrice Lillie New Lady Peel – Sir Robert Peel's Death Makes Her Husband Successor to Baronetcy," *The New York Times*, 14 Feb. 1925, 2; also "Special to *The New York Times*," 14 Feb. 1925, 2. Although reviews of her performances did not include her title, articles that focused on her personality or private life often called her both "Lady Peel" and "Beatrice Lillie." See, for example, "'Making Faces' Took Lady Peel to Fame," *The Longview Daily News* [TX], 13 Oct. 1925, 1; "Beatrice Lillie. Lady Peel," 9 Aug. 1926, 7 (an advertisement for ginger ale); Margaret Green, "Straight from Paris," *The Burlington Free Press* [VT], 6 July 1928, 11; Lady Peel (Beatrice Lillie), "Have Women a Sense of Humour?" *Daily Mail Atlantic Edition*, 31 July 1925, 2.
132 The title of Lillie's memoir, *Every Other Inch a Lady*, encapsulates her ability to poke fun at herself and at social pretensions.
133 "Lady Peel Prefers Life upon Stage. Finds Social Career Much Too Dull," *Argus-Leader* [Sioux Falls, SD], 19 Apr. 1931, 13.

134 Grace Turner, "Feeding the 'Lillie,'" *The Baltimore Sun*, 28 Mar. 1937, 19.
135 "Miss Beatrice Lillie. A Woman's Charges Withdrawn. Sir Robert Peel's Anger at Them," *Daily Mail*, 16 Oct. 1926, 9.
136 "She's Glad U.S. Is Dry!" *Arizona Daily Star*, 23 May 1920, 6.
137 "Says Peel Planned to Divorce Beatrice Lillie," *St. Louis Star and Times*, 14 Mar. 1935, 2. Nothing seems to have come out of this incident; it is mentioned in Lillie's biography, but her biographer claims that while she knew Peel was living with another woman, she did not know it was Draper (Laffey, *Beatrice Lillie*, 97).
138 John Dickinson Sherman, "Wed? Not Even for a Crown," *Brown County Democrat* [Nashville], 9 Aug. 1923, 4.
139 Michel Mok, "King Edward VIII – the Bachelor King," *New York Post*, reprinted in *Los Angeles Times*, 29 Jan. 1936, 9.
140 Robert Peel to Beatrice Lillie, 10 Mar. 1930, and Robert Peel to Beatrice Lillie, n.d., Folder 10 Correspondence – Personal – Beatrice Lillie – Unidentified 1930–88, Box 1, Beatrice Lillie Papers; John Lupane to Lady Peel, 9 Apr. and 28 Dec. 1935, Folder 4 Correspondence – Personal – Beatrice Lillie K–L 1935–73, Beatrice Lillie Papers.
141 "People and Their Doings," *Daily Mail*, 21 Oct. 1929, 10.
142 Margaret Lane, "Beatrice Lillie Journeys 3,000 Miles to Send Her Son to School," *Daily Mail*, 27 Aug. 1934, 9; "Beatrice Lillie's London Visit to See Schoolboy Son," *Daily Mail*, 20 Aug. 1934, 11; "Will Meet Son," *The Morning News* [Wilmington, DE], 30 Dec. 1937, 18.
143 "Makes $26,000 Error," *The Tennessean* [Nashville], 22 July 1932, 3.
144 Bobbie Peel to Lillie, 19 Apr. 1929, 27 Apr. and 18 Sept. 1932; see also the seven undated letters from him to Lillie; Lillie to Bobbie: 9 and 28 Oct. 1935; 22 Jan., 14 Feb., and 18 Mar. 1936; R.A.A. Beresford to Lady Peel, 8 Apr. 1932, Folder 6 Correspondence – Personal – Bobbie Peel, 1929–32, Box 1, Lillie Papers.
145 Pat Proud, "Beatrice Lillie. She Hitched Her Funny Bone to a Star ... And Took a Sky-Ride to Glory," *Canadian Home Journal*, May 1946, 2, 18.
146 "Play without a Star. Good Comedy in 'Polly Preferred,'" *The Daily Express*, 7 Apr. 1924, 7; "Good Acting of a Young Actress. Impressive Playing by Miss Frances Doble," *The Daily Express*, 15 Dec. 1925, 9.
147 "A New Revue. 'Vaudeville Varieties,'" *The Times*, 18 Nov. 1926, 12; "New Crook Play. Frances Doble a Fascinating Rogue in 'The Black Spider,'" *The Daily Mirror*, 27 Dec. 1927, 4.
148 R.B. Marriott, "Frances Doble: A Short but Memorable Career," *The Era*, 1 Jan. 1970, 14.

149 "Scene at New Noel Coward Play. Booing after Fall of Final Curtain of 'Sirocco,'" *The Daily Mirror*, 25 Nov. 1927, 2; "Entertainments. The Theatres. 'Sirocco' to Be Withdrawn," *The Times*, 12 Dec. 1927, 12.

150 "Public School Play. Original and Arresting Story That Censor Once Banned. 'Young Woodley,'" *The Daily Mirror*, 6 Mar. 1928, 2; "Fine Acting on the Modern English Stage," *Illustrated London News*, 17 Mar. 1928, 441. Doble may have replaced Kathleen O'Regan in the production, as O'Regan originated the role. The play was first refused a public licence by the Lord Chamberlain's Office because of its "indecency" but a well-received private production resulted in that decision being overturned (Eltis, *Sex on Stage*, 211–12).

151 "Duke of York's Theatre. 'The Chinese Bungalow,'" *The Times*, 10 Jan. 1929, 10.

152 "Royalty Theatre. 'While Parents Sleep,'" *The Times*, 20 Jan. 1932, 10. Nigel Playfair, the well-known actor-manager who renovated the Lyric Theatre Hammersmith in 1918 and staged several very popular Restoration and eighteenth-century dramas there, played Doble's husband, Colonel Hammond (Postlewait, "Playfair, Nigel," in Kennedy, ed., *Oxford Companion to Theatre and Performance*, 469).

153 "Entertainments. Gaiety Theatre. 'Ballerina,'" *The Times*, 11 Oct. 1933, 10.

154 V.S.-J., "'*Ballerina*' at the Gaiety. Another Circus-Tent Romance," *The Yorkshire Post*, 11 Oct. 1933, 12.

155 "Gossip. Mejou Loses His Hat," *The Daily Mirror*, 17 Dec. 1931, 9; "As I See at the Military Meeting. Lady Lindsay-Hogg's Tartan," *The Daily Mirror*, 24 Mar. 1930, 22; "The Talk of London. Attractive," *The Daily Express*, 27 Apr. 1927, 4; "As I See Life. Spring Song," *The Daily Mirror*, 14 Mar. 1929, 6; Melisande, "A Notable Black Frock," *The Daily Express*, 29 Dec. 1928, 5; "London Fashions. Dress on the Stage," *The Times*, 25 May 1927, 19.

156 "Divorced," *Dundee Evening Telegraph*, 14 Jun. 1933; "425 Divorces in Few Minutes. Decree for Famous Actress," *The Daily Express*, 16 Jan. 1934, 3; "Frances Doble Gets Decree. Undefended Divorce Suit," *The Daily Mirror*, 15 Jun. 1933, 7; "High Court of Justice," *The Times*, 20 July 1932, 4.

157 "Stage Star at War Front," *Daily Mirror*, 23 May 1938, 1.

158 Page, Leitch, and Knightley, *Philby*, 113, 115–16, 117; Seale and McConville, *Philby: The Long Road to Moscow*, 93–6, 102, 112; Brown, *Treason in the Blood*, 183, 191.

159 Knightley, *Philby: The Life and Views of the K.G.B. Masterspy*, 56.

160 Georgia also had an affair with Mosley (Gottlieb, *Feminine Fascism*, 204, 377). Further research in Georgia's personal papers, housed at the Harry Ransom Center, University of Texas at Austin, might give us more insights into her

sister's career and politics: https://norman.hrc.utexas.edu/fasearch/findingAid.cfm?eadid=00355.
161 Marriott, "Frances Doble."

EPILOGUE

1 "Viola Allen Rites at Little Church," *The New York Times*, 13 May 1948, 26. See also "Annie Russell, Stage Star, Dead," *The New York Times*, 17 Jan. 1936, 19; "Margaret Bannerman," *The New York Times*, 28 Apr. 1976, 40.
2 "Beatrice Lillie. Comic Genius of a Theatre Generation," *The Times*, 21 Jan. 1989, 10.
3 "Miss Lena Ashwell. An Actress of Force and Sincerity," *The Times*, 15 Mar. 1957.
4 "Margaret Anglin of Stage Is Dead," *The New York Times*, 8 Jan. 1958, 47; also "Margaret Anglin, 81, Dies in Toronto," *The Bridgeport Post* [CT], 8 Jan. 1958, 72; "Margaret Anglin. Ex-Actress Dies at 81," *Hartford Courant* [CT], 8 Jan. 1958, 5.
5 "Margaret Anglin. Ottawa-Born Actress One of America's Best," *The Globe and Mail*, 8 Jan. 1958, 4.
6 N.t., *The Windsor Star* [ON], 8 Jan. 1958, 29.
7 Carlson, *The Haunted Stage*. Other explorations of nostalgia and memory in theatre and performance include Pascoe, *The Sarah Siddons Audio Files*.
8 A superb example of this process is Richardson, *Possessions: The History and Uses of Hauntings in the Hudson River Valley*.

BIBLIOGRAPHY

PRIMARY SOURCES

Archival Sources

Billy Rose Theatre Collection, New York Library for the Performing Arts
 Viola Allen. *Scrapbook*, 8-MWEZ-7607.
 Margaret Anglin. *Papers, 1898–1952*. T-MSS 2010-993.
 Beatrice Lillie. *Papers*. Per. Arts T-MSS2000-12.
Folger Shakespeare Library
 Letters:
 Viola Allen. Y.c.29 (1–8), Y.c. 156 (1–2), 222–3, 518 (1), 531 (1), 558 (1–3), 598 (1), 634 (1), 636 (1), 775 (1), 818 (1), 1022 (1), 5895.
 Margaret Anglin. Y.c.38 (1).
 Julia (Cheney) Arthur. Y.c. 511 (1), 2447.
 Lena Ashwell. Y.c.55 (1).
 May Irwin. Y.c.4351 (1–7).
 Clara Morris. Y.c.985 (21–30).
 Louis Nethersole. Y.c.7008 & 6648.
 Tony Pastor. Y.c.4724 (1–5).
 H. Riddell. Y.c.4805 (1).
Halifax Municipal Archives
 City of Halifax Fonds. 102-39H-1, 1947.
Hamilton Public Library, Special Collections
 Julia Arthur. *Papers and Scrapbook*.
Houghton Library Theatre Collection, Harvard University
 Julia Arthur. *Papers and Scrapbooks*. MS Thr 431.
Margaret Herrick Library, Los Angeles
 Mary Pickford. *Papers*. File 1338.
National Library of Australia
 J.C. Williamson *Papers*. MS4573.
Toronto Reference Library
 Mae Edwards. *Collection*, 1923–1967.

University of Rochester, Special Collections
Lena Ashwell. *Papers*.

Newspapers and Periodicals

AUSTRALIA
Advertiser (Adelaide)
Advocate (Melbourne)
Age (Melbourne)
Argus (Melbourne)
Australasian (Melbourne)
Ballarat Star
Brisbane Courier
Cairns Post
Catholic Press (Sydney)
Chronicle (Adelaide)
Daily Mail (Brisbane)
Daily Mercury (Mackay, QLD)
Daily News (Perth)
Freeman's Journal (Sydney)
Geelong Advertiser
Maitland Daily Mercury (NSW)
Mercury (Hobart)
Mirror (Perth)
National Advocate (Bathurst, NSW)
News (Adelaide)
Prahran Telegraph
Punch (Melbourne)
Referee (Sydney)
Register (Adelaide)
Saturday Journal (Adelaide)
Sun (Sydney)
Sunday Times (Perth)
Sydney Mail
Sydney Morning Herald
Sydney Sportsman
Sydney Times
Table Talk (Melbourne)
Tasmania News
Telegraph (Brisbane)

Weekly Times (Melbourne)
Western Mail (Perth)
World's News (Sydney)

BRITAIN
Aberdeen Daily Journal
Aberdeen Weekly Journal
Baily Magazine of Sports and Pastimes (London)
The Church Times
The Country Gentleman / Sporting Gazette, Commercial Advertiser (London)
Courier and Advertiser (Dundee)
Courier and Argus (Dundee)
Daily Mail
Daily Mail Atlantic Edition
Daily Express
The Daily Illustrated Mirror (London)
The Daily Mirror (London)
The Era
Evening Post (London)
The Evening Telegraph and Post (London)
Freeman's Journal and Daily Commercial Advertiser (Dublin)
Glasgow Herald
Huddersfield Chronicle
The Illustrated London News
Moonshine (London)
Punch
The Sketch
The Stage
The Tamworth Herald
The Times
The Yorkshire Post

CANADA
The Canadian Magazine
The Evening Telegram (Toronto)
Everywoman's World
The Globe
The Globe and Mail
Hamilton Spectator
London Free Press

Maclean's
The Mail and Empire
The Mail Star (Halifax)
Manitoba Morning Free Press
Massey's Magazine
The Montreal Daily Star
The Ottawa Evening Journal
The Ottawa Journal
Saturday Night
The Toronto Daily News
The Toronto Daily Star
The Toronto World
Vancouver Daily World
Winnipeg Free Press
The Winnipeg Tribune

UNITED STATES
The Akron Beacon Journal (OH)
Albany Argus
Altoona Times (PA)
The Anaconda Standard (MT)
The Anniston Star (AL)
Argus-Leader (Sioux Falls, SD)
Baltimore American
The Baltimore News
The Baltimore Sun
The Bangor Daily Whig and Courier (ME)
The Billboard
Boston American
Boston Daily Advertiser
Boston Daily Globe
Boston Daily Herald
Boston Evening Transcript
Boston Post
Boston Sunday Post
The Boston Traveller
Broad Axe (Chicago)
Broadway Weekly
The Brooklyn Daily Eagle

The Brown County Democrat (Nashville, TN)
The Buffalo Commercial
Buffalo Daily Courier
The Buffalo Daily Republic
The Buffalo Enquirer
Buffalo Express
The Buffalo Sunday Morning News
The Bulletin (San Francisco)
The Burlington Free Press (VT)
The Butte Daily Post (MT)
Chicago Daily News
Chicago Evening Post
Chicago Herald and Examiner
Chicago Tribune
The Cincinnati Commercial
Cincinnati Daily Gazette
The Cincinnati Enquirer
Clarion Ledger (Jackson, MS)
The Cleveland News
The Cleveland Times and Commercial Advertiser
Colorado Springs Gazette
The Cosmopolitan
Courier Journal (Louisville, KY)
Criterion (New York)
Daily Evening Bulletin (San Francisco)
The Daily Gazette (Lawrence, KS)
The Daily Inter-Ocean (Chicago)
The Daily News (New York)
The Daily Picayune (New Orleans)
The Daily Signal (Crowley, LA)
The Daily Telegram (Eau-Claire, WI)
The Daily Times (Davenport, IA)
Davenport Republican (IA)
Detroit Free Press
Donahoe's Magazine (New York)
Dramatic Mirror (Washington, DC)
The Duluth News (MI)
The Duluth News Tribune (MI)
El Paso Daily News

The Emporia Daily Gazette (KS)
Evening Star (New York)
The Evening Statesman (Walla Walla, WA)
The Evening Times (Sayre, PA)
The Evening Telegram (New York)
Every Month Magazine
The Fort Worth Register (TX)
The Globe and Commercial Advertiser (New York)
Good Housekeeping Magazine
The Grand Rapids Herald (MI)
Harrisburg Telegraph (PA)
Hartford Courant (CT)
Hearst Magazine
The Honolulu Advertiser
Human Life (New York)
The Idaho Daily Statesman
The Illustrated American
The Independent Record (Helena, MT)
The Indianapolis Journal
International Gazette (Black Rock, NY)
Jackson Daily News (MS)
Journal (Boston)
Journal and Courier (Lafayette, IN)
The Ladies Home Journal
The Lake County Star (Chase, MI)
The Leavenworth Post (KS)
Lewiston Journal Magazine (Lewiston-Auburn, ME)
The Longview Daily News (TX)
Longview News-Journal (TX)
The Los Angeles Times
Macon Daily Telegraph (GA)
The Marion Star (OH)
Marshall County Democrat (KS)
Men and Women
The Milwaukee Journal (WI)
The Milwaukee Sentinel (WI)
The Montgomery Advertiser (AL)
The Morning Democrat (Davenport, IA)
The Morning Herald (Lexington, KY)

The Morning News
Morning Oregonian (Portland, OR)
Muncie Evening Press (IN)
National Magazine
New England Home Magazine
New York Daily News
The New York Daily Times
New York Evening Journal
New York Herald
New York Morning Telegraph
New York Press
New York Review
The New York Times
New York Tribune
New York World
Newport News
News Journal (Mansfield, OH)
The North American (Philadelphia)
Oakland Enquirer (CA)
Oakland Tribune (CA)
Ogden Standard Examiner (UT)
The Oregon Daily Journal (Portland, OR)
Palladium Item (Richmond, IN)
The Penny Press (Minneapolis)
The Philadelphia Inquirer
Pitts Leader (Pittsburgh)
The Pittsburgh Gazette
The Pittsburgh Post
The Pittsburgh Press
The Plain Dealer (Cleveland, OH)
Portland Daily Press (ME)
Public Ledger (Philadelphia)
The Public Ledger (Maysville, KY)
Quad-City Times (Davenport, IA)
Quincy Evening Telegram (MA)
Reno Gazette-Journal (NV)
Republican (Denver)
Rocky Mountain News (Denver)
St. Louis Globe-Democrat (MO)

St. Louis Post (MO)
St. Louis Republic (MO)
The St. Louis Star and Times (MO)
Salt Lake City Telegram
Salt Lake Semi-Weekly
Salt Lake Telegram
San Francisco Bulletin
Saturday Evening Herald
The Seattle Star
The Sentinel (Carlisle, PA)
Shamokin News-Dispatch (PA)
The Sketch (New York)
The Spokane Press (WA)
Springfield Republican
The Springfield Sunday Republican
Star-Gazette (Elmira, NY)
Star Tribune (Minneapolis)
The Suffragist
The Sun (New York)
The Sunday Herald (Boston)
The Sunday Telegraph (Boston)
The Sunday Times-Herald (Chicago)
The Tennessean (Nashville, TN)
The Theatre Magazine (New York)
The Times (Shreveport, LA)
The Times-Democrat (New Orleans)
The Times Dispatch (Richmond, VA)
Toledo Blade
Transcript
Trenton Evening Times (NJ)
Trenton Times (NJ)
Vanity Fair
The Washington Herald
Washington Post
The Weekly Wisconsin
Willmar Tribune (MN)
The Winchester Star (KS)
The Woman Citizen
The World (New York)

Online Primary Sources

ANCESTRY.CA
Julia Arthur.
May Tully.
Lucille Watson.

HENRY IRVING PAPERS
Bram Stoker, "Memorandum of Agreement, Julia Arthur," Ref. # 6903, http://www.henryirving.co.uk/correspondence.php?search=Julia+Arthur.

ACTRESSES' PLAYING CARDS
"1908 Theatrical Actors and Actresses Deck of Playing Cards," Immortal Ephemera, https://immortalephemera.com/movie-collectibles/1908-playing-cards-actors-actresses/.

ELIZABETH PHILLIPS PAPERS
Phillips's correspondence originated from a now-defunct website, http://maryglenchitty.com/ejp.htm/. These letters have been downloaded and are in the author's personal collection.

SECONDARY SOURCES

Ahmed, Sara. "Collective Feelings or, the Impressions Left by Others." *Theory, Culture & Society* 21, no. 2 (2004): 25–42.

Alexander, Kristine. "Can the Girl Guide Speak? The Perils and Pleasures of Looking for Children's Voices in Archival Research." *Jeunesse: Young People, Texts, Cultures* 4, no. 1 (Summer 2012): 132–45.

— *Guiding Modern Girls: Girlhood, Empire, and Internationalism in the 1920s and 1930s*. Vancouver, BC: University of British Columbia Press, 2017.

Alonso, Harriet Hyman, ed. *Women's History Review, Special Issue: Where Politics and Performance Meet in U.S. Women's History* 11, no. 1 (2002).

Ammen, Sharon. *May Irwin: Singing, Shouting, and the Shadow of Minstrelsy*. Urbana: University of Illinois Press, 2017.

Arceneaux, Noah. "News on the Air: *The New York Herald*, Newspapers, and Wireless Telegraphy, 1899–1917." *American Journalism* 30, no. 2 (2013): 160–81.

Ardis, Ann, and Patrick Collier, eds. *Transatlantic Print Culture, 1880–1940: Emerging Media, Emerging Modernisms*. Basingstoke, UK: Palgrave Macmillan, 2008.

Arrighi, Gillian, and Victor Emeljanow. "Entertaining Children: An Exploration of the Business and Politics of Childhood." *New Theatre Quarterly* 28, no. 1 (Feb. 2012): 41–55.

Ash, Susan. "'Panoramas' and 'Living Pictures': Dr. Barnardo's Annual Meetings." *Early Popular Visual Culture* 8, no. 4 (Nov. 2010): 431–50.

Ashwell, Lena. *Modern Troubadours*. London: n.p., 1922.

— *Myself a Player*. London: Michael Joseph, 1936.

Auster, Albert. *Actresses and Suffragists: Women in the American Theatre, 1890–1920*. New York: Praeger, 1984.

Baena, Rosalia. "'Not Home but Here': Rewriting Englishness in Colonial Childhood Memoirs." *English Studies* 90, no. 4 (Aug. 2009): 439–59.

Bailey, Peter. "'Hullo Ragtime!': West End Revue and the Americanisation of Popular Culture in pre-1914 London." In *Popular Musical Theatre in London and Berlin 1890 to 1939*, edited by Len Platt, Tobias Becker, and David Linton, 135–52. Cambridge: Cambridge University Press, 2014.

— *Popular Culture and Performance in the Victorian City*. Cambridge: Cambridge University Press, 1998.

Baker, William M. "Anglin, Timothy Warren." In *Dictionary of Canadian Biography*, vol. 12. Toronto and Laval, QC: University of Toronto / Université Laval, 2003.

Baldwin, Page. "Subject to Empire? Married Women and the British Nationality and Status of Aliens Act." *Journal of British Studies* 40, no. 4 (Oct. 2001): 522–56.

Ball, Erica L., Tatiana Seijas, and Terri L. Snyder, eds. *As if She Were Free: A Collective Biography of Women and Emancipation in the Americas*. Cambridge: Cambridge University Press, 2020.

Ballantyne, Tony, and Antoinette Burton, eds. *Moving Subjects: Gender, Mobility, and Intimacy in an Age of Global Empire*. Urbana and Chicago, IL: University of Illinois Press, 2009.

Balme, Christopher B. "The Bandmann Circuit: Theatrical Networks in the First Age of Globalization." *Theatre Research International* 40, no. 1 (Mar. 2015): 19–36.

Bank, Rosemary K. *Theatre Culture in America, 1825–1860*. Cambridge: Cambridge University Press, 1997.

Banks, Olive. *Becoming a Feminist: The Social Origins of "First Wave" Feminism*. Athens, GA: University of Georgia Press, 1987.

Banner, Lois W. "Biography as History." *American Historical Review* 114, no. 3 (Jun. 2009): 579–86.

Banta, Martha. *Imaging American Women: Ideas and Ideals in Cultural History*. New York: Columbia University Press, 1987.

Barker, Clive, and Maggie B. Gale, eds. *British Theatre between the Wars 1919–1939*. Cambridge: Cambridge University Press, 2000.

Barker, Roberta. "The Gallant Invalid: The Stage Consumptive and the Making of a Canadian Myth." *Theatre Research in Canada* 35, no. 1 (Spring 2014): 69–88.

Barrière, Mireille. "Horn, Kate M." In *Dictionary of Canadian Biography*, vol. 9. Toronto and Laval, QC: University of Toronto / Université Laval, 2003.

Barstow, Susan Torrey. "'Hedda Is All of Us': Late-Victorian Women at the Matinee." *Victorian Studies* 43, no. 3 (Spring 2001): 387–411.

Bayly, C.A., Sven Beckert, Matthew Connolly, Isabel Hofmeyr, Wendy Kozol, and Patricia Seed. "*AHR* Conversation: On Transnational History." *American Historical Review* 111, no. 5 (Dec. 2006): 1441–64.

Bederman, Gail. *Manliness and Civilization: A Cultural History of Gender and Race in the United States, 1880–1917*. Chicago, IL: University of Chicago Press, 1996.

Berg, Frederic. "Structure and Philosophy in *Man and Superman* and *Major Barbara*." In *The Cambridge Companion to George Bernard Shaw*, edited by Christopher Innes, 144–61. Cambridge: Cambridge University Press, 2006.

Berger, Molly W. *Hotel Dreams: Luxury, Technology, and Urban Ambition in America, 1829–1929*. Baltimore, MD: Johns Hopkins University Press, 2011.

Berlanstein, Lenard R. "Historicizing and Gendering Celebrity Culture in Nineteenth-Century France." *Journal of Women's History* 16, no. 4 (Dec. 2000): 65–91.

Bernstein, Robin. *Racial Innocence: Performing American Childhood from Slavery to Civil Rights*. New York: New York University Press, 2011.

Bial, Henry, and Scott Magelssen, eds. *Theatre Historiography: Critical Interventions*. Ann Arbor, MI: University of Michigan Press, 2010.

Bingham, Adrian. *Family Newspapers? Sex, Private Life, and the British Popular Press 1918–1978*. Oxford, UK: Oxford University Press, 2009.

Bird, Kym. *Redressing the Past: The Politics of Early English-Canadian Women's Drama, 1880–1920*. Montreal, QC, and Kingston, ON: McGill-Queen's University Press, 2004.

Blake, L.J. "Asche, Thomas Stange Heiss Oscar (1871–1936)." In *Australian Dictionary of Biography*. Canberra: National Centre of Biography, Australian National University. http://adb.anu.edu.au/biography/asche-thomas-stange-heiss-oscar-5063/text8441 (accessed 25 Jan. 2018).

Bland, Lucy. *Modern Women on Trial: Sexual Transgression in the Age of the Flapper*. Manchester, UK, and New York: Manchester University Press, 2013.

Blum, Justin A. "The Lyceum Theatre and Its Double: Richard Mansfield's Visit to the Greenwich Meridian of Late-Victorian Theatre." *Nineteenth-Century Theatre and Film* 41, no. 2 (Winter 2014): 102–21.

Blumin, Stuart. *The Emergence of the Middle Class: Social Experience in the American City, 1760–1900.* Cambridge: Cambridge University Press, 1989.

Bold, Christine. *The Frontier Club: Popular Westerns and Cultural Power, 1880–1924.* Oxford, UK: Oxford University Press, 2013.

Bonapfel, Elizabeth M. "Reading Publicity Photographs through the Elizabeth Robins Archive: How Images of the Actress and the Queen Constructed a New Sexual Ideal." *Theatre Survey* 57, no. 1 (Jan. 2016): 109–31.

Booth, Alison. "The Lessons of the Medusa: Anna Jameson and Collective Biographies of Women." *Victorian Studies* 42, no. 2 (Winter 1999/2000): 257–88.

Booth, Michael R., and Joel H. Kaplan, eds. *The Edwardian Theatre: Essays on Performance and the Stage.* Cambridge: Cambridge University Press, 1996.

Bordman, Gerald. *American Theatre: A Chronicle of Comedy and Drama, 1868–1914.* New York: Oxford University Press, 1994.

Bordman, Gerald, and Thomas S. Hischak. "Actors Equity Association." In *The Oxford Companion to the American Theatre*, edited by Bordman and Hischak, online edition. New York: Oxford University Press, 2004.

— "Esmerelda." In *The Oxford Companion to the American Theatre*, edited by Bordman and Hischak, online edition. New York: Oxford University Press, 2004.

— "Eytinge, Rose." In *The Oxford Companion to the American Theatre*, edited by Bordman and Hischak, online edition. New York: Oxford University Press, 2004.

— "Miller, [John] Henry." In *The Oxford Companion to the American Theatre*, edited by Bordman and Hischak, online edition. New York: Oxford University Press, 2004.

— eds. *The Oxford Companion to the American Theatre.* New York: Oxford University Press, 2004.

— "Platt, Livingston." In *The Oxford Companion to the American Theatre*, edited by Bordman and Hischak, online edition. New York: Oxford University Press, 2004.

— "Russell, Annie." In *The Oxford Companion to the American Theatre*, edited by Bordman and Hischak, online edition. New York: Oxford University Press, 2004.

— "Tyler, George Crouse." In *The Oxford Companion to the American Theatre*, edited by Bordman and Hischak, online edition. New York: Oxford University Press, 2004.

Bratton, Jacky, ed. *Acts of Supremacy: The British Empire and the Stage, 1790–1930.* Manchester, UK: Manchester University Press, 1991.

— *The Making of the West End Stage: Marriage, Management, and the Mapping of Gender in London, 1830–1870.* Cambridge: Cambridge University Press, 2011.

— *New Readings in Theatre History*. Cambridge: Cambridge University Press, 2003.

Brégent-Heald, Dominque. "Five Little Stars: The Dionne Quintuplets, Motherhood, Film and Tourism during the Great Depression." *Historical Journal of Film, Radio & Television* 38, no. 1 (Mar. 2019): 54–74.

Brennan, Patrick H. "Saturday Night." In *Oxford Companion to Canadian History*, edited by Gerry Hallowell, 566. Toronto: University of Toronto Press, 2006.

Bretz, Andrew. "An Effigy of Empire: *A Midsummer Night's Dream* and Canadian Imperial Nationalism during the Second Boer War." *Theatre Research in Canada / Recherches théâtrales au Canada* 38, no. 1 (Spring 2017): 31–51.

Broadway, Michael J. "Urban Tourist Development in the Nineteenth Century Canadian City." *The American Review of Canadian Studies* 26, no. 1 (Spring 1996): 83–99.

Brooks, Daphne. *Bodies in Dissent: Spectacular Performances of Race and Freedom 1850–1910*. Durham, NC, and London: Duke University Press, 2010.

Brown, Anthony Cave. *Treason in the Blood: H. St. John Philby, Kim Philby, and the Spy Case of the Century*. Boston, MA: Houghton Mifflin, 1994.

Brown, Jayna. *Babylon Girls: Black Women Performers and the Shaping of the Modern*. Durham, NC: Duke University Press, 2008.

Brown, Jennifer S.H. "Frances Nickawa: 'A Gifted Interpreter of the Poetry of Her Race.'" In *Recollecting: Lives of Aboriginal Women of the Canadian Northwest and Borderland*, edited by Sarah Carter and Patricia McCormack, 263–85. Edmonton: Athabasca University Press, 2011.

Brown, Mary M. "Entertainers of the Road." In *Early Stages: Theatre in Ontario 1800–1914*, edited by Ann Saddlemyer, 123–65. Toronto: University of Toronto Press, 1990.

Brown, Thomas Alston. *Brown's History of the American Stage*. New York: Dick and Fitzgerald, 1870.

Burley, David. *A Particular Condition in Life: Self-Employment and Social Mobility in Mid-Victorian Brantford*. Montreal, QC, and Kingston, ON: McGill-Queen's University Press, 1994.

Burnet, John. *Destiny Obscure: Autobiographies of Childhood, Education and Family from the 1820s to the 1920s*. London: Allen Lane, 1982.

Burnett, Frances Hodgson, and William Gillette. *Esmerelda*. New York: Samuel French, 1909.

Burroughs, Robert. "Sailors and Slaves: The 'Enslaved Tar' in Naval Reform and Nautical Melodrama." *Journal of Victorian Culture* 16, no. 3 (December 2011): 305–22.

Burton, Antoinette, and Tony Ballantyne, eds. *Bodies in Contact: Rethinking Colonial Encounters in World History*. Durham, NC: Duke University Press, 2005.

Butsch, Richard. "Bowery B'hoys and Matinee Ladies: Re-Gendering of Nineteenth Century American Theater Audiences." *American Quarterly* 46, no. 3 (Sept. 1994): 374–405.

Callaway, Anita. *Visual Ephemera: Theatrical Art in Nineteenth-Century Australia*. Sydney: University of New South Wales Press, 2000.

Canning, Charlotte. "Constructing Experience: Theorizing a Feminist Theatre History." *Theatre Journal* 45 (1993): 529–40.

Canning, Charlotte, and Thomas Postlewait, eds. *Representing the Past: Essays in Performance Historiography*. Iowa City, IA: University of Iowa Press, 2010.

Canning, Kathleen. "The Body as Method: Reflections on the Place of the Body in Gender History." *Gender and History* 11, no. 3 (Nov. 1999): 499–513.

Carlson, Marvin. *The Haunted Stage: The Theatre as Memory Machine*. Ann Arbor, MI: University of Michigan Press, 2001.

Carr, Graham. "Visualizing 'the Sound of Genius': Glen Gould and the Culture of Celebrity in the 1950s." *Journal of Canadian Studies* 40, no. 3 (Fall 2006): 5–42.

Carr, Richard, and Bradley W. Hart. *The Global 1920s: Politics, Economics and Society*. London: Routledge, 2016.

Carroll, Kathleen L. "The Americanization of Beatrice: Nineteenth-Century Style." *Theatre Survey* 31 (1990): 67–84.

Carson, William Glasgow Bruce. *Dear Josephine, the Theatrical Career of Josephine Hull*. Norman, OK: University of Oklahoma Press, 1963.

Chauncey, George. *Gay New York: Gender, Urban Culture, and the Makings of the Gay Male World, 1890–1940*. New York: Basic Books, 1994.

Chunn, Dorothy E., Robert J. Menzies, and Robert Adamoski, eds. *Contesting Canadian Citizenship: Historical Readings*. Peterborough, ON: Broadview Press, 2002.

Cochrane, Claire. "The Pervasiveness of the Commonplace: The Historian and Amateur Theatre." *Theatre Research International* 26, no. 3 (2001): 233–42.

Codell, Julie, ed. *Imperial Co-Histories: National Identities and the British and Colonial Press*. Madison, NJ: Fairleigh Dickinson University Press, 2003.

Colcough, Dyan. *Child Labour in the British Victorian Entertainment Industry*. Houndmills, UK: Palgrave Macmillan, 2016.

Collins, L.J. *Theatre at War, 1914–1918*. Basingstoke, UK: St Martin's Press, 1998.

Condon, Denis. "Receiving News from the Seat of War: Dublin Audiences Respond to Boer War Entertainments." *Early Popular Visual Culture* 9, no. 2 (2011): 93–106.

Conti, Meredith. *Playing Sick: Performances of Illness in the Age of Victorian Medicine*. London and New York: Routledge, 2019.

Cook, Tim. *Clio's Warriors: Canadian Historians and the Writing of the World Wars.* Vancouver, BC: University of British Columbia Press, 2006.

Corbett, Mary Jean. "Performing Identities: Actresses and Autobiography." *Biography* 24, no. 1 (Winter 2001): 15–23.

Cott, Nancy F. *Public Vows: A History of Marriage and the Nation.* Cambridge, MA: Harvard University Press, 2009.

Crowhurst, Andrew. "Butt, Sir Alfred, first baronet (1878–1962)." In *Oxford Dictionary of National Biography*, edited by H.C.G. Matthew and Brian Harrison, online edition. Oxford, UK: Oxford University Press, 2004.

Crozier-De Rosa, Sharon. *Shame and the Anti-Feminist Backlash: Britain, Ireland and Australia, 1890–1920.* New York and Abingdon, UK: Routledge, 2018.

Cullen, Frank, with Florence Hackman and Donal McNelly. "May Tully." In *Vaudeville Old and New: An Encyclopedia of Variety Performances in America*, edited by Cullen, with Hackman and McNelly, 1132–3. New York: Routledge, 2007.

Curry, Jane Kathleen. *Nineteenth-Century American Women Theatre Managers.* Westport, CT: Greenwood Press, 1994.

Curthoys, Ann, and Marilyn Lake, eds. *Connected Worlds: History in Transnational Perspectives.* Canberra: ANU Press, 2005.

Daunton, Martin, and Bernhard Rieger, eds. *Meanings of Modernity: Britain from the Late-Victorian Era to World War II.* Oxford, UK: Berg, 2001.

Davidoff, Leonore, and Catherine Hall. *Family Fortunes: Men and Women of the English Middle Class 1780–1850*, rev. ed. London: Routledge, 2002.

Davies, Andrew. "The Scottish Chicago? From 'Hooligans' to 'Gangsters' in Inter-War Glasgow." *Cultural and Social History* 4, no. 4 (2007): 511–27.

Davis, Jim. "Freaks, Prodigies, and Marvellous Mimicry: Child Actors of Shakespeare on the Nineteenth-Century Stage." *Shakespeare* 2, no. 2 (Dec. 2006): 179–93.

Davis, Tracy C. *Actresses as Working Women: Their Social Identity in Victorian Culture.* London and New York: Routledge, 1990.

— *The Economics of the British Stage, 1800–1914.* Cambridge: Cambridge University Press, 2000.

— "The Employment of Children in Theatres." *New Theatre Quarterly* 2, no. 6 (1986): 117–35.

— "Female Managers, Lessees and Proprietors of the British Stage (to 1914)." *Nineteenth Century Theatre and Film* 28, no. 2 (Dec. 2000): 115–44.

— "Reading for Economic History." *Theatre Journal* 45 (1993): 487–503.

Davis, Tracy C., and Ellen Donkins, eds. *Women and Playwriting in Late Victorian England.* Cambridge: Cambridge University Press, 1999.

Davis, Tracy C., and Peter Holland, eds. *The Performing Century: Nineteenth-Century Theatre's History*. Basingstoke, UK: Palgrave Macmillan, 2007.

Davis-Fisch, Heather, ed. *New Essays on Canadian Theatre, vol. 7: Canadian Performance Histories and Historiographies*. Toronto: Playwrights Canada Press, 2017.

Deacon, Desley. "Celebrity, Empire, and American Morals in 1927: Australia Rejects the Young Judith Anderson." Paper presented at the Australian Historical Association's Annual Conference, Australia Federation University, Ballarat, VIC, 6 July 2016.

— "Celebrity Sexuality: Judith Anderson, Mrs. Danvers, Sexuality, and 'Truthfulness' in Biography." *Australian Historical Studies* 43, no. 1 (Mar. 2012): 43–60.

— "'Films as Foreign Offices': Transnationalism at Paramount in the Twenties and Thirties." In *Connected Worlds: History in Transnational Perspectives*, edited by Ann Curthoys and Marilyn Lake, 139–56. Canberra: ANU Press, 2005.

— "Location! Location! Location! Mind Maps and Theatrical Circuits in Australian Transnational History." *History Australia* 5, no. 3 (Dec. 2008): 81.1–81.16.

Deacon, Desley, Penny Russell, and Angela Woollacott. "Introduction." In *Transnational Lives: Biographies of Global Modernity, 1700–Present*, edited by Deacon, Russell, and Woollacott, 1–11. Basingstoke, UK: Palgrave Macmillan Transnational History Series, 2010.

— eds. *Transnational Lives: Biographies of Global Modernity, 1700–Present*. Basingstoke, UK: Palgrave Macmillan Transnational History Series, 2010.

— eds. *Transnational Ties: Australian Lives in the World*. Canberra: ANU Press, 2009.

de Grazia, Victoria. *Irresistible Empire: America's Advance through Twentieth-Century Europe*. Boston, MA: Harvard University Press, 2006.

Dejung, Christof, David Motadel, and Jürgen Osterhammel. "Worlds of the Bourgeoisie." In *The Global Bourgeoisie: The Rise of the Middle Classes in the Age of Empire*, edited by Dejung, Motadel, and Osterhammel, 1–39. Princeton, NJ: Princeton University Press, 2019.

de Leon, Charles Ponce. *Self-Exposure: Human-Interest Journalism and the Emergence of Celebrity in America, 1890–1940*. Chapel Hill, NC: University of North Carolina Press, 2002.

Derrick, Patty S. "Julia Marlowe: An Actress Caught between Traditions." *Theatre Survey* 32 (May 1991): 85–105.

— "Julia Marlowe's Ophelia: A Portrait of Resistance and Failure." *Theatre History Studies* 23 (Jun. 2003): 25–47.

— "Rosalind and the Nineteenth-Century Woman: Four Stage Interventions." *Theatre Survey* 26, no. 2 (Nov. 1985): 143–62.

Domosi, Mona. *American Commodities in an Age of Empire*. New York: Routledge, 2006.

Donohue, Joseph. *The Cambridge History of British Theatre vol. 2, 1660–1895*. Cambridge: Cambridge University Press, 2004.

Double, Oliver. "Teddy Brown and the Art of Performing for the British Variety Stage." *New Theatre Quarterly* 25, no. 4 (Nov. 2009): 379–90.

Dubinsky, Karen. *Babies without Borders: Adoption and Migration across the Americas*. Toronto: University of Toronto Press, 2010.

Dubinsky, Karen, Adele Perry, and Henry Yu, eds. *Within and Without the Nation: Canadian History as Transnational History*. Toronto: University of Toronto Press, 2015.

Dudden, Faye E. *Women in the American Theatre: Actresses and Audiences 1790–1870*. New Haven, CT, and London: Yale University Press, 1994.

Duncan, Joanna. "Benson's *Dream*: Touring a 'Grand Production' to the Provinces." *Theatre Notebook* 68, no. 3 (2015): 165–76.

Durham, Weldon B. *Liberty Theatres: Entertaining the United States' Army, 1917–1919*. Jefferson, NC: McFarland and Co., 2008.

Ehnenn, Jill. "'An Attractive Dramatic Exhibition?': Female Friendship, Shakespeare's Women, and Female Performativity in 19th-Century Britain." *Women's Studies* 26 (1997): 315–41.

Eltis, Sos. *Acts of Desire: Women and Sex on Stage, 1800–1930*. Oxford, UK: Oxford University Press, 2013.

— "The Fallen Woman on Stage: Maidens, Magdalens, and the Emancipated Female." In *The Cambridge Companion to Victorian and Edwardian Theatre*, edited by Kerry Powell, 222–36. New York: Cambridge University Press, 2004.

— "Private Lives and Public Spaces: Reputation, Celebrity and the Late Victorian Actress." In *Theatre and Celebrity in Britain, 1660–2000*, edited by Mary Luckhurst and Jane Moody, 169–88. Basingstoke, UK: Palgrave Macmillan, 2005.

— "Women's Suffrage and Theatricality." In *Politics, Performance and Popular Culture: Theatre and Society in Nineteenth-Century Britain*, edited by Peter Yeandle, Katherine Newey, and Jeffrey Richards, 111–27. Manchester, UK: Manchester University Press, 2016.

Ernst, Christopher. "The Transgressive Stage: Public Entertainment in Late Victorian Toronto." PhD thesis. Toronto: University of Toronto, 2011.

Evans, James W., and Gardner L. Harding. *Entertaining the American Army: The American Stage and Lyceum in the World War*. New York: Association Press, 1921.

Fass, Paula. "Childhood and Memory." *The Journal of the History of Childhood and Youth* 3, no. 2 (Spring 2010): 155–64.

Fielder, Mari Kathleen. "Lyceum Players." In *American Theatre Companies, 1888–1930*, edited by Weldon B. Durham, 271–7. Westport, CT: Greenwood Press, 1987.

Filewod, Alan. *Committing Theatre: Theatre Radicalism and Political Intervention in Canada*. Toronto: Between the Lines, 2011.

— "Erect Sons and Dutiful Daughters: Imperialism, Empires and Canadian Theatre." In *Imperialism and Theatre: Essays on World Theatre, Drama and Performance 1795–1995*, edited by Ellen J. Gainor, 55–68. London: Routledge, 1995.

Fisher, James, and Felicia Hardison Londré. "Cocroft, Thoda [1893–1943]." In *Historical Dictionary of American Theatre: Modernism*, edited by Fisher and Londré, 145. Lanham, MD: Rowman and Littlefield, 2018.

Fisher, Judith L., and Stephen Watt, eds. *When They Weren't Doing Shakespeare: Essays on Nineteenth-Century British and American Theatre*. Athens, GA: University of Georgia Press, 1989.

Fletcher, Ian Christopher, Laura Mayhall, and Philippa Levine, eds. *Women's Suffrage in the British Empire: Citizenship, Nation and Race*. Chicago, IL: Routledge, 2000.

Flynn, Karen. *Moving beyond Borders: A History of Black Canadian and Caribbean Women in the Diaspora*. Toronto: University of Toronto Press, 2011.

Foley, Helene P. *Reimagining Greek Tragedy on the American Stage*. Berkeley, CA: University of California Press, 2012.

Foulkes, Richard. *Church and Stage in Victorian England*. Cambridge: Cambridge University Press, 1997.

— *Performing Shakespeare in the Age of Empire*. Cambridge: Cambridge University Press, 2002.

— ed. *Henry Irving, A Re-Evaluation of the Pre-Eminent Victorian Actor Manager*. Aldershot, UK: Ashgate, 2008.

Fraser, Kathleen. "Theatre Management in the Nineteenth Century: Eugene A. McDowell in Canada, 1847–1891." *Theatre Research in Canada / Recherches théâtrales au Canada* 1, no. 1 (Spring 1980): 39–54.

Frey, Heather Fitzsimmons. "Singing and Dancing 'Their Bit' for the Nation: Canadian Children's Performances for Charity circa the First World War." *Jeunesse: Young People, Texts, Cultures* 9, no. 2 (Winter 2017): 43–68.

Frick, John W. *Theatre, Culture and Temperance Reform in Nineteenth-Century America*. Cambridge: Cambridge University Press, 2003.

Frierson, Eddie. "Christy Mathewson." *Society for American Baseball Research.* https://sabr.org/bioproj/person/christy-mathewson/ (accessed 7 Feb. 2018).

Fulgate, Liz. "Crothers, Rachel." In *Notable Women in the American Theatre: A Biographical Dictionary*, edited by Alice M. Robinson, Vera Mowry Roberts, and Milly S. Barranger, 193–7. Westport, CT: Greenwood Press, 1989.

Fuller, J.G. *Troop Morale and Popular Culture in the British and Dominion Armies, 1914–18.* Oxford: Oxford University Press, 1990.

Gainor, J. Ellen. *Imperialism and Theatre: Essays on World Theatre, Drama, and Performance.* London: Routledge, 1995.

Gale, Maggie. "The London Stage, 1918–1945." In *The Cambridge History of the British Theatre, Vol. 3: Since 1885*, edited by Dennis Kennedy, 143–66. Cambridge: Cambridge University Press, 2004.

Gale, Maggie B. *West End Women: Women and the London Stage, 1916–1962.* London: Routledge, 1996.

Gale, Maggie B., and Viv Gardner, eds. *Women, Theatre, and Performance: New Histories, New Historiographies.* Manchester, UK: Manchester University Press, 2000.

Gale, Maggie B., and John Stokes. *The Cambridge Companion to the Actress.* Cambridge: Cambridge University Press, 2007.

Gardner, David. "Finlayson, Margaret, Margaret Bloomer, Margaret Mather." In *Dictionary of Canadian Biography*, vol. 12. Toronto and Laval, QC: University of Toronto / Université Laval, 2003.

– "Nickinson, Charlotte." In *Dictionary of Canadian Biography*, vol. 13. Toronto and Laval, QC: University of Toronto / Université Laval, 2003.

– "McLeay, James Franklin." In *Dictionary of Canadian Biography*, vol. 12. Toronto and Laval, QC: University of Toronto / Université Laval, 2003.

– "Scales, Caroline, Caroline Miskel, Caroline Miskel-Hoyt." In *Dictionary of Canadian Biography*, vol. 12. Toronto and Laval, QC: University of Toronto / Université Laval, 2003.

– "Townsend, John." In *Dictionary of Canadian Biography*, vol. 12. Toronto and Laval, QC: University of Toronto / Université Laval, 2003.

Gardner, Martha. *The Qualities of a Citizen: Women, Immigration, and Citizenship, 1870–1965.* Princeton, NJ: Princeton University Press, 2005.

Gardner, Viv. "Provincial Stages, 1900–1934: Touring and Early Repertory Theatre." In *The Cambridge History of British Theatre, Vol. 3: Since 1895*, edited by Baz Kershaw, 60–85. Cambridge: Cambridge University Press, 2008.

Geddes, Andrea Poole. *Philanthropy and the Construction of Victorian Women's Citizenship: Lady Frederick Cavendish and Miss Emma Cons.* Toronto: University of Toronto Press, 2013.

Gentile, Patrizia, and Jane Nicholas. "Introduction." In *Contesting Bodies and Nation in Canadian History*, edited by Gentile and Nicholas, 3–27. Toronto: University of Toronto Press, 2013.

Gidney, R.D., and W.P.J. Millar. "From Voluntarism to State Schooling: The Creation of the Public School System in Ontario." *Canadian Historical Review* 66, no. 4 (Dec. 1985): 444–73.

Ginzberg, Lori D. "The Pleasures (and Dangers) of Biography." *Journal of Women's History* 19, no. 3 (Sept. 2007): 205–12.

Girard, Philip. "'If Two Ride a Horse, One Must Ride in Front': Married Women's Nationality and the Law in Canada 1880–1950." *Canadian Historical Review* 94, no. 1 (Mar. 2013): 28–54.

Glassberg, David. *American Historical Pageantry: The Uses of Tradition in the Early Twentieth Century*. Chapel Hill, NC: University of North Carolina Press, 1990.

Glenn, Evelyn Nakano. *Unequal Freedom: How Race and Gender Shaped American Citizenship and Labor*. Cambridge, MA: Harvard University Press, 2002.

Glenn, Susan A. *Female Spectacle: The Theatrical Roots of Modern Feminism*. Cambridge, MA: Harvard University Press, 2000.

Goddard, Leslie. "'Women Know Her to Be a Real Woman': Femininity, Nationalism, and the Suffrage Activism of Lillian Russell." *Theatre History Studies* 22 (Jan. 2002): 137–54.

Gordon, Beverly. *Bazaars and Fair Ladies: The History of the American Fundraising Fair*. Knoxville, TN: University of Tennessee Press, 1998.

Gordon, Linda. *The Great Arizona Orphan Abduction*. Cambridge, MA: Harvard University Press, 1999

– *Heroes of Their Own Lives: The Politics and History of Family Violence, Boston, 1880–1960*. New York: Viking, 1988.

Gottlieb, Julie. *Feminine Fascism: Women in Britain's Fascist Movement 1923–1945*. London: I.B. Tauris, 2000.

Gould, Marty. *Nineteenth-Century Theatre and the Imperial Encounter*. London: Routledge, 2011.

Granshaw, Michele. "Performing Cultural Memory: The Travelling Hibernicon and the Transnational Irish Community in the United States and Australia." *Nineteenth Century Theatre and Film* 41, no. 2 (Winter 2014): 76–101.

Gräser, Marcus. "The 'Middle Class' in the Nineteenth-Century United States." In *The Global Bourgeoisie: The Rise of the Middle Classes in the Age of Empire*, edited by Christof Dejung, David Motadel, and Jürgen Osterhammel, 64–84. Princeton, NJ: Princeton University Press, 2019.

Gregory, Fiona. "Mrs. Pat's Two Bodies: Ghosting and the Landmark Performance." *Theatre Survey* 57, no. 2 (May 2016): 218–31.

Grossman, Barbara Wallace. *A Spectacle of Suffering: Clara Morris on the American Stage*. Carbondale, IL: Southern Illinois University Press, 2009.

Groth, Paul. *Living Downtown: The History of Residential Hotels in the United States*. Berkeley, CA: University of California Press, 1994.

Gubar, Marah. "Entertaining Children of All Ages: Nineteenth-Century Popular Theatre as Children's Theatre." *American Quarterly* 66, no. 1 (Mar. 2014): 1–34.

— "Who Watched *The Children's Pinafore*? Age Transvestism on the Nineteenth-Century Stage." *Victorian Studies* 54, no. 3 (Spring 2012): 410–26.

Guest, Kirsten. "The Subject of Money: Late-Victorian Melodrama's Crisis of Masculinity." *Victorian Studies* 49, no. 4 (Summer 2007): 635–57.

Guiget, Kristina. *The Ideal World of Mrs. Widder's Soirée Musicale: Social Identity and Musical Life in Nineteenth-Century Ontario*. Ottawa: Canadian Museum of Civilization, 2004.

Gunn, Simon. "Between Modernity and Backwardness: The Case of the English Middle Class." In *The Making of the Middle Class: Toward a Transnational History of the Middle Class*, edited by A. Ricardo López and Barbara Weinstein, 58–74. Durham, NC: Duke University Press, 2012.

Hall, Jacquelyn Dowd. *Sisters and Rebels: A Struggle for the Soul of America*. New York: W.W. Norton, 2019.

Hall, Roger A. *Performing the American Frontier, 1870–1906*. Cambridge: Cambridge University Press, 2001.

Hamilton, Craig. "Constructing a Cultural Icon: *Nomos* and Shaw's *Saint Joan* in Paris." *Modern Drama* 43, no. 3 (Fall 2000): 359–75.

Hammill, Faye. *Women, Celebrity, and Literary Culture between the Wars*. Austin: University of Texas Press Austin, 2007.

Hanners, John. *"It Was Play or Starve": Acting in the Nineteenth Century American Popular Theatre*. Bowling Green, OH: Bowling Green State University Popular Press, 1993.

Harrison, Brian. *Separate Spheres: The Opposition to Women's Suffrage in Britain*. London: Routledge, 1978 [e-book 2013].

Hay, Samuel A. *African-American Theatre: An Historical and Critical Analysis*. Cambridge: Cambridge University Press, 1994.

Hays, Michael. "Representing Empire: Class, Culture, and the Popular Theatre in the Nineteenth Century." *Theatre Journal* 47 (1995): 65–82.

Hendley, Matthew C. "Cultural Mobilization and British Responses to Cultural Transfer in Total War: The Shakespeare Tercentenary of 1916." *First World War Studies* 3, no. 1 (March 2012): 25–49.

— *Organized Patriotism and the Crucible of War: Popular Imperialism in Britain, 1914–1932*. Montreal, QC: McGill-Queen's University Press, 2012.

Hindson, Catherine. *Female Performance Practice on the Fin-de-Siècle Popular Stages of London and Paris: Experiment and Advertisement.* Manchester, UK: Manchester University Press, 2007.

— *London's West End Actresses and the Origins of Celebrity Charity, 1880–1920.* Iowa City, IA: University of Iowa Press, 2016.

Hirshfield, Claire. "The Actress as Social Activist: The Case of Lena Ashwell." In *Politics, Gender, and the Arts: Women, the Arts, and Society*, edited by Ronald L. Dotterer and Susan Bowers, 72–84. Susquehanna, PA, and Toronto: Associated University Press, 1992.

— "The Actresses' Franchise League and the Campaign for Women's Suffrage 1908–1914." *Theatre Research International* 10, no. 2 (Summer 1985): 129–53.

Hodes, Martha. *The Sea Captain's Wife: A True Story of Love, Race, and War in the Nineteenth Century.* New York: W.W. Norton, 2006.

Hodin, Mark. "The Disavowal of Ethnicity: Legitimate Theatre and the Social Construction of Literary Value in Turn-of-the-Century America." *Theatre Journal* 52 (2000): 211–26.

Hoganson, Kristine. *Consumers' Imperium: The Global Production of American Domesticity, 1865–1920.* Chapel Hill, NC: University of North Carolina Press, 2007.

Holder, Heidi J. "Melodrama, Realism and Empire on the British Stage." In *Acts of Supremacy: The British Empire and the Stage, 1790–1930*, edited by J.S. Bratton, Richard Allen Cave, Breandan Gregory, Heidi J. Holder, and Michael Pickering, 129–49. Manchester, UK: Manchester University Press, 1991.

Holman, Andrew C. *A Sense of Their Duty: Middle-Class Formation in Victorian Ontario. Towns.* Montreal, QC, and Kingston, ON: McGill-Queen's University Press, 2000.

Holmes, Sean P. "All the World's a Stage! The Actors' Strike of 1919." *Journal of American History* 91, no. 4 (Mar. 2005): 1291–1317.

Holmstrom, Bethany D. "Civil War Memories on the Nineteenth-Century Amateur Stage: Preserving the Union (and Its White Manly Parts)." *Theatre History Studies* 33 (2014): 4–34.

Holroyd, Michael. *A Strange Eventful History: The Dramatic Lives of Ellen Terry, Henry Irving, and Their Remarkable Families.* London: Vintage Books, 2009.

Horn, Pamela. "English Theatre Children, 1880–1914: A Study in Ambivalence." *History of Education* 25, no. 1 (1995): 37–54.

Houlbrook, Matt. *Queer London: Perils and Pleasures in the Sexual Metropolis, 1918–1957.* Chicago, IL: University of Chicago Press, 2005.

Howard, Bronson. *The Henrietta: A Comedy in Four Acts.* New York: Samuel French, 1901.

Huff, Mary Helen. "'That Benefit Racket': Women and the Benefit in New York Theatre, 1840–1875." PhD thesis. New York: City University of New York, 2000.

Iacovetta, Franca. "The Gate Keepers: Middle-Class Campaigns of Citizenship in Early Cold War Canada." In *The Making of the Middle Class: Toward a Transnational History*, edited by A. Ricardo López and Barbara Weinstein, 87–106. Durham, NC: Duke University Press, 2012.

Innes, Christopher, ed. *The Cambridge Companion to George Bernard Shaw*. Cambridge: Cambridge University Press, 1998.

Iriye, Akira. *Global and Transnational History: The Past, Present, and Future*. Basingstoke, UK, and New York: Palgrave Macmillan, 2013.

Isbell, Mary. "Editorial: Amateur Theatre in the Long Nineteenth Century." *Nineteenth Century Theatre and Film* 38, no. 2 (Winter 2011): xvii–xix.

— "Documents of Performance: Illustrated Reviews of Naval Theatricals." *Nineteenth Century Theatre and Film* 38, no. 2 (Winter 2011): 67–74.

— "When Ditchers and Jack Tars Collide: Theatricals at the Calcutta Lyric Theatre in the Wake of the Indian Mutiny." *Victorian Literature and Culture* 42 (2014): 407–23.

Jackson, Russell. "Oscar Asche: An Edwardian in Transition." *New Theatre Quarterly* 12, no. 47 (Aug. 1996): 216–28.

Jackson, Shannon. "Civic Play-Housekeeping: Gender, Theatre, and American Reform." *Theatre Journal* 48 (1996): 337–61.

Jasen, Patricia. *Wild Things: Nature, Culture, and Tourism in Ontario, 1790–1914*. Toronto: University of Toronto Press, 1995.

Joannou, Maoula. "'Hilda, Harnessed to a Purpose': Elizabeth Robins, Ibsen, and the Vote." *Comparative Drama* 44, no. 2 (Summer 2010): 179–200.

John, Angela V. *Elizabeth Robins: Staging a Life, 1862–1952*. London and New York: Routledge, 1995.

"'John 'Chief' Meyers." https://www.californiaindianeducation.org/sports_heros/big_chief_meyers/ (accessed 26 Aug. 2021).

Johnson, Katie N. *Sisters in Sin: Brothel Drama in America, 1900–1920*. Cambridge: Cambridge University Press, 2006.

Kalman, Harold D. *The Railway Hotels and the Development of the Château Style in Canada*. Victoria: University of Victoria Maltwood Museum, 1968.

Kammen, Michael. *Mystic Chords of Memory: The Transformation of Tradition in American Culture*. New York: Vintage Books, 1991.

Kaplan, Joel H. "Henry Arthur Jones and the Lime-Lit Imagination." *Nineteenth-Century Theatre* 15, no. 2 (Winter 1987): 115–41.

Kaplan, Joel H., and Sheila Stovell. *Theatre and Fashion: Oscar Wilde to the Suffragettes*. Cambridge: Cambridge University Press, 1994.

Kelly, Ethel Knight. *Twelve Milestones: Being the Peregrinations of Ethel Knight Kelly*. London: Brentano's, 1929.

Kelly, Veronica. "An Australian Idol of Modernist Consumerism: Minnie Tittell Brune and the Gallery Girls." *Theatre Research International* 31, no. 1 (2006): 17–36.

— "Beauty and the Market: Actress Postcards and Their Senders in Early Twentieth-Century Australia." *New Theatre Quarterly* 20, no. 2 (May 2004): 99–116.

— "Shakespeare in Settler-Built Spaces: Oscar Asche's 'Recitals' of *Julius Caesar* in the Melbourne and Sydney Town Halls." *Contemporary Theatre Review* 19, no. 3 (2009): 353–66.

Kennedy, Dennis. "British Theatre, 1895–1946: Art, Entertainment, Audiences – An Introduction." In *The Cambridge History of British Theatre, Vol. 3: Since 1895*, edited by Kershaw, 1–33. Cambridge: Cambridge University Press, 2008.

— ed. *The Oxford Encyclopedia of Theatre and Performance*. Oxford, UK: Oxford University Press, 2005.

Kennedy, Matthew. *Marie Dressler: A Biography*. Jefferson, NC, and London: McFarland and Co., 1999.

Kershaw, Baz. *The Cambridge History of British Theatre, Vol. 3: Since 1895*. Cambridge: Cambridge University Press, 2008.

Kibler, M. Alison. *Rank Ladies: Gender and Cultural Hierarchy in American Vaudeville*. Chapel Hill, NC: University of North Carolina Press, 1999.

King, Steven. *Women, Welfare and Local Politics, 1880–1920: "We Might Be Trusted."* Brighton, UK: Sussex Academic Press, 2006.

King, W.D. *Henry Irving's Waterloo*. Berkeley, CA: University of California Press, 1993.

Kobbé, Gustav. *Famous Actresses and Their Homes*. Boston, MA: Little Brown, 1905.

Kovacs, Alexandra. "Beyond Shame and Blame in Pauline Johnson's Performance Historiographies." In *New Essays on Canadian Theatre, vol. 7: Canadian Performance Histories and Historiographies*, edited by Heather Davis-Fisch, 31–51. Toronto: Canadian Playwrights Press, 2017.

Koven, Seth. *The Match Girl and the Heiress*. Princeton, NJ: Princeton University Press, 2015.

— *Slumming: Sexual and Social Politics in Victorian London*. Princeton, NJ: Princeton University Press, 2006.

Kovitz, Amy. "Dancing the Orient for England: Maud Allan's 'The Vision of Salome.'" *Theatre Journal* 46 (1994): 63–78.

Laffey, Bruce. *Bea Lillie: Funniest Woman in the World*. London: Robson Books, 1998.

Lake, Marilyn. "Nationalist Historiography, Feminist Scholarship, and the Promise and Problems of New Transnational Histories: The Australian Case." *Journal of Women's History* 19, no. 1 (Jan. 2007): 180–6.

Lake, Marilyn, and Harry Reynolds. *Drawing the Global Colour Line: White Man's Countries and the International Challenge of Racial Equality*. Cambridge: Cambridge University Press, 2008.

Lambert, David, and Alan Lester, eds. *Colonial Lives across the British Empire: Imperial Careering in the Long Nineteenth Century*. Cambridge: Cambridge University Press, 2006.

Landro, Vincent. "Faking It: The Press Agent and Celebrity Theatre in Early Twentieth-Century American Theatre." *Theatre History Studies* 15 (Jun. 2002): 95–114.

Lanning, Robert. "Morgan, Henry James." *Dictionary of Canadian Biography*, vol. 14. Toronto and Laval, QC: University of Toronto / Université Laval, 2003.

Latham, Angela J. "The Right to Bare: Containing and Encoding American Women in Popular Entertainments of the 1920s." *Theatre Journal* 49 (1997): 455–73.

Lears, T.J. Jackson. *No Place of Grace: Antimodernism and the Transformation of American Culture, 1880–1920*. Chicago, IL: University of Chicago Press, 1994.

Leask, Margaret. *Lena Ashwell: Actress, Patriot, Pioneer*. Hatfield, UK: University of Hertfordshire Press, 2013.

Leonard, John William. "Amelia Summerville." In *Woman's Who's Who of America: A Biographical Dictionary of Contemporary Women of the United States and Canada 1914–1915*, edited by John Willian Leonard, 794–5. New York: American Commonwealth Co., 1914.

Lesch, R.J. "Chief Meyers." *Society for American Baseball Research*. https://sabr.org/bioproj/person/jack-meyers/ (accessed 7 Feb. 2018).

LeVay, John. *Margaret Anglin: A Stage Life*. Toronto: Simon and Pierre, 1985.

Levenstein, Harvey. *Seductive Journey: American Tourists in France from Jefferson to the Jazz Age*. Chicago, IL: University of Chicago Press, 1998.

Levine, Philippa. *The British Empire: Sunrise to Sunset*. Harlow, UK: Pearson, 2007.

Light, Alison. *Forever England: Femininity, Literature, and Conservatism between the Wars*. London: Routledge, 1991.

Lillie, Beatrice, with James Brough. *Every Other Inch a Lady. Aided and Abetted by John Phillip*. New York: Doubleday, 1972.

Lindesmith, William. "Watson, Lucille." In *Notable Women in the American Theatre: A Biographical Dictionary*, edited by Alice M. Robinson, Vera Mowry Roberts, and Milly S. Barranger, 919–20. New York: Greenwood Press, 1989.

Linton, David. "English West End Revue: The First World War and After." In *The Oxford Handbook of the British Musical*, edited by Robert Gordon and Olaf Jubin, 143–63. Oxford, UK: Oxford University Press, 2017.

Litt, Paul. "The Cult of Nation and the Gnat of Culture." *Acadiensis* 38, no. 2 (Summer/Autumn 2009): 150–8.

Loggie, Jean. "Notable Benefit Performances and Fund Raising Affairs." In *A History of the Actors' Fund of America*, edited by Louis M. Simon, 152–71. New York: Theatre Arts Books, 1972.

López, A. Ricardo, with Barbara Weinstein. "We Shall Be All: Towards a Transnational History of the Middle Class." In *The Making of the Middle Class: Toward a Transnational History of the Middle Class*, edited by López and Weinstein, 2–25. Durham, NC: Duke University Press, 2012.

Lott, Eric. *Love and Theft: Blackface Minstrelsy and the American Working Class*. New York: Oxford University Press, 1993.

Luckhurst, Mary, and Jane Moody. "Introduction." In *Theatre and Celebrity in Britain, 1660–2000*, edited by Luckhurst and Moody, 1–11. Basingstoke, UK: Palgrave Macmillan, 2005.

— eds. *Theatre and Celebrity in Britain, 1660–2000*. Basingstoke, UK: Palgrave Macmillan, 2005.

Lydon, Jane. *Eye Contact: Photographing Indigenous Australians*. Durham, NC, and London: Duke University Press, 2005.

Mackenzie, John M., ed. *Imperialism and Popular Culture*. Manchester, UK: Manchester University Press, 1986.

Mackinnon, Alison. "Collective Biography: Reading Early University Women from Their Own Texts." *Australian Feminist Studies* 7, no. 16 (Dec. 1992): 94–102.

Magee, Gary B., and Andrew S. Thompson. *Empire and Globalisation: Networks of People, Goods, and Capital in the British World, c. 1850–1914*. Cambridge: Cambridge University Press, 2010.

Magelssen, Scott, and Henry Bial. "Theater Historiography." Ann Arbor, MI: University of Michigan. http://www.theater-historiography.org/.

Marcus, Sharon. *The Drama of Celebrity*. Princeton, NJ: Princeton University Press, 2019.

— "The Theatrical Scrapbook." *Theatre Survey* 54, no. 2 (May 2013): 283–307.

Margadant, Jo. "The Duchesse de Berry and Royalist Political Culture in Postrevolutionary France." In *The New Biography: Performing Femininity in*

19th-Century France, edited by Jo Margadant, 34–59. Berkeley, CA: University of California Press, 2000.
— ed. *The New Biography: Performing Femininity in 19th-Century France*. Berkeley, CA: University of California Press, 2000.
Markwyn, Abigail M. "Queen of Joy Zone Meets Hercules: Gendering Imperial California at the Panama-Pacific International Exposition." *The Western Historical Quarterly* 47 (Spring 2016): 51–72.
Marra, Kim. *Strange Duets: Impresarios and Actresses in the American Theatre, 1865–1914*. Iowa City, IA: University of Iowa Press, 2006.
— "Taming America as Actress: Augustin Daly, Ada Rehan, and the Discourse of Imperial Frontier Conquest." In *Performing America: Cultural Nationalism in American Theater*, edited by J. Ellen Gainor and Jeffrey D. Mason, 52–72. Ann Arbor, MI: University of Michigan Press, 1999.
Marshall, Gail. "Ellen Terry: Shakespearean Actress and Critic." *European Journal of Women's Studies* 11, no. 3 (2004): 355–64.
— *Shakespeare and Victorian Women*. Cambridge: Cambridge University Press, 2009.
— ed. *Shakespeare in the Nineteenth Century*. Cambridge: Cambridge University Press, 2012.
Marx, Peter W. "A Cultural History of Theatre in the Age of Empire." In *A Cultural History of Theatre in the Age of Empire, Volume 5*, edited by Peter W. Marx, 1–32. London: Bloomsbury, 2017.
Mason, Jeffrey D., and J. Ellen Gainor, eds. *Performing America: Cultural Nationalism in American Theatre*. Ann Arbor, MI: University of Michigan Press, 1999.
Matthew, Jill Julius. "Modern Nomads and National Film History: The Multi-Continual Career of J.D. Williams." In *Connected Worlds: History in Transnational Perspective*, edited by Ann Curthoys and Marilyn Lake, 157–70. Canberra: ANU Press, 2005.
McArthur, Benjamin. *Actors and American Culture 1880–1920*. Philadelphia: Temple University Press, 1984.
— "'Forbid Them Not': Child Actor Labor Laws and Political Activism in the Theatre." *Theatre Survey* 36, no. 2 (Nov. 1995): 63–80.
McConachie, Bruce. "Narrative Possibilities for U.S. Theatre Histories." In *Writing and Rewriting National Theatre Histories*, edited by S.E. Wilmer, 127–52. Iowa City, IA: University of Iowa Press, 2004.
McClintock, Anne. *Imperial Leather: Race, Gender, and Sexuality in the Colonial Contest*. New York: Routledge, 1995.
McHenry, Robert. "Russell, Annie." In *Famous American Women: A Biographical Dictionary from Colonial Times to the Present*, edited by McHenry, 360. New York: Dover Publications, 1980.

McKenzie, Beatrice. "Gender and United States Citizenship in Nation and Empire." *History Compass Journal* 4, no. 3 (May 2006): 592–602.

McKenzie, Kirsten. *A Swindler's Progress: Nobles and Convicts in the Age of Liberty*. Cambridge, MA: Harvard University Press, 2010.

McKibbin, Ross. *Classes and Cultures: England 1918–1951*. Oxford, UK: Oxford University Press, 1998.

Meeuwis, Michael. "'The Theatre Royal Back Drawing-Room': Professionalizing Domestic Entertainment in Victorian Acting Manuals." *Victorian Studies* 54, no. 3 (Spring 2012): 427–37.

Melman, Billie. *The Culture of History: English Uses of the Past 1800–1953*. Oxford, UK: Oxford University Press, 2006.

— "Horror and Pleasure: Visual Histories, Sensationalism, and Modernity in Britain in the Long Nineteenth Century." *Geschichte und Gesellschaft* 37 (Jan.–Mar. 2011): 26–46.

Miles, Ellie. "Characterising the Nation: How T.P. Cooke Embodied the Naval Hero in Nineteenth-Century Nautical Melodrama." *Journal for Maritime Research* 19, no. 2 (2017): 107–20.

Milligan, Ian. "Illusionary Order: Online Databases, Optical Character Recognition, and Canadian History, 1997–2010." *Canadian Historical Review* 94, no. 4 (Dec. 2013): 540–69.

Mills, Sara. *Discourses of Difference: An Analysis of Women's Travel Writing and Colonialism*. London: Routledge, 1991.

Mizejewski, Linda. *Ziegfeld Girl: Image and Icon in Culture and Cinema*. Durham, NC, and London: Duke University Press, 1999.

The Modern Girl Around the World Research Group (Alys Eve Weinbuam, Lynn M. Thomas, Priti Ramamurthy, Uta G. Poige, Madeline Y. Dong, and Tani E. Barlow). *The Modern Girl Around the World: Consumption, Modernity, and Globalization*. Durham, NC, and London: Duke University Press, 2008.

— "The Modern Girl Around the World: Cosmetics Advertising and the Politics of Race and Style." In *The Modern Girl Around the World: Consumption, Modernity, and Globalization*, edited by The Modern Girl Around the World Research Group, 25–54. Durham, NC: Duke University Press, 2008.

Monod, David. "The Eyes of Anna Held: Sex and Sight in the Progressive Era." *Journal of the Gilded Age and Progressive Era* 10, no. 3 (2011): 289–327.

— *The Soul of Pleasure: Sentiment and Sensation in Nineteenth-Century American Mass Entertainment*. Ithaca, NY, and London: Cornell University Press, 2016.

Moon, Krystyn R. *Yellowface: Creating the Chinese in American Popular Music and Performance, 1850s–1920s*. Newark, NJ: Rutgers University Press, 2005.

Moore, James Ross. *André Charlot: The Genius of Intimate Musical Revue*. Jefferson, NC: McFarland and Co., 2005.

— "Girl Crazy: Musicals and Revue Between the Wars." In *British Theatre Between the Wars 1918–1939*, edited by Clive Barker and Maggie B. Gale, 88–112. Cambridge: Cambridge University Press, 2000.

Morgan, Cecilia. *Building Better Britains? Settler Societies within the British Empire, 1783–1920*. Toronto: University of Toronto Press, 2017.

— "Celebrity within the Transatlantic World: The Ojibwa of Upper Canada, 1830–1860." In *Celebrity Colonialism: Fame, Power, and Representation in (Post) Colonial Cultures*, edited by Robert Clarke, 15–38. Newcastle, UK: Cambridge Scholars Press, 2009.

— *Commemorating Canada: History, Heritage, and Memory 1850s–1990s*. Toronto: University of Toronto Press, 2016.

— *"A Happy Holiday": English-Canadian and Transatlantic Tourism, 1870–1930*. Toronto: University of Toronto Press, 2008.

— "Performing for 'Imperial Eyes': Bernice Loft and Ethel Brant Monture, Ontario, 1930s–1960s." In *Contact Zones: Aboriginal and Settler Women in Canada's Colonial Past*, edited by Katie Pickles and Myra Rutherdale, 65–90. Vancouver, BC: University of British Columbia Press, 2005.

— *Public Men and Virtuous Women: The Gendered Languages of Religion and Politics in Upper Canada, 1791–1850*. Toronto: University of Toronto Press, 1996.

— "'A Sweet Canadian Girl': Canadian Actresses' Transatlantic and Transnational Careers through the Lenses of Canadian Magazines, 1890s–1940s." *International Journal of Canadian Studies / Revue internationale des études canadiennes, Special Issue on Print Culture, Mobility, and the Middlebrow / Imprimé, mobilité et culture moyenne* 48 (2014): 119–36.

— "'A Wigwam to Westminster': Performing Mohawk Identity in Imperial Britain, 1890s–1900s." *Gender and History* 25, no. 2 (Aug. 2003): 319–41.

Morgan, Henry J. *Types of Canadian Women*, vol. 1. Toronto: Wm. Briggs, 1903.

Morris, Clara. *Life on the Stage*. New York: McClure, Phillips, 1901.

— *Stage Confidences: Talks about Players and Play Acting*. Boston, MA: Lathrop Publishing, 1902.

Moskowitz, Marina. "'Aren't We All?': Aspiration, Acquisition and the American Middle Class." In *The Making of the Middle Class: Toward a Transnational History of the Middle Class*, edited by A. Ricardo López and Barbara Weinstein, 75–86. Durham, NC: Duke University Press, 2012.

Mount, Nicholas. *When Canadian Literature Moved to New York*. Toronto: University of Toronto Press, 2005.

Mullenneaux, Nan. "Our Genius, Goodness, and Gumption: Child Actresses and National Identity in Mid-Nineteenth-Century America." *The Journal of the History of Childhood and Youth* 5, no. 2 (Spring 2012): 283–308.

Myers, Andrew B. "Allen, Viola Emily." In *Notable American Women, 1607–1950, vol. 1: A–F*, edited by Edward T. James, Janet Wilson James, and Paul S. Boyer, 84. Cambridge, MA: Harvard University Press, 1971.

Nagler, Jörg. "The Mobilization of Emotions: Propaganda and Social Violence on the American Home Front during World War I." In *Emotions in American History: An International Assessment*, edited by Jessica C.E. Gienow-Hecht, 66–91. New York and Oxford, UK: Berghahn Books, 2010.

Nasaw, David. *Going Out: The Rise and Fall of Public Amusements*. New York: Basic Books, 1993.

National Council of Women of Canada. *Women of Canada: Their Life and Work*. Ottawa: Department of Agriculture, 1900.

Newman, Louise Michelle. *White Women's Rights: The Racial Origins of Feminism in the United States*. Oxford, UK: Oxford University Press, 1999.

Nicholas, Jane. "'A Figure of a Nude Woman': Art, Popular Culture, and Modernity at the Canadian National Exhibition, 1927." *Histoire sociale / Social History* 41, no. 82 (Nov. 2008): 314–44.

— "Gendering the Jubilee: Gender and Modernity in the Diamond Jubilee of Confederation Celebrations, 1927." *Canadian Historical Review* 90, no. 2 (Jun. 2009): 249–74.

— *The Modern Girl: Feminine Modernities, the Body, and Commodities in the 1920s*. Toronto: University of Toronto Press, 2015.

— "On Display: Bodies and Consumption in the 'New' Canadian Cultural History." *History Compass* 17, no. 2 (Feb. 2019): 1–13.

Nicolosi, Anne Marie. "'The Most Beautiful Suffragette': Inez Mulholland and the Political Currency of Beauty." *Journal of the Gilded Age and Progressive Era* 6, no. 3 (July 2007): 287–309.

Nield, Sophie. "Popular Theatre, 1895–1940." In *The Cambridge History of British Theatre, Vol. 3: Since 1895*, edited by Baz Kershaw, 86–109. Cambridge: Cambridge University Press, 2004.

Noël, Françoise. *Family Life and Sociability in Upper and Lower Canada, 1780–1870*. Montreal, QC, and Kingston, ON: McGill-Queen's University Press, 2003.

Noles, Randy. "The Importance of Being Annie." *Winter Park Magazine* (5 Jun. 2015). https://winterparkmag.com/2015/06/05/importance-annie/.

Norwood, Janice. "Picturing Nineteenth-Century Female Theatre Managers: The Iconology of Eliza Vestris and Sara Lane." *New Theatre Quarterly* 33, no. 1 (Feb. 2017): 3–31.

Nussbaum, Felicity. "Actresses and the Economy of Celebrity, 1700–1800." In *Theatre and Celebrity in Britain, 1660–2000*, edited by Mary Luckhurst and Jane Moody, 148–68. Basingstoke, UK: Palgrave Macmillan, 2005.

Odell, George C.D. *Annals of the New York Stage, vol. 14: 1888–1891*. New York: Columbia University Press, 1945.

O'Dell, Leslie. "Amateurs of the Regiment, 1815–1870." In *Early Stages: Theatre in Ontario 1800–1914*, edited by Ann Saddlemyer, 52–89. Toronto: University of Toronto Press, 1990.

Oldenziel, Ruth, and Mikael Hård. *Consumers, Tinkerers, Rebels: The People Who Shaped Europe*. Basingstoke, UK: Palgrave Macmillan, 2013.

O'Neill, Louisa Peat. "When Canada Went Wilde." *Canadian Theatre Review* 18 (Spring 1978): 33–5.

O'Neill, Patrick B.A. "A History of Theatrical Activity in Toronto, Canada: From Its Beginnings to 1858." PhD thesis. Baton Rouge: Louisiana State University, 1973.

— "Margaret Bannerman." *The Canadian Encyclopedia*. https://www.thecanadianencyclopedia.ca/en/article/margaret-bannerman (accessed 26 Aug. 2021).

Osterhammel, Jürgen. *The Transformation of the World: A Global History of the Nineteenth Century*. Princeton, NJ: Princeton University Press, 2014.

Page, Bruce, David Leitch, and Philip Knightley. *Philby: The Spy Who Betrayed a Generation*. Harmondsworth, UK: Penguin, 1969.

Paisley, Fiona, and Pamela Scully. *Writing Transnational History*. London: Bloomsbury, 2019.

Pascoe, Judith. *The Sarah Siddons Audio Files: Romanticism and the Lost Voice*. Ann Arbor, MI: University of Michigan Press, 2011.

Pascoe, Peggy. *Relations of Rescue: The Search for Female Moral Authority in the American West, 1874–1939*. New York: Oxford University Press, 1990.

Peiss, Kathy. *Cheap Amusements: Working Women and Leisure in Turn-of-the-Century New York*. Philadelphia: Temple University Press, 1985.

Peters, Sally. "Shaw's Life: A Feminist in Spite of Himself." In *The Cambridge Companion to George Bernard Shaw*, edited by Christopher Innes, 3–24. Cambridge: Cambridge University Press, 2006.

Phillips, Scott. "Rational Entertainment, Music Hall, and the Nineteenth-Century British Periodical Press." *Theatre History Studies* 22 (Jan. 2002): 195–213.

Pickford, Mary. *Sunshine and Shadow*. New York: Doubleday, 1955.

Pickles, Katie. *Transnational Outrage: The Death and Commemoration of Edith Cavell*. Basingstoke, UK: Palgrave Macmillan, 2007.

Piepmeier, Alison. *Out in Public: Configurations of Women's Bodies in Nineteenth-Century America*. Chapel Hill, NC: University of North Carolina Press, 2004.

Plotnicki, Rita M. "Viola Allen." In *Notable Women in the American Theatre: A Biographical Dictionary*, edited by Plotnicki, 18–20. New York: Greenwood Press, 1989.

Pollock, Della, ed. *Exceptional Spaces: Essays in Performance and History*. Chapel Hill, NC: University of North Carolina Press, 2000.

Polster, Joshua E. *Stages of Engagement: U.S. Theatre and Performance 1898–1940*. New York: Routledge, 2016.

Postlewait, Thomas. *The Cambridge Introduction to Theatre Historiography*. Cambridge: Cambridge University Press, 2009.

— "George Edwardes and Musical Comedy: The Transformation of London Theatre and Society, 1878–1914." In *The Performing Century: Nineteenth-Century Theatre's History*, edited by Tracy C. Davis and Peter Holland, 80–102. London: Palgrave Macmillan, 2007.

— "The Hieroglyphic Stage: American Theatre and Society Post-Civil War to 1945." In *The Cambridge History of American Theatre*, edited by Don B. Wilmeth and Christopher Bigsby, 107–95. Cambridge: Cambridge University Press, 2008.

— "The London Stage: 1895–1918." In *The Cambridge History of British Theatre, Vol. 3: Since 1895*, edited by Baz Kershaw, 34–59. Cambridge: Cambridge University Press, 2008.

Potter, Simon. "Communications and Integration: The British and Dominion Press and the British World, c. 1876–1914." In *The British World: Diaspora, Culture and Identity*, edited by Carl Bridge and Kent Fedorowich, 190–206. London: Frank Cass, 2003.

— "Webs, Networks, and Systems: Globalization and the Mass Media in the Nineteenth and Twentieth-Century British Empire." *Journal of British Studies* 46, no. 3 (July 2007): 621–46.

Powell, Kerry. "New Women, New Plays, and Shaw in the 1890s." In *The Cambridge Companion to George Bernard Shaw*, edited by Christopher Innes, 76–100. Cambridge: Cambridge University Press, 2006.

— *Women and Victorian Theatre*. Cambridge: Cambridge University Press, 1997.

Preston, Andrew, and Doug Rossinow. *Outside In: The Transnational Circuitry of U.S. History*. Oxford, UK: Oxford University Press, 2017.

Price, Peter. "Naturalising Subjects, Creating Citizens: Naturalisation Law and the Conditioning of 'Citizenship' in Canada, 1881–1914." *Journal of Imperial and Commonwealth History* 45, no. 1 (Jan. 2017): 1–21.

Prochaska, Frank K. *Women and Philanthropy in Nineteenth-Century England*. Oxford, UK: Clarendon Press, 1980.

Professional Woman's League. *Souvenir Book Woman's Exhibition*. New York: Freytag Press, 1902.

Putnam, Lara. "The Transnational and the Text-Searchable: Digitized Sources and the Shadows They Cast." *American Historical Review* 121, no. 2 (Apr. 2016): 377–402.

Pybus, Cassandra. *Epic Journeys of Freedom: Runaway Slaves of the American Revolution and Their Global Quest for Liberty*. Boston, MA: Beacon Press, 2006.

Pye, Deborah. "'Irreproachable Women and Patient Workers': The Memoirs of Victorian Leading Ladies." *Texas Studies in Literature and Language* 45, no. 1 (Spring 2003): 73–91.

Radforth, Ian. *Royal Spectacle: The 1860 Visit of the Prince of Wales to Canada and the United States*. Toronto: University of Toronto Press, 2004.

Richards, Jeffrey. "Drury Lane Imperialism." In *Politics, Performance and Popular Culture: Theatre and Society in Nineteenth-Century Britain*, edited by Peter Yeandle, Katherine Newey, and Jeffrey Richards, 174–94. Manchester, UK: Manchester University Press, 2016.

— "Henry Irving: The Actor-Manager as Auteur." *Nineteenth-Century Theatre and Film* 32, no. 2 (Winter 2005): 20–35.

— *Sir Henry Irving: A Victorian Actor and His World*. London: Hambledon and London, 2005.

Richardson, Judith. *Possessions: The History and Uses of Hauntings in the Hudson River Valley*. Cambridge, MA: Harvard University Press, 2003.

Roach, Joseph. "Public Intimacy: The Prior History of 'It.'" In *Theatre and Celebrity in Britain, 1660–2000*, edited by Mary Luckhurst and Jane Moody, 15–30. Basingstoke, UK: Palgrave Macmillan, 2005.

Roberts, Mary Louise. "Making the Modern Girl French: From New Woman to Éclaireuse." In *The Modern Girl Around the World: Consumption, Modernity, and Globalization*, edited by The Modern Girl Around the World Research Group (Alys Eve Weinbuam, Lynn M. Thomas, Priti Ramamurthy, Uta G. Poige, Madeline Y. Dong, and Tani E. Barlow), 77–95. Durham, NC: Duke University Press, 2008.

Robinson, Alice M., Vera Mowry Roberts, and Milly S. Barranger, eds. *Notable Women in the American Theatre: A Biographical Dictionary*. New York: Greenwood Press, 1989.

Rose, Jonathan. *The Intellectual Life of the British Working Classes*. New Haven, CT: Yale University Press, 2001.

Rosenberg, Emily S. "Transnational Currents in a Shrinking World." In *A World Connecting 1870–1945*, edited by Rosenberg, 815–960. Cambridge and London: Belknap Press, 2012.

Ross, Becki. *Burlesque West: Showgirls, Sex, and Sin in Postwar Vancouver*. Toronto: University of Toronto Press, 2009.

Ross, Ellen. *Love and Toil: Motherhood in Outcast London, 1870–1918*. New York: Oxford University Press, 1993.

Rozmovits, Linda. *Shakespeare and the Politics of Culture in Late Victorian England*. Baltimore, MD: Johns Hopkins University Press, 1998.

Russell, Annie. "George Bernard Shaw at Rehearsals of 'Major Barbara.'" *The Shaw Review* 19, no. 2 (May 1976): 73–82. Orig. delivered 28 Apr. 1908.

Russell, Gillian. *Theatres of War: Performance, Politics, and Society 1793–1815*. Oxford, UK: Oxford University Press, 1995.

Rutledge, Martha. "Kelly, Ethel Knight [1875–1949]." *Australian Dictionary of Biography*. https://adb.anu.edu.au/biography/kelly-ethel-knight-6917 (accessed 26 Aug. 2021).

— "Kelly, Thomas Herbert [1875–1948]." *Australian Dictionary of Biography*. https://adb.anu.edu.au/biography/kelly-thomas-herbert-6924 (accessed 26 Aug. 2021).

Ryan, Mary P. *Cradle of the Middle Class: The Family in Oneida County, New York, 1790–1865*. Cambridge: Cambridge University Press, 1981.

Saddlemyer, Ann, ed. *Early Stages: Theatre in Ontario 1800–1914*. Toronto: University of Toronto Press, 1990.

Saddlemyer, Ann, and Richard Plant, eds. *Later Stages: Essays in Ontario Theatre from the First World War to the 1970s*. Toronto: University of Toronto Press, 1997.

Salter, Denis. "At Home and Abroad: The Acting Career of Julia Arthur (1869–1950)." *Theatre Research in Canada* 5, no. 1 (Spring 1984). http://journals.hil.unb.ca/index.php/tric/article/view/7446/8505 (accessed 23 Aug. 2012).

Sánchez-Eppler, Karen. *Dependent States: The Child's Part in Nineteenth-Century American Culture*. Chicago, IL: University of Chicago Press, 2005.

Sander, Kathleen Waters. *The Business of Charity: The Woman's Exchange Movement, 1832–1900*. Urbana and Chicago, IL: University of Illinois Press, 1998.

Sandoval-Strauss, A.R. *Hotel: An American History*. New Haven, CT: Yale University Press, 2007.

Saunier, Pierre-Yves. *Transnational History*. Houndmills, UK: Palgrave Macmillan, 2013.

Scanlan, Padraic X. "Bureaucratic Civilization: Emancipation and the Global British Middle Class." In *The Global Bourgeoisie: The Rise of the Middle Classes in the Age of Empire*, edited by Christof Dejung, David Motadel, and Jürgen Osterhammel, 143–61. Princeton, NJ: Princeton University Press, 2019.

Schoch, Richard. "Theatre and Mid-Victorian Society, 1851–1870." In *The Cambridge History of British Theatre, vol. 2*, edited by Joseph Donohue, 331–51. Cambridge: Cambridge University Press, 2004.

Schoch, Richard, ed. *Macready, Booth, Terry, Irving*. London and New York: Continuum, 2011.

Schwartz, Michael. *Broadway and Corporate Capitalism: The Rise of the Professional-Managerial Class, 1900–1920*. New York: Palgrave Macmillan, 2009.

Schweitzer, Marlis. "Accessible Feelings, Modern Looks: Irene Castle, Ira L. Hill, and Broadway's Affective Economy." In *Feeling Photography*, edited by Elspeth H. Brown, 204–36. Durham, NC: Duke University Press, 2014.

- "'Darn That Merry Widow Hat': The On- and Offstage Life of a Theatrical Commodity, Circa 1907–1908." *Theatre Survey* 50, no. 2 (Nov. 2009): 189–221.
- "'The Mad Search for Beauty': Actresses' Testimonials, the Cosmetic Industry, and the Democratization of Beauty." *Journal of the Gilded Age and Progressive Era* 4, no. 3 (July 2005): 255–92.
- "Patriotic Acts of Consumption: Lucile (Lady Duff Gordon) and the Vaudeville Fashion Craze." *Theatre Journal* 60, no. 4 (Dec. 2008): 585–608.
- "Singing Her Own Song: Writing the Female Press Agent Back into History." *Journal of American Drama and Theatre* 20, no. 2 (Spring 2008): 87–106.
- *Transatlantic Broadway: The Infrastructural Politics of Performance*. Houndmills, UK: Palgrave Macmillan, 2015.
- *When Broadway Was the Runway: Theater, Fashion, and American Culture*. Philadelphia: University of Pennsylvania Press, 2009.

Schweitzer, Marlis, and Joanne Zerdy, eds. *Performing Objects and Theatrical Things*. Basingstoke, UK: Palgrave Macmillan, 2014.

Scott, Robert B. "Professional Performers and Companies." In *Later Stages: Essays in Ontario Theatre from the First World War to the 1970s*, edited by Ann Saddlemyer and Richard Plant, 13–120. Toronto: University of Toronto Press, 1997.

Seale, Patrick, and Maureen McConville. *Philby: The Long Road to Moscow*. London: H. Hamilton, 1973.

Sehat, David. "Gender and Theatrical Realism: The Problem of Clyde Fitch." *Journal of the Gilded Age and Progressive Era* 7, no. 3 (July 2008): 325–52.

Sentilles, Renée M. *Performing Menken: Adah Isaacs Menken and the Birth of American Celebrity*. Cambridge: Cambridge University Press, 2003.
- "Toiling in the Archives of Cyberspace." In *Archives Stories: Fact, Fictions, and the Writing of History*, edited by Antoinette Burton, 136–56. Durham, NC: Duke University Press, 2005

Shaw, Amy J., and Sarah Carlene Glassford, eds. *A Sisterhood of Suffering and Sacrifice: Women and Girls of Canada and Newfoundland during the First World War*. Vancouver, BC: University of British Columbia Press, 2012.

Siegel, Micol. "Beyond Compare: Comparative Method after the Transnational Turn." *Radical History Review* 91 (Winter 2005): 61–90.

Simmons, Jack, and Gordon Biddle, eds. *The Oxford Companion to British Railway History: From 1603 to the 1990s*, 2nd ed. Oxford, UK: Oxford University Press, 1999.

Simon, Louis M. *A History of the Actors' Fund of America*. New York: Theatre Arts Books, 1972.

Skinner, Otis. *Footlights and Spotlights: Recollections of My Life on the Stage*. Indianapolis: The Bobbs-Merrill Company, 1924.

Smith, Adam I.P. "The Politics of Theatrical Reform in Victorian America." *American Nineteenth Century History* 13, no. 3 (Sept. 2012): 321–46.

Sperdakos, Paula. "Canada's Daughters, America's Sweethearts: The Careers of Canadian 'Footlights Favourites' in the United States." *Theatre Research in Canada* 20, no. 2 (Fall 1989): 1–28.

— *Dora Mavor Moore: Pioneer of the Canadian Theatre*. Toronto: ECW Press, 1995.

Stansell, Christine. *American Moderns: Bohemian New York and the Creation of a New Century*. New York: Metropolitan Books, 2000.

Steedman, Carolyn. *Strange Dislocations: Childhood and the Idea of Human Interiority, 1780–1930*. Cambridge, MA: Harvard University Press, 1995.

Stowell, Sheila. "'Dame Joan, Saint Christabel.'" *Modern Drama* 37, no. 3 (Fall 1994): 421–36.

Strange, Carolyn. *Toronto's Girl Problem: The Perils and Pleasures of the City, 1880–1930*. Toronto: University of Toronto Press, 1995.

Strong-Boag, Veronica. "'The Citizenship Debates': The 1885 Franchise Act." In *Contesting Canadian Citizenship*, edited by Robert Adamoski, Dorothy Chunn, and Robert Menzies, 69–94. Toronto: Broadview Press, 2002.

Strong-Boag, Veronica, and Carole Gerson. *Paddling Her Own Canoe: The Times and Texts of E. Pauline Johnson (Tekahionwake)*. Toronto: University of Toronto Press, 2000.

Swain, Shurlee, and Margot Hillel. *Child, Nation, Race and Empire: Child Rescue Discourse, England, Canada and Australia 1850–1915*. Manchester, UK: Manchester University Press, 2015.

Thelen, David. "Of Audiences, Borderlands and Comparisons: Toward the Internationalization of American History." *The Journal of American History* 79, no. 2 (Sept. 1992): 432–62.

Tickner, Lisa. *The Spectacle of Women: Imagery of the Suffrage Campaigns 1907–1914*. Chicago, IL: University of Chicago Press, 1988.

Tilghman, Carolyn. "Staging Suffrage: Women, Politics, and the Edwardian Theater." *Comparative Drama* 45, no. 4 (Winter 2011): 339–60.

Tippett, Maria. *Making Culture: English-Canadian Institutions and the Arts before the Massey Commission*. Toronto: University of Toronto Press, 1990.

Troubridge, St Vincent. *The Benefit System in the British Theatre*. London: Society for Theatre Research, 1967.

Turner, Mary M. *Forgotten Leading Ladies of the American Theatre: Lives of Eight Female Players, Playwrights, Directors, Managers, and Activists of the Eighteenth, Nineteenth, and Early Twentieth Centuries*. Jefferson, NC: McFarland, 1990.

Valchon, Pierre. "Lajeunesse, Emma (Marie-Louise-Cécile-Emma)." *Dictionary of Canadian Biography*, vol. 15. Toronto and Laval, QC: University of Toronto / Université Laval, 2003.

Valverde, Mariana. *The Age of Light, Soap, and Water: Moral Reform in English Canada, 1885–1925*, 2nd ed. Toronto: University of Toronto Press, 2008.

Vance, Jonathan. *Death So Noble: Memory, Meaning, and the First World War*. Vancouver, BC: University of British Columbia Press, 1997.

— *A History of Canadian Culture*. Toronto: Oxford University Press, 2009.

Varty, Anne. *Children and Theatre in Victorian Britain: "All Work, No Play."* Houndmills, UK: Palgrave Macmillan, 2008.

— "The Rise and Fall of the Victorian Stage Baby." *New Theatre Quarterly* 21, no. 3 (Aug. 2005): 218–29.

Vester, Katharina. "Regime Change: Gender, Class, and the Invention of Dieting in Post-Bellum America." *Journal of Social History* 44, no. 1 (Fall 2010): 39–70.

Vey, Shauna. "Good Intentions and Fearsome Prejudice: New York's 1876 Act to Prevent and Punish Wrongs to Children." *Theatre Survey* 42, no. 1 (May 2001): 53–68.

Vincent, David. *Bread, Knowledge and Freedom: A Study of Nineteenth Century Working Class Autobiographies*. London: Europa Publications, 1981.

Walden, Keith. "Toronto's Responses to Celebrity Performers, 1887–1914." *Canadian Historical Review* 89, no. 3 (Sept. 2008): 373–97.

— "Whose Method? Culture, Commerce, and American Performer Training." *New Theatre Quarterly* 19, no. 4 (Nov. 2003): 318–25.

Walkowitz, Judith R. "Cosmopolitanism, Feminism, and the Moving Body." *Victorian Literature and Culture* 38 (2010): 427–49.

— *Nights Out: Life in Cosmopolitan London*. New Haven, CT, and London: Yale University Press, 2012.

Waltonen, Karma. "*Saint Joan*: From Renaissance Witch to New Woman." *SHAW The Annual of Bernard Shaw Studies* 24 (2004): 186–203.

Ward, Brian. "Music, Musical Theater, and the Imagined South in Interwar Britain." *The Journal of Southern History* 80, no. 1 (Feb. 2014): 39–72.

Ware, Amy M. "Unexpected Cowboy, Unexpected Indian: The Case of Will Rogers." *Ethnohistory* 56, no. 1 (Winter 2009): 1–34.

Ware, Susan. "The Book I Couldn't Write: Alice Paul and the Challenge of Feminist Biography." *Journal of Women's History* 24, no. 2 (Summer 2012): 13–36.

Wattenberg, Richard. *Early-Twentieth-Century Frontier Dramas on Broadway: Situating the Western Experience in the Performing Arts*. New York: Palgrave Macmillan, 2011.

Weiner, Gaby. "Olive Banks and the Collective Biography of British Feminism." *British Journal of Sociology of Education* 29, no. 4 (July 2008): 403–10.

Werner, Robin A. "The Angel in the Theatre: Marie Wilton, the Performance of Femininity and Intertheatrical Playwrighting." *Theatre History Studies* 21 (Jan. 2001): 43–59.

Whitfeld, Eileen. *Pickford: The Woman Who Made Hollywood*. Toronto: McFarlane, Walter, and Ross, 1997.

Whittaker, Robin C. "'Entirely Free of Any Amateurishness': Private Training, Public Taste and the Women's Dramatic Club of University College, Toronto (1905–21)." *Nineteenth Century Theatre & Film* 38, no. 2 (Winter 2011): 51–66.

Willard, Frances E., and Mary Livermore. "Mather, Margaret." In *American Women: Fifteen Hundred Biographies with Over 1,400 Portraits: A Comprehensive Encyclopedia of the Lives and Achievements of American Women during the Nineteenth Century*, vol. III, edited by Willard and Livermore, 495–6. New York: Mast, Crowell, and Kirkpatrick, 1897.

Wilmer, S.E. "Introduction." In *Writing and Rewriting National Theatre Histories*, edited by S.E. Wilmer, ix–xi. Iowa City, IA: University of Iowa Press, 2004.

– *Writing and Rewriting National Theatre Histories*. Iowa City, IA: University of Iowa Press, 2004.

Wilmeth, Don B., and Christopher Bigsby, eds. *The Cambridge History of American Theatre*. Cambridge: Cambridge University Press, 2004.

Wilson, Kathleen. "Introduction: Three Theses on Performance and History." *Eighteenth-Century Studies* 48, no. 4 (Summer 2015): 375–90.

– "The Lure of the Other: Sheridan, Identity and Performance in Kingston and Calcutta." *Eighteenth-Century Fiction* 27, nos. 3–4 (Spring–Summer 2015): 509–34.

– "Rowe's *Fair Penitent* as Global History: Or, a Diversionary Voyage to New South Wales." *Eighteenth-Century Studies* 41, no. 2 (Winter 2008): 231–52.

Winnipeg Kiddies. *Photographic Souvenir of the Winnipeg Kiddies*. Edmonton: Peel Library, University of Alberta, c. 1915. http://peel.library.ualberta.ca/bibliography/10081/1.html.

Winter, Jay. *Sites of Memory, Sites of Mourning: The Great War in European Cultural History*. Cambridge: Cambridge University Press, 1995.

Winter, William. *Shakespeare on the Stage*. New York: Moffat, Yard, 1911.

Woods, Leigh. "American Vaudeville, American Empire." In *Performing America: Cultural Nationalism in American Theatre*, edited by Jeffrey D. Mason and J. Ellen Gainor, 73–90. Ann Arbor, MI: University of Michigan Press, 1999.

– *Transatlantic Stage Stars in Vaudeville and Variety Celebrity Turns*. Basingstoke, UK: Palgrave Macmillan, 2006.

Woodworth, Christine. "The Company She Kept: The Radical Activism of Actress Kitty Marion from Piccadilly Circus to Times Square." *Theatre History Studies* 32 (2012): 80–92.

Woollacott, Angela. "'All This Is the Empire, I Told Myself': Australian Women's Voyages 'Home' and the Articulation of Colonial Whiteness." *American Historical Review* 102, no. 4 (Oct. 1997): 1003–29.

— *Race and the Modern Exotic: Three 'Australian' Women on Global Display.* Melbourne: Monash University Press, 2011.
— *To Try Her Fortune in London: Australian Women, Colonialism, and Modernity.* London: Oxford University Press, 2001.
Wozniak, Heather Anne. "The Play with a Past: Arthur Wing Pinero's New Drama." *Victorian Literature and Culture* 37, no. 2 (2009): 391–409.
Yeandle, Peter, Katherine Newey, and Jeffrey Richards, eds. *Politics, Performance and Popular Culture: Theatre and Society in Nineteenth-Century Britain.* Manchester, UK: Manchester University Press, 2016.
Young, Harvey, ed. *The Cambridge Companion to African-American Theatre.* Cambridge: Cambridge University Press, 2013.
Young, Linda. *Middle-Class Culture in the Nineteenth Century: America, Australia and Britain.* Basingstoke, UK, and New York: Palgrave Macmillan, 2003.

INDEX

Actors' Equity, 234–6
Actors' Fidelity League, 234
Actors' Fund: Fairs, 179; formation, 178; Home, 303; nature of, 189
actresses: advertising consumer goods, 157–61; and charity, 175–91; and economic uncertainty, 53–8; as emotional performers, 101–6; family life and domesticity, 152–7; geographic mobility of, 6–7, 9, 51–2; hardworking and intelligent, 143–52; health concerns of, 148–9; historiography, 4–6; in history plays, 106–24; and interwar modernity, 262; interwar transnational networks, 262–74; as managers, 63–82; marriages, 161–4; memoir and autobiography, 38–9; memory of, 303–4; national identity of, 130–42, 270–4; as New Women, 120, 126–7; religious convictions of, 105–6; social mobility of, 148; spreading middle-class culture, 11–13; and stalkers, 165–8; and suffrage, 191–8; sumptuousness of costumes, 117; as tourists, 58–62; in World War I, 199–213
Adams, Maude, 101, 108, 148, 242, 256
Allan, Maude, 134, 138
Allen, Viola: Actors' Fund Fair, 179; advice on acting, 146; American, 130; benefit organizer, 176–7; Canadian, 139; and charity, 185, 188; child performer, 33–4; *The Christian*, 104; *The Daughter of Heaven*, 121–4; death, 303; domesticity, 153–4; emotional performer, 104; hard worker, 143; history plays, 107–10; intelligent, 145; as manager, 68–71; marriage, 161, 163; *In the Palace of the King*, 108; *Sowing the Wind*, 107; Twelfth Night Club, 180; *Under the Red Robe*, 107–8
Anglin, Margaret: Actors' Fund Fair, 179; advice on acting, 145, 146, 147, 149–52; audience reaction to, 226–30, 237–8; *The Awakening of Helena Ritchie*, 102–3; Canadian, 132, 135–6, 139; and charity, 183–8; death, 303; domesticity, 153, 154–8; education and family, 24–5, 28–9, 164–5; emotional performer, 101–3; *The Great Divide*, 97–9; Greek theatre, 77–8; *Green Stockings*, 92–4; hard worker, 143; health problems, 149; intelligent, 145; Irish-Canadian, 141; as manager, 76–81; as moral exemplar, 233–4; *Mrs. Dane's Defence*, 90–2; National Stage Women's Exchange, 181; opposition to Actors' Equity, 234–6; and Catherine Proctor, 242; radio, 232, 237–8; Roman Catholic

Church, 229–31; stalkers, 165–7; and suffrage, 191–4, 197–8; as tourist, 62; *The Trial of Joan of Arc*, 228–9; *The Woman of Bronze*, 225–8; in World War I, 210; *Zira*, 92

Arthur, Julia: advice on acting, 145; American, 130; Canadian, 132–9; and charity, 182–3; child performer, 40–2; death, 303; education and family, 27–8, 165; *Hamlet*, 218–22; hard worker, 143; history plays, 111–16; intelligent, 145; *A Lady of Quality*, 115–20; *Macbeth*, 218; as manager, 73–4; marriage, 161, 172, 216; *Mercedes*, 111; *More than Queen*, 111, 117; and Catherine Proctor, 242; and Professional Women's League, 180; *Saint Joan*, 222–5; and stalker, 168; in World War I, 200, 202–6, 210

Ashwell, Lena: British Empire, 141; Canadian, 138–9; and charity, 181–8; in commercial theatre, 251; complaints about touring, 52; *Darling of the Gods*, 120–1; death, 303; *Diana of Dobson's*, 126–7; emotional performer, 101; education and family, 26; *Judith Zaraine*, 127–8; *Leah Kleschna*, 86; as manager, 74–6; marriages and divorce, 163–4; *Mrs. Dane's Defence*, 90–2; *Resurrection*, 86; salary, 148; *The Shulamite*, 94–7; and suffrage, 195–6; in World War I, 202–6, 210

audiences: emotional identification, 106–7; reaction to Margaret Anglin, 226–30, 237–8; reaction to Margaret Bannerman, 262, 287–8; stalkers, 165–8

Australia: Margaret Anglin in, 62, 141, 150–1, 154–5; Margaret Bannerman in, 267–70

Bannerman, Margaret: advertising consumer goods, 285; beauty advice, 284–5; Canadian, 270–3; and charity, 274; compared to Mary Pickford, 261; death, 303; *Decameron Nights*, 266–7; *Diplomacy*, 268; female admirers, 262, 287–8; icon of beauty and fashion, 256, 277–81; *Lady Audley's Secret*, 256; marriage and divorce, 288–91; *Other Men's Wives*, 268–9; *Our Betters*, 256–61, 267–8; *Three Waltzes*, 265; Toronto origins and education, 249–50; tour of Australia and New Zealand, 267–70; *Trelawny of the Wells*, 262; *Under Cover*, 256; in World War I, 201–2

Barrymore, Ethel, 236
Barrymore, Lionel, 218
Beaudet, Louise, 139
Belasco, David, 46–7, 120–1, 242
Bell, Archie, 122, 220
benefit performances, 175–8
Bernhardt, Sarah, 101, 130, 148, 149, 220
Bonstelle, Jessie, 242
Boucicault, Dion, 188
Buchanan, Jack, 251, 265
Burnett, Frances Hodgson, 115

Campbell, Mrs Pat, 148, 149
Cargill, Jerry, 234
Carleton, Carl E., 290–1
Carter, Mrs Leslie, 101
Casson, Lewis, 297

Charlot, André, 249–51, 263, 264
Cheney, Benjamin, 73–4, 116, 161, 172, 216, 218. *See also* Arthur, Julia
child performers, debates over, 29–33. *See also* Allen, Viola; Arthur, Julia; Morris, Clara; Russell, Annie; White, Marjorie Guthrie
Clarendon, Anita, 181
Clarke, Grace Olmstead, 195
Cocroft, Thoda, 236
Coward, Noel, 251, 265, 296
Crosby, Florence, 172
Curley, James M., 137

Dale, Alan, 218
Daly, Augustin, 86, 103, 124
Damrosch, Anita, 151
Damrosch, Walter, 151
Das Gupta, K.W., 233
Day, Edith, 288–9, 290
Dempsey, Lotta, 242
Doble, Frances: *Ballerina*, 297; *The Black Spider*, 296; *The Chinese Bungalow*, 296; fashionable beauty, 299; *The Goddess*, 296; *The Man in Dress Clothes*, 296; marriage and motherhood, 299; Montreal origins, 296; relationship with Kim Philby, 299–302; *Sirocco*, 296; support for Franco, 299; *Vaudeville Varieties*, 296; *While Parents Sleep*, 297; *Young Woodley*, 296
Dolin, Anton, 297
Dressler, Marie: Canadian, 138; early career, 45; education and family, 28; and Professional Women's League, 180; and suffrage, 197
Duncan, Sara Jeannette, 90

Duryea, Peter, 74, 161–3. *See also* Allen, Viola

Edwards, Mae: advice on health, 247; *Dope*, 246; Mae Edwards Players, 246–7; Passers By company, 246; popularity, 247; retirement in Lindsay, 247

fashion, European aristocracy and, 116. *See also* Bannerman, Margaret
Faversham, William, 79–81
feminist collective biography, 14–15
Fiske, Harrison, 178
Fiske, Minnie Maddern, 86, 235, 242
France, 84–6, 89, 117, 278–81
French, John M., 234
Friganza, Trixie, 221–2
Frohman, Charles, 86, 107
Frohman, Daniel, 218

Gautier, Judith, 121
Gerry, Eldridge, 30
Gillmore, Frank, 235
Godwin, George, 261
Goldberg, Harry, 273
Grahame, Gwynethe, 270–2
Grein, J.T., 249, 253–4, 256
Grundy, Sidney, 107

Haberkorn, Emil, 66, 162. *See also* Mather, Margaret
Hamilton, Cecily, 104, 126, 191, 194
Hammond, Percy, 265
Hill, J.M., 64–6, 162, 168
Horn, Kate, 63, 139
hotels, 56–8
Hoyt, Caroline Miskel, 123, 134, 139, 185

Hull, Howard, 79, 105, 151–2, 234–6, 238. *See also* Anglin, Margaret
Hull, Josephine, 238, 241
Hurlburt, Jack, 251

imperialism, 92–6, 14, 224, 270, 281–4
International Alliance of Theatre and Stage Employees, 178, 235
Irving, Henry, 18, 63, 73, 117, 121, 130, 132, 135, 137, 145. *See also* Arthur, Julia; Ashwell, Lena
Irwin, May: Canadian, 139; child performer, 37; salary, 148; and suffrage, 195; in World War I, 206–8

Jacobs-Bond, Carrie, 238

Kauser, Alice, 237–8
Keegan, Mary, 17, 52, 135
Kelly, Ethel Knight Mollison, 61–2, 73, 139
Kershaw, Willette, 266
Kester, Paul, 225
King, William Lyon Mackenzie, 237
Kobbé, Gustav, 153

Langtry, Lillie, 148
Lawrence, Everetta, 139
Lawrence, Gertrude, 251, 264–5, 294
Leigh, Margaret, 233
Lillie, Beatrice: advertising consumer goods, 285; and charity, 274; in André Charlot's revues, 251–6; compares Britain to America, 273–4; death, 249; debut at Alhambra, 249; fashion, 275–7; marriage, 291–5; motherhood, 294–5; and Prince of Wales, 294; sexually ambiguous, 256; Tony Award, 249; transatlantic culture, 263–5; *This Year of Grace*, 269
Lindsay-Hogg, Anthony, 299. *See also* Doble, Frances
Loftus, Cecilia, 188
Long, John Luther, 120
Loti, Pierre, 121
Lyceum Players, 246

MacDonnell, Katherine, 138
Macmillan, Cyrus, 138
Manners, J. Hartley, 92
Mantle, Burns, 221
Marbury, Elisabeth (also Elsa), 229, 236
Marriot, R.B., 299
Mather, Margaret: Canadian, 139; divorce, 168–72; education and family, 27–8; emotional performer, 101; health problems, 149; *Leah the Forsaken*, 84; as manager, 64–8; marriage, 162–3
Maugham, Somerset, 246, 256
McIntyre, O.O., 277
McLellan, C.S., 127
middle-class culture: actresses as representative of, 143–65; advice literature, 148; charity, 190; domesticity, 152–7; global spread of, 11–12; potential threats to, 104–5
Miller, Henry, 92, 97, 138, 166
Modern Girl, the, 215, 248
Moody, William Vaughan, 97
Moreau, Emile, 228
Morgan, Henry James, 139–40
Morris, Clara: and Actors' Fund, 179; advice on acting, 147; *Alixe*, 85–6; benefit performance

for, 177–8; Canadian, 138, 139; child performer, 37–8, 42–5; emotional performer, 101, 103; French-Canadian, 131; health problems, 149; *Miss Multon*, 84; as tourist, 59–60

Mosley, Oswald, 301

national identity: American, 92; Canadian, 9–10, 16, 131–42, 270–3; English, 264–5, 281–4

National Stage Women's Exchange, 181

Native Americans, 100–1

newspapers, 19–21

New Zealand, 267–8, 270. *See also* Bannerman, Margaret

Nickinson, Charlotte, 63, 139

Novello, Ivor, 263, 297

Pabst, Gustav, 168, 172

Peel, Pollie, 136, 152

Peters, Eliza Nickinson, 26

Philby, Kim, 299–302

Phillips, Elizabeth Jane, 52–60, 153, 180

Pickford, Mary, 39–40, 45–7, 261

Playfair, Arthur W., 163–4. *See also* Ashwell, Lena

Pollock, William, 261

Powell, S. Morgan, 223

Prinsep, Anthony, 272, 291. *See also* Bannerman, Margaret

Proctor, Catherine: Actors' Fund Fair, 179; *Ah Wilderness*, 246; *Arsenic and Old Lace*, 246; and David Belasco, 242; Jessie Bonstelle's Stock Company, 242, 246; Canadian, 138; early education, 242; *East of Suez*, 245–6; *The Great Divide*, 245; *Jalna*, 246; Lyceum Players, 246; *A Midsummer Night's Dream*, 242; *Mrs. Tayler*, 246

Professional Women's League, 180, 196–7

race, 13–14, 61–2; representations of Asians, 121–4, 296; representations of white womanhood, 97–106

Rehan, Ada, 101, 103

Réjane, Gabrielle, 188

Robson, May Waldron, 124, 134, 139

Roman Catholicism, cultural attractions of, 116. *See also* Anglin, Margaret

Royal Alexandra Theatre, 127–8

Russell, Annie: advice on acting, 147; benefit performance for, 175–6; Canadian, 138; charity, 183; child performer, 34–7; death, 303; domesticity, 155; *Esmeralda*, 86–90; family, 165; health problems, 149; intelligent, 145; *Major Barbara*, 124–6; manager, 63–4; marriages and divorces, 163; *A Midsummer Night's Dream*, 242; *The Nigger*, 99–100; and Professional Women's League, 180; at Rollins College, 303; *The Royal Family*, 90; and suffrage, 194–5

Sandwell, Bernard K., 133–4

Shaw, George Bernard, 104, 124–6, 222, 251

Sheldon, Edward, 99

Simson, Henry, 163, 195, 196, 303

Sitwell, Georgia Doble, 299. *See also* Doble, Frances

Sitwell, Sacheverell, 299, 301. *See also* Doble, Frances

Skinner, Otis, 65–6
Smith, Eleanor, 297
Somerset, Pat, 288–91. *See also* Bannerman, Margaret
Stage Women's War Relief, 210
Stoddard, Lorimer, 108
Summerville, Amelia: and Actors' Fund Fair, 179; and charity, 182; and Democratic Party, 213; as manager, 17; motherhood, 164; national identity, 131, 138; and Professional Women's League, 180; and suffrage, 195; in World War I, 185, 188, 210
Swan, Gilbert, 265

Tallis, George, 267
Terry, Ellen, 117, 130, 134, 136, 138, 139, 148, 181–2. *See also* Arthur, Julia; Ashwell, Lena
Thorold, W.J., 134
transnational history: Canadian actresses, 9–10; characteristics, 7–8; theatre history, 8–9; theatrical networks, 262–74; war, 213
Tree, Herbert Beerbohm, 120–1, 135, 188, 195
Tremayne, Julia, 219
Tully, May: Canadian, 131–2, 138; *Curves*, 100–1; education and family, 27; and stalker, 167–8; *Stop, Look and Listen*, 50
Tyler, George C., 237

Van Gundy, Pearl, 186–7. *See also* Allen, Viola
vaudeville, 100–1, 200, 218–22. *See also* Arthur, Julia; Dressler, Marie; Irwin, May; Tully, May

Watson, Lucille: acting advice, 242; *Dancing Mothers*, 239; education, 25; France, 239; in movies, 239, 241–2; *Watch on the Rhine*, 241; in World War II, 241
Webber, John E., 135
Whiffen, Blanche, 184
Whiffen, Thomas, 184–5
White, Marjorie Guthrie, 47–8
Whittaker, Alma, 265
Whittaker, Herbert, 246
Wilde, Oscar, 29, 83
Wilding, Dorothy, 278
Williamson, J.C., 151, 267
Winnipeg Kiddies. *See* White, Marjorie Guthrie
Winter, William, 68–71, 111, 176–7
Wren, Jennie, 224

Yorke, Alicia, 138